HIDDEN HERITAGE

HIDDEN HERITAGE

Rediscovering Britain's
Lost Love of the Orient

Fatima Manji

Chatto & Windus
LONDON

1 3 5 7 9 10 8 6 4 2

Chatto & Windus, an imprint of Vintage, is part of the
Penguin Random House group of companies whose addresses can be
found at global.penguinrandomhouse.com

Penguin
Random House
UK

First published by Chatto & Windus in 2021

penguin.co.uk/vintage

A CIP catalogue record for this book is available from the British Library

ISBN 9781784742911

Typeset in 12.5/15 pt Dante MT Std
by Integra Software Services Pvt. Ltd, Pondicherry

Printed and bound in Great Britain by Clays Ltd, Elcograf S.p.A

The authorised representative in the EEA is Penguin Random House Ireland,
Morrison Chambers, 32 Nassau Street, Dublin D02 YH68

Penguin Random House is committed to a sustainable future for
our business, our readers and our planet. This book is made from
Forest Stewardship Council® certified paper.

For the little explorers who traverse our galleries, museums and heritage sites wondering where their own story fits in

... how strangely the East has come to the West in these times of upheaval.

Brighton Herald
28 August 1915

Contents

Introduction

HAVE YOU BEEN to a stately home lately? Despite the unique history of each building, it often seems like there is a rhythm to these visits. Walk through the hallways to see portraits of a lionised landed family with their porcelain skins and a compulsory display of European art, collected by a son on the Grand Tour. Admire the architecture; allow yourself to be amused by the story of a rogue uncle or scorned lover; and end your trip with tea and a scone. If you are interested in interior design, there is inspiration enough in the coving and the sconces; the gardens often prove delightful; and lovers of art will find enough to impress them. But beyond the twee trappings, Britain's heritage sites are home to a hidden history.

Every so often, strolling through marbled halls on my own such trips, I would encounter a familiar swirl of Arabic, Persian or Urdu letters, or the brown hue of a sitter's skin in a portrait. In these moments, I would excitedly attempt to seek out more information, from an explanatory sign or from the person manning the room or giving tours around the site. Yet what I sought was not always easily found. This did not seem malicious or deliberate. Often the answer was simply that the staff or volunteers did not know much about these objects, and even a frenzied flick through their guide-books proved unsatisfactory. Each time this happened, I would return home, my mind abuzz with questions: *Why was that there? How did it come about? What's the story behind this object? Who is that person? Why have I never heard about it?* Then I would trawl through

books, fire off emails and wade through manuscripts to find the answers, and upon finally obtaining more information, I would share these discoveries in delight with friends: *'Did you know there was once a mosque built inside Kew Gardens?'* ... *'An actual mosque?'* ... *'Yes, in the Georgian period!'* ... *'Why have I never heard about that?'* That's when I knew it wasn't just me.

After the first few occasions, it became a ritual. I would walk into a gallery or museum, eyes already narrowed, seeking out that unusual object, searching for the unanswered question. It turned into a treasure hunt. I was pursuing these objects and places out of curiosity but, without knowing it, also perhaps using them to find a sense of belonging in my own country. In some strange way, because of my connections through language, culture or religion to these objects, it was like a part of me could be found here. The heritage in these places now felt more mine. *Ours.* I felt a compulsion to share the excitement and the evidence with others, because this was not just a personal adventure. It is proof of a more complex story – one that has implications for who we believe has the right to comment on Britain's history and identity.

Britain seems to suffer from historical amnesia. The popular national imagination often pictures no person of colour to have set foot on these isles before the arrival of Caribbean migrants on board the *Empire Windrush* in 1948, with South Asians following them in the 1950s and 1960s. In this telling of British history, people of colour are cast only as recent immigrants – grateful guests required to integrate into the preordained 'British' way of life. This version of history would have us believe two world wars were fought only by young white men from Europe. It produces narrow period dramas in television and film, wrongly supposing that there are no interactions with the rest of the world to depict, no significant stories of people of colour in Britain to reflect and no debts owed – cultural or otherwise.

Yet hidden away in heritage sites – in stately homes, museums and galleries, the temples of Britishness – I was finding clues to

suggest otherwise. Objects and places that were revealing rarely told histories and, simultaneously, had something to say about our current divisions, at a time when Britain is reshaping its role in the world and debates abound over the legacy of Empire, the role of immigration and what 'Britain' or 'Britishness' is. But despite the abundance of polemic, a thoughtful interrogation of Britishness through the lens of cultural heritage is rare. In conversations around immigration, race and Islam in particular, dehumanising language has become the norm. As a journalist, I often witness first-hand a news narrative dictated by underlying assumptions that are racist and Islamophobic, perpetuated even by those who regard themselves as gatekeepers of civility. It is time to have a more thoughtful conversation about culture and heritage. Currently, stories from Britain's heritage buildings are told by a narrow set of people. Some of the objects illuminated in this book are only ever presented as the rewards of brave colonial conquest, while others are ignored altogether.

All the objects and places described in this book are derived from or inspired by the 'Orient'. Though the term 'Orient' has become unfashionable, I have deliberately chosen it in full knowledge of the connotations. Geographically it encompasses West Asia (described through the British imperial gaze as 'the Middle East') and South Asia. Much of this region was, in some important ways, culturally contiguous for centuries until the fall of the Ottoman Empire. Using only contemporary labels for countries or regions ignores how they were interconnected and influenced each other. For instance, in the Victorian period, a pair of wood carvers from modern-day Pakistan (then India) were inspired by elements of North African architecture, and they used these inspirations to decorate an object due to be displayed in London; they then signed their names in Persian calligraphy. Only the word 'Orient' captures the multitude of influences here. It was also the term commonly used during the periods when the objects and places in this book were acquired or built.

I am aware too that, while this book calls for a more complex and accurate understanding of British history and identity, to refer to the 'Orient' today is to invite charges of flattening the history of West and South Asia. But to use the term 'Orient' is not necessarily to engage in orientalism – the practice of caricaturing people and cultures across West and South Asia as all possessing the same 'essential' characteristics and then using such caricatures to dominate, oppress and subjugate them.

On the contrary, I write with the intention of reminding us how the cultural objects discussed in this book were acquired or built – often simultaneously in a performance of appreciation of the Orient and its cultures, and as part of a political project to dominate the regions and their peoples. That honest reappraisal must be the first step towards liberating British discourse on our history from the tyranny of jingoism.

The heritage sites introduced in this book include places managed by the National Trust, English Heritage and other charitable institutions. I have generally avoided the larger museums and more famous objects or places, unless they are a crucial part of the story in a particular chapter, because this work is about things we have forgotten and how they might help us understand some contemporary events in Britain.

This book does not offer a comprehensive narrative history or geography. It covers a vast period, beginning in the sixteenth century when Elizabethan England was a vulnerable state seeking alliances with the powers of the Orient and developing its own privateering empire. It ends with stories from the final years of the British Empire, when Britain had become the stronger power and used the people of the Orient to fight its wars. These tales are based on a collection of objects and places that have caught my attention in a combination of fortuitous *flânerie* and sober study. There are many more that will capture you, and I look forward to hearing about them. I sincerely hope this is merely the beginning of a process – an adventure for you as you look anew at

familiar and less familiar heritage sites, but also for us collectively to think about our heritage differently.

It is important to emphasise that the investigative energy with which I want us to think about heritage sites should not cast attention away from nor excuse the brutalities of the colonial relationships Britain had with so many countries and peoples. Some of these heritage sites were built directly from the proceeds of such cruelties, and others could never exist without the structure of subjugation, extraction and racialised oppression of the British Empire. As a result, there is contention over whether some of the objects should be in Britain at all. There are many good scholars and organisations tackling these issues, and although it is not the focus of my work, these conversations are essential in our reckoning with the suppression of Britain's past.

A whitewashed presentation of history directly affects how Britons today perceive the people, buildings and languages of the Orient. All are regarded as alien threats and new arrivals to be defended against. The thread running through the pages that follow shows the opposite – that in fact, the Orient always had an established place within British (and before it English) history, sometimes in unexpected ways. Our story begins with the mystery of a gentleman on horseback. It details his diplomatic mission from Morocco to Britain and how admiration of this refined visitor was sparked in society circles as he was whirled through dinners of pickled eels in Cambridge and a hurricane in Oxford. We later find ourselves under the reimagined dome of an eighteenth-century Turkish mosque erased as much from the soil as from our collective memory. The delicately designed mosque – the first to be built in Britain – was not in a faraway land, but in Richmond, and was commissioned by the Princess of Wales. Later in our journey, we will explore how the languages of West and South Asia, now regarded with such suspicion that their utterance is cause for teachers to consider reporting children to security services, were once the most desirable proof of cultural refinement in Britain's ruling class, including for Queen Victoria.

This, then, is my rediscovery of lost histories – a way to rethink the simplistic, divisive and alienating history we have previously been presented with. The narratives around Britain's heritage sites inform the national imagination of who is British and who has the right to speak about this country's past and present. I want to inspire those who are searching for a complex, grounded alternative to a parochial sense of Britishness fixated on arbitrary ideas of race.

In heritage buildings across Britain lie paintings, drawings, carvings, statues and tiles that serve as evidence for the sons and daughters of the Orient that there are roots connecting us to these islands hundreds of years before we were born. They suggest that people of colour need not imagine themselves as eternal newcomers, as 'the immigrants' who must 'integrate'; objects and individuals and, even more, ideas and inspirations have travelled here before us and shaped these islands. They are a reminder that we too have a history to draw on in this place and it is as British as any other. That is not a request to be granted. It is merely a reality that can no longer be denied.

Consider this in part a love letter to our heritage sites. They are fascinating and important places, and exist for us all. You may be an avid visitor already. Or you may find the prospect of their vaulted ceilings and gilded grandiosity unnerving. But no one is out of place in these sites, however much or little you may think you know about the history of the buildings, the people and the art that populates them, or once did. Walking into a heritage site is often akin to walking on stage into history itself, and through this book I hope you will find, just as I did, that there may be surprises hiding in plain sight, which perhaps can tell you something unexpected about your own connection to these isles.

We need to share more effectively the stories of these places and the objects that reside in them. Britain has been schooled out of its admiration of the Orient. A knowledge and understanding of these objects and places and the stories they tell can kindle that

affection anew – with conquest supplanted as the motivating factor by a curiosity born of respect and admiration. Yet curiosity is not a panacea. It is what originally motivated some of the interactions you will find in the pages that follow. As all children of Empire know, it is a thin line between curiosity and conquest.

These themes recur constantly in the stories detailed in this book. But neither curiosity nor admiration for other cultures is a safeguard against racist policies or the persistent widening of inequalities rooted in racial hierarchies. Curiosity, or even sympathy, does not amount to material support. In fact, some of the most influential inspirations for those who see themselves as fighting to preserve a virtuous (and white) origin tale for Britain espoused a deep love for the Orient. Enoch Powell, now remembered almost solely for the 'Rivers of Blood' speech that marked him as a founding father of Britain's postcolonial white nationalist movement, said as late as 1968: 'I fell head over heels in love with it [India]. If I'd have gone there a 100 years earlier, I'd have left my bones there.'[1]

Powell was renowned for giving florid speeches about his longing for India and had added Urdu to his linguistic repertoire, along with Greek and Latin, 'to identify' himself 'with the life and language of the country' as a colonial officer in the British Raj. There is a compelling case that it was the Raj and its systematised colonial power that he loved rather than India itself. Nevertheless, his desire for an egalitarian British Commonwealth modelled on Rome, with open borders and a freedom for all to settle anywhere across its territory, was suffused with romance. That lasted until Caribbean and South Asian subjects of the Crown were implored to journey to these shores in the mid-twentieth century to supply a Britain reeling from the 'loss' of Empire with much-needed labour. It was at that point that Powell began painting Britain as a state under siege. His invention of Britain as a *victim* of Oriental conquest is a myth infused throughout our media and political language, and is, arguably, the defining belief that underlies all mainstream debates on immigration. It is also Powell's victimhood myth that

enables far-right firebrands to position themselves as defenders of heritage when they lionise an inanimate Churchill in Parliament Square. They are able to do so because, in the orthodox, nativist telling of our national history, conquest is divorced from the Empire – to the point where it has become normal to hear that Britain was merely helping those it colonised.

Indeed, in the course of researching this book, I overheard a guide at one heritage site announcing to a tour group that Britain's Empire came about because 'the English were asked to help the Indians', while at another site a guide in conversation with a visitor bemoaned the fact he had been to India and not seen signs 'thanking' the British for all the 'good things'. Clearly, these ahistorical narratives have been so embedded in the national culture that even some of those who give of their time to educate others about our past have had their curiosity dimmed.

In the hysterical reaction to the 2020 toppling of Edward Colston's statue by protesters inspired by the Black Lives Matter movement on an avenue named after the slaver in Bristol, it was often ignored that local activists had been trying for some time to place a plaque on the statue explaining Colston's deeds and beliefs. But suggestions to update the language on the existing plaque to reflect his importance in the slave trade had been struck down as 'vandalism' and 'utterly devoid of impartiality' by a local right-wing councillor who campaigned against the changes. Part of his concern was that Colston would be named on the revised plaque as a Conservative MP. This dispute, long before anyone took action to dump Colston in the city's harbour, illustrates the difficulty of relying on our political parties to lead us into honest discussions on heritage. Their long histories of support for Empire abroad and forced 'integration' at home renders them ill-equipped to escape the narrow, parochial parameters of our national debate, which is still caught in the grip of Powell's ghost. This book is partly motivated by a desire to take back control of our national history and empower others to find themselves in it.

In recent years, those who have argued for a nuanced account of Britain's imperial past to be taught in schools have been shouted down as 'hating Britain'. This is short-sighted. Britain's state and civic institutions have been trapped in a confused sense of their purpose in the postcolonial period, still geared at moulding loyal imperial subjects rather than producing well-informed citizens. A less monochrome account of our history is essential as Britain reckons anew with its place in the world. We must have the curiosity to seek out the stories hidden from us, the courage to confront the uncomfortable truths within them and the grace to remember that culture is always the product of interwoven influences and exchange.

The Ambassador

Chiswick House, London

IT WAS CREATED as a temple of the arts. A villa to be filled with paintings – inspired by the architecture of ancient Rome and built in the eighteenth century to show off an art collection. Today, Chiswick House is a neo-Palladian oasis in the architectural desert of suburban west London. The building's perfect proportions are a picture of symmetry. Atop white Corinthian columns sits a pediment – a triangular gable, heavily referencing the Pantheon – and an octagonal dome. The scene has provided an ideal backdrop for many a period drama and, even as I walk through the exquisitely kept grounds, I instantly feel transported to another era.

As I enter, the interior is surprisingly intimate, in contrast with the grandeur of the exterior. At first glance, the ground-level rooms feel a little sparse. I am greeted by stone floors and cream walls with sketches of the building displayed upon them. Only the geometric shapes of the rooms themselves seem striking. But after I climb up a set of unassuming stone steps, an astonishing set of lavish interiors is revealed. These are rooms with velvet walls in striking crimson, cornflower blue and an olive green so dark it almost looks black, with a trimming of gold leaf surrounding the coving, the moulding between the wall and ceiling. Above some doors, this gilding is finished in a scaled pattern, as if large shells are hanging down, while on the floor mythical creatures and cherubs of gold hold up tables of marble.

Underneath the building's central octagonal dome, half-moon windows let in small glimmers of sunlight whenever the clouds

deem it worthy. Though it is summer, the rain is pelting down. A little more light is offered by a chandelier hanging so low it nearly obscures the view of what adorns each of the eight walls of this room. Above busts of sleepy-looking Roman emperors on gilded podiums hang large paintings. Some are typical of the eighteenth-century European style, featuring voluptuous neoclassical nudes with porcelain skin, Cupid with his wings and bow hovering above them. Others depict Stuart kings and their families, a series of pretty, upturned mouths and daintily formed noses. But in this sea of white faces, one regal figure stands apart. His striking visage has darker, warmer-coloured skin. He is tall, turbaned and seated upon a horse. A lance firmly gripped in his left hand, the wind blows back his cloak, making him look as if he might be flying. The rampant horse's legs rise upwards in a stunt or an act of rebellion, yet the rider stares back calmly, very much in control. The pose is used as a metaphor to show the power this man wields. In the distance, similarly clad characters ride towards us, but it is he who looms large. Below his painting, a small sign providing a date and a title: 'The Moroccan Ambassador.' Who is this mysterious man?

His name was Muhammad bin Haddu al-Attar. In January 1682, he arrived in London as an ambassador from Morocco tasked with negotiating peace and trade. It was a visit that mattered greatly to the English polity, which was riven by sectarianism, the grim fallout of civil war, and the threat in Europe of an ever-more dominant France under Louis XIV. Political relations between Morocco and England had first begun over a century before, when England had sought various diplomatic and trading alliances as it warred with Spain following its attempt to seize Spanish territories in the Netherlands. But maintaining this relationship with Morocco was complex; England's diplomatic priorities changed over the years, and as rival European powers went to war with each other, they attacked port cities in North Africa, claiming them for themselves.

In the late sixteenth and seventeenth centuries, the kingdom of Morocco was an independent state ruled over the years by the

Sa'adi and then the Alawite dynasties. The latter is the family from which the present-day Moroccan King is descended. For most of this era, the Kingdom's capital was the city of Marrakesh, but in later years it shifted to Meknes. Threats to the Kingdom came from internal rebellions, occasionally from the Ottoman Empire as it expanded its reach in North Africa and from incursions by European powers.

In 1662, King Charles II – then King of England, Scotland and Ireland – took control of the Moroccan port city of Tangier, which had been captured by the Portuguese and given to Charles as a part of his dowry upon his marriage to the Portuguese princess Catharine of Braganza. The decision was unpopular with Moroccans. Settlers from the British Isles populated Tangier as part of English efforts to fortify the city against the possibility of its liberation by Moroccan forces, and found themselves in constant clashes with locals. Though there were extensive trade opportunities, many fishermen and sailors feared being taken captive by pirates. Charles hoped for a truce with Morocco to ease conditions for his countrymen. So when an ambassador was sent to England from the court of the Moroccan King Mawlay Ismail, it was essential that he should be treated extremely well. Besides, Charles enjoyed pomp and pleasantry. The Ambassador's visit lasted six months and prompted great intrigue and excitement in England. The accounts of his trip illustrate forgotten exchanges between Britain and kingdoms of the Orient, and reactions to Muhammad bin Haddu paint a picture of how men from Muslim countries were perceived in this period of history.

The Ambassador travelled from Tangier aboard a ship named *The Golden Horse* and arrived at the town of Deal, on the east Kent coast, on 26 December 1681. As he stepped onto the shingle beach, he would have been greeted by the bustle of a major port and the sight of a creamy-yellow limestone castle, created in circular Tudor Rose shape. Its walls would perhaps have showed some damage from a battle fought during the English civil war only

three decades earlier. Deal Castle still stands on the Kent coastline today, but the town is no longer a magnet for the shipping trade. In December 1681, state officials sent orders from Charles II for the Ambassador's ship to be unloaded as quickly as possible, not just out of respect for the visiting dignitary, but also because of their worries for the menagerie consisting of seven horses and thirty-two ostriches that he had brought along with him.[1] Perhaps of even more concern was one of the Ambassador's human companions, an English soldier who had deserted in Tangier and converted to Islam. In official state correspondence between the King's diplomats, he is described as a 'villain' and officials express frustration over the fact that they cannot demand the man be 'given up to justice'.[2] In English letters and newspapers at the time, he is mainly referred to as 'the renegado' (a term often used in the period, originally derived from Italian, meaning to 'renege' on your religion). It is believed his name was originally either Lucas or Jonas Rowland, though, having converted to Islam, he was now using the name Lucas Muhammad, and throughout the Ambassador's visit he accompanied him as an interpreter. The state officials were likely angered by his apostasy, but the concerns they raised about Lucas were rather prescient, and 'the renegado' would do his moniker justice.

Once the ship had docked, four coaches including the King's own were sent to fetch the Ambassador from Deal. The Moroccan and his party travelled via Canterbury to Rochester and then headed into Greenwich, stopping each day just before sunset to pray for an hour. Along the way they were met with many offers of wine, but they refused them all.[3] At Greenwich, the Ambassador and his twenty-five-strong entourage were met by the King's courtiers, who accompanied him onto the royal barge and along the Thames towards Tower Hill, where they were greeted by gun salutes. Muhammad bin Haddu and his companions then settled in at a house prepared for him on the Strand, where a number of nobles dropped by to pay their respects in the days that followed.[4]

On 11 January 1682, the Ambassador met the King and his Queen Consort for the very first time, presenting himself at the Banqueting House. From the very moment of his arrival at court, the Ambassador caused a stir by presenting Charles II with an extraordinary gift: two lions and thirty of the ostriches he had brought on board his ship. Though the King was amused, and homes were quickly found for the gifts – St James's Park for the ostriches and the Tower of London for the lions – Charles II was at a loss as to how he should match such a gift, suggesting he might only be able to offer up 'a flock of geese' in return.[5] Then, as now, the art of diplomatic gift exchange was far from straightforward and fraught with anxieties over status, symbolism and respect.

Today, the Banqueting House is all that remains of the Palace of Whitehall, the rest of which was destroyed by a devastating fire in 1698. As I walk along Whitehall, throngs of tourists are absorbed in trying to distract the mounted trooper on duty at Horse Guards. The man may change, but the image is always the same: goldtopped hat, scarlet cloak, still and solemn face above an even stiller body, tall and upright on a black horse. The iconic London postcard, often enlivened in reality by the echoes of a protest under way further down the road outside the gates of Number Ten Downing Street. Those images tend not to make it onto the postcards. I muse to myself on the way in which tourism is divorced from reality – how we serve visitors an idealised version of history that is centred on inanimate objects rather than tackling the complex questions raised by the forces that animate progress. We glory in our architecture without asking the price of its beauty; we salute the static soldier without a thought of where he has marched and what for. I cross the road, moving away from these delicate questions, and am met with an unostentatious entrance to a grand interior.

The Banqueting House still boasts its stunning original ceiling commissioned by Charles I and painted by Rubens. Nine canvases

set in gilded frames; classical creatures and mythical beings all proclaim the divine right of kings and glorify their infinite wisdom. A crimson throne with a royal gold crest is centre stage. I settle down onto one of the fortuitously placed brown leather beanbags to gaze at the ceiling, trying to ignore the very sensible modern addition of fire extinguishers on the walls as I conjure up an image of a royal reception in Stuart England.

Some 300 years ago, the excited crowds who had gathered inside the hall to catch a glimpse of the visitors from Morocco made such a cacophony of noise that they could not be controlled by the King's soldiers. The small party of Moroccans accompanying the Ambassador looked back at them, astonished at the scene.[6] The diarist John Evelyn described how the Ambassador and his party were dressed in what he calls the 'Moorish habit', outfits of silk coloured cassocks 'with buttons and loops' and 'calico sleeved shirts', over which were white woollen cloaks wrapping their entire bodies. Their feet were clad in 'leather socks like the Turks', their heads adorned with small turbans – with a string of pearls woven into the Ambassador's. They came armed with short, richly decorated, curved swords. To Evelyn's eye, they exuded grandeur and were reminiscent of ancient Romans in their togas. The Ambassador walked up to the throne without showing deference or bowing to the King; the Rubens ceiling designed to overwhelm visitors obviously did not quite do the job here. With Lucas beside him to interpret, he made a short speech and offered up a letter to Charles II, and despite the lack of a bow to the King, Muhammad bin Haddu seemed to have left a good impression. Evelyn describes him on that day as a 'handsome person, well featured, of a wise look, subtle, and extremely civil'.[7]

This was the first of very many engagements for the Ambassador. A few days after their first meeting, he had a private audience with the King in his bedchamber, and was then much in demand among the nobles of England. One of those he dined with was the scholar Elias Ashmole, whose curious collections would later

be donated to form the Ashmolean Museum in Oxford. The Ambassador admired the rarities Ashmole was collecting and he recommended recipes, including eating crushed snails to help with gout. Ashmole in turn gave the Ambassador a magnifying glass as a present.[8] Muhammad bin Haddu was also invited to a banquet hosted by one of the King's mistresses, a Frenchwoman named Louise de Kéroualle. She had been given the title of the Duchess of Portsmouth, a far kinder way of referring to her rather than the nickname that had been devised by a rival mistress – 'Squinta-bella'. The Duchess of Portsmouth had glamorous apartments in Whitehall featuring lavish French tapestries, cabinets from Japan and other luxurious furniture, said to be 'ten times the richness and glory of the Queen's'. Here she entertained politicians and courtiers, playing her part in political intrigues. At the banquet, sweetmeats, music and perhaps less innocent activities were on offer. Yet the Ambassador and his party only drank a little milk and water, tasted some chocolate, but not a drop of wine; something the diarist John Evelyn noted with praise, adding that 'the Moors' behaved with 'extraordinary moderation and modesty ... did not stare at the ladies' and that the Ambassador showed a 'courtly countenance' with his 'wit and gallantry'. Ultimately, he declared Muhammad bin Haddu to be a 'civil heathen', a relative compliment given that he deemed the Russian Ambassador who was visiting at the same time 'a clown'.[9]

Muhammad bin Haddu's conduct was also praised by the Puritan minister and political journalist Roger Morrice who kept a diary in secret code, which was deciphered by specialist code-breakers and academics at the University of Cambridge in 2003. He describes an incident when the Ambassador was urged by 'English gentlemen' to 'receive a whore into his bed'. The Ambassador apparently responded with a rebuke, saying that his religion forbade such a thing: 'Does not yours?' Morrice declares Muhammad bin Haddu to be a man of 'great bravery and honour', praising his devout behaviour, including the fact that the Ambassador had been to visit

the grave of the Prophet Muhammad in Madina. He wistfully adds
that if only 'this brave man had fallen into acquaintance of grave
wise and religious persons ... he would have become a Christian'.[10]

The Ambassador from Morocco toured the sights of London,
including the House of Commons, the House of Lords and the
tombs of Westminster Abbey. He observed the new St Paul's
Cathedral being built, after the original structure had been destroyed
in the Fire of London. Here he tipped the workmen fifteen
guineas.[11] He dined with lawyers at Lincoln's Inn, enjoyed a tour
of their gardens and signed their golden guestbook.[12] His signature
in Arabic can still be found in the archives of Lincoln's Inn. Entered
on 4 March 1682, it reads 'Praise be to God and God alone. Written
by the servant of the wise, the pilgrim to God, Muhammad the
son of Muhammed the son of Haddu, from Sus, the Bahamwani.
May God be gracious unto him! Amen.'[13] A second signature in
Roman script alongside his reads 'Al Hajj Muhammad Lucas
Abençerahe', likely to be the same Lucas who was his interpreter.

In the evenings, the Ambassador went to theatres to take in
performances of *The Tempest* and *Coriolanus*.[14] He also travelled
beyond the capital, spending time in Newmarket, Windsor,
Cambridge and Oxford. On 1 April between eleven o'clock and
noon, the Ambassador arrived at Cambridge University. A local
official wrote an account of the visit in his diary, describing
Muhammad bin Haddu wearing a gold cloak, with a cap on his
head 'like a night cap'. He was accompanied in the king's coach
by some of his attendants who were dressed in scarlet-red garments.
Other companions rode on horseback alongside them, wearing
white mantles and with their heads 'bound' in turbans of the
same material. All of them are described as having a 'very swarthy
complexion'.[15] Since the Ambassador himself had apparently been
keen to see the curiosities of Cambridge, Charles II sent instruc-
tions to the Vice Chancellor of the university to put on a gradu-
ation ceremony for his benefit. It was, of course, the wrong time
of year for such a ceremony, so the degrees to be awarded would

have to be honorary.[16] With a critical peace treaty at stake, a good show was necessary. In the evening, the Ambassador and his party were treated to a banquet hosted by the Vice Chancellor. They dined on pickled eels, sturgeon and salmon, and then took a walk around Trinity and St John's colleges. But the culinary combination served up to the Ambassador seemed to leave him feeling a little ill and in need of a lie-down shortly after the walk, the party then later headed back to Newmarket, where they had been based for a few days. Despite the impact of the pickled eels on his stomach, it was reported Muhammad bin Haddu returned to Newmarket 'extremely pleased'.[17]

His visit to Oxford the following month was much more hectic. When it was first planned, the various heads of the university's colleges were apparently reticent, worried that it would set a lavish precedent for other Ambassadors.[18] But the King sent strict instructions that Muhammad bin Haddu was to be received with every honour, so on arrival the Ambassador was greeted by more than a hundred academics.[19] He took up lodgings at the Angel Inn, which at the time was an important coaching inn visited by many dignitaries. The site on which it once stood is now partly the Examination Schools of Oxford University built in the nineteenth century, and partly a cafe and a series of shops along the High Street. On the evening of 30 May 1682, Muhammad bin Haddu met the Vice Chancellor of Oxford and a number of academics dressed in scarlet robes, including the first chair of Arabic studies at Oxford, the Orientalist scholar Dr Edward Pococke.

The organised study of Arabic and Islamic studies had begun at Western European universities in the sixteenth and seventeenth centuries, but while scholars had already taken up the subjects in Paris and Rome, English educational establishments were late adopters. The earliest reasons for the interest were religious; it was believed Arabic could aid with understanding of Hebrew and the Bible, and knowledge of the language and Islam itself could provide material for polemical arguments with Muslims. Later, the interest

extended beyond theology. Arabic was invaluable in unlocking knowledge of medicine, astronomy and maths, with Muslim scholars having dominated output in these fields from the seventh century. It began to be useful for trade too, as English merchants had begun to head to the Levant and the Ottoman Empire.[20]

Dr Edward Pococke was one of the earliest students of Arabic in England. Before taking up his post at Oxford, Pococke had studied for a number of years in Aleppo in Syria, where he had been working as a chaplain, and after intensive Arabic study with tutors there, he produced extensive works including translations of Arabic literature and a dictionary. He wrote of the crucial role Arabs played in preserving knowledge from the ancient Greeks throughout the Middle Ages, and of their contributions to medicine. Pococke also believed his contemporaries 'unjustly despised' Arabic philosophy, advising fellow scholars to study Arab historians to 'dispose themselves of common fables and errors'.[21] On the first evening of Muhammad bin Haddu's visit, it was noted that Pococke amused the Ambassador, making him laugh aloud when he said 'something in Arabic', but sadly we are unable to share in the joke, as there are no details reported of what it actually was.[22]

The next day brought an action-packed schedule for the visitor, starting with a tour of The Queen's College in the morning, where Muhammad bin Haddu turned down offers of beer as refreshment, followed by visits to a series of chapels and colleges, during which he was shown numerous windows, paintings and a church organ. Every Oxford notable demanded to be included in the visit. Even if that led, as in the case of meeting botanist Dr Robert Morison in the Botanic Gardens, to the Ambassador being 'harangued' at times.[23] That afternoon, as the Ambassador returned to the Angel Inn to rest, a severe storm began brewing outside, eventually breaking boughs from trees, blowing around thatch from roofs and generally causing havoc. One diarist describes it as 'a hurricane never known in the memory of man'.[24] This may have been an exaggeration, because by three o'clock that same afternoon,

this 'hurricane' had not prevented some 4,000 people gathering at a theatre to see the Ambassador, with 1,000 of them unable to get in because the building was at capacity. Or, perhaps such was their curiosity, that they were willing to brave a hurricane. The crowds had to wait quite a while, as the Ambassador arrived two hours late, apparently delayed by his nap. Nevertheless, the pomp continued, with a loud musical fanfare announcing his arrival.[25] He then sat through a speech in Latin, a musical performance and a speech in Arabic given by another Orientalist scholar, Dr Thomas Hyde. Hyde was a highly accomplished linguist with knowledge not just of Arabic, but also Persian, Hebrew, Turkish, Syriac and Malay; he served as an official interpreter for the government. The evening was completed with yet more visits to colleges and a library, another banquet and then a presentation of gifts – mainly Arabic books presented to the Ambassador by the Vice Chancellor.

Not all the visit was so literary and formal. The Ambassador particularly enjoyed riding his horse at Hyde Park in London, as captured in the portrait now displayed at Chiswick House. No wonder that the official royal court artist Sir Godfrey Kneller chose to picture him in such a scene, as the performances he and his party gave managed to delight the gathered crowds. Muhammad bin Haddu and his men showed off their horsemanship with tricks such as flinging lances and spears and then catching them at full speed. Newspapers reported on these displays, with one detailing an occasion where thousands of spectators were left 'infinitely satisfied'.[26]

Overall, it seems Muhammad bin Haddu charmed and was charmed in England. Wherever he travelled, masses of people flocked after him to catch a glimpse. He went hunting and shooting with dukes and even received honours. In May 1682, he was admitted as an honorary member of the Royal Society, the scientific institution which would a few years later publish Sir Isaac Newton's famous theory of gravity. The Ambassador in turn, if official accounts are to believed, declared 'the English nation the

best people in Europe'. He was also reported as saying that the experiences on this visit had undone stereotypes he had previously held, stating that in Morocco they believed 'Christians worship a god made of wood or stone which they may throw into the fire and see consumed', but that now 'thanks to God', he had seen the contrary.[27] With such grand pleasantries, the stage was set for a peace treaty to be concluded. Indeed, just four months into the visit, newspapers reported it already had been.[28] But their celebrations were premature.

In July 1682, as the Ambassador prepared to head back home, he took his leave of the King and embarked on a farewell ride through London with all his attendants, giving money to poor people who had gathered to watch him. What must they have made of him, and he of England? Perhaps he was amused by the interest he provoked, or impressed by both the performances put on for him and the men he had conversed and dined with during the visit? As for the food itself, he would not have been in any hurry to eat again the pickled eels he had tried in Cambridge. Muhammad bin Haddu and his men were all set to board the King's barge and then head back once again to the port of Deal to a ship named *The Woolwich*, which would carry the party back to Tangier. With them would be a gift from Charles II to the Emperor of Morocco: 300 musket barrels and a supply of gunpowder. This was not just a gesture of friendship. Charles was obviously hoping the weapons would be used by the Moroccans to stop the attacks on British troops in Tangier and finalise the treaty of peace, to which he had already applied his seal. The Ambassador himself purchased 1,000 more guns for his ruler, 'some pieces of cloth and not much else'.[29] All was ready for their departure, but then there came a delay, thanks to Lucas – the interpreter.

Lucas had enjoyed the privileges of accompanying the Ambassador in all the grand ceremonies of the visit and, with his blessings, had even married an 'English servant maid' in a church, despite now

being a Muslim.[30] She would accompany him back to Morocco. But just as the Ambassador and the whole entourage was ready to leave in the King's barge for their onward journey, Lucas reportedly stole some of the Ambassador's money, disguised himself in English clothing and made a run for it. He was soon enough found and taken to a judge, who summoned the King's advisors to join in with questioning the 'renegade'. Upon cross-examination, Lucas now claimed he had converted back to Christianity. Unfortunately for him, the assembled lords did not believe him, because he had apparently tried the same trick before when detained by an English army officer in Tangier. Then he had used the reversion story to win his freedom, only to later head back to the Moroccans to live as a Muslim. Now Lucas faced being locked up at Newgate prison. But his employer was feeling generous. The Ambassador offered Lucas forgiveness and his job back and so 'the renegade', as reported by a newspaper at the time, 'put on his Moorish clothes and religion again and returned to the Ambassador'. But the story did not end there. Once aboard *The Woolwich*, Lucas apparently made yet another attempt to escape, though this time he was unsuccessful.[31]

An even more intriguing story about Lucas exists, according to a letter sent from Tangier dated August 1682, a variation of which was then repeated in an English newspaper a few months later. It is a rather fantastical account suggesting Lucas had been at the centre of a plot on board the ship to discredit and even murder the Ambassador but was caught out. Upon arrival in the Moroccan court, where the whole affair was exposed, he was reportedly punished by being imprisoned, then had his body rubbed with fish oil and was hung naked for three days so that insects could eat away at it. Still alive, he was apparently plunged into a cauldron of boiling oil, which finally killed him; his corpse was then thrown out to sea. Meanwhile, the same report claims, three other rogue servants of the Ambassador were fed to lions.[32] This tale of gruesome torture seems rather unreliable, firstly because the man who wrote the letter had not witnessed any of it himself. He claims to

have heard the story from the 'Renegade's Wife' who had apparently turned up in Tangier saying she now wanted to return to England. If this had happened, she may well have had her own reasons for telling such a tale, including a desire to hasten a return home to England. Secondly, another letter sent from Morocco to London in the same period stated that many lies were spreading about the Ambassador, something the author describes as a 'confusing heap of falsehood and imaginary inventions'.[33] Lucas is not mentioned by name, but it is plausible that scandalous rumours about him may also have been invented.

The astonishing story of Lucas's plot and execution seems likely to have been an exaggeration and part of a long tradition in which accounts of such visits quickly slipped into embellishment and fantasy. Of course, the danger of such stories being popularised in the media is that they served to reinforce negative stereotypes about the Orient. The gruesome nature of his supposed death may have been based on myths about the region, or this tale may have been designed to serve as a deterrent against anyone considering turning renegade – or becoming Muslim – themselves. Whether Lucas met such a sticky end or not, it is interesting to note some of the reaction to his alleged death. In 1682, a poem by an unknown author was published claiming that the 'renegado' had been executed and that he 'deserved' death. The poem describes his becoming a 'Moor' (meaning here a Muslim) as being 'against the rules of Nature'; he is condemned as 'a wretch' who every man and woman in England is now scorning, and in the starkest warning against conversion, it clearly states: 'make him an example ... men from their Religion may not turn'.[34]

Meanwhile, as rumours spread in Britain about him and his entourage, by his own account Muhammad bin Haddu arrived in Morocco initially hopeful of a peace treaty being concluded. He wrote to Charles II, praising him and his officials, saying he had seen 'nothing but good' from them. He urged Charles to intervene in the case of a Moroccan captive held by an English soldier in

Tangier and said he would correspond again after meeting with the Moroccan ruler Mawlay Ismail.[35] He did indeed write another letter, but the news would not be good for Charles.

Muhammad bin Haddu had ended up in a quarrel with other Moroccan officials. In a letter to Charles II, he reports it was driven by 'enmity and envy' and that 'matters reached such a pitch' that he might now even face the prospect of the death penalty.[36] It seems the Ambassador had been severely maligned by rival courtiers, leading him to lose both the trust of the Moroccan King and his credibility at court. It is likely that this turn of events fed the salacious stories circulating around London. The less outrageous reports now said the Ambassador had been put in prison because Mawlay Ismail was angered at Muhammad bin Haddu drafting a peace treaty with Charles II while Tangier remained occupied.[37] The peace treaty written in London and so celebrated in newspapers during the visit was therefore not ratified, and Mawlay Ismail insisted the port city must be handed back to his control. In February 1684, the Moroccan King personally wrote to Charles II, insisting that he could not make peace while the English occupied Tangier 'by force'.[38] All the cultural exchange and pomp and ceremony laid on for the Ambassador had not been enough for the Moroccans to forget the hard reality of an occupation. A reminder that curiosity is no cure for conquest.

Muhammad bin Haddu's mission had not been an entire failure, however. He somehow managed to escape the death or prison sentence planned for him and regained the trust of the Moroccan ruler. The following year a secret letter was sent to Charles II, apparently from Muhammad bin Haddu himself, warning him of Mawlay Ismail's intention to attack Tangier in an attempt to regain it, and advising Charles that he should give up the port city to reach a truce before such an attack. The long and rambling letter takes a mixed tone; although the Ambassador repeatedly compliments and thanks the King for his 'benevolence' during the visit, Charles is also urged to 'think about your country while you have

the chance' and almost threatened with the consequences of attempting to fight the Moroccan ruler: 'you would lose all your wealth of your island in a week'. Charles is also asked to read the letter in secret and destroy it after reading to avoid detection.[39] Fortunately for us, he failed to follow these instructions, as the letter is still held in the National Archives today. Whether or not this secret letter of warning influenced him, Charles II did abandon the port of Tangier in 1684 and a kind of truce was achieved, though the problem of prisoners taken by both sides still remained. After the English had left Tangier, Mawlay Ismail wrote to Charles again in an apparent gesture of friendship, saying 'now since you have alleviated our country and been sensible about it you will see nothing but good from us'.[40]

These highs and lows in the relationship between the two kingdoms demonstrate that the diplomatic task of Muhammad bin Haddu was not a simple one, and that despite the honours they bestowed upon him during his visit, politically it did not turn out as the British had hoped. But, aside from the diplomatic wrangling, the details of the Ambassador's stay in England are themselves illuminating in showing us how a man from the Orient was perceived in this period. By the accounts of him, Muhammad bin Haddu and his companions seem to have been regarded as a curiosity, yet he was respected and treated as an equal to the nobility of England. On his departure, a poem was even written imploring him as 'a man truly worthy of Glory' to 'Stay, stay, Dearest Sir, a little longer, if you do our love too will grow stronger'.

It added that the King himself would be miserable in the absence of the Ambassador, who was now his 'dear brother', and promised an 'olive branch of peace' to come, for which Muhammad bin Haddu had the 'thanks of each English heart, Paid to you as a man of Mighty Art'.[41]

This level of respect was obviously primarily motivated by the need to secure a political treaty. As a diplomat, Muhammad bin Haddu was no ordinary man, and yet it seems extraordinary that

during the Stuart period a Muslim man was hosted and honoured in the highest circles of English society. The details of his encounters also break current common beliefs about Britain not being influenced by the culture or politics of the Orient in this period. When Muhammad bin Haddu arrived, there were already some scholars who could speak to him in Arabic and there is evidence that open exchanges about his religious beliefs and that of his hosts took place. That is not to say that religious antagonism and prejudice towards Muslims did not exist, but simply that this period is more nuanced than popular history would have us believe. The enthusiasm expressed by people in England, rich and poor alike, to see the Ambassador in person, even when diplomatic relations between the two polities may have been fraught, demonstrates that many showed the maturity of inquiring minds, and not the small island mentality we may attribute to them retrospectively.

In fact, Muhammad bin Haddu was not even the first ambassador to visit from a country of the Orient; a number of Moroccan ambassadors had come to London before him as Tudor and Stuart monarchs sought to make alliances with Muslim nations. The attempt to negotiate such political and economic relationships was actually at its height a number of decades before Muhammad bin Haddu's visit, under the reign of Queen Elizabeth I. These political exchanges led to a popular cultural fascination with the figure of 'the Moor' and perhaps even influenced the most treasured playwright in the British canon – Shakespeare.

<p style="text-align:center">*</p>

Having broken away from the Catholic Church, in 1570 Elizabeth found herself excommunicated and declared a heretic by the Pope. She faced the risks of both a hostile military invasion from Catholic Spain and broader political and economic isolation, with England now unable to trade with Catholic countries. So the Queen sought new alliances and friendships, and for these she turned to the

empires and kingdoms of the Orient – the Ottomans, the Mughals, the Safavids and the Moroccans.

With the Kingdom of Morocco, she found a common enemy in Spain. Through correspondence and the exchange of diplomats, the Queen and the Moroccan ruler of the day, Ahmad Al Mansur, began a political and trading alliance. The English supplied the Moroccans with guns, and in turn imported sugar and saltpetre, used for making gunpowder. Elizabeth also wrote to the Mughal emperor Akbar, requesting him to be 'favourable and friendly' to one of her subjects who had arrived at the court in Agra in northern India. She stated that she had heard of Akbar's humanity, and that she hoped her subjects would be 'honestly treated and received', with a view to advancing 'mutual and friendly traffic of merchandise' between their states.[42] This marked the very early beginning of commercial activity by the English in India; however, at this stage it was extremely limited and little was known about India in England itself. Trading exchanges began with the Safavid Empire of Iran too. Here it was cloth that was the key commodity – wool was exported and silk imported. Elizabeth dispatched an envoy to the Safavid Palace in Qazvin in an attempt to secure privileges for English merchants and the right for them to travel freely through the Safavid Empire towards India, where they sought to purchase spices. This mission was not successful. The Safavid ruler Shah Tahmasb was reportedly angered at Elizabeth having written him a letter in Latin, Hebrew and Italian. The Shah demanded to know 'of what country of Franks' (referring to Germanic people in Western Europe) the envoy had come from, to which the reply was 'the famous City of London within the noble realm of England'. But 'nobody at the shah's court knew anything about this tiny place called England'.[43] Even then, before the emergence of the British Empire, England had an outsized perception of its own importance abroad.

Nevertheless, Elizabeth's envoy Anthony Jenkinson did bring home something – or, more accurately, someone – from his travels.

In the city of Astrakhan in central Asia, Jenkinson purchased a young Central Asian slave girl named Aura Sultana. He then presented her as a gift to the Queen. Aura Sultana was of Tatar heritage and is perhaps the first Muslim woman recorded in England. It is not clear if Aura Sultana was her original name or a title given to her ('Sultana' is the feminine rendition in Arabic of a title ascribed to a ruler). In any case, the girl was christened and referred to by a new name at Elizabeth's court: Ipolita the Tartarian. Though not brought to the country of her own accord, Aura Sultana lived a comfortable life at court and Elizabeth was clearly very fond of her company, describing her as 'our deare and well-beloved woman'. The Queen bought her expensive clothing made of silk, furred cassocks, gold and silver, and a baby doll made of pewter. It seems Aura Sultana was something of a trendsetter; after she began wearing Spanish leather shoes, Elizabeth decided she wanted to try out this new fashion too, in addition to her usual velvet pairs.[44]

As well as bringing the Queen a new companion, Anthony Jenkinson was also one of the first to introduce to England a basic understanding of the theological differences between the Shi'a Safavids and the Sunni Ottomans. Despite his initial rejection by the Shah, he made several more journeys to the region, but he was not the only Englishman to head to Iran during Elizabeth's reign. Two adventurer brothers from Sussex – Anthony and Robert Shirley – presented themselves at the Safavid court of Shah Abbas I and they were more successful at courting the Safavids than Jenkinson had been around thirty-seven years earlier or, indeed, any other Englishmen had been before them. The Shirley brothers eventually became influential advisors and envoys of Shah Abbas, and a portrait of Robert Shirley in Safavid court regalia painted by Anthony Van Dyck is displayed at Petworth House in Sussex. It shows a rather pudgy man swathed in a golden tunic with a blue velvet collar and scarlet fastenings. An extremely intricate gold cloak casually hangs on his right shoulder, featuring embroidery

of angelic figurines, flowers and leaves. On his head sits a huge and ornately twisted turban, gold with flecks of scarlet, fastened with a sizeable jewel; in his left hand is a bow with the arrows stacked up close to his left foot, while his right hand clutches at a sabre stashed in a sash around his waist. Shirley is clearly a man who has profited from his travels to the Orient.

A painting of Shirley's wife by the same artist also hangs at Petworth House. Sat on a beautiful carpet, she too is dressed in gold; a long dress embroidered with floral motifs covers her entire body, leaving only her hands, neck and head exposed. A large swathe of fabric in the same pattern as the dress is draped over her shoulders and back. It covers much of her hair, but it is pinned so that her wispy brown curls are visible at the front. She wears a jewelled feather headdress and several items of jewellery featuring precious stones. Teresia Ismael Khan met Robert Shirley at the Safavid court of Shah Abbas and was a relative of a woman in the Shah's household. Lady Shirley was a Circassian, meaning that she had ancestral heritage in Central Asia, but more recently her family had lived in the Black Sea region. It is unclear whether she was born a Muslim or an Eastern Orthodox Christian, but she was baptised as a Catholic shortly before she married Shirley. She accompanied her husband on his travels through the Mughal Empire, Russia and many European cities, and joined him on his return to England as Ambassador from the Safavids. The Van Dyck portraits were painted while the couple were on a diplomatic mission to Rome. After her husband's death in the Safavid city of Qazvin, Teresia remained in Iran, but later moved to Constantinople (known in Ottoman Turkish as Konstantinye, and nowadays as Istanbul) and then Rome, which became her own final resting place.[45]

Elizabeth's reign would see new companies run by merchants being granted charters by the Queen to allow them to trade exclusively in various geographic regions. One such company would become infamous in British history. The East India Company was created in 1600 initially so merchants could join in the spice trade

in South and South East Asia. Thirty years earlier, the Barbary Company had been established for commercial enterprise in Morocco, while the Turkey Company (later renamed the Levant Company) was set up to build links with the Ottoman Empire. While their activities were profit-driven, they also served the political purpose of advancing relations with Muslim empires. Delegating diplomacy to companies allowed Elizabeth to create some distance for the monarchy and, to an extent, conceal the closeness of these alliances from her own subjects.[46] But these companies were not yet grand colonial enterprises. England was by far the weaker state in comparison to its rivals and somewhat parochial on the world stage. The Ottoman Empire was the superpower of the age. During Elizabeth's reign, the Ottoman Empire was already a 400-year-old polity, ruling over diverse peoples in large parts of Central and West Asia, North Africa, the Balkans and south-eastern Europe. It had military might and great wealth through its control of lucrative trade routes stretching as far as China and India.

Nevertheless, Elizabeth managed to persuade Sultan Murad III of the Ottoman Empire to grant her merchants trading privileges. He issued a decree confirming peace and an alliance with England, commanding Ottoman officials to allow all English merchants to pass freely through the Empire and to be assisted should they face any attacks from criminals.[47] Like other European powers such as the Venetians and the French, the English would now also be granted the right to create consulates not just in Constantinople but across the Ottoman Empire, in cities including Alexandria, Damascus, Tunis and Tripoli. So essential was this charter of privileges that it became the basis for all following contracts between Britain and the Ottoman Empire until the latter was abolished in 1922.[48]

As if to emphasise their freedom from the Catholic Church, English merchants loaded up stripped lead and other metals from the roofs, bells and statues of churches destroyed in the Reformation, to be sold in the new-found markets of the Orient. Lead and tin were important commodities for munition-making and invaluable

to the Ottomans, who needed arms to secure and expand their territory. French and Spanish Ambassadors sent back reports to their own countries of bell metal and tin being sent to the 'infidel' by the English.[49] These freshly forged trading links and Elizabeth's burgeoning friendship with the Ottomans alarmed the Pope, who was concerned that England and the Ottoman Empire were now actively collaborating against Catholic states.[50]

The selling of church bells may have seemed particularly symbolic, but collusion against Catholic countries was not so straightforward. Alliances with the empires of the Orient shifted according to various factors. But the impact of these new relationships went beyond the political and economic. They started to affect society and culture – and also meant that men of the Orient empires began arriving on the British Isles as sailors, merchants, captives and ambassadors.

Elizabeth received at least three Moroccan ambassadors. Just as with the Ottomans, it was England that was considered the weaker power of the two. The Moroccan ruler Ahmad Al Mansur saw Elizabeth as 'insular because she had never left her island', whereas he had travelled widely.[51] When the Queen first dispatched an English ambassador to Marrakesh, the presents he took with him were considered so insignificant that, unlike gifts brought by the French, Spanish and the Ottomans, these were not even recorded by Moroccan court scribes. But once she had shown strength in fending off the Spanish Armada, Elizabeth was suddenly considered a serious ally. Now the Moroccan court scribes proclaimed that God was on the side of England's Queen and had 'sent a sharp wind against the fleets' of the Spanish.[52] A year after the battle, a Moroccan ambassador named Ahmed Bil Qasim arrived in London. He brought a tempting offer from the Moroccan ruler; he would pay for the military expenses of attacking Spain. In return, Ahmad Al Mansur wanted the use of some of her ships and the right for Moroccans to hire English labourers. He also set an additional condition to his funding, that the assault on Spanish territories

should begin with an attack on the city of Tangier (then held by Spain).[53] This, he proposed, would be a 'perfect league between them'. An alliance was forged, but the ensuing military campaign launched by the English ended in disaster and a furious Elizabeth blamed almost everyone, including Ahmad Al Mansur.[54]

Nevertheless, the diplomatic exchanges continued. In 1600, Ambassador Abdul Wahid bin Messaoud Al Annuri was sent to London, carrying with him a letter from the Moroccan ruler where he details his 'love and friendship' for Elizabeth, whom he called 'Sultana Isabel'.[55] Once again, Ahmad Al Mansur made a proposal for attacking the kingdom of Spain. This time he suggested attacking Spanish territories in the Americas. But Elizabeth had plans too. She tried to enlist Ambassador Abdul Wahid into her own counter-plot, preferring an English-led attack directly on Spain itself. She failed to persuade him and neither plan came to fruition.

Beyond the political negotiations, the arrival of this visitor to London provoked curiosity, just as Muhammad bin Haddu would some eighty years later. One account from 1600 details how Abdul Wahid bin Messaoud and his entourage ate – by slaughtering meat for themselves and facing east while they did so, as per the requirements of preparing halal meat.[56] During his visit Abdul Wahid bin Messaoud sat for his portrait, which now hangs at the University of Birmingham's Shakespeare Institute in Stratford-upon-Avon. With his sharp face, pointed ebony beard, reddened cheeks and robes of black and white, he looks a rather stern character, though there is a glimmer of amusement in his eyes. A sword in a sheath of black and gold is fastened to his cloak.

In addition to these ambassadorial visits, Elizabeth also directly engaged in correspondence with rulers of the Orient, making her the first English monarch to communicate in this way with non-Christian rulers. As well as writing to the Moroccan ruler Ahmad Al Mansur and the Safavid Shah, she also sent letters to the Ottoman Sultan Murad III, whom she addressed as 'most august Caesar'.[57]

In these exchanges it was clear who was the more important sovereign. Murad's replies to Elizabeth were sent in a silver pouch rather than gold, which was only used by the Ottomans for correspondence with a major monarch.[58] Nevertheless, Murad offered security to those of Elizabeth's subjects travelling through his empire for trade; responded to her requests asking for the release of prisoners; and even made peace with Poland, claiming to have done it as a personal favour to Elizabeth. One of the ways in which the Queen may have won him over was her emphasis on shared theology between Protestant Christianity and Islam; specifically, the rejection of 'idolatry' – something Catholics, with their veneration of images in church, were often accused of. Elizabeth pointedly wrote about a 'God who is above all things' and described herself as a 'mighty and invincible defender of the Christian faith against all idolatries, of all who live among the Christians and falsely profess the Name of Christ'.[59] For their part, the Turks would refer to the English merchants as being of the 'Luteran mezhabi' – the Lutheran sect – and believed that their break away from the Pope potentially made these particular Christians closer to them in both theology and politics.[60]

Beyond regal diplomacy and religious debate, Elizabeth exchanged fascinating letters with Sultana Safiye, the 'first lady' of the Ottoman Empire. Safiye was Murad's consort and mother of the heir to the throne, Mehmed III, a position which gave her immense power. She was also responsible for commissioning the famous Valide mosque in Istanbul (now known as the Yeni Çamii), which may have later inspired a mosque built at Kew Gardens in the Georgian period.

Safiye first wrote to Elizabeth in 1593; her letter is kept in a collection at the British Library, a manuscript so fragile it can only be viewed by special permission. On yellowing parchment, I carefully follow the Ottoman Turkish letters beautifully calligraphed in neat rows of black, blue, crimson, gold and scarlet ink. The black letters remain the clearest, while some of the blue are now

barely visible.[61] The whole page is sprinkled with gold dust. I feel a shiver looking at it, as if I have been let into a secret between these two women. The letter originally had a seal of gold with small diamonds and rubies.[62] The manuscript has an accompanying document, an Italian translation for Elizabeth to read. The contents of the original Turkish letter, like its calligraphy, is elaborate. It begins by praising God, then her husband the Sultan and then goes on to offer the English Queen:

> a salutation so gracious that all the rose garden's roses are but one petal from it and a speech so sincere that the whole reper-toire of the garden's nightingales is but one stanza of it.[63]

Safiye hails Elizabeth as the 'crowned lady', 'a cradle of chastity' and a 'woman of Mary's way', likening the unmarried Queen to the Virgin Mary. In later letters, she writes of her 'firm friendship' towards Elizabeth and confirms she will influence her son to act favourably towards her. For her part, Elizabeth sent Safiye gifts including a portrait of herself, a supply of cloth and an elaborate coach, along with a clockwork organ for her son Mehmed. The delivery of this last item turned into quite the debacle.

Upon the death of his father in 1595, Mehmed took the throne and the title of Sultan; unsurprisingly, every European embassy in Constantinople was keen to curry favour with him in an effort to boost their own trading privileges. The Venetians had already presented him with a model ship made of silver 'so heavy two men were needed to carry it', and a lot of Parmesan cheese.[64] The English merchants were keen not to be outdone and so concocted a plan for a gift from their Queen to be sent too, a sixteen-foot-high clockwork organ. Elizabeth herself approved the instrument, but its construction was paid for by the merchants of the Levant Company. It was described as a 'great and curious present going to the great Turk which no doubt will be much talked of and be very scandalous among other nations, especially the Germans'.[65]

The clockwork organ was built by a musician and blacksmith called Thomas Dallam who was from Warrington in Lancashire. A carved and gilded oak cabinet contained a diamond-, ruby- and emerald-encrusted twenty-four-hour clock, and a dial showing the phases of the sun and moon. Underneath these was an organ which could be played by hand or set to play tunes automatically for six hours.[66] Dallam had played it at the Banqueting Hall before the Queen so that she could approve the gift and now he accompanied it on board the ship to the Ottoman Empire. The journey took six months and Dallam kept a detailed diary of his adventures. He saw whales and porpoises in the ocean; experienced the ship's flight from pirates; and he met all kinds of characters including two English-born Muslim converts who acted as Turkish interpreters on his journey to and from Constantinople. One of these men was from Cornwall and the other was a man named Finch from Chorley in Lancashire, Dallam's own home county. Dallam says Finch was 'in religion a perfect Turk but he was our trusted friend'.[67] The backstory of how these two men learnt Turkish and obtained their roles as interpreters is unclear, but it demonstrates the fluidity of exchange between the British Isles and the Ottoman Empire.

On arrival in Constantinople, it became clear the gift from the Queen to the Sultan was badly damaged. The carefully constructed organ arrived with its glued parts decayed and its metal pipes bruised and broken by both the extreme heat inside the ship's hold and the movement caused by the waves it had sailed upon. This prompted much mirth among the French and Venetian diplomats, who 'turned up to laugh at the pile of broken pipes'.[68] Meanwhile the English diplomats were distinctly unimpressed. This was meant to be a gift of great political importance and what was before them did not seem to be anywhere near good enough. They wondered if the coach for Safiye, sent on the same journey, could be presented to Mehmet instead. But this was not an option. Safiye knew the coach was coming and in her excitement had already sent two horses to meet it.[69] So, the organ had to be repaired. Fortunately its maker

was determined to do it. For the next few weeks, first on board the ship, then at Topkapi Palace, he embarked on the task as Safiye herself and other grandees watched on in fascination.[70]

The organ was successfully repaired. Now Dallam was instructed to present it to the man described by the English diplomats as the 'the mighty monarch of the world', the Sultan Mehmed.[71] The stage was set at the palace, Mehmed sat down on his throne and the entire court – including some 400 courtiers all dressed in silk robes with gold caps on their heads – waited in silence. Then, just as Dallam had planned, the present 'began to salute' the Sultan. First the clock struck twenty-two to mark the time, then came the chime of sixteen bells, followed by a song played in four parts. Once it was over, two figurines at each side of the organ lifted silver trumpets to their mouths and 'sounded a tantarra'. The music continued to play, until a holly bush full of blackbirds and thrushes popped out of the top of the organ, and shook their wings to mark the end of the song.[72] Mehmed was delighted and Dallam was duly rewarded with gold.

Meanwhile, in gratitude for her coach, in which she now enjoyed parading around town, Safiye sent clothing and jewels including crowns of pearls, rubies and diamonds to Elizabeth.[73] At the same time, a servant of Sultana Safiye also wrote to the English Queen with a more explicit request. She introduced herself as Esperanza Malchi, a Jewish woman, and rather audaciously asked Elizabeth to send them cosmetics, saying:

> on account of your Majesty's being a woman I can without any embarrassment employ you with this notice, which is that as there are to be found in your kingdom rare distilled waters of every kind for the face and odiferous oils for the hands, your Majesty would favour me by sending some of them ...

We do not know if Elizabeth ever responded to this request, but perhaps it serves as an example of the intimacy which the Ottomans and the English now had with each other.

The final letter Elizabeth sent to her Moroccan counterpart Ahmad Al Mansur in 1603 ends with her signing off as 'your sister and relative according to the law of crown and sceptre'.[74] An intimate farewell that seems to mark what would soon be the end of an era – both Ahmad Al Mansur and Elizabeth died that year. When Elizabeth's rule ended, alliances with countries of the Orient weakened. Where Elizabeth saw friends and allies, her immediate Stuart successor James I 'detested' such dealings.[75] But the political developments under Elizabeth had a lasting impact beyond her reign. The visits of ambassadors, exchange of letters and talk of alliances influenced the wider culture in both the Elizabethan period and the ensuing Stuart era. These influences were clearly visible in food, in dress and in theatre.

*

The increase in trade in the late-Tudor period meant the homes of the rich began to be decorated with elaborate carpets from Turkey, Egypt, Syria and Persia.[76] An embroidery still hanging today at Hardwick Hall in Derbyshire is illuminating. The Countess of Shrewsbury, known as Bess of Hardwick, collected embroideries and Turkish rugs and commissioned this piece. Entitled 'True Faith and Mahomet', it shows Elizabeth standing tall in a brocaded gold dress, a large crucifix by her right hand, which clutches a Bible. With her left hand she offers a cup to the figure who is lying close to her feet. He is turbaned, with a darker face and far less intricate clothing. His left hand touches a book – very likely meant to be the Qur'an – and his right palm is tucked under his chin, as if he were deep in contemplation. Above him is a rectangular inset, apparently meant to depict a scene from the life of the Prophet Muhammad.[77]

The figure representing the Prophet in this scene stands in a building that has the arches and windows of a Gothic church and ornamental ceiling vaulting, resembling honeycombs as often seen in Turkish, Central Asian or Iranian mosques. He holds a book

and is perhaps meant to be receiving revelations as angels fly above his head. In front of him are four men, all dressed in turbans, conversing with each other. It is an artwork which followed a tradition of showing 'true faith' overwhelming the infidels. Although the scene representing revelations appears fairly neutral, it is likely that those who created it would have believed this to be a depiction of a false faith, and the superior position of Elizabeth standing by a cross and towering over the Muslim figure suggests it is not meant to be a particularly positive depiction of Islam or Muslims.

Today, the embroidery is kept inside a glass case, with no obvious explanation close by. This is merely one of many embroideries on display at Hardwick Hall. Understandably it is not an artwork that the estate's guides are proud to show off to modern Britain, given that it may have been an apparent attempt to assert the supremacy of Christianity, as embodied in the figure of Elizabeth. Yet the display could offer context around its creation, explaining an era when some Englishmen and women felt horror at people converting to Islam. Some academic analysis has pointed out that Elizabeth – the symbol of Christianity here – is not displayed crushing her enemy, instead she is generously offering him a cup.[78] Was this some small conciliatory gesture to Muslims on the part of its commissioner, a woman who adored collecting rugs of the Orient? This too should be offered up as part of the explanation for visitors.

A new beverage was also introduced to the British Isles during this period. Often known as the 'Mahometan Berry' or the 'Turkish drink', a craze for coffee had begun.[79] Initially, small amounts were brought to the country by merchants who had travelled to the Ottoman Empire and these were consumed privately at home. But by 1652, the first coffeehouse in Britain had been established by a man named Pasqua Rosée. He had been a servant to an English merchant who had been trading in the city of Smyrna (now known as Izmir in Turkey). Rosée's coffeehouse was set up in St Michael's Alley, Cornhill, with an advertising board featuring an image of the owner wearing a turban. There is a sign marking the site in the City

of London today. A pamphlet advertising Rosée's coffee advised of
its medical benefits, proclaiming:

> It is observed in Turkey where it is generally drunk that they
> are not trobled with the Stone, Gout, Dropsie or Scurvey and
> that their skins are exceeding clear and white.[80]

He was not the only one to praise the virtues of this new drink.
The scholar Edward Pococke (who had met the Moroccan
Ambassador Muhammad bin Haddu in Oxford) translated an
Arabic book extolling the health benefits of coffee. Pococke was
addicted to the caffeine and consumed so much that he developed
hand tremors.[81]

After this first one, many more coffeehouses would follow
boasting signage featuring symbols of the Orient. 'The Turk's Head'
was a popular name and coffeehouse keepers commonly adopted
dress from the Orient, swapping hats for turbans.[82] But not everyone
was in favour of this fashion. With traditional alehouses threatened
by the new beverage, a simultaneous campaign was being waged
against coffee. Some claimed those who drank it would be 'turned
Turk' and end up 'swarthy' and 'Moorish' in their appearance.
Others feared coffee was a secret weapon sent by Muslims to 'entice
Englishmen away from their religion'. One writer warned that the
drink was 'an ugly Turkish enchantress which put the English drinker
under the power of this Turkish spell'.[83] 'The Women's Petition
Against Coffee', a political pamphlet which may or may not have
been written by women (it was penned anonymously), bemoaned
husbands being seduced by the 'Turkish Enchantress' and spending
their money on drinking this 'base, black, thick, nasty, bitter, stinking,
nauseous puddle-water', instead of buying bread for their children.[84]
But, despite these campaigns, the coffeehouse thrived, becoming an
important place for conversation, the exchange of financial transac-
tions and the development of political ideas – all made possible
because of a drink from the Orient.

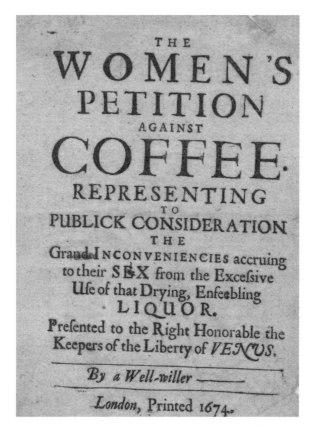

THE

WOMEN'S

PETITION

AGAINST

COFFEE.

REPRESENTING

TO

PUBLICK CONSIDERATION

THE

Grand INCONVENIENCIES accruing
to their SEX from the Excefsive
Ufe of that Drying, Enfeebling
· LIQUOR.

Prefented to the Right Honorable the
Keepers of the Liberty of VENUS.

By a Well-willer ——

London, Printed 1674.

A political pamphlet expressing the moral panic about the popularity of coffee, a mysterious new drink from the Orient, in 1674.

It was not just coffeehouse keepers who adopted dress from the Orient. In a sign of how it lent a person prestige, it was worn by some fraudsters too, as they purported to be ambassadors of the Ottoman court.[85] The diarist John Evelyn wrote of a man who appeared at court in London styling himself in 'Ottoman Garb' and calling himself 'Muhammad Bei'. He said that the man was born a Christian and hailed from a region now in Romania. He had spent time in Constantinople, having absconded from his home-town after being accused of various 'misdemeanours', including a

scandalous affair with a priest's wife conducted as he simultane-
ously pretended to court the priest's daughter. On the run, he now
presented himself as a 'Turk' and a relative of the most senior
Ottoman minister, moving between countries where he was
unknown, telling elaborate stories about his adventures travelling
through the Ottoman Empire and the honours he had received
from the Sultan. He had apparently duped the King of France, but
in England his story unravelled when a royal courtier recognised
him, having seen him before while travelling in Vienna. The
imposter denied the connection, but the courtier's story was later
confirmed by an unnamed 'Persian Gentleman', who happened to
be in the country at the time, and was able to provide an authentic
history of the 'audacious hypocrite'.[86]

By the seventeenth century, the character of the 'Turk' also
frequently appeared in English ballads, which were sung in streets
and marketplaces, where printed copies of the lyrics were also
sold. These published ballads sometimes featured woodblock
printed images showing ships with crescent flags or images of men
in Oriental turban and dress, inspired by the visits of Moroccan
ambassadors.[87] But the references in these ballads usually drew on
negative tropes, perhaps because of the fear of conversion to Islam
and, sadly, they would have been one of few references to Muslims
for poorer people at the time. These street ballads seem like a
reaction against the political openness towards the Orient of the
Elizabethan era.

One cultural impact of the new political alliances which remains
with us today took place in theatres. The 'Turk' or the 'Moor'
became an almost essential character for every playwright at that
time, including the man who remains Britain's most famous:
Shakespeare. *Othello* was written in 1603, a tragedy which centres
around the downfall of a Moor who serves as a military commander
for the Venetian state and fights the Turks in Cyprus. The play
depicts Othello's secret marriage to a white woman named
Desdemona and the villainy of his standard bearer Iago who,

through lies, leads Othello to kill his wife in a fit of jealousy, and then himself. It was first performed at the Banqueting House in Whitehall and then later staged at the Globe Theatre. In most plays at the time, the Turk or the Moor was a villainous character; in *Othello*, the ultimate villain of the whole affair is Iago (the European), while Othello (the Moor) is the flawed and tragic victim of his machinations. Shakespeare managed to create a more complex narrative than simply painting the Moor as the enemy, as many of his contemporaries did.

Modern productions and analyses of *Othello* focus primarily on the title character's race. It is worth noting that in the period Shakespeare was writing, the word 'Moor' was not only used to refer to someone with black skin: it could also mean a North African, a Muslim or a person from any part of the Orient. Among literary critics, a debate has long raged over Othello's true identity. Othello is called 'an old black ram' by Iago in the play, his skin is described as 'sooty' and his lips 'thick', all of which suggest he was meant to be a black African character. But he is also referred to as a 'barbary horse'; Barbary being the term for North Africa. Some have suggested part of the inspiration for this character was the Moroccan Ambassador of 1600, Abdul Wahid bin Messaoud. A distinguished historian of the period argues that Shakespeare had likely seen Abdul Wahid bin Messaoud in London – perhaps his actors had even performed a play in front of him at Elizabeth's court – and that the assemblies of Venetian senators in *Othello* resemble the gatherings of the Elizabethan court.[88] While more recent productions have ended the practice of white actors adopting 'blackface' to play Othello, a debate about Othello's religious past continues. Clearly in the play he is a Christian who is fighting Turks. In his final soliloquy he even talks of killing 'in Aleppo once ... a malignant and turbaned Turk', but was Othello himself meant to be a Muslim who converted to Christianity? A thought-provoking production by the English Touring Theatre in 2017–18 explored the idea of Othello as a secretly practising Muslim and links the

play's themes with contemporary discussions around religious and cultural identity.[89] A character and play created under the reign of Tudors and Stuarts, in the context of anxieties around Muslims, still has much to say to us today.

★

Four centuries on from the popularisation of coffee in England, some of the same tropes and fears still exist. They are reproduced not just by the far right (who still sing an infamous racist chant about not being 'a Turk' from the football terraces), but also in the political and cultural mainstream. In multicultural and caffeine-addicted Britain, few would dare malign coffee as puddle water and deem it a 'Turkish enchantress', but the fear of being 'turned Turk' somehow still exists. Now, it is expressed in newspapers and political sloganeering by alluding to a 'takeover' by Muslims.

Despite extensive evidence to the contrary, the longstanding belief in British 'no-go zones' where the police or non-Muslims dare not tread continues to pop up at regular intervals, and in recent years these claims have been boosted by US President Trump's tweets. Such myths may be mocked on social media, but they have an impact; a poll by the charity Show Racism the Red Card showed that around one third of schoolchildren believe 'Muslims are taking over England'.[90]

During the 2016 campaign around the EU referendum, the official campaign for Leave unveiled a poster claiming 'Turkey (population: 76 million) is joining the EU'. It was factually inaccurate. Turkey could not have imminently become a member of the European Union. Nevertheless, analysis shows the poster was 'almost certain to have shaped the views of a significant number of voters'.[91] Regardless of whether it was right or wrong to leave the European Union, it is telling that this campaign managed to

tap into a pre-existing and specific fear of immigrants from a Muslim-majority country. Where 400 years ago 'Turk' was used as a synonym for 'Muslim' out of ignorance, here it was being employed as a code word.

In August 2017, *The Times* newspaper repeatedly ran a false news story on its front page which had strong echoes of seventeenth-century paranoia over being 'turned Turk'. The stories claimed that a white Christian child had her crucifix necklace removed, was stopped from eating food containing bacon, and was being made to learn Arabic by her Muslim foster parents, who could not speak English.[92] Despite the journalist writing the story being warned of the unreliability of his source and of some claims likely being entirely wrong – foster carers are required to speak English, for instance – the newspaper chose to continue publishing a series of inflammatory and inaccurate reports. A hysterical reaction was generated as a result, not just from far-right activists spewing hatred on social media, but also from the halls of power. Some Members of Parliament began publicly decrying the decision taken by the council's children's services, without full knowledge of the facts in the case, with one MP stating the local authority was 'completely wrong'.[93] Meanwhile, a prominent commentator on race issues claimed it was 'like child abuse' and that the authorities had 'placed being pro-Muslim over the welfare of the child'.[94]

Given the intense publicity around the case, a judge made the rare decision of publishing a summary of the family court judgement which revealed the truth. The story's source was primarily the birth mother of the child, a woman with alcohol addiction problems and a user of cocaine, who had convictions for drink driving and whose child had been removed from her care at a hotel bar by police while she was drunk. But these facts were omitted from the story told in *The Times*. The newspaper also failed to mention that the child was at risk of domestic violence because

of the mother's partner. Crucially, it also omitted that the girl's
maternal grandparents were Muslims themselves, meaning that a
placement with Muslim foster parents would have been far from
culturally alien or inappropriate for the child.[95] It is tragic that the
sad circumstances around the welfare of a little girl were manip-
ulated in this way. Yet it seems the authors of the story chose to
frame it in a particular way, knowing that it would result in a
frenzied reaction.

The myths of a Muslim takeover are not limited to Britain, of
course. A poll by the Pew Research Center, USA, shows that
people in other European countries, including Italy, Germany and
the Netherlands, are even more likely than Britons to view
Muslims unfavourably.[96] Almost every European country has its
own variety of a 'creeping sharia' themed political campaign or
factually inaccurate news story making claims of 'Islamisation'.
These anti-'Islamisation' campaigns are highly networked across
international boundaries, ideologically driven and very well
funded. They are also grounded in neoconservative political
movements, some of which have successfully disseminated their
ideas in the halls of power in the USA, Europe and the Gulf.
Those who want to whip up hatred draw on contemporary events,
but are successful because they are able to tap into more histor-
ically deeply rooted fears.

For Britain, an alternative history exists. Even four centuries ago,
at the same time that some were developing fears of 'turning Turk',
an excitement and curiosity over people, objects and ideas from
the Orient also existed. These encounters break popular stereotypes
about late-Tudor and Stuart Britain. Too often our depictions of
this era are inward-looking and forgetful of interactions with the
world beyond Britain's shores or Europe's borders. They are not
merely fascinating stories, but a tradition to draw on. It can be
found in the political openness of that iconic English Queen
exchanging friendly letters with rulers of the Orient and gifts with

a Turkish princess. It can be tasted in every sip of a drink which first arrived as a 'Mahometan Berry'. And it can be seen in a portrait of a Moroccan man hidden away in a place of heritage – a memory of an exchange that is all-too-often forgotten.

The Lost Mosque

Kew Gardens, Richmond

IN A GARDEN of many acres, even as thousands of plants and animals lie in slumber, parakeets proclaim a tropical song, unaware they are at odds with the weather. Warmer months bring crowds, but on the bitterly cold day of my visit, few others are venturing through the trail of conifers offering their lingering pine smell of a Christmas gone by. Fewer still pay any attention to the eyesore poking out from behind the conifers. It's an ugly tower, whose ten storeys are covered by dull grey-white tarpaulin, almost camouflaging it against an even duller grey-white January sky. But soon this construction site will disappear and the building underneath will be restored to its eighteenth-century majesty. In a few months the Great Pagoda at Kew Gardens will be resplendent with a gilded roof, fresh paint, and blue-and-gold dragons adorning its every side, eighty in total.

There has been much fanfare around the restoration of these creatures who disappeared from the pagoda either, as legend has it, because of a scandal involving a royal gambling debt or, rather less romantically, because the wood simply weathered away.[1] Yet they are not all that is missing from the garden. The pagoda once had companions: two other buildings standing close by. Though built in the same period and marvelled at by those who visited, now they are confined to black-and-white sketches. A Turkish mosque and an Alhambra arch once stood here, and their histories offer an intriguing window into eighteenth-century attitudes towards the Orient. But how and why was the first mosque to be

found in Britain built here, and might the hidden story of its construction disrupt our received ideas about mosques and their place in Britain today? Three fascinating and often forgotten characters in Georgian history offer us some answers.

The mosque at Kew stood on a small hill against a thicket of trees, its large onion dome, topped with a garlic bulb and crowned with a crescent, flanked by two smaller domes and tall minarets at either end.[2] Each minaret had a simple Grecian-style vase at the front of its base, while at their highest points the towers each bore a streamer flag, looking like wisps of smoke from chimneys against the skyline. At the centre of the mosque was a bright yellow octagonal hall with palm trees painted in each of its eight corners. These were varnished in various hues of green, mimicking the waxy shades found on palm leaves. The painted trees then spread up to the top of the dome, becoming entwined with each other and giving the illusion that the building was being held up by delicate reeds bound together with silk. Above these columns of trees was a summer sky, finely painted by the landscape artist Richard Wilson.[3] Twenty-eight little arched windows just below the dome let in light.

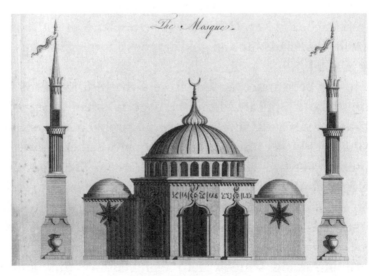

William Chambers' plan for the mosque at Kew.

The architect Sir William Chambers sought a marriage between an authentic Turkish exterior in a traditional Islamic geometric style, and a more experimental rococo-influenced interior, in keeping with the eighteenth-century craving for French fashions. Under the two smaller domes on each side of the building were windows exquisitely crafted in the shape of asymmetrical eight-pointed stars that gave the appearance of exploding fireworks, while the inside walls of these two smaller sections were painted a rich rose colour.[4] Three doors enabled entry to the mosque, above which there were verses from the Qur'an inscribed in golden Arabic characters proclaiming:

> There is no compulsion in religion
> There is no God except God
> There should be no likeness of God.[5]

Although there is no suggestion that the mosque was used for worship, this attention to detail and effort to accurately use scripture suggests a certain seriousness in the building process, and a respect towards the religion and culture from which the building was derived.

The mosque was completed in 1761, in the same year that the pagoda was built and King George III was crowned. Two years earlier a 'Moorish style' building called the Alhambra,[6] a tribute to the famous Moorish palace (and symbol of Islamic Europe) in southern Spain, was erected in the area. The Alhambra of Kew glittered in colours of red, blue, green, yellow and white. Several arches and columns with ornaments, stars and crescents decorated its outside, while the interior featured a ceiling based on 'an antique Roman vault'.[7] The initial plan for an Alhambra building was conceived by Frederick, Prince of Wales, who had purchased the land at Kew in 1758 but never lived to see it built. Instead, it was his wife Augusta, the Dowager Princess of Wales and mother of the future King George III, who commissioned a series of decorative

buildings in the gardens. These are often described and dismissed as mere follies, but to do so is folly itself because the buildings offer us an insight into how Augusta chose to project her power and what she wished to say about her worldview. Today the memory of one of these buildings has something even more to offer – a chance to rethink the idea of mosques in Britain.

The pagoda, the Alhambra to its east and the mosque to its west clearly seem to have been designed as a sort of trio – Chambers' original plans feature illustrations showing the three set in the Kew landscape. It appears that the buildings were built to simultane-ously impress and still somehow feel a part of the natural land-scape surrounding them. One drawing shows a gentleman and two ladies conversing under the pagoda, while a young boy ambles up the path towards the mosque carrying a basket.[8] The Eastern-style buildings look perfectly at ease in the same frame as the fences and foliage of south-east England. It is as if the patron or the designer wished to send out a message about the place of these buildings in Britain and, through them, the place of Britain in the world; that these ornate Oriental buildings are not alien to this landscape but, rather, that they belong.

Shortly after their construction, this approach was met with both praise and detraction. Some visitors were firmly dismissive, with Horace Walpole claiming 'little invention or taste' was shown at Kew.[9] Others felt it confusing; Sir John Parnell wrote it was 'absurd' to put 'different nations' together and that the buildings should instead have been hidden from each other by a 'hill, wood or clump of trees'.[10] But others marvelled. The *Gentleman's Magazine* declared: 'The buildings in Kew Gardens are deservedly the admi-ration of all foreigners; and, among them, none deserves greater applause than the beautiful mosque'.[11]

What none of the critics at the time noted was that this was the first recorded mosque built on British soil, something that may surprise many today who imagine the arrival of mosques to be a recent one. Though of course the mosque at Kew was

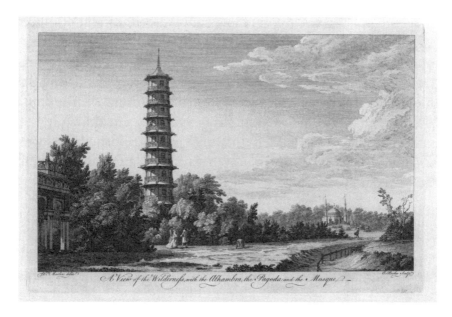

The Alhambra arch, the Chinese pagoda and the Turkish mosque
at Kew, 1763.

entirely lacking in worshippers, it seems clear the creators sought
a kind of authenticity, which suggests this was more than mere
whimsy.

But why build a mosque at all? Since neither the architect nor
the woman who commissioned the building had ever set foot in
the Ottoman Empire, where would they have derived ideas about
such architecture? How were they inspired by the cultures of the
Orient and who might have introduced them to such influences
in Britain? The answer is a surprising one. Long before a British
princess commissioned a Turkish mosque for her garden, two men
of Turkish origin were wielding immense influence at the heart
of the Georgian royal court, to the great alarm of the nobility. To
discover their story and the ensuing scandal, we must head six
miles east from Kew, where a clue lies hidden inside a royal palace.

*

In Kensington Palace, the servants and courtiers of King George I await visitors impatiently, lining the two walls of the King's staircase to my left and straight ahead of me as I climb up the steps. They attend me with curiosity, but are unmoved as I approach, immortalised as they are in a grand fresco by William Kent in 1724. The servants and courtiers lean across a balcony under four arches contained by six Corinthian columns, inspecting all those who ascend the building. Among these characters are two Turkish men: Muhammad and Mustafa.

The King's Staircase, Kensington Palace, featuring Muhammad and Mustafa, the 'two Turks'.

Muhammad is painted in profile: his stark black eyebrows stand out against the light skin of his clean-shaven face. He has a youthful blush about his cheeks, rather like an aged cherub, with a hat on his head that gives the appearance of a halo. What we can see of his hair is trimmed close, such that it's barely there. Though he can be no older than forty in this painting, he seems to telegraph importance. His wealth is evident from his robes: an ornate orange coat,

intricately brocaded with gold; and a teal cloak, decorated with gilded threads and buttons. He leans confidently against the balcony while placing his rather delicate hand on the ledge. Muhammad is gazing with interest at the woman standing beside him. With a flute in her hand, as if preparing to play, she seems a little distracted by whoever is arriving up these stairs – on this occasion, me.

The other Turk, Mustafa, is depicted as an older man, possibly in his sixties, his age indicated by his fulsome white beard and puffy cloud brows. His skin is darker, but he too is clearly a man who can afford luxury, wearing a sumptuous-looking red waistcoat with gold brocade work and a green cloak of velvet or some other heavy material over his shoulders. Above a face that looks on almost worriedly at those approaching sits his white turban. Decorated with red and gold embellishment, it makes his overall appearance look more starkly 'Eastern' than Muhammad's. Mustafa's red-gloved hand rests close to the arm of a young black boy, dressed in a similar style to himself, suggesting a connection between the two. Perhaps this unnamed boy was an assistant to Mustafa or even his own servant, as palace records show Mustafa was certainly rich enough to employ some personal staff such as a private tutor for his children.[12] The boy's robes suggest a connection to the Orient too: his own head is crowned by a white-and-blue turban topped with plumes of orange, while a gold coat and a blue sash partially cover his white shirt.

Although the portraits on the staircase suggest they could be twenty years apart in age, both Mustafa and Muhammad were reportedly young men when taken as prisoners in separate incidents shortly after the battle of Vienna between the Ottoman and Hapsburg empires in 1683. Muhammad was born in the Castle of Koron in the Morea (modern-day Greece) and his father was believed to have been an important Ottoman *pasha* or official serving as governor of the region.[13] Shortly after being captured, he joined the service of George I (then the Prince Elector of Hanover) and at some stage converted to Christianity, adopting the name Ludwig

Maximilian Mahomet. His closeness to George at this point was already apparent, as the then Prince Elector acted as godfather at his baptism. George later ennobled him in the German system, with the title of *von Königstreu*, (meaning true to the King). Muhammad's sister was initially captured alongside him, but the two were separated and the last record of her seems to suggest she ended up in France.[14] Meanwhile Mustafa was captured by a Swedish officer, but he too eventually found himself in the employ of George.[15] In 1717, as George left Hanover and arrived in Britain to become King of Great Britain and Ireland, the two Turks were alongside him. Their presence would in time become the cause of much envy.

Though it involved literally helping a man wash, undress and excrete, the position of Groom of the Stool to the King was the most coveted, because with such close physical proximity came political power. But the newly arrived German (now British) King decided he would not appoint a British courtier to the position. Instead, his two Turkish companions Muhammad and Mustafa were granted this intimate access.[16] As Keeper of the King's Closet, Muhammad was in charge of the monarch's private accounts. Records show he would buy hats and wigs for George and make payments to tailors and shirt-makers.[17] But he was no mere servant: said to always be with the King, he possessed great influence and seems to have also been a trusted friend and advisor.

The Georgians would become notorious for their family feuding. In ongoing quarrels between George I and his son and daughter-in-law – George II and Caroline of Ansbach – it was Muhammad who was seen as a source of intelligence about the King's thoughts and trusted to act as the King's messenger.[18] He also seemed to be one of the few who could take liberties around an often ill-tempered monarch. One of Caroline's courtiers detailed in her diary an occasion when the King visited, accompanied by Muhammad. While George I met with Princess Caroline in private, it was Muhammad who entertained the rest of the court. He told the story of how the King's sister had died in Hanover, 'suspected of having been

poisoned with Diamond Powder'. Muhammad provided gruesome details about her stomach; it was so worn that people could thrust their fingers through its lining, something Muhammad said he had done himself. He also furnished his audience with a detailed account of how the King had reacted to his sister's death. George had apparently refused to eat, drink or sleep for five days, and constantly wept and wailed. He had begun hitting his toes, until his shoes became so worn out that two inches of his feet crept out of them. So immersed was he in this grief that George had refused to see a soul, until Muhammad himself intervened, bringing in a relative to console him without asking prior permission from George.[19] Behaving in such a daring way towards the monarch and then being comfortable enough to relate the story to others is proof of Muhammad's status at court and his intimacy with the King.

It was an intimacy that did not go unnoticed. One observer of the court noted how the King preferred his Turkish friends to the English nobles, seeing this as evidence that the King seemed to have no 'predilection' for the English nation.[20] Legend would grow about the closeness of the Turks to the King. A story of how one or both of them had been instrumental in saving his life when he was wounded in battle at Vienna in 1683 has been often repeated in mentions of them.[21] But not all the rumours were so kind. The resentment of their proximity to the King, and George I's broader unpopularity among British nobles who saw him as too German, fuelled claims that the Turks were either arranging or performing sexual services for him. The politician John Perceval notes in his diary of 1715 that the 'King's enemies' accused him of various misdemeanours, including that he 'keeps two Turks for abominable purposes'. (Another apocryphal tale at that time was that the King apparently made 'the English' kiss his hand while placing it on his backside, 'so that they may at the same time kiss his breach'.) There is no evidence of these scandals being anything more than false rumours, but they heightened the mystery and suspicion around the King and his Turkish courtiers. John Perceval notes: 'We

that are every day at court knew all these things to be lyes, but they serve to give people in the country an ill impression.'[22] Despite the resentment it caused, George I continued to keep the two Turks close to him. When Muhammad died in 1726, Mustafa took over his duties and served the King. Indeed, it was Mustafa who was in a trusted enough position to inform doctors about George's sleeping patterns before the monarch's fatal stroke.[23]

Muhammad and Mustafa died nearly four decades before plans were conceived for a Turkish mosque in Britain. Both men had converted to Christianity, and accounts of them suggest neither seemed to openly practise any of the religious or cultural rituals they were born into. In the Kensington Palace staircase painting, Muhammad is depicted in a fur hat, as he is in another portrait of him commissioned by the King, which is in the Royal Collection today.[24] Mustafa, by contrast, is painted in a turban and traditional Turkish robes. Would he have been wearing these around court, or was this an emphasis on his origins from the Orient by the artist?

The presence of the pair in Britain aroused both envy and intrigue, and then there is of course much that remains undocumented. Evidently Muhammad was a skilled raconteur. Might he have told stories of his childhood in the Ottoman Empire as well as tales about the King? Though both were assimilated – having married Hanoverian women and become fluent in European languages – they were still continually referred to as 'the Turks'. Muhammad's mother also apparently accompanied him to Britain and would have served as some reminder of his background.[25] With little record of her, it is difficult to assess how much she might have introduced ideas or influences from the Orient to nobles in Britain and whether any such influences would have informed their ideas about mosques or architecture.

History, however, notes a woman who did. Her first-hand knowledge of the Ottoman Empire would be influential not just culturally, but in also introducing a major scientific development to Britain, which is still invaluable in medical practice today. And her

reflections on travelling to Turkish cities may even have directly influenced the building of the mosque at Kew.

<center>*</center>

In a quieter corner of the National Portrait Gallery, away from the grander frames of kings and queens, hang paintings depicting key figures in scientific developments of the eighteenth century. They are almost entirely of great men renowned for inventions such as the steam engine, but I have come to look at the one woman, Lady Mary Wortley Montagu. While the gentlemen in all the other portraits lean against books or papers with diagrams indicating their scientific achievements, Lady Mary stands with her young son at the centre of a scene clearly set in the Orient. To her left, a bearded and turbaned messenger offers up an envelope to her. On her right, a musician sat on an Oriental rug and floor cushions plays the lute. Though the colours aren't as vivid as they once would have been, with the painting in need of conservation, a close look shows the outline of a mosque, with its minarets reaching for a sunset still visible behind her. Lady Mary is depicted in 'Turkish dress' – a brocaded dress and cloak of gold, sapphire and ivory – with her hair tied up in a golden turbaned headpiece.

The only woman in this room secured her place here by being the first to introduce and champion the practice of inoculation against smallpox to Britain. It was an introduction at the highest levels of society, with Lady Mary making Princess (later Queen) Caroline, wife of George II, aware of the practice. She herself came across inoculation while living in the Ottoman Empire. Her letters documenting the experiences she had there, the people she met and the ideas she discovered, made her the first Englishwoman to report life from a non-Christian country.[26] Lady Mary would also become directly connected through her daughter and son-in-law to Augusta, the Dowager Princess of Wales, commissioner of the Turkish mosque at Kew.

The opportunity for Lady Mary to experience cultures of the Orient first-hand came through the appointment of her husband, the Whig politician Sir Edward Wortley Montagu, as British Ambassador to Constantinople. In 1716 the couple journeyed through Europe towards the Ottoman Empire. His task was to negotiate between the Ottoman and Hapsburg Empires, and hers was to accompany him, though it is her observations of their time abroad that would end up leaving the real legacy.

Lady Mary first began to question misconceptions about the Orient held by her own society during a cold and miserable stopover in Belgrade on their journey towards the Ottoman capital. Lady Mary and her husband stayed at the home of an *effendi* (scholar) named Ahmed Bey (Bey being a title of respect), and in the three weeks they spent with him she became absorbed by conversations on culture and religion. While they dined and even wined, despite Ahmed Bey being a Muslim (he proclaimed to a surprised Lady Mary that he believed the prophetic ban on alcohol was a diktat for the common person and not for the educated classes in the privacy of their own homes), they would discuss music, Arabic poetry and theology. She informed Ahmed Bey on debates in Christian theology and seemed pleased that he shared her negative views on Catholic theological principles such as transubstantiation. In turn, Lady Mary learned about different sects of Islam and noted that the diversity of Muslims was just like that of Christians. She admired his scholarship and fluency of languages, and delighted in the education she was receiving from this Muslim man. In her correspondence, Lady Mary excitedly wrote, 'I really believe I should learn to read Arabic if I were to stay here a few months.'[27] Perhaps most surprisingly, she displayed a remarkable capacity to think critically about how her own prejudices may have developed because of her inability to access a text directly, pointing out that the Qur'an could have been maliciously and falsely translated by 'Greek priests', which in turn might have led Christians to claim unfairly that it was 'nonsense'.[28] In an effort to rectify some of her ignorance, Lady

Mary would later, while living in Constantinople, devote time to studying the Turkish language and 'Oriental learning'. She became so fluent in Turkish that she joked she was in danger of forgetting English.

Lady Mary took pride in her first-hand reportage. She criticised other Europeans for having written absurdities about the Ottoman Empire based on ignorance, decrying 'they never fail giving you an account of the women who tis certain they never saw and talking very wisely of the genius of the men into whose company they are never admitted and very often describe mosques which they dare not even peep into'.[29] Lady Mary herself quite happily dared to peep into mosques and many more places rarely frequented by Europeans. Some of her recollections of encounters with Turkish women would be condemned when her letters were published posthumously. One scene detailed in her correspondence was seen as especially salacious. In the city of Sofia, Lady Mary first stepped in to a Turkish bathhouse and, to her astonishment, came across some 200 women drinking coffee or fruit juice while playing with each other's hair – all 'stark naked'.[30] She marvelled at their beauty and the egalitarianism of not being able to tell the status of a lady through dress. In turn, she was entreated to unclothe from her riding dress, an item of clothing which the Turkish women found 'extraordinary'.[31] In a letter to a friend, Lady Mary details rather amusingly how the Turkish women believed her husband had 'locked' her up in a 'machine', leaving her powerless and unable to undress herself from her stiffly sculpted bodice.[32]

A scene where a group of naked Muslim women deem a white Christian woman to be oppressed by her husband because of her layers of clothing is ironic when one considers the current context in Europe. The clothing of Muslim women has so often become a political totem in European countries that it has led to absurd and degrading scenes, such as a woman wearing a wetsuit on a beach being forcibly undressed by French police for 'not respecting good morals'.[33] In Georgian Britain, with its emphasis on elegance

and elaborate aesthetics, it was the absence of clothing that was regarded as immoral. Lady Mary delighted in the openness of the all-female experience in an Ottoman city, likening it to the all-male space of coffeehouses, but she would be lambasted for writing about it. Her contemporaries accused her of being mistaken about the scenes she had witnessed, or even lying about the nakedness of the women.[34]

This exchange with women of the Ottoman Empire was merely the first of many, and her interactions with local women while living in Constantinople would influence Lady Mary in several ways. She was certainly inspired by the fashions. Upon entering Ottoman territory, she quickly adopted a Turkish style of dress, writing a detailed description to her sister of her white silk embroidered smock, worn over a trouser of thin rose-coloured damask brocaded with silver flowers, a matching kaftan, shoes of white kid leather and a green robe lined with ermine.[35] These outfits served more than an aesthetic purpose. They enabled Lady Mary to travel through the city inconspicuously so that she could shop, see the sights or visit mosques. She regarded the common practice of face veiling by local women as an act which granted freedom because of the disguise it offered. In her letters, Lady Mary wrote this 'perpetual masquerade gives them entire liberty of following their inclinations without danger', including the ability to make appointments with lovers in secret, without being discovered. She also noted that women often had financial independence and the ability to divorce their husbands, leading her to declare 'Turkish women as the only free people in the empire'.[36]

Most significantly, it was during her time in Constantinople that Lady Mary learned about the practice of inoculation, then unknown in Britain. She saw that in this society, smallpox was taken in doses 'as they take water in other countries'. She described to friends how old women would visit homes in the autumn months with a 'nut shell full of the matter of the best of smallpox' and inject it into a person's vein using a needle.[37] Seeing how effective it was

on thousands of children, Lady Mary had her own four-year-old son inoculated in this way, rather boldly instructing the British Embassy surgeon Charles Maitland to carry out the procedure without consulting her husband. Smallpox had already caused suffering to Lady Mary, so it is no surprise she took an interest in the prevention of the disease. She had lost her own brother to the illness and remained scarred herself, having nearly died of it the year before she travelled. At the time her skin had become so excessively swollen that it had made her face unrecognisable. As she struggled through the fever and friends feared the worst, Lady Mary was offered the only treatments known in Britain at the time, a bizarre sequence of applying heat and then cold as a means of recovery. First she had to try and sweat out the smallpox, lying under thick layers of bedding in a darkened room as heavy curtains draped across closed windows successfully trapped in every particle of heat from the nearby roaring fire. Then came the 'cold' treatment. She had to lie shivering under wet bedsheets, while the open windows let in the bitter cold draughts of December. Whether these 'hot and cold treatments' helped or hindered her recovery is unclear, but Lady Mary made it through. She was, however, left with permanent reminders of the smallpox. Her eyelashes were so damaged by the disease they would never grow back, giving her eyes a certain 'fierceness', and she suffered with recurring eye inflammation throughout her life.[38]

Upon her return to Britain, she became a determined advocate for the practice of inoculation and in 1721, amid a global outbreak of smallpox, she instructed a reluctant Maitland to carry out the procedure on her daughter too, making the young Mary (later Lady Bute) the very first person to be inoculated in Britain. It was denounced by doctors and clerics, but Lady Mary considered it her patriotic duty to take the practice home, and she was unafraid to go 'to war' with the medical establishment.[39] So influential was Lady Mary and so successful was her campaign that it reached the royal court and received the backing of a high-profile patron. Princess

Caroline was persuaded to have her own children inoculated, albeit after having the jab tested on inmates of Newgate prison. It caused great fury that a procedure discovered in the Orient, practised mainly by women and then championed by one, should take hold in Britain, with one doctor angrily denouncing it as 'an experiment practised by a few ignorant women, amongst an illiterate and unthinking people' and lamenting that it should have been 'received into the Royal Palace' of 'one of the politest nations of the world'.[40]

Lady Mary's impact on medical science is evident, but might she also have influenced the building of a mosque at Kew? Although her writings about the Ottoman Empire were not widely published until shortly after her death in 1762, it is likely she would have shared the details of her encounters with family, friends and others she met. We know that she recorded vivid descriptions of mosques she entered. She marvelled at the marble galleries and pillars of the Suleimaniye mosque, but declared her favourite was the Valide, describing it as the most 'beautiful structure' she had ever seen and daringly stating that St Paul's Cathedral would make a 'pitiful figure' in comparison. She particularly singled out the Valide for praise because it 'honoured' her own sex; Valide was the Ottoman Turkish word for 'mother' and the mosque had been commissioned by Safiye, the mother of Sultan Mehmed III (who had herself corresponded with Queen Elizabeth I).[41] Perhaps this small detail struck a chord with the commissioner of the mosque at Kew, Augusta, herself mother of a future king. Lady Mary had a direct personal connection to Augusta through her daughter, who was also named Mary. Born in Constantinople, the very child who had sparked the inoculation controversy in Britain would in 1736 become the wife of Lord Bute, Augusta's closest advisor and confidant and, briefly, prime minister of Great Britain.

In 1747, while at the Maidenhead races, Lord Bute met Frederick, the Prince of Wales and son of George II. Frederick was the husband of Augusta and father of the future George III. Bute 'dazzled' him with his knowledge of botany and rare plants.[42] The

two quickly became friends and Bute helped Frederick develop ideas for a cosmopolitan garden which could reflect the then future King's interests. True to Georgian form, Frederick was continually embroiled in rows with his father and they were effectively estranged. He ran his own court and used his patronage of the arts and sciences to promote an alternative vision of the monarchy. This was the plan for Kew too. But Frederick died unexpectedly before his father, at the age of just forty-four, and so the legacy at Kew became that of his wife Augusta.

Augusta continued to develop the gardens at Kew, in close connection with Lord Bute. Bute recommended the architect William Chambers, who would later design the Oriental structures that adorned the gardens. Bute and Augusta enjoyed such an intimate friendship, and so influential was he over her, that rumours of an affair were rife. One satirical drawing was entitled 'A view of Lord Bute's Erection at Kew' and purported to show hidden routes within the garden which he was secretly using to meet the Princess.[43] Other cartoons printed at the time played on Bute's Scottish ancestry to suggest he was encouraging Augusta and her son to favour the Scots over the English. A sexually explicit drawing shows them both riding through the air on broomsticks. Another has them both inside a giant boot, in a play on his name.[44]

Lady Mary remained in touch with her daughter and son-in-law after moving to Italy in later life, so it is likely that Augusta's ideas about mosques would have been influenced by Lady Mary's views. The Dowager Princess of Wales was a shrewd political operator. Shortly after her husband died, she burnt his papers to ensure nothing incriminating could be used against her by her father-in-law George II.[45] She feared that discovery of Frederick's political activities could lead to her son (the future George III, now heir to the throne but still only a child) being removed from her care, which would not only be personally devastating for her, but also politically significant in denying her the chance to act as regent in the event of the King's death. Her choices at Kew were not just

about personal tastes. Aware that many visitors would frequent the gardens, she saw it as a chance to set out a landscape for a new Britain in a subtle act with great political meaning.

What, then, are we to make of the fact she commissioned a mosque to be included in this vision? Augusta was drawing attention to a new era, with her son soon to be King. Including symbols and buildings from around the world and representing religions and cultures other than Britain's own would display cosmopolitan openness. Indeed the mosque was completed only two months before George III was crowned. Newspapers in the summer of 1762 noted how 'a great number of persons of distinction' visited the gardens to admire its buildings.[46] Britain at the time was also beginning to forge an empire, looking eastwards in particular for new trade routes. The designs at Kew may have been attempting to invoke the 'visual language of older empires'.[47] Many in Europe were fascinated by Constantinople as 'a city where Roman, Byzantine, Christian and Muslim architecture stood side by side'.[48] Presenting such a range of buildings at Kew seems to emulate this diverse atmosphere and, by including a mosque in the Turkish style, the new King could be seen as just as powerful as Ottoman sultans before him.

But even if the mosque had been built as a cynical display of power or an assertion of imperial ambition, its presence represented a respect for the Orient, its history, culture and religion. It demonstrated Britain's appreciation for the architecture of Islam and it was to influence other Europeans. In Baden, the Prince Elector commissioned a mosque for Schwetzingen Palace gardens and the court architect there was directly influenced by Kew, though sadly the Arabic phrases inscribed on its walls are written with many mistakes. This was effectively Germany's first mosque, designed as a symbol of tolerance. It still stands today and visitors are encouraged to regard it as a place of contemplation. Meanwhile in Sweden, a Turkish kiosk built in 1786 in Haga Park, just north of Stockholm, is also believed to have been inspired by Kew.[49] This yellow-walled building with a crescent-topped green dome can still be visited.

The influence of the mosque at Kew lasted far longer than the building itself. Exactly when it was destroyed is unclear, but in 1785 a travel guide for the area notes: 'it is much to be regretted that upon a survey taken a few years since, the whole was found to be so generally out of repair, that it was thought proper to take it entirely down'.[50] Augusta had died of cancer eight years earlier, and was by then so unpopular (partly because of her relationship with Bute) that a mob turned up at her funeral to heckle and chant insults.[51] The mosque's structure was always likely to be fragile, being made of wood and plaster, but clearly no one had taken sufficient interest in seeing it maintained or rebuilt.

*

A century later, the only memory of the mosque seemed to be hidden within the name of the piece of land on which it once stood. In 1908, a curator at Kew Gardens wrote that workmen called it 'Moss Hill' and that this was a corruption of the word mosque.[52] But even this legacy would not last. In 1910, Kew Gardens was offered a replica of a sixteenth-century Buddhist gateway originally made for the Japan-British exhibition. The site chosen for it was Moss Hill.[53] Today the Chokushi-Mon or Gateway of the Imperial Messenger stands surrounded by Japanese cypresses known as hinoki, some of which were planted by Japanese royals on a visit in 1976. Under a copper roof, the cypress wood structure is embossed with panels of metal detailing, showing swirling foliage, flowers and fiery dragons. The creatures are depicted in different poses: one large dragon feeds a baby from her mouth, another lies craftily in wait, while a third looks ready to pounce.

The Gateway of the Imperial Messenger provides a sanctuary, disturbed only by the roar of planes flying above and the patter of tourists heading towards it. Sitting close to the Gateway on an unexpectedly hot spring day, I observe them: hats on heads, camera straps around necks, they gaze at the grandeur. Some walk up to

the steps and throw pennies into the fencing surrounding the gate, quietly wishing for luck, while a group of French teenagers noisily pile up their bags in a corner, whip out their phones and perform their well-practised selfie poses. The Japanese structure, it appears, provides the perfect backdrop for Instagram. Few stop to read the nearby sign providing information on the Chokushi-Mon, though those who do will learn only that it was restored in the mid-1990s. But with no sign that anything else ever stood here, the memory of the mosque has been well and truly erased.

So what if the curators at Kew were to decide they wanted to rebuild Augusta's mosque today, perhaps in a part of the garden close to the original site? What sort of reaction would it generate? Would this even be possible? There are now hundreds of mosques in Britain, and they are no mere ornaments, being active spaces for collective worship, socialisation and charitable activities. Some have been converted from houses, factories or even churches. Others have been built from scratch, with styles varying according to the traditions or outlooks of the congregations.

In the cathedral city of Lincoln, a mosque constructed on the site of a former dairy opened for the very first time in 2018. It followed a twelve-year campaign of applications, fundraising and fending off hatred. On an industrial estate, past the slopping sounds of cars being mechanically washed and before the entrance of a Lidl supermarket, a small emerald-green dome glistens in the sun. This May weekend marks the official inauguration of the mosque and it is being celebrated with an open day. As I walk into the entrance, I see a mother turning to her daughter as they both take off their shoes, telling her how the building reminds her of when she 'used to go to Leicester to buy Eastern earrings'. By the tea stall, a young white man in blue jeans and scruffy T-shirt and a grandmother dressed in a purple shalwar kameez sit together, both in peals of laughter over a joke shared only between the two of them, while an elderly Asian gentleman mills through various groups, a silver war medal proudly displayed on his breast. A young

black man takes a small group of us on a tour of the building, pointing out the Qur'anic calligraphy adorning the walls and pausing patiently while we click away with our camera phones, trying our best to capture the golden light from the chandelier above. One woman asks if the call for prayer will be proclaimed from loudspeakers to the whole neighbourhood. 'Not asking for me, you see,' she adds quickly, looking a little embarrassed. 'I'm okay with it, it's just I know other people were worried.' The guide tells her it will only be heard by those inside the mosque walls and that the surrounding community need not worry. It is just one of the myths they have had to bust over many years.

Some 300 Muslims live in Lincoln and its neighbouring villages. Many are doctors or staff at the hospital, others run takeaways or study at the university. It is a diverse congregation, boasting up to thirty nationalities and ethnic backgrounds, with the eldest members having lived in the area for more than forty years. Now they finally have the mosque they have so longed for. Professor Tanveer Ahmed, Chairman of the Islamic Association of Lincoln, tells me that seeing the building finished is as much a 'relief' as it is 'exciting', after 'many, many sleepless nights'.

In 2008, a derelict church purchased by the community to be used as a mosque was burnt down in a suspected arson attack after they had received planning permission. Professor Ahmed says they had received threatening messages before the fire, but the police investigation was unable to establish who was responsible for the attack. A quest to find a new site and another series of planning applications ensued. Throughout this time, Professor Ahmed and others in the congregation worked hard to find compromises on parking issues and allay the fears of neighbours – by knocking on every door, holding meetings at the local naval club and joining in with the wreath laying at a nearby war memorial. Meanwhile far-right groups exploited the situation, marching through the city several times in opposition to the mosque. In 2014, the East Anglian Patriots brandished signs calling for 'No More Mosques' alongside

Union Jacks.[54] The group's Facebook page peddles Islamophobic propaganda and calls for the use of 'bacon grenades' against Muslims, while expressing pride in England and Britain. The following year, the English Defence League walked through Lincoln singing a chant calling for mosques to be burnt.[55] Each time, these marches were met by anti-racist campaigners, urging unity against hatred and condemning the fanning of racial tension in their city.

At the eventual opening of the mosque, on the early-May bank holiday in 2018, such is the curiosity that more than 800 visitors have come to see the finished building and the sounds of anger have been replaced by shared laughter. Professor Ahmed says that for months, many of the neighbours had been asking if and when they could visit. He emphasises this will not be just a place of prayer, but 'a community space for everyone in Lincoln', and he takes particular pride in showing me the creamy-gold carved tiles that make up the *mihrab* (front of the prayer area), having commissioned them from a Lincoln craftsman.

While tensions in Lincoln may have been subdued for now, this story has played out in towns and cities across Britain, where plans to build mosques are nearly always met with opposition. Some of that resistance may simply be local residents concerned about parking or noise, but much of it is orchestrated by individuals and groups who care little for neighbourhood cohesion. The most notorious self-styled 'mosque buster' is planning lawyer Gavin Boby. He boasts of having successfully opposed more than thirty mosque applications, each time mobilising people to present their concerns on grounds of traffic or disturbances, when he seems to be motivated by a hatred of Islam. Both online and in speeches on the street, Boby has linked mosques and Muslims to sexual abuse, words which have won him acclaim from many far-right groups and hate preachers, both in Britain and in the USA. This linking of Muslims to sexual abuse is another well-worn medieval-era myth that has been revitalised by a veritable industry dedicated to stirring Islamophobia, perpetuated by politicians, political

movements and media outlets invested in stoking hatred. Although Boby has been publicly exposed for his apparent Islamophobia numerous times, he continues to carry out his activities not just in Britain, where he has most recently campaigned against mosque plans in Reading and north London, but also in other countries such as Canada and Australia.[56]

Existing mosques have suffered arson attacks and their congregations have been victims of terror and hate crime. In 2013, an 82-year-old worshipper in Birmingham, Muhammed Saleem, was leaving a mosque to return home when he was stabbed to death by a Ukrainian white supremacist terrorist who also attempted to bomb three mosques in the West Midlands. In 2017, an investigation by the Press Association found hate crimes targeting mosques had doubled within a year.[57] Those incidents included windows being smashed and assaults or threats against worshippers, as well as the petty vindictiveness of bacon being left on doorsteps. Most famously, in June 2017, terrorist Darren Osborne ploughed a van into worshippers close to a mosque in Finsbury Park, north London, killing a grandfather, Makram Ali, and injuring several others. I arrived at the scene of that attack in the aftermath, to report on the incident. It was a sweltering night, after a boiling day during Ramadhan, the Muslim month of fasting, as my two colleagues and I tried to weave our way around roads and pavements already sealed off by the police, to try and piece together what had happened in the last few hours. We frantically spoke to eyewitnesses and those who had heard from eyewitnesses, each of whom furnished us with partial details about how the attack had unfolded, how Osborne had been restrained by a crowd and then handed over to police. Fear remained in the air and there were rumours about a second attacker still being on the loose. By morning these thankfully proved to be untrue, but after that deadly attack in the pitch black of the night, every shadow seemed to be a potential threat. A neighbour of the elderly gentleman who had been killed led me to the road he lived on, not far from the mosque. Some of Makram Ali's family members and neighbours

were standing outside his home, raw with grief, frozen in shock. Months later, at the trial, his daughter paid tribute to him, describing him as a 'peaceful and simple man' who 'had no bad thoughts for anyone'. She added that her family was still 'struggling not to fall apart under the weight of grief, with her mother too afraid to go outside and her five-year-old son still asking for his grandad'.[58]

While these attacks and the opinions of the so-called 'mosque buster' may not constitute a majority view, the far right's campaign to mainstream negative attitudes towards Muslims and present mosques as alien to the UK has been successful. One recent poll showed more than half of Britons supported racial profiling of Muslims and Arabs,[59] while another found 55 per cent would be bothered by the prospect of a mosque being built in their community.[60] It seems a far cry from the days of being inspired by Islamic architecture.

A mosque as a garden ornament and a mosque frequented by living, breathing human beings are obviously two very different things. But there is something to be learned from that first mosque-like structure on British soil. It denies those flaunting flags while spewing hatred a monopoly on history and demonstrates that mosques are neither new nor alien in Britain. In fact, respect for the buildings of the Orient existed even in the early modern history of this nation. A German noble turned British princess first commissioned a mosque on these islands. She did so to display power and possibly to indicate imperial ambitions – but also because she admired and respected the architecture of the Orient. Augusta was likely inspired by stories of foreign characters in the Georgian royal court and almost certainly by a woman who brought back both scientific and cultural knowledge of the Orient. This princess understood that the beauty of a mosque had a place in Britain and, in doing so, she presented a model for other Europeans. Though the mosque at Kew may not physically exist today, it seems fitting to recall the forgotten histories of the characters who may have influenced it and to channel the spirit of those who constructed it.

The Tiger and the Lion

*Apsley House, London; Belmont House,
Kent; and Powis Castle, Welshpool*

RUMOUR HAS IT that, should you ever write only the words 'Number One London' on an envelope and pop it in a postbox, this building is where your letter will end up. Once the first in a line of great houses after the tollgates to enter London from the west, Apsley House is now the only one still standing. It is a grand Georgian building with four Corinthian columns; anywhere else it would feel imposing and eye-catching, but stood beside the gates of Hyde Park, most people in the area seem to walk by without even giving it a glance. There is a roar of buses and taxis whizzing past, and the Wellington Arch towering high on the roundabout opposite proves distracting too, so it often seems like Apsley House is almost hiding away in plain sight. But today, I am walking up to it on a quest.

Apart from its memorable yet unofficial postal address, Apsley House boasts a wealth of art treasures, many of them linked to the Napoleonic wars. But there are small glimmers of another battle too. This was the home of Arthur Wellesley, the first Duke of Wellington, a soldier, a statesman and a prime minister of Great Britain, best known for his defeat of Napoleon at the Battle of Waterloo in 1815. But long before this famous military clash, Arthur Wellesley was involved in battle with another foe – a man whose myth intrigued Britain for many years, even after his death. This opponent was not European like Napoleon, but from a country of the Orient. He was both a warrior and a bibliophile, a man who was superstitious yet strategic, glorified by his supporters and

demonised by his enemies. In both life and death, Tipu Sultan was legendary.

Between the years of 1782 to 1799, Tipu Sultan ruled over the southern Indian kingdom of Mysore. He was a thorn in the side of British colonial ambitions and fiercely resisted the East India Company's attempts to dislodge him and conquer his lands. But after years of protracted battle, Tipu suffered eventual defeat, and when he was killed a five-year-old boy was installed as the new ruler of the kingdom, a mere puppet, for it would now be indirectly governed by the British. Meanwhile Tipu's belongings were captured and divided up as booty by British soldiers. Many of them made their way back to Britain, as did the stories surrounding him. Known as the 'Tiger of Mysore', after his adopted symbol, he became a representation of barbarity and a justification for British colonial rule in India. Ironic then that his death and the subsequent plunder of his kingdom represent a moment of historical British barbarity. Where previously the country had felt fascination, curiosity and even respect for the Orient, now a more overt desire for the conquest, subjugation and moulding of its peoples and cultures to be more like Britain had emerged. Today, hundreds of items apparently belonging to Tipu remain scattered around heritage sites and, unlike many of the other objects in this book, these came to Britain as prizes in a colonial war. They are glittering clues to a conflict, a much-discussed character and a pivotal moment in history, now in danger of being forgotten by mass audiences.

Most visitors to Apsley House will find their attention captured by a naked Napoleon. At the main stairwell stands a marble statue of the French emperor as the Roman god Mars; his strong muscular body is almost three and a half metres tall, his large right arm brandishes a staff, while his left hand presents an orb topped with a gilded figure of the Greek goddess Nike, representing victory. Between his legs, a small fig leaf is delicately placed for modesty. It was meant to be a prestigious piece of propaganda, an idealised figure of the French emperor carved out over four years, designed

to be a timeless tribute. But Napoleon himself hated the statue and he banned the public from seeing it, believing it portrayed him as too athletic. The statue was banished to storage until after the Battle of Waterloo, when the French leader was defeated, and it was then sold to the British government and presented to the Duke of Wellington, who decided to install it in his home. There is a debate over whether this was an act of triumphalism over a foe or because Arthur Wellesley actually admired the sculptor's work.

Those traipsing around the house today might perhaps also be charmed by the Egyptian dinner service sitting in the Wellington museum room. These are hand-painted porcelain plates depicting obelisks, pyramids, gods and hieroglyphics, accompanied by an extraordinary centrepiece; an elaborately crafted, almost seven-metre-long porcelain model of an ancient Egyptian temple, complete with porcelain pharaohs guarding the entrances. This collection comes courtesy of Napoleon too; he had commissioned it as a divorce present for his wife Josephine. Whether out of pride or dislike of the set, she rejected it, and the dinner service was sent back to the factory. It too was later gifted to the Duke of Wellington.

But for me, there is one small glass cabinet in the corner of this same room that provides special intrigue. Behind the glass there are no Napoleonic rejects and the contents of this cabinet are entirely unconnected to Waterloo – though, arguably, Napoleon did have some indirect bearing on these particular objects ending up here.

This is a small collection of swords – Indian and Persian – some gilded, others silver, engraved with Arabic letters or repeating motifs. Among them a long, glimmering sword with a flower-and-leaf pattern, its hilt curved and curling; and a dagger, the sharp silver glint of its lethal blade catching the light from every angle, looking more menacing by the minute. The dagger has sweeping cross guards to protect the wielder's wrists, these are connected by an intricate double grip that looks like two sweets wrapped up tightly in gold paper. It is both deadly and dazzling. Beside it, a mustard-yellow

velvet sheath, with some faded dark spots from ageing, provides a clue, with an affixed note written in a cursive hand: 'Tippoo Saib's Dagger ... Presented by the Marquess Wellesley.'

These blades are just a few of very many objects that were brought to Britain after the death of Tipu Sultan and fall of his kingdom in 1799. Today, some of these objects are prominently displayed in museums; the best known is the toy tiger at the Victoria and Albert Museum in London. Many of them, however, remain in private collections. Some have been sold at auctions, sometimes generating controversy, their ownership still a subject of contention given that they were captured in colonial conquest and then passed down to the descendants of those involved in the battle against Tipu's forces. In 2014, a gold ring supposedly taken from the finger of Tipu Sultan by Arthur Wellesley himself fetched £145,000 at a Christie's auction, while a year later a collection of Tipu's arms sold for a total of more than £6 million.[1] A few items have been returned to India; in 1956, the seventh Duke of Wellington handed over several of Tipu's personal items, previously held in Apsley House, to the Indian government. He also passed on the house itself to the British state and it is now run by English Heritage as a museum, with a part of the building sectioned off as family apartments for the current Duke of Wellington and the Wellesley family.

In Britain today, the Tipu relics that remain continue to be displayed in stately homes around the country as objects of curiosity, but perhaps not with the same prominence they might have had in a previous era. Yet, possessing an object linked to Tipu Sultan once held great prestige as his legend loomed large over Britain. In fact, even into the nineteenth century, decades after his death, the country experienced a kind of 'Tipu mania'. So just who was the man provoking this obsession and how did so many of his apparent possessions end up in Britain?

★

By the late eighteenth century, a British trading company first granted a charter by Queen Elizabeth I had become a dominant force across the Indian subcontinent. The East India Company had managed to secure a monopoly over trade and now directly ruled huge swathes of the country. In the south of India, there was just one major obstacle left preventing British dominance – the 'Tiger of Mysore', Tipu Sultan. For more than three decades, the kingdom of Mysore fought a series of wars against the British, first under the leadership of Haider Ali, Tipu's father, and then during the reign of Tipu himself. In the course of these battles, a propaganda war against the enemy ensued at home in Britain. Newspapers most often referred to the ruler of Mysore as 'the tyrant Tipu', and painted a picture of a villain. One report stated that 'his disposition is naturally cruel: his temper is passionate and revengeful; and he is prone to be abusive; and his words are false and hypocritical as suit his purposes'.[2] While another detailed his offences against British officers, accusing him of 'representing Indian ferocity', which 'nature' itself would 'shudder at'.[3]

Anti-Tipu songs were written and published, some of which had overtly racist tones: one referred to his 'blackamoor party' and includes a lyric claiming Tipu would 'kill us and eat us', although the tone is rather tongue-in-cheek.[4] A series of plays on the London stage brought to life Tipu's apparent transgressions, including stories of gruesome treatment encountered by Britons while they were held prisoners by Tipu, which added to his ruthless reputation. One account claims prisoners were left 'languishing in agony' and 'literally crawling with maggots'.[5] Worse still were the claims of British men being forced to undergo circumcision, which were mostly met with horror and seen as evidence of Tipu's cruelty, although a certain mention of this in a parliamentary debate perhaps went too far in claiming Tipu 'not only circumcised the officers who had become his prisoners by the fate of war, but cut off their "doodle doos"!' Members in the House of Commons became convulsed in a fit of laughter upon hearing this claim.[6]

At the same time as this barrage of barbarities was attributed to Tipu, the East India Company was portrayed as a humane British force. In previous years, the Company had come under fire for corruption; parliamentarians used speeches to lay out accusations of abuses it had perpetrated, while satirical cartoons portrayed some of the Company's employees as being motivated by personal greed. Casting Tipu as an arch-villain allowed the Company to reinvent itself. Now it could claim it was fighting to liberate the oppressed of Mysore from a brutal despot who had usurped a throne. Tipu was a Muslim, ruling over a majority Hindu population. His administration was made up of many Hindu advisors, his coinage featured images of Hindu gods, and Tipu himself, despite being a devout Muslim, was clearly influenced by Hindu beliefs – Vedic astrology in particular – but his enemies still attempted to weaponise this difference. It was claimed Tipu was an illegitimate ruler and that, although he was powerful, he was held in 'utter detestation by his own subjects'.[7] However, a report from *The Times* newspaper, while alleging that 'his subjects are disaffected with his Government', also could not resist pointing out Tipu's 'treasury, rich beyond conception'[8] – a matter which would prove to be of more interest to the British than the welfare of the citizens of Mysore.

British 'benevolence' was also emphasised using art. During the third of the Anglo-Mysore wars, as a condition of a peace treaty, Tipu Sultan was forced to give up half his territory and hand over two of his young sons as hostages to British forces. The scene of this hostage handover is shown in a carving inside the walls of the Foreign Office, as well as in at least two paintings which hang in British galleries today, one at the Bowes Museum in County Durham, the other at the National Army Museum in London. Here the large artwork depicts two boys dressed in ivory robes, with red-and-gold turbans on their heads and matching sashes around their waists; the elder has a brocaded gold cloak around his shoulders, while a string of pearls hangs around each of their

necks. The British officers gently take the boys' hands, the younger seems to offer his out willingly and both seem perfectly at ease with the arrangement. Behind them are their Indian attendants and a procession of elephants on which they had been transported to the British camp; in the background a Union Jack flutters away. The artist who was present at the scene and included a self-portrait – standing behind the army officers in civilian clothing with a portfolio of sketches under his arm – produced this as a propaganda image to show British paternalism, in contrast to 'Tipu the tyrant'. Reports at the time described the boys being greeted with a gun salute and then being received in a 'tender and affectionate manner'.[9] Today, curators have hung it as part of a display asking visitors to consider the ethics of war, including whether it is ever acceptable to take hostages. Perhaps even this is a euphemism, given it was in fact state-sanctioned kidnap of children.

Despite British efforts to present the battle against Tipu as a moral war fighting injustice, the East India Company's real concern was the threat Tipu posed to their commercial and military interests. Tipu's kingdom had control of the trade routes along the Malabar coast (the south-west coast of modern India) and there were significant economic benefits to be gained from the port cities there. An enemy state in this region prevented the East India Company from marching through southern India and further expanding its sphere of control. The kingdom of Mysore was a serious danger as a foe, being a pioneer in military technology, in particular the use of iron rockets which could be fired at their enemies. A British officer who had to battle against them said that 'the shrieks of our men from these unusual weapons was terrific' and that they were capable of causing 'death, wounds and dreadful lacerations'.[10] So advanced were these Mysorean rockets that, after being shocked by them on the battlefield, British forces sent samples back home which were then reverse-engineered to create weapons for successful use in the Napoleonic wars that would follow.

As Tipu resisted Britain's attempts to conquer the region, he also sought alliances with its European rival: France. He employed French advisors to help develop military techniques among his forces, and on numerous occasions requested help from France against the British. With Napoleon having invaded Egypt, British forces now feared he would set his sights on India and challenge the East India Company's growing monopoly. In February 1799, Napoleon wrote a letter to Tipu boasting of his 'innumerable and invincible army' being 'full of the desire of delivering you from the iron yoke of England'.[11] Tipu never managed to read the letter himself as it was intercepted en route by the British in Jeddah, but the damage was done. It acted as proof of a full-blown alliance between Tipu and Napoleon and was all the pretext needed to finish off the kingdom of Mysore. British forces now went to war with Tipu again; this time it was to be a final battle, one that would be key to Britain, not just as a moment of imperial expansion, but also in forming an image of victory over a villain who would loom large in cultural production for years to come.

Two brothers were key characters in the defeat of Tipu: Richard and Arthur Wellesley. They were of Anglo-Irish descent and sought to increase their status and personal wealth in British society through their posts in India. Richard, who was also known as Marquess Wellesley or Lord Mornington, had just been appointed Governor General of India. He was keen to 'make his mark' politically before the age of forty and expanding the British Empire in India would certainly do that. Towards the end of the eighteenth century, the East India Company already controlled the states of Bengal and Bihar in the north-east, Orissa on the eastern coast and some parts of southern India captured in previous clashes with the kingdom of Mysore, as well the key port settlements of Bombay and Madras. It was the strongest military force in India and gained substantial revenues from taxing the local population. The rest of the subcontinent was governed by an extremely diminished Mughal Empire and a variety of regional princes who had broken away

from being local representatives of the Mughals to create independent states. Lord Mornington now wanted all these local rulers to be subordinate to British power. Under his governorship, he pursued aggressive expansion of the Empire, both through battles with rulers of these states in order to directly annex them to British territory, and by creating alliances with princes who were perceived as controllable. These 'alliances' required the 'native' princes to give up their own armies and instead pay the British for the defence of their territory. Lord Mornington was also obsessed with the idea of French plots, either because he genuinely felt threatened by the possibility of French encroachments on British territory in India or, more likely, because they provided him with a justification for the East India Company to continue financing British expansionism.[12] At this time the directors of the East India Company believed military action in quest of further land in India was not necessary. The Company was focused on profits, and battles were expensive. Mornington, by contrast, had an imperial vision, and so he utilised the French threat to strengthen his case for immediate war against Mysore. He decided a surprise attack should be launched against Tipu, despite this contravening official British government policy. Among those sent towards Srirangapatna (known by the British as Seringapatam), the capital of Mysore, was his younger brother Arthur Wellesley, who would later become the Duke of Wellington. The younger Wellesley commanded a division in the fight, but as well as this military role, he was also crucial in overseeing the dispersal of Tipu's treasures.

On 4 May 1799, Tipu Sultan was found dead. An enormous painting depicting the scene hangs in the Scottish National Gallery in Edinburgh. A dark muscular man with a prominent moustache, naked above the waist, has fallen onto the floor below some dungeon steps. His eyes are closed, his soul has left him, but the bloodstains on the white-and-gold clothing covering his lower half look fresh, suggesting he has only just died. Close to his red-and-gold slippered feet lies the corpse of a smaller man – perhaps a

comrade or a servant – while in Tipu's right hand, a silver glimmer shows he is still grasping a sabre. Three brown-skinned men with turbans on their heads clutch Tipu's neck and arm in anguish and shock. I can almost feel them shaking him, checking for a pulse, willing their leader not to be dead. There is a sense of pandemonium. Other men and what looks like a girl seem to be crying and reaching out helplessly towards the body. But towering above them are three white-skinned British officers, the first, with a bearskin hat topping his head, grasps a gun and gazes down unmoved by the hysteria below. Another officer with the same headgear brandishes a flame torch to shed light on the scene, while also helpfully illuminating his Scottish heritage; he is wearing a green-and-blue tartan kilt and calf-high red-and-white-checked socks. He appears to be in the uniform of the Black Watch. Between them and at the centre of all this drama, one British officer stands triumphant and powerful, his body taking up more space than anyone else, his hat sporting plumes of feathers to signify his seniority and his hand aloft in victorious declaration. This is General Sir David Baird, once held prisoner in Mysore himself, after being caught in a previous battle with Tipu and his father. Now he has stormed the palace and found the body of his enemy. Personal revenge for Baird and victory for the British have been achieved.

This victory followed a siege of the city and a bloody battle in which Tipu's forces were vastly outnumbered by the British. Earlier that day, the Muslim ruler of Mysore had made one of his regular visits to his Hindu priests, only to be told that the omens were bad. He had distributed alms in both monetary and animal form, including an elephant, and reportedly had performed various rituals in an attempt to avert misfortune. They did not prove enough.[13] Hours before his death, Tipu Sultan made a 'gallant last stand'. As British forces breached the walls of his fort, he stood within 200 yards of them with a small party of his supporters. With assailants heading towards them, Tipu fired seven or eight shots, personally killing three or four British soldiers, but was wounded in the

process. A musket shell flew at him, hitting the right side of his body and injuring either his shoulder or his breast, then came a second bullet, inflicting a second wound. Tipu fell from his horse. Seeing his injured condition, an attendant suggested that they surrender. Tipu refused, told him he was 'mad' to make such a suggestion and urged him to be silent. Those of his party still alive placed Tipu upon a palanquin and took him towards a gateway. During this process, a British soldier apparently lunged at Tipu, attempting to snatch away his gold-buckled sword belt. Tipu struck back at him with the blade still in his hand, but a bullet was fired into his right temple and Tipu Sultan was killed.[14]

Reports that Tipu was lying among the dead in a gateway quickly reached British commanding officers. One who was present described the initial frantic search inside the fort for Tipu's body:

The number of dead, and the darkness of the place, made it difficult to distinguish one person from another, and the scene was altogether shocking; but, aware of the great political importance of ascertaining beyond the possibility of doubt, the death of Tipu, the bodies were ordered to be dragged out ...[15]

Eventually the body was found and identified by Tipu's servants. The officer wrote in detail about Tipu's appearance and dress:

When Tipu was brought from under the gateway, his eyes were open, and the body was so warm, that for a few moments Colonel Wellesley and myself were doubtful whether he was not alive: on feeling his pulse and heart, that doubt was removed. He had four wounds, three in the body, and one in the temple; the ball having entered a little above the right ear, and lodged in the cheek ... he had an amulet on his arm, but no ornament whatever ... he had an appearance of dignity, or perhaps sternness, in his countenance, which distinguished him above the common order people.[16]

The amulet mentioned here was further confirmation for those who found him that this was in fact the ruler himself. The painting in Edinburgh shows a red-and-gold band around Tipu's upper right arm. It was removed by the British officers and is described in further detail in an account supposedly based on interviews with Tipu's relatives and servants:

> . . . an officer who was present, with the leave of Major-General Baird, took from off the right arm the talisman, which contained, sewed up in pieces of fine flowered silk, an amulet of a brittle metallic substance, of the colour of silver, and some manuscripts in magic, Arabic, and Persian characters, the purport of which, had there been any doubt, would have fully ascertained the identity of the Sultan's body.[17]

A red-and-gold armband made of silk floral material with a pocket for carrying an amulet now lies inside the National War Museum in Edinburgh Castle. A letter from 1960 that accompanies it states that this was once tied around Tipu's arm. The actual amulet – believed to be a silver plate inscribed with Arabic and Persian prayers – has been lost. It was merely the first of many Tipu relics to be seized.

On the night Mysore fell, mass looting of the city by British forces ensued. The palace was filled with soldiers loading themselves up with gold and jewels; even the higher ranking officers who were meant to be urging restraint took their fill, while simultaneously shouting at the lower orders to stop. Some accounts rather euphemistically describe men as 'committing all sorts of excesses', but even these declare the events that followed to be shameful.[18] In fact it was nothing less than a series of atrocities. A senior officer described the wounded being left among piles of unburied bodies causing 'a disgusting stench'. Some houses had been burnt to the ground, while others were still on fire. He also saw 'women of a prominent Muslim family sitting half naked

among the ruins'.[19] Another officer talked of the 'horror and a ghastly spectacle' of 'bodies of the slain in every direction, lying in the verandahs and along the principal street'. In one gateway alone, he saw 300 bodies.[20] Another report details how 'women alarmed for their personal safety, emptied their coffers and brought forth whatever jewels they possessed', adding that the 'carnage' is 'much to be lamented'.[21]

A few days after the death of Tipu, Arthur Wellesley wrote to his brother, saying 'scarcely a house in the town was left unplundered'.[22] Soldiers had hauled antiques, jewels and bars of gold into the bazaars to sell them, clearly caring little for their actual value; Wellesley describes 'priceless pearls' being 'offered in exchange for a bottle of liquor'. A eulogy for Tipu written some years later (originally in Persian), perhaps best summarises the feelings of those who were the victims of this looting:

> ... from the morning, blood flowed from every wall and
> door in the streets of Seringapatam ...
> Ah at the destruction of this prince and his kingdom.
> Let the world shed tears of blood.
> For him the sun and moon share equally in grief.
> The heavens were turned upside down and the earth darkened.[23]

The most senior ranking Britons were alarmed at the wild behaviour of their troops. Public notices and a drummer were sent out to the streets to proclaim that anyone caught stealing from a home or molesting its inhabitants faced the threat of hanging.[24] Wellesley, who had by now been appointed Governor of the city, wrote to his brother saying he had instructed looters to be flogged and was trying to regain order, but 'the property of everyone is gone'.[25] The disorder only ended when at least four men were executed for looting.

But this did not mean an end to the taking of Tipu's treasures. Instead, a plan was devised for a more orderly allocation; each

soldier would receive a share according to their rank and a Prize Committee was set up to oversee the task. A memoir from David Price, one of the officers given responsibility as a prize agent, provides careful detail on how this was conducted. All the items were set out on tables, where they were first carefully valued by a goldsmith or jeweller and then registered. During the course of this process, Price was alarmed to suddenly hear gunshots being fired behind them. He turned, expecting to see the townspeople in revolt, but instead was met with the sight of 'several tigers scampering loose about the square'. He quickly snatched up the handful of emeralds he had been assessing and made his way to safety behind a door. These were likely to be the tigers that had previously guarded the entrance to Tipu's *toshkhana* or treasury, where he stored precious jewels, important state documents and other valuables.[26] The poor tigers were eventually shot dead and the officer describes hearing one of them giving his 'last roar' close by.[27]

Once all the goods had been registered, the shares were allocated. Jewels, coins, furniture, firearms, swords, carpets, plates, glass and all manner of antiques, as well as animals including elephants, camels and horses were either handed out as prizes or auctioned. The Commander in Chief of the whole military operation, General Harris, received one eighth of the total value of all the goods. This was paid in gold coins and 'bracelets and necklaces of the finest pearls, rubies, emeralds and diamonds'.[28] Harris sold the majority of these and used the proceeds to buy Belmont House in Kent when he returned to Britain.

<p style="text-align:center">*</p>

Today the Belmont estate comprises some 3,500 acres, including Faversham golf course. It was passed down through General Harris's descendants, but is now run by a private charitable trust. The yellow-bricked neoclassical mansion is surrounded by gorgeous

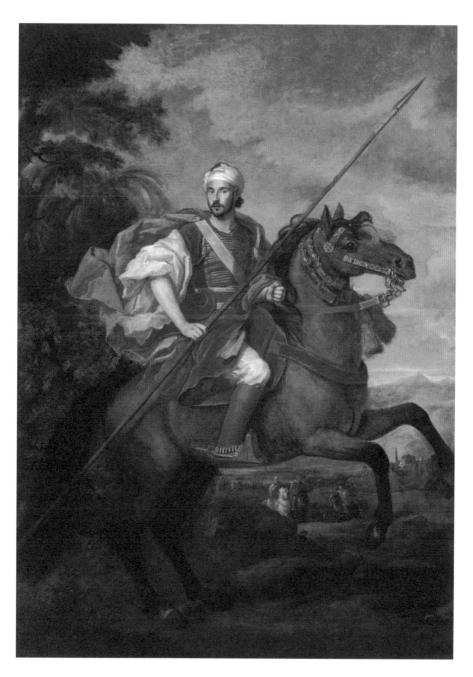

The Moroccan Ambassador Muhammad bin Haddu al-Attar, who visited England as a diplomat in the reign of Charles II, tasked with negotiating peace and trade between the two countries.

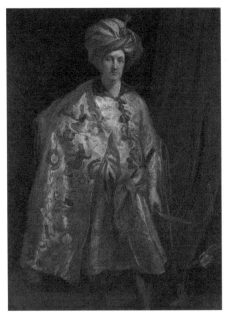
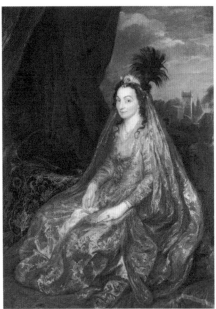

Sir Anthony van Dyck painted portraits of Sir Robert Shirley and his wife Lady Teresia Shirley (formerly known as Teresia Ismael Khan), who met one another at the Safavid court of Shah Abbas.

Commissioned by Bess of Hardwick, the sixteenth-century 'True Faith and Mahomet' embroidery reflects both the friendly trading relationship between Elizabethan England and the Ottoman Empire, and the fear many held of Christians being 'turned Turk' (converting to Islam).

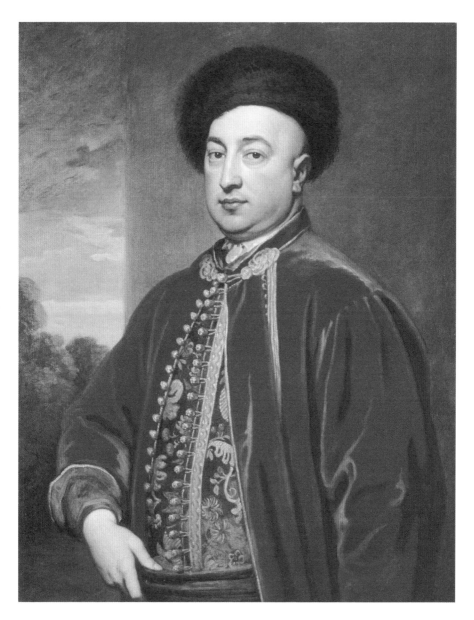

Muhammad, one of the Turkish courtiers of King George I,
held a highly coveted and influential position in the royal court.

Lady Mary Wortley Montagu kept detailed diaries of her experiences in the Ottoman Empire and brought the practice of inoculation to Britain.

As a condition of a peace treaty, Tipu Sultan's sons – ten-year-old Abdul Khaliq and his eight-year-old brother – were handed over to the East India Company. Robert Home's depiction of the event was used as propaganda to emphasise British benevolence.

gardens; on the bright summer's day of my visit, I observe a floral feast inside a walled area under the clock tower, an orangery and an orchard and, beyond that, miles of green fields as far as my eyes can see, disrupted only by small specks of yellow buttercups in the meadow wafting gently in the wind. The house boasts the largest clock collection in Europe, but is also home to a number of items from India collected by generations of the Harris family, beginning with General Harris himself. In the armoury room, which I am given special permission to look at in detail, case after case is filled with daggers, swords and guns, some of them obtained in Mysore. Propped up in a corner on a mannequin is a suit of armour, claimed to have been worn by Tipu in his youth. The steel breastplate is surrounded by a gilded pattern, while the accompanying bronze-coloured helmet is inscribed all over with detailed Arabic script in gold – verses from the Qur'an, traditionally believed to grant protection.

Harris was also made a peer and adopted the title Baron Harris of Seringapatam and Mysore, in the East Indies, and of Belmont in the County of Kent. His coat of arms is still used by Belmont House on its publicity material and can also be found engraved onto various items inside the house which belonged to the family, such as cutlery and chairs. It features a rather comically sad-looking tiger, six sharp whiskers pointing out of each side of his face, a crown on his head and a drop of blood on his chest as he is pierced by an arrow. Clearly, the new Baron Harris wanted all his visitors to give him personal credit for the death of Tipu. Although most of the jewels he received were sold off to fund his new home, he kept those of least value and handed them as gifts to his wife.[29] These were emeralds, rubies and diamonds, originally set in necklaces; as they were passed down within the Harris family, they were refashioned according to the styles of the day. On the stairwell inside Belmont House, paintings of the Harris family ladies show them wearing these gems. The collection, which includes stunning emerald earrings and a ruby-and-diamond necklace, is

now considered too valuable to be kept at Belmont House and is on loan to the Victoria and Albert Museum.

Back in south India in 1799, there were a few hiccups with the carefully devised plan for 'prize' giving. Some returned to complain about the goods they had been allocated, saying they were not as valuable as declared; an emerald necklace with the largest of its gems the size of a 'greengage plum' was returned because it was seen to be of inferior quality. This complainant was offered another item in exchange, but even the diligent Prize Committee could not keep track of what happened to every object; the prize agent David Price writes that he does not know where this particular necklace ended up and speculates that it may have been sold as broken up parts. General Baird also appeared in front of the Prize Committee, angry that a large ruby ring he had been given was 'proving to be nothing more than a lump of coloured glass'. Price noted that the committee 'rejoiced at the opportunity of doing him justice' and exchanged it for something else of sufficient value.[30]

It was not just a poor-quality ruby ring that was upsetting General Baird, however. Although he had led the storming of Srirangapatna and triumphed over the discovery of Tipu himself, it was Arthur Wellesley, then a lower ranking officer, who now superseded him, having been appointed Governor of the city after the battle. Perhaps this slighting of Baird explains why the artist – commissioned by Baird's wife – needed to portray him in such a glorified manner in the painting which now hangs in Edinburgh. For his part, Wellesley believed himself to have been quite rightly appointed over Baird, whom he later described as having 'no talent, no tact' and 'strong prejudices against the natives'.[31] But, as a way of making amends for his leapfrogging, he wrote Baird a friendly note to accompany a gift – a sword found in Tipu's bedchamber – only for the Prize Committee to then demand it back saying it was not Wellesley's to give. Instead, they wanted to present it to Baird themselves.[32] Even looting has its own bureaucracy.

The plundering may have become more organised, but the prize agents could not, it seems, prevent certain acts of disrespect. David Price describes in his memoirs how he entered the treasury to find a crowd gathered around the 'lifeless remains' of Tipu. He was shocked as a fellow officer asked to borrow his pen-knife and promptly cut off a part of Tipu's moustache, saying he had promised to give it to a friend. While this sometimes gruesome search for souvenirs was ongoing among British troops, Wellesley was also concerned about what the locals might do with items belonging to Tipu, should they obtain them. He wrote to his brother, worried that the prize agents intended to sell Tipu's clothes at a public auction, saying that he feared the 'discontented' of the town would buy these up as sacred relics. Wellesley claimed such a scene would 'not only be disgraceful but very unpleasant', obviously believing it could foment some revolt. After all Tipu, who had now been buried in a mausoleum alongside his father, had been declared a martyr locally. The drama on the night of his funeral had already been heightened when a freak thunderstorm burst out and seven British soldiers were killed after being struck by lightning.[33] Wellesley recommended the entire contents of Tipu's wardrobe should be bought up by the British government to prevent the public sale, adding that this would be the only way of preventing the situation, because the prize agents were 'sharks' and he had already been forced to send out an order to 'prevent them from selling the doors in the palace'.[34]

As suggested by Wellesley, aside from a few items that were given to his sons, all of Tipu's clothing was purchased and swiftly dispatched to the East India Company in London, with memoranda detailing the items. The wardrobe included *jamas* (long gowns or dress jackets) and *pyjamas* (originally meaning trousers). It also contained turbans and handkerchiefs embroidered with Qur'anic inscriptions to be worn on the battlefield or hung on swords. Some of these items were sent to members of the royal family.[35] Newspapers reported the arrival of the wardrobe in London,

describing the dresses as 'immensely heavy and magnificent', adding that 'the turbans would almost crush the slender frame of some of our Bond Street Beux'. They gave details of a green 'war dress' containing forty folds, which came with a matching turban that had been dipped in the Zamzam fountain – the holy water stream in Makkah. The collection included a couple of other war helmets, which had also been daubed with this holy water, and these were presented to King George III, along with Tipu's bedding.[36]

Today a few items of clothing remain in museum collections, mostly at the Victoria and Albert Museum, while a green velvet helmet belonging to Tipu is kept in the stores at the National Army Museum. The Royal Collection also retains some pieces, including a faded silk war coat with tassels and a red-and-green helmet. However, most of the items of clothing were distributed within a month of reaching Britain and quickly disappeared.[37] They are most likely destroyed and lost forever.

Similarly, most of Tipu's extensive library was lost. Price was a keen collector of Persian manuscripts and later went on to write a book about the history of Islam from the early days of the Prophet until the Mughal era. As prize agent, he was tasked with making a selection of manuscripts from Tipu's library for the East India Company, based on content, the beauty of the penmanship or the richness of the book's decoration. The full library contained up to 4,000 volumes on subjects as varied as history, astronomy, theology, medicine and poetry, but only a few hundred were sent to London. A decade later, a British scholar of Oriental languages at the East India Company college in Hertfordshire published a catalogue of this collection, with a glowing introduction that recognised how valuable it was:

... in Asia, at a period when Europe was overcast with ignorance and barbarism, Literature was ardently cultivated, and Science flourished. If our progress in the arts enables us to

look with contempt on the attainments of the Mohammaden schools, we should reflect, that they were our precursors in knowledge and that for much of our information we are indebted to them.[38]

Most of these manuscripts are now at the British Library. They include Tipu's own intricately bound personal copy of the Qur'an, a love story written in Persian, and a book of army regulations. Perhaps the most fascinating book, though, is Tipu's dream diary. In his own handwriting, Tipu describes his dreams, which feature animals like white elephants from China and, naturally, tigers. Others have more religious themes where he feels he is receiving messages from the Prophet and, of course, there are several about expelling his enemies, the British or, as he sometimes called them, the 'hat wearers'. This was a common term used for Europeans in India at the time, given that their choice of head covering contrasted with the turbans sported by the local population.

In the days after the fall of Srirangapatna, this dream diary was found under his pillow.[39] But the vast bulk of Tipu's library was never logged. However, Tipu's state papers, including diplomatic correspondence with the French and the Ottomans, were recorded and then passed on for translation into English. These state papers were written in a variety of languages. Tipu himself was highly educated, having studied Arabic and Persian, which was his everyday vernacular, and he also dictated letters in a number of local languages including Kannada, Telugu and Marathi.[40] This seemed to shock some of the British men, who obviously believed him to be a savage. One officer remarked that 'this horrid ferocious being, this harpy tiger is reported to be a man of some learning'.[41] Ironically, in Srirangapatna it was the British men who were seen as the savages. While the British were combing through the books, Tipu's sons, who had been given permission to attend, watched in disgust. One of them whispered loudly to an attendant: 'See how these hogs are allowed to contaminate my father's books.'[42]

The library was not the only one of Tipu's possessions to be broken up and disseminated. Having handed out treasures to all the officers, who apparently numbered more than 1,000, the prize agents were running out of items with which to reward the lower orders of the army. Even the women's quarter of the palace was searched for valuables, though nothing substantial was found. The Prize Committee decided Tipu's magnificent throne should be taken apart, so that the gold sheets overlaying it could be handed out as individual pieces.[43] Today, the memory of this throne survives in descriptions and a contemporaneous painting, which was itself based on a verbal description. This painting, a piece of the throne and a whole haul of Tipu treasures can now be found in a Welsh castle.

<p style="text-align:center">*</p>

As I drive up to the Powis Castle estate on a late-spring afternoon, lambs lie lazily in a field alongside their mothers, their fleeces as yet unshorn. Further along the winding road, a hefty brown cow and her calf amble in front of my car and at first slowly appear to be heading back onto the grassy verge, but then promptly decide to stop in the middle of the lane. I am forced to wait until they change their minds, feeling a little impatient to see the objects I have driven for hours to glimpse. But nature will not be rushed. Eventually, the cows having moved to the field, I get to park and walk towards a medieval castle with red-stone walls, sitting on a rock above a series of stunning gardens. Inside its main rooms, initially there are only a few clues to the treasures held here. My eyes dart around constantly in their search. I glance down from the balcony onto the Grand Staircase, which is out of bounds for climbing, and a large tiger skin draped over the intermediate floor is revealed. The creature is open-mouthed, all ferocity having escaped it, as if it had already accepted its fate in the moments before it was killed. At the entrance to the ballroom, there is

another tiger skin, this time accompanied by two cheetahs, all of the poor creatures now hanging on the high walls.

Opposite this entrance is a tapestry – the oldest in the castle – dating back to 1545. On it, men with beards and turbans are in conversation with men in European dress, as domes and turrets tower above them in the background. The unknown weaver sought to depict a European embassy at an Ottoman court in Constantinople. Towards the end of the corridor where it hangs, above an entrance to a smaller room, a large painting shows 'Clive of India' receiving legal recognition for the East India Company from the Mughal emperor in 1765.

After victory in a series of battles against Mughal state governors, the East India Company forced the Mughal emperor into handing over his right to collect taxes in the states of Bengal, Bihar and Orissa. This secured revenues for the Company, established the British as the most powerful force in India and marked the formal beginning of its empire on the subcontinent. The painting suggests a grand event took place to mark this transfer of power; the Mughal emperor Shah Alam II is seated on a gold throne under a canopy inside what appears to be a palace, handing over a scroll to Clive, who receives it magnanimously. Scores of beautifully dressed Mughal courtiers, including some on elephants, and British gentlemen watch on. In reality, this ornate public ceremony did not happen at all. The document granting the powers was privately handed to Clive by the Mughal emperor inside an army tent. The 'throne' was an armchair covered in a chintz bedsheet perilously placed upon a dining table to lend some distinction to the occasion.[44] Suffice it to say, the artist invented the grandeur and was not present at the event. He had in fact never been to India and was commissioned by Clive himself to create a piece of propaganda.

Robert Clive, better known as 'Clive of India', was a key architect in the founding of the British Empire in India. Even today, a statue of him stands outside the Foreign Office in London, though

it would certainly be enhanced by a clear description of his deeds and the beliefs that motivated them. These actions include using the agreement with Shah Alam II to pioneer a method of imperial plunder in Bengal that was soon replicated across the British Empire. Partly underlying this new technique of plunder was Clive's view of Muslims: 'The Moors are indolent, luxurious, ignorant and cowardly beyond all conception.'[45]

There have been recent suggestions that Robert Clive's statue belongs in a museum rather than outside the Foreign Office. The risk of such symbolic acts is that they are used to present a view of reformed institutions through gesture, which are not reflected in actual policy. After all, moving the statue would not alter the motivations and foundational purpose of the Foreign Office. Offering honest context to passers-by, however, is much needed.

Taxes on Mughal subjects were not the only source of the Clive family wealth. Robert's son Edward Clive married Henrietta Herbert, the daughter of the first Earl of Powis, and through this marriage the Clive family inherited the Powis title and castle. In 1798, Edward Clive was appointed Governor of Madras. Henrietta and their two daughters travelled with him to India and, while there, they collected a huge number of objects including some belonging to Tipu. Today, these are housed alongside objects collected by her father-in-law, in a small part of the castle dubbed the 'Clive Museum', which contains over 300 items, including ornate weapons, small ivory carved chess pieces, gold Mughal dresses and silver hookah (Eastern tobacco pipes). Powis Castle was bequeathed to the National Trust in 1952 and the organisation now runs the grounds and museum.

In the months following the death of Tipu, Henrietta Clive made a journey of more than 1,000 miles in a tour of southern India, including to Mysore to see what was left of his former kingdom, travelling with her daughters and their Italian governess, the painter Anna Tonelli. It was Tonelli who produced a record of Tipu's throne in a watercolour, based on descriptions from Tipu's former

treasurer. Henrietta sent the painting to her husband in Madras, accompanied by a letter explaining they had 'asked many questions' of the treasurer and 'made him write down exactly' which verses of the Qur'an were inscribed upon it. She bemoaned the break-up of the throne, adding 'the zeal with which it was destroyed did not give the plundering time to know that there was an inscription on the canopy'.[46] Today the painting is inside a cabinet in the Clive Museum; it shows Tipu clutching a sword, seated upon his throne and staring expectantly into the distance.

Anna Tonelli's 1800 watercolour of Tipu on his throne.

The throne itself looked like a life-size tiger holding up a seat. It was made of wood but covered entirely in gold, and had both tiger stripes and Arabic verses from the Qur'an engraved into it. The tiger's head and forelegs popped out at the front feet, while the seat was laid out on its back. This seat was an octagonal frame, eight foot by five, surrounded by a low railing, on top of which were eight small tiger heads; three inches tall, each of these finials

was made of gold and studded with precious stones. A ladder made of solid silver needed to be climbed to sit on the throne, while at the back a seven-foot-high iron pillar held up a wooden canopy shaped like an umbrella, which was also covered with gold and decorated with a fringe of pearls. Fluttering on top of this canopy was the most beautiful ornament of all, the *huma*, a glittering gold bird the size and shape of a small pigeon, with a tail rising up from its back like a peacock's feathers; its body, wings and tail covered with tightly set diamonds, rubies and emeralds. In Iranian mythology, the *huma* is said to constantly fly in the air, never touching the ground, and is a symbol associated with kingship and majesty. The ornament was made in a distinctive south Indian style and also drew on Hindu traditions. On the bird's back is an amulet with nine stones – the *navaratna* – representing the planets of Hindu cosmology.[47] The bird was acquired by Lord Mornington for presentation to King George III; it remains in the Royal Collection today and has previously been lent to the Victoria and Albert Museum as part of a special exhibition on jewels, where I was fortunate enough to see it personally. It is an astonishingly beautiful piece of work which I could have stared at for days.

What of the rest of the throne? The head of the large gold tiger from the bottom of the throne is also in the Royal Collection and has featured in special exhibitions at Windsor Castle and Buckingham Palace. In the Edwardian era, it once took pride of place at a banquet inside the Foreign Office. The head has eyes and teeth made of rock crystal, with a gold tongue visible in an open mouth, as if it were roaring. The creature's head is embossed with tiger stripes, and at the very top is a 'tiger mask' that simultaneously appears to be a drawing of a tiger's face and yet is made up of Arabic letters in a mirrored pattern, writing the words '*Bismillah*' ('In the Name of God') and 'Muhammad' (the Prophet). This tiger mask motif is also found on Tipu's flags and banners, some of which are now also in the Royal Collection, and on many of the weapons attributed to him.

As for the small tiger finials, only one is on display in Britain and that is here at Powis Castle. Inside a glass case directly facing the entrance of the Clive Museum, the tiger's teeth of gold grin at incoming visitors, as he sticks out his ruby tongue and stares at them with matching ruby eyes. The creature's entire face is encrusted with rubies and diamonds, cut and set in Tipu's distinctive tiger-stripe motif, while its neck is covered by alternating collars of rubies and emeralds. Rubies make up the tiger's whiskers too, which are set in an almost moustache-like shape, while even tinier rubies make a T-shaped pattern from above its nose up to the highest point of its head, which is then topped by a single emerald. Only the animal's small round ears and nose are without precious stones and are instead represented by careful carvings in the gold.

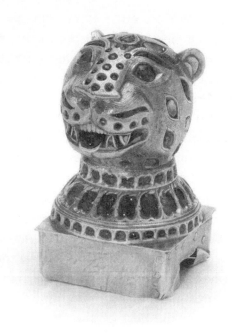

One of eight finials from Tipu's famed throne, some of which remain missing.

In 2009 and 2010, two other tiger finials sold at auctions in London and now belong to private collections abroad. One of them had been lying inside Featherstone Castle in Northumberland for more than a century. Five other tiger finials remain missing. A book published in 1970 refers to one being in a private collection in Cornwall and another being owned by an individual in Hampstead in London, alongside a tiger foot from the throne, but these have not been heard of since.[48] In 1974, a tiger finial was sold at auction in London and was then offered for sale the following year by an antique dealer in the city, but its whereabouts today is unknown.[49] Perhaps even now, in some British home somewhere, Tipu's tigers are still hidden away. The jewelled tiger at Powis was given to Henrietta Clive as a gift by Lord Mornington. While still in Madras she had written a letter to her brother who was back at Powis, informing him that she had heard the 'plunder of Seringapatam is immense ... the riches are quite extraordinary', and that she would 'like to have the picking of some of the boxes'.[50]

Henrietta certainly obtained quite a selection; today, the Clive Museum is filled with Tipu's treasures. In the same cabinet as the watercolour of his throne are two silver rosewater sprinklers taken from Tipu's bedroom – a couple of accompanying saucers state that they were 'presented to' Henrietta. A dozen coffee cups and saucers from Sèvres, a gift from France to Tipu, have finished up here too. Also in this cabinet is one of Tipu's gilded swords. This one is elaborately decorated with tiger stripes, and five swirling tiger heads make up the hilt. The blade appears to spout from the mouth of one of these tigers and on it a poetic Persian inscription claims the sword 'lays down the foundations of victory' and 'is the lightning that flashes through the lives of the infidels'. As with many of Tipu's swords, this has inscriptions invoking holy names: sometimes they call on the help of the Prophet and his family, especially his son-in-law, Imam Ali, as is common among Shi'a Muslims. On others the four caliphs revered by Sunni Muslims are addressed, illustrating how Tipu combined both schools of thought

in his personal beliefs. A number of other weapons from Mysore are also in the Clive collection.

Weaponry used by Tipu was much sought after. Lord Mornington wrote to his brother asking him to obtain 'some swords and handsome guns', which he wanted to present to the royal family, adding 'any sword known to have been used by Tippoo would be curious'.[51] Although it is likely Tipu had an extensive weaponry collection, he cannot possibly have personally used all the many swords now attributed to him in various stately homes. At the Wallace Collection in London, among reams of astonishing armoury, the origins of a particularly exquisite sword long believed to have belonged to the ruler of Mysore are now considered questionable. The blade is engraved with praise for Tipu and a drawing of a tiger, it also has a hilt of jade encrusted with diamonds, rubies and emeralds. But on closer inspection in recent years, curators discovered the engravings and the hilt appear to have been added to the blade at a later stage; they now suspect the item was given a wonderful story linked to Tipu to increase its value in the nineteenth century.

Some of the objects at the Clive collection are now too fragile to be put on permanent display, such as a huge white cotton tent printed with a symmetrical red and green vase and flower pattern, in the Turkish style. The tent is likely to have been used by Tipu for official receptions. When it first came to Powis it was used by the Clives as a marquee for garden parties.[52] Tipu's beaded gold-and-red slippers and his travelling bed carved from sandalwood are also currently kept in stores.

A number of Tipu's personal items were presented to Henrietta Clive in Madras as gifts from British officers. Others were picked up on her own journey to Srirangapatna, where she travelled with an impressive entourage: 700 people including infantry, cooks and grooms; and animals including camels, bullocks and a number of elephants formerly belonging to Tipu.[53] Her diary and letters detail a fascinating first-hand encounter with the city, in the aftermath of its destruction. She saw the gate where Tipu had been killed

and noticed a great number of bloodstains still on the walls; she also visited his tomb and met the women of his family. This meeting seems to have been somewhat disappointing for Henrietta. Like many others who had visited the Orient before and, indeed, after her, she had hoped for a more romantic scene. The reality was a group of grieving women, some of whom – particularly Tipu's wife – were very distressed and crying. Lady Clive noted their features carefully, writing that 'some were handsome but still nothing like the beauties in the Arabian nights' and that Tipu's daughters looked very like him. But she was also quick to cast her eye over their belongings; the daughters were 'dressed with jewels and pearls', while 'filigree' bottles were used to sprinkle rosewater and sandalwood oil upon her, as a welcome from the women.[54]

However, her interests were not just limited to material goods. Henrietta Clive appears to have also taken a genuine interest in the culture of Tipu's court. As well as eliciting a detailed description of Tipu's throne from his former treasurer, she employed him as a Persian tutor and attempted to translate the poetry of Hafez. She had already been studying the language used in both the Mughal and Tipu's courts in an attempt to 'understand and be understood', as well as to study 'all the learned books'.[55] At one point she even expresses frustration at the scramble for Tipu treasures, saying, 'I am almost tired of hearing of Tipu Sultan and all belonging to him. People think of nothing but pearls and emeralds ... '[56]

Regardless of this sentiment, Lady Clive herself came back to Britain with quite the haul. Apart from the ornaments and weapons, she also took Tipu's horse on to the ship she and her family boarded from Madras. She was an avid collector of animals and plant specimens. The family even wanted to take an elephant, but his excessive drinking – fourteen gallons of water a day – meant he was left behind.[57] A pair of identical cannon, however, did make it to Wales. They now stand on either side of the main entrance of the castle, although you could be forgiven for missing them entirely, as there is no sign or label pointing them out. There are plenty of diversions from them: the

stunning vista of the surrounding hills, the majesty of the castle itself and, on the afternoon of my visit, a peacock deciding to stand in the middle of the entrance, feathers fanned out, screeching out its mating call. This seems to be his favourite spot for attracting attention, and he gets plenty of it. But as I step closer to the cannon, the tiger heads at their mouths and the tiger stripes along their lengths are unmistakeable. In her journal entry about a visit to Tipu's fort, Henrietta describes seeing 'nine hundred pieces of cannon, some were ornamented with two tigers ... some with a tiger tearing a man's head'.[58] The pair brought back to Powis were fired here on at least two occasions: once at the wedding of Lord and Lady Clive's son, as part of the celebratory toasts – the alarming sounds they made and vibrations they caused were felt from a distance of thirty miles away. They were also fired in honour of a royal visit from a young Victoria in 1832.[59]

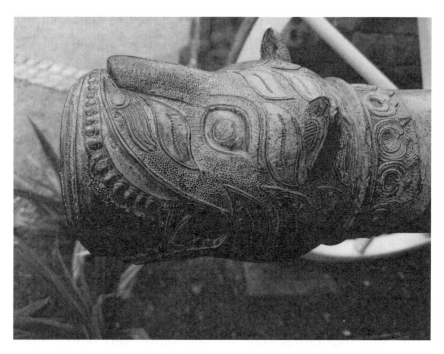

The mouth of one of Tipu's cannon at Powis Castle, crafted in Srirangapatna in 1790–1 by Ahmad Khosrau.

The cannon are bronze, but oxidisation from the weather has turned them a turquoise-green hue. Along each cannon, Persian inscriptions supply the craftsman's name, the weight of the cannon and place of manufacture. They also contain an Arabic phrase often found on Tipu's weapons, saluting 'Assadullah al Ghalib', meaning the 'Victorious Lion of God'. This phrase had personal and religious significance for Tipu; historically, the 'Lion of God' was an epithet given by the Prophet to Imam Ali for his courage and military prowess. Another word for lion in Arabic is *Haider* – the name of Tipu's father – and further along the cannon is a diamond pattern of four separated Persian letters spelling out this very name. After Tipu's fall, one British officer claimed that Tipu's tiger obsession was a tribute to Imam Ali.[60] The officer also quoted Tipu as apparently saying he would 'rather live two days like a tiger, than two hundred years like a sheep', something that would later often be repeated by both Tipu's detractors and supporters. Others point to tigers being an important part of the cultural mythology of the region Tipu was governing; Hindus in Mysore believed tigers were a gift from the Himalayan mountains to the goddess Chamundeshwari (a form of the goddess Durga).[61] As Tipu clearly liked to marry together different beliefs, perhaps both these explanations hold some truth.

<center>*</center>

Tipu's most famous tiger, though, is 200 miles away from Powis, in London; it is the toy tiger at the Victoria and Albert Museum, a showpiece and a must-see for millions of visitors. Today it is located in a glass cabinet in the South Asia section, alongside various personal objects belonging to Tipu including a robe, a walking stick and a telescope. I personally make a point of checking on it every time I step into the museum, as a sort of ritual or greeting. Tour group after tour group stops in front of it to hear a little of its history, while children press their faces against the glass in fascination, fear and awe. A wooden tiger is in the act of devouring a

'hat wearer' – a British soldier. The amber-coloured animal is painted with the black-and-brown tiger-stripe motif that so often appeared on Tipu's possessions. The tiger's rear claws are on top of the man's thighs, its front claws are on his chest, while its teeth are sinking into his neck and collarbone. The pink-hued soldier is wearing a low-rimmed black hat, as well as a scarlet coat with cuffs that might once have been dappled in gold and now appear brassy, stockings that are now a dirty yellow hue but may once have been white, and small black shoes. He is wide-eyed and open-mouthed, with his left hand placed upon his lips in shock at his fate, while his right arm lies flat by his side. The tiger has a thin black-and-amber tail, and midway down the left side of its body is a handle camouflaged among the stripes. Turning this handle on the tiger's shoulder would rotate a crank with a wire within its body, working two sets of bellows. The first would force air through a pipe ending inside the man's mouth, causing him to let out a cry of distress while raising his right arm up in a further emphasis of his agony. Inside the tiger's head, a second pair of bellows would create a harsh growl sound. The timing was set so that the victim would scream about a dozen times, then a tiger's growl would sound. On one side of the creature's insides there is also a small organ made up of eighteen keys and two rows of copper pipes.[62]

Found in a room dedicated to musical instruments inside Tipu's palace, Wellesley sent the tiger, along with 'other curiosities' including Tipu's war turban and dress, to his brother, who in turn dispatched the items to Britain.[63] The tiger's arrival was eagerly anticipated since newspapers had reported its discovery. Official dispatches declared the musical animal was 'proof' of Tipu's 'deep hate and extreme loathing ... towards the English nation', while Lord Mornington stated that it would serve as a 'memorial of the arrogance and barbarous cruelty' of Tipu Sultan.[64] Perhaps that was why, unlike the throne and the library, it escaped the fate of being broken up. It was believed Tipu Sultan had overseen the design of the contraption himself and found great amusement in

it. One report even stated that this 'semblance of torture was not always sufficient for the pampered appetites of the sanguinary tyrant', claiming that Tipu regularly used real tigers in his palace to tear 'unfortunate Europeans' to pieces for his own entertainment.[65] No evidence exists to support this claim.

There were also suggestions that Tipu may have been inspired by the gruesome death of a young British man killed by a tiger, which was widely reported in newspapers and chronicles. The victim's father was Sir Hector Munro, a British general who had made a name for himself in military campaigns in India. An eyewitness described how their hunting party had been on Sagar Island, close to Calcutta, to shoot deer. They had spotted some tiger tracks and were aware of danger but decided to continue with their hunting plans anyway. As the day passed, they took a pause in shooting and sat down to eat a meal of cold meats, when they suddenly heard a 'roar like thunder' and then witnessed an 'immense tiger spring upon the unfortunate Munro'. The eyewitness then describes the 'agonies of horror' unfolding as the tiger clutched Munro by his head and rushed into the jungle with him. Other tigers then sprang out but were eventually shot and the poor young man was dropped by the initial tiger. He lived on for another 'twenty four hours ... in extreme torture ...' because 'his head and skull were torn and broke to pieces'.[66] Though the shocking report spread in Britain, it is unlikely Tipu would have heard it, given how frequently tigers killed people in India. However, the story has often been linked to why the musical tiger was created.

In 1800, the toy tiger arrived at East India Docks in London and crowds eagerly gathered at the Company's warehouse, having heard about the animal and that parts of the throne and items of clothing were being sent as gifts for the royal family. But at first the East India Company simply kept the tiger within their stores. After a few years it was put on display for the public to visit at the India Museum, which was initially at the East India House, on Leadenhall Street in the City of London. It proved to be immensely popular,

much to the frustration of students who were trying to work in the building's library, as visitors were constantly turning the tiger's handle, delighting in hearing the shrieks and growls, which were described at the time as 'unearthly sounds'.[67] So enthusiastically was it turned, that by 1870 the original handle had dropped off and was lost. Meanwhile, the organ inside the tiger's body was used to play triumphant musical choices such as 'God Save the King' and 'Rule Britannia' at performances inside the India Museum.[68]

The tiger served as evidence not only of Tipu's savagery but that of the Orient for years to come. One Victorian account claimed the 'truly barbarous' instrument conveyed 'a lively impression of the mingled ferocity and childish want of taste so characteristic of the majority of Asiatic princes'.[69] It was an object that could be used to justify British colonial rule, but it also contributed to 'Tipu mania'. Tipu was a villain in Britain, yet people quite literally wanted a piece of him – owning a Tipu object brought prestige and was so desirable that even today some items that claim a Tipu connection have questionable authenticity. The ruler of Mysore and his tiger also started to become cultural figures who would appear in British literature, theatre and the arts. The poet John Keats visited the museum at East India House and in his satirical poem 'The Cap and Bells' referred to an emperor with a 'Man-Tiger-Organ':

> Replied the Page: 'that little buzzing noise,
> Whate'er your palmistry may make of it,
> Comes from a play-thing of the Emperor's choice,
> From a Man-Tiger-Organ, prettiest of his toys . . .'[70]

In the immediate aftermath of Tipu's fall, a 120-foot panoramic painting in the Lyceum in London's Covent Garden offered visitors the opportunity to see the 'Storming of Seringapatam' brought to life, while a series of theatre productions on the same subject took

pride in advertising their elaborate scenery, which included 'the Sultan's Splendid Pavilion'. Some of these plays were adapted from earlier productions first created during the long-running wars with Tipu and featured themes and songs that would be familiar to audiences; at least one referred to Tipu's 'black looks', while another entitled *Come Soldiers Cheer* demonstrates the jingoistic tone:

> Come soldiers cheer now the danger's past and the tyrant
> Tippoo flies at last
> Since victory smiles to crown our toils
> We are britons once again
> Let the cymbals bang with a merry merry clang to the joys
> of the next campaign
> Let the music found and the song go round and delights
> abound upon eastern ground
>
> May victory still be the soldier's share
> Who draws his sword to defend the fair
> May he still overthrow the Tyrant Foe
> And a Briton's boast maintain.[71]

These productions were hugely successful and continued for a number of years. In 1829 an Easter Monday extravaganza promised to include scenes of 'a cruel murder and outrage by Tippoo ... his spectacular Death ... Colonel Wellesley's address to his Troops ... and the well known tableau of the Sons of Tippoo Delivered up as Hostages'. A theatre review praised the performance as one of the most splendid military spectacles the correspondent had witnessed for years, adding the actor playing Tipu 'looked very fierce and roared as loud as any of the tigers of that royal Sultan ever did'.[72] The character of Tipu continued to appear on stage even into the twentieth century; in 1969 a surreal play performed in Devon featured 'King Tippoo' alongside 'the Duke of Wellington, Father Christmas and a Merman. King Tippoo survived two deaths

and reappeared to collect money from the audience.'[73] He popped up in novels too, most famously in the book widely regarded as the first British detective novel, *The Moonstone* by Wilkie Collins, written almost seventy years after Tipu's death. The opening scenes of the story are set during the plunder of Mysore, after the fall of Tipu, and the 'Moonstone', which carries a curse to Britain, is supposedly a yellow diamond kept in the handle of a dagger by the Indian ruler.[74]

Perhaps most fascinatingly, Tipu's tiger obsession influenced a military honour issued to all British men who had fought in the final battle against him, the Seringapatam Medal. On the front, a lion (symbolising Britain) has pounced on top of a tiger (obviously representing Tipu) and a Union Jack flies high above them. The dates are printed in Roman numerals, but there are no English words upon the medal, only a familiar phrase written in Arabic, '*Assadullah al Ghalib*' – 'the Victorious Lion of God'. The back of the medal has an inscription written in Persian which translates to 'Seringapatam, 4 May 1799, given by God', and shows a sketch of the final assault by British forces. Manufactured at the Soho Mint in Birmingham, a soldier's rank determined the metal of their medal: gold, silver, bronze or tin. Several of these medals are on public display in Britain today; General Harris's gold one is in a cabinet at Belmont House in Kent, another is at the National Army Museum, while a silver medal is placed close by the tiger toy in the Victoria and Albert Museum.

Tipu's own imagery and religious iconography were turned against him, and the motif of the lion conquering the tiger endured. More than a half a century later, the image featured in a cartoon published by *Punch Magazine* to mark the British defeat of Indians who had taken part in a major uprising in 1857. The revolt began with a mutiny by Indian soldiers who were serving in the East India Company's army in Bengal, with insurrection then spreading across northern and north-western regions of the subcontinent, as the rebels attempted to revive the Mughal Empire in defiance

of the British. It took a year to do so, but the revolt was eventually crushed by the Company. However, it did lead to the British government directly taking over rule of India from the East India Company, and is a landmark event in the history of Britain and India, known as the Mutiny, Rebellion or even First War of Indian Independence, depending on your political perspective. The *Punch* cartoon was entitled 'The British Lion's Vengeance on the Bengal Tiger' and depicts a ferocious lion pouncing on a growling tiger who has just killed a woman and her baby. The popular understanding being promoted in Britain by the East India Company was that Indian soldiers had been attacking defenceless women and children, so violence was needed in retribution. In this image the tiger is evidently dangerous, but it appears smaller and it is clear the lion will prevail.[75] Even today, in the entrance hall at Belmont House in Kent, two opposing glass cages containing a stuffed lion and a tiger stand snarling at each other. The tiger's skin is a beautiful beige and honey colour that has almost faded to cream in some places. Both unfortunate creatures were shot in India by General Harris's great-grandson almost a century after his own triumph against Tipu. Ironically, here the tiger looks more ferocious, while the lion looks rather cowed.

Tipu's musical tiger arrived in South Kensington in 1879, and it has lived there ever since, even surviving the Second World War, though it received some wounds at this time. One account claims a bombing caused part of a building's roof and staircase to collapse onto it.[76] However, the V&A's archives suggest that it was the fault of workmen who were building a partition and were rather careless in how they went about it.[77] After the war, it was extensively repaired and a party was held to celebrate the tiger's return, where it was once again played with a new handle, though the damage meant 'the tiger's roar had diminished to a mere whimper'.[78] Nowadays, it is entirely mute inside its glass cage – understandable, given that it is a fragile antique. But are we in danger of silencing the tiger's stories too?

★

In the early 1990s, Channel 4 television aired a historical drama made in India entitled *The Sword of Tipu Sultan*. It was screened in the original Urdu/Hindi with English subtitles, and was a hit among minority audiences, whom the channel had been particularly set up to serve. It may seem surprising that a drama depicting Tipu Sultan as the hero and British colonisers as the villains could have been broadcast three decades ago, given how one-dimensional Britain's national discourse on Empire has become. But the channel had been established with a mandate to serve as an alternative to the fusty BBC and managed this with aplomb in its early years, when it served as a platform for black activist-intellectuals and alternative histories. Nevertheless, *The Sword of Tipu Sultan* appears to have been scheduled for viewers from a South Asian background. So where once the story of the tiger and the lion was a British one, albeit told merely through propaganda by the victors, now it was considered a 'niche' story for a 'niche' audience.

The man who brought the programme to British screens was Farrukh Dhondy, a distinguished writer, playwright and activist who worked as a commissioner for the channel from 1984 to 1997. Dhondy strongly believes that 'television is the best conversation society can have with itself'. In the 1980s and 1990s, he and others sought to give black and Asian communities in Britain a voice through programming, insisting that they should have a place in mainstream culture. Many of the ambitious programmes broadcast by Dhondy and his fellow commissioners, straddling multiple genres – *Devil's Advocate*, *The Mahabharata*, *Desmond's*, *Black Box*, *Kabbadi* – retain a cult status today, especially among people of colour. That is understandable. Nowadays, it is difficult to remember, given the limits of current cultural debates, that when there were only four terrestrial TV channels in this country, one of them aired a primetime half-hour discussion on the validity of core Rastafari

beliefs between two tenacious black activist-intellectuals which hinged on the question 'Is Babylon falling?'.

Dhondy believes programmes which tell difficult stories about British colonialism would not make it to air on British television today, saying that even though 'sections of British society want to explore these stories', it is seen as too niche or too radical for a mainstream broadcaster. He accuses current commissioners employed by British broadcasters of 'not being bold enough to risk leading the conversation', believing all too often they are tied down by commercial pressures. Dhondy also argues that recent measures to improve diversity have been counterproductive, suggesting that, instead of enhancing the 'cultural conversation', diversity has become a game of statistics and 'a cover for not doing anything'. Diversity in hues does not always lead to a diversity or depth of views, and the term 'diversity' carries far more meaning for television executives than people of colour.

Assessing recent output, it is difficult to disagree with Dhondy. For the past two decades British news and factual programming have been steeped in narratives and content that act as a foil for power rather than questioning it, which has a particularly pernicious effect in shaping British views of the Orient. In broadcast news, depictions of these regions today often keep audiences in a constant state of low-intensity fear of a new Oriental enemy, largely indistinguishable from the last, with a series of banal and perennially recycled tropes about Islam. In liberal settings, sharper language about 'threats' is often eschewed in favour of concern over 'human rights', whether genuinely felt or cynically weaponised. Factual programming on the Orient often consists largely of documentaries made by polemicists attempting to whip up fear of obscure new Muslim enemies abroad; sensationalist 'exposés' of what Muslims might be up to behind the closed doors of our mosques in Britain; or a relatively new category that Dhondy alludes to, where reality TV principles are applied to minority communities, allowing commissioners to hide behind cod anthropology to make programmes

like *Sharia Street*, *Muslims Like Us* or *My Week as a Muslim*, which was criticised for having a white non-Muslim woman 'brown up' and put on a prosthetic nose to apparently 'experience' life as a Muslim. In comedy commissioning, too, there have been backwards steps since the 1990s. The brave social commentary of *Goodness Gracious Me*, which often subverted conventional narratives of Empire, has given way on primetime to *Citizen Khan*, which plays on dated stereotypes about older South Asian men for laughs and serves only the narrative purpose of reinforcing a colonial-era political cliché of the 'indolent, luxurious, ignorant and cowardly' Muslim community leader of Robert Clive's imagination.

Time and again, the enlightening tales of Britain's colonial encounters which shape our society today – including that with Tipu – are seen as stories for minorities. One current senior television executive who asked to remain unnamed says some of these histories feel 'too difficult' and 'overly negative'. She feels that focusing on the positives of diversity is more helpful and added, while acknowledging her own cynicism, that it is also 'more sellable'.

There is hope, however, from a new generation of cultural producers. In 2018, an episode of the BBC drama *Doctor Who* centred its storyline around the division of British India into India and Pakistan at the end of the colonial period in 1947. 'Demons of the Punjab' was a clever, moving and mesmerising watch, and received critical acclaim, as well great responses from fans of *Doctor Who*. It felt remarkable that a children's science-fiction programme could take on a difficult subject and turn it into brilliant television. The writer of the episode, Vinay Patel, explains how he was asked by the show's producers to come up with a story he wanted to tell on British television, and he chose the issue of Partition. He believed that the mainstream, family-focused and majority-white audience for *Doctor Who* needed to be told this story and informed about the role of the British in Partition. He points out that, for a show about space and time, *Doctor Who* had previously neglected 'times that are inconvenient for the British Empire'. Patel says he

felt a 'massive weight of responsibility' in working out how to make 'the emotions flow through the experience of minority characters', as well as doing justice to the history. He is proud that the episode meant that a show of such prestige had the 'first writers of colour in fifty-five years' and an 'all non-white guest cast'. It has left him hopeful, believing there is now an appetite for these stories, partly driven by the fact that streaming services want programmes that can be sold internationally, although he adds that the industry should not become 'complacent' and that 'a critical mass' of writers, actors and other talent are still required to tell alternative stories.

The *Doctor Who* episode was an example of thoughtful commissioning rather than chasing 'diversity' for its own sake. And, importantly, it tackled historical questions in a way that explained how the world around us came into being. Contrast it with a characteristically pithy quote from Farrukh Dhondy in 2014: 'So what if a black person gets to do the tango on Strictly Come Dancing? What does that explore about race and culture? Don't be fooled.'[79] Dhondy was making the point that, in a post-New Labour age when the passage of equalities legislation led many to believe that 'the race question' had been put to bed, 'colour-blind' commissioning, writing and casting was used as an excuse to cut programming which had something meaningful to say to minorities that was born of their own thoughts, beliefs and experiences on the subjects of history, culture and religion.

The treasures of Tipu's rule found around our country remind us that the power Britain amassed as an empire was wrested from the hands of others who also have proud stories to tell. Like Tipu Sultan's belongings, many children and grandchildren of Empire find themselves scattered across Britain. Perhaps it is time we deployed the tiger's roar – to demand better depictions and more honest histories, and to shape our own narratives.

Portraits of the Forgotten

Osborne House, Isle of Wight

A GLOWING MAY day makes mesmerising the sight of sea sprays hitting the side of the ship. As I sit on board the *Red Osprey* from Southampton to East Cowes on the Isle of Wight, I watch and listen to the gentle shutting of car doors, the fastening of dog leads and quiet chatter among the passengers, composed largely of gilet-clad couples, as they make their way up to the deck. The hour-long journey is uneventful, except for occasional interruptions from a seemingly synchronised chorus of car alarms, as if they were dogs barking and setting each other off. At one point a sudden sounding of the ship's horn startles almost all of the passengers, and then moments later leaves us all laughing at our seemingly nervous dispositions. The town of East Cowes itself initially seems a stock picture of suburbia: children bickering over some sort of electronic gadget as they trudge along behind parents struggling with super-market bags; a pair of runners earnestly pounding the pavement in training for a marathon; and of course, the constant hum of lawnmowers. Yet there is a gem on this part of the island.

It is a glorious building, sun-kissed, sand-coloured and structured in the style of an Italian villa with two tall towers, curving arch-ways over the windows and symmetrical stairways on each side leading to a courtyard with stunning terraced gardens and a gushing fountain. The front of the house grants a glimmering glimpse of the sea and further ahead is a beach where a monarch bathed. Osborne House was the much loved summer home of Queen Victoria, designed personally by her husband Prince Albert as a

retreat for their family. It was also where Victoria spent her final moments. After her death, the royal apartments were closed off and the building was used as a naval training college for many years. It has since been extensively restored and is now run by English Heritage. Inside, the first few passageways offer paintings of dogs, podiums with classical busts and plenty of gilding. So far, so stately home. But then an unexpected turn.

Portraits of men and women with brown skin fill an entire corridor. Almost every spot of wall at eye level is covered, and the effect is a little overwhelming. There are maharajas and military men, but ordinary workers too. Some of the frames have inscriptions: a name, a title, sometimes even an age and occupation; *Shaban, Silkspinner and Gold Silver Weaver, From Benares, 45 years old*; *Ramlal, Carpet Weaver, 9 years old*. Others are placed in collections, multiple portraits in frames with no names attached. The oils used to paint the faces show shades of different brown skin tones and there are turbans of orange, yellow and white, worn in varying styles; caps too, and dupattas[1] and knotted scarves covering heads. Some of the characters wear jewellery on their ears and around their necks. All of them wear serious, sombre expressions. There is not a smile in sight. The youngest of these sitters was just four, while the eldest was believed to be 103 years old. This area was built as an additional wing of Osborne House and is known as the Durbar Corridor. The word *durbar* means court in Persian and Urdu, and was the term used by the Mughals to denote the formal court of a ruler discussing matters of state. It was later adopted by the British Raj to describe ceremonial gatherings. But who are the men, women and children in these portraits?

Their story began in a prison in Agra in northern India, where some thirty inmates had been selected by Dr John William Tyler, the superintendent of the jail, to make a journey to London with him. While in prison, these men had learned crafts and become incredibly skilled at them. Now they would work on them in a live display in London, the star exhibit at the Indian and Colonial

Exhibition of 1886. Over six months, more than five and a half million people travelled to Kensington to visit the exhibition. A series of temporary buildings had been set up behind the Royal Albert Hall and on display were arts and crafts, horticulture and produce from British colonies including Australia, Canada, the West Indies, Gambia and Sierra Leone, but the most extensive section was that of India.

On 4 May 1886, the exhibition was formally opened by Queen Victoria in a grand ceremony. As she headed towards the exhibition from Windsor Castle, around 12,000 people had begun gathering inside the Royal Albert Hall in Kensington. These included dignitaries, military personnel, noble families from the Indian princely states who had formed alliances with the British Empire, and members of the British public who had managed to obtain much sought after tickets. The press delighted in noting the 'flashing jewels' in 'rainbow colours', the 'handsome turbans' and 'dazzling white and gold gauzes' sported by the Indian royal guests.[2] By contrast, Victoria would appear draped in the colour of mourning she had adopted some twenty-five years earlier upon the death of her husband. The only ornamentation on her plain black silk dress and black bonnet was a single silver grey feather.

At noon, the royal trumpeters announced her arrival at the entrance of the exhibition. Victoria was met by various members of the royal family, including her eldest son Edward, the Prince of Wales, who had been appointed executive head of the exhibition. He proceeded to introduce the Queen to the numerous officials and administrators responsible for putting together the displays, and the party then headed for a tour through the various exhibits. Among those people presented to the monarch was Trailokyanath Mukherji, an Indian civil servant and writer who produced a detailed diary of his visit to Britain, which was later published as a travelogue. The Queen also met the group of Indian craftsmen who had been brought over from Agra prison. Mukherji describes how these workers were instructed to greet the Queen with a salutation

of 'Ram Ram', a Hindu greeting referring to the deity Lord Rama. This must have felt odd to those among the group who were devout Muslims, for they decided to give the greeting their own touch, adding the word 'Alhamdulillah', an Arabic phrase used by Muslims meaning 'thanks be to God'. So the group repeatedly cried out in a syncretic Hindu–Muslim chorus: 'Ram, Ram, Alhamdulillah'.[3] In the Orient it might have sounded bizarre, but to the British ear at the time, it was sufficiently exotic. So too was the soundtrack to Victoria's entourage entering the Royal Albert Hall from the exhibition; the choir sang the national anthem with a twist – the first verse of 'God Save the Queen' was sung as normal in English, but the second in the ancient Indian language of Sanskrit. This divided commentators in the press ranks. One correspondent declared it a 'strange metamorphosis' but nevertheless 'satisfying' to hear the 'fine old broad tune' remaining. Another declared it a 'mistake', pointing out that as the language was an ancient one, rather than an everyday vernacular, so 'even among the Indians present there, were very few who understood the words'. A third journalist took the opportunity to mock the pomposity of his colleagues, sarcastically stating that the 'occupants of the press box who no doubt have made Sanskrit the main study of their leisure hours had been unanimously of opinion that the grammar and pronunciation were all wrong'.[4]

Victoria completed her walk through the hall and took her place on the stage for the ceremony, helped up the steps by the Prince of Wales. Her seat was a throne composed of two tiers designed to resemble lotus petals. The object was made from wood and covered in thick gold sheets which were delicately engraved with further lotus-flower patterns, evoking a symbol often used in many Indian religious traditions, which would have been important for its original owner. The throne had been made in Lahore for Maharaja Ranjit Singh, founder and leader of the Sikh Empire in Punjab in north-west India. It had been captured at the fall of the Sikh Empire in 1849, when the East India Company annexed

the Punjab region. Unlike Tipu's throne, this one survived the aftermath of a war and conquest, and was sent intact to Britain and initially displayed at the East India Company Museum. Today it can be viewed at the Victoria and Albert Museum, in a glass cabinet close to Tipu's tiger.

As Victoria made herself comfortable on the soft red and gold cushions of Ranjit Singh's throne, the ceremony began with a reading of a poem especially composed for the occasion by the Poet Laureate Alfred, Lord Tennyson. It welcomed and called on the 'brothers' of the British Empire to:

> '... be welded each and all
> Into one imperial whole,
> One with Britain, heart and soul!
> One life, one flag, one fleet, one throne!'
> Britons, hold your own![5]

A formal exchange of proclamations between Victoria and her son then followed. The Prince of Wales, as executive head of the exhibition, made declarations about the 'greatness' of the 'colonial and Indian possessions' and uttered a 'heartfelt prayer' that the exhibition would 'stimulate commercial interests' and 'brotherly sympathy'.

Exhibitions featuring culture, architecture and produce from the Orient were not unique to Britain. In the latter half of the nineteenth century, expositions featuring Ottoman pavilions, Turkish baths and replica palaces took place in several European cities, most notably Paris and Vienna, and even in the United States such as at the Chicago World Fair. In 1851, the Great Exhibition at Crystal Palace in London had featured a replica of an Alhambra arch, as well as a significant display of objects from India in the 'Indian Court'. But the Indian section in the 1886 exhibition was on a much larger scale. By now Britain had a fully-fledged empire in the country and Victoria had been established as Empress. This,

then, was an opportunity to show off the imperial project, boost trade and bring the Empire home to Britons.

Mukherji was employed as an official at the exhibition. His travelogue provides a fascinating account of Britain as seen through the eyes of an Indian visitor at the time. Based at the Museum Hotel in Bloomsbury, he would travel daily to the exhibition in Kensington using the London Underground and describes seeing stations so 'full of advertisements' that at first he thought the stations themselves were actually named 'Pears Soap' or 'Colman's Mustard'. In the evenings he would see the city sights, walking along Oxford Street, across Westminster Bridge or past Whitehall Palace, and he would sometimes observe or become involved in the political conversations of the day, such as the ongoing debate over Home Rule in Ireland and the campaigning around the general election of that year. He also spent time touring Britain, with official receptions being held for the organisers of the exhibition in cities including Bristol, Bath, Liverpool, Edinburgh, Perth and Aberdeen. His favourite, though, was Manchester, where he says the best parties and 'intellectual enjoyments' were to be had. Here, he made visits to 'weaving mills, the dyeing and printing industries and various engineering establishments'.[6] Most of all, Mukherji was keen to observe the people of the country which loomed so large over his own:

> I was now in that great England of which I had been reading from my childhood and among the English people with whom Providence has so closely united us ... I was thankful for the opportunity ... to see the British people at home and study those virtues which have made them the most powerful nation now on the face of the globe.[7]

Whether he discovered what those 'virtues' were is not clear. Mukherji did, however, find himself and his fellow Indians the subject of great fascination among middle- and working-class

Britons, and he in turn found it amusing to see and hear their reactions. As he dined in a London restaurant one evening, a man walked up to his table pleading for Mukherji to talk to his wife. He said he was a sailor on leave and planned to take his wife to Kensington to see the exhibits; however, she had decided she 'would not be happy nor would she enjoy the sights of the Exhibition' – unless Mukherji now spoke to her personally. She sat looking downcast and gloomy at a nearby table, while her husband begged Mukherji to entertain the request, and although he found it absurd, he obliged and the woman 'cheered up at once'.[8] On another occasion, as he stood by an exhibit in Kensington, a 'fat elderly woman … came bustling through the crowd' and took him 'by storm', demanding to know if Mukherji knew her nephew named 'Jim Robinson' who had gone to India. Despite Mukherji politely replying no to this question, she began furnishing him with a full history of her nephew, and insisted he must pass on a message of importance to him: 'that Mrs Jones' fat pig had won a prize at the Smithfield Agricultural Show'.[9] Mukherji also pointedly remarked on the differences in the way visitors of different skin colours were regarded, something that feels pertinent in Britain even today:

> We are all natives now – We poor Indians, the Aborigines of Australia, the Negroes … and other races of Africa … the English people came to see the 'natives' at the Exhibition and often asked me where the natives were working and English papers wrote about natives. In England, a French, German or Italian is a foreigner, an Indian or an African is a native.[10]

The Indian section of the exhibition was divided into a number of courts for art and a separate Economic Court for showcasing produce including tea, coffee and silk. The artware was categorised and laid out according to regions of India. Each court had a distinctive screen carved out in wood or stone. These featured references to local buildings and drew on cultural and religious

influences. The screens representing the north-west provinces of India consisted of marbled pillars inlaid with precious stones in a similar style to that of the Taj Mahal, while the carved timber screen from Mysore featured pillars and arches copied from the garden palace built by Tipu Sultan and occupied by Arthur Wellesley after the fall of Tipu's kingdom. One of these carved works can now be found standing in Sussex – the Jaipur Gateway. Built in wood and meant to resemble the entrance to a palace or temple, eight pillars stand below a raised kiosk, where at the exhibition musical instruments had been arranged, as if ready for court musicians to play. In the middle of this kiosk, four thin pillars rise up to support a small dome above. Paid for by the Maharaja of Jaipur, on the front of the gateway a picture of the sun is carved, together with an inscription in Sanskrit, Latin and English – 'Where virtue is, there is victory' – while on the back was a moon, with a Latin phrase inscribed: *'Ex Oriente lux'*, meaning 'From the East Comes Light'.[11] Nowadays it can be seen at the entrance of Hove Museum, where it has stood since 1926 when it was donated to the institution.

<p style="text-align:center">*</p>

The Jaipur Gateway stands in the museum's small front garden, facing a dentist's surgery and a concrete block of 1960s-style flats. A sign titled 'Heritage Hove' on the opposite side of the lawn includes two lines of explanation about the gateway's provenance: 'In front of the museum stands the Jaipur Gate, a wooden pavilion sent by the Maharaja of Jaipur to London in 1886 and re-erected here in 1926.' In 2004, specialist conservation work took place. The timber, which was never meant for outside use, was decaying, and so the gateway was taken apart and restored piece by piece. A new copper dome and lead roof were installed to provide protection against the rain. The wood is now a neat dark grey colour, the gilding on the inscriptions and the sun and moon faces gleam in

the sunlight and, apart from the odd spiderweb in the top corner of a pillar or two, it is pristinely kept. There are no musical instruments on display nowadays, but somehow the surrounding sounds of everyday life provide their own rhythm; the growl of cars starting up, the creaky wheels of a pram being pushed along a pavement and a rustling from trees dancing in the wind.

Forty miles along the south coast, another piece of the exhibition can be found inside Hastings Museum. At the exhibition of 1886, an 'Indian Palace' was built for display as an example of a 'typical' royal residence. It featured a courtyard, a fountain, a gateway and a reception room known as the Durbar Hall. Today, this Durbar Hall and some of the wooden screens constructed for the exhibition form the basis of a spectacular centrepiece for the museum. As I walk through a gallery of paintings of fishermen and life at sea, an entrance presents itself to a room ornately carved from trees of teak, Himalayan cedar and Indian rosewood. Consisting of two floors of wooden panels and archways, it has an intricacy and sophistication that feels so unexpected when you stumble upon it. One of my companions on this visit – unaware of what we had come to specifically see – lets out an audible gasp of astonishment. The room has a magical glow about it; there are four brass lamps – originals from the exhibition – and even more light comes from the contemporary addition of fairy lights strung carefully around the curves of the archways, their soft white glow hitting the stained-glass windows underneath and revealing a kaleidoscope of repeating floral motifs in cloudy citrus colours. The richly coloured wood is so dark that I must step closer to fully appreciate the carvings of foliage and geometric patterns that make up different sections. I follow the swirls and curves by pressing my finger in between the lattices and think of the painstaking hours required to construct this room. An inscription carved out in Persian high upon one side reveals the names of the two craftsmen who put it together; Muhammad Buksh and Juma, both of whom were from the city of Bhera in Punjab (now in

modern-day Pakistan). The pair arrived in Britain in June 1885 to work on its construction.[12]

When the 1886 exhibition closed, the reception room and several of the wooden carved screens were bought by one of the commissioners involved in the exhibition, and installed in his own home in Park Lane, with a view to creating a museum there. Several of the objects inside the room in Hastings today belong to this collection, including the beautifully embroidered sofa seats on the wooden benches, which were bought in Cairo in the late nineteenth century. In 1919, the room was donated to the Borough of Hastings, and some years later it was entirely re-erected at the museum's site. The upper floor of this Durbar Room is used to display the museum's collections of objects from around the world, while the lower can now be rented out as a wedding venue.

<div align="center">*</div>

Aside from artwork and produce, the displays at the 1886 exhibition also included models of animals and people. A 'jungle life' scene was created featuring all manner of creatures: a herd of monkeys crouched beneath a leafy tree branch, a startled-looking elephant with an uplifted trunk, and numerous big cats, including a tiger, a cheetah and a leopard, were dotted about the scene.[13] A pamphlet published during the exhibition found the grouping of animals rather 'amusing' and warned:

> ... it must not be supposed that the exile on India's tropical swamps and impenetrable jungles meets at every step a tiger, a cheetah, an albino black buck, an alligator and a python.[14]

But a reporter for the *Pall Mall Gazette* waxed lyrical about the scene, proclaiming it showed 'wonderful vigour and verve' and 'a great picture of jungle realism'.[15] Mukherji, however, decided it was rather 'overdrawn'. Meanwhile, life-sized figures of human

beings made of clay and plaster were placed in the Economic Court to represent the different 'races' of India. Each figure was dressed with clothing, ornaments and weapons. The display had been inspired by an exhibition in Amsterdam some three years earlier.[16] Though perhaps not designed to be insulting, this display enforced racial stereotypes.

By far the most popular 'exhibit', though, was of the 'live' variety, featuring the Indian artisans of Agra prison. On three sides of the courtyard, in the shadow of the 'Indian Palace' construction, a series of open workshops had been set up. Inside each, craftsmen worked away at their various specialisms – weaving, carving, engraving and dyeing – all while being constantly watched by onlookers. One newspaper advised visitors to arrive as early as possible to secure a place in the crowds of spectators gathering every day by these workshops.[17] Mukherji describes how closely all of the Indians at the exhibition were observed:

It was from the ladies we received the largest amount of patronage, we were pierced through and through by stares from eyes of all colours – green, grey, blue and black – and every movement and act of ours, walking, sitting, eating, reading, received its full share of 'O I never'.[18]

Their most important female patron was of course Queen Victoria. Two days after the opening ceremony, she visited the exhibition again and spent time talking to the craftsmen. She was interested in the details of their trade and their backgrounds, and was extremely pleased with what she saw. She described the visit in her diary as 'curious and interesting', noting the 'pretty designs and colours' of cottons and carpets and writing that she had bought several items.[19] A month earlier, she had met a young Austrian artist named Rudolf Swoboda, who she believed to be 'full of talent', and Victoria decided he should now paint some of these craftsmen for her in individual portraits.[20]

The eldest of the workers was Bukshiram, a Hindu man from Agra believed to be more than one hundred years old. Bukshiram sat at his pottery wheel making pots, bricks, tiles and toys. Upon meeting him, Victoria reportedly turned to her entourage to say that the elderly man must be taken care of. She was immediately assured 'that the best doctor from India was in charge of the men and that they were all being looked after and happy'.[21] Bukshiram's face is now one of those lining the corridor at Osborne House, his glistening eyes earnestly staring back at those who stand gazing at the painting. Tufts of his white hair peek out from a bright orange turban wrapped above a weathered, wrinkled face with a long white moustache. There is an air of dignity to this painting, but Bukshiram seems tired. In contrast, the youngest artisans were a group of children. Five boys worked away at weaving woollen carpets; they had already made a rug which had been placed under the Queen's throne at the opening ceremony inside the Royal Albert Hall, now they continued at their looms making much-admired carpets while singing, to the delight of onlookers. Several newspaper reports described them as 'cheerful and happy', while at the same time solemnly noting that the youngest two boys were just nine years old. The eldest among them and leader of these carpet weavers was a boy called Petharam. He had been incarcerated in Agra prison for 'some juvenile misdeed' and had apparently 'begged hard not to be sent back to his poor and ignorant parents' after serving his sentence, as he feared being caught up in crime again. One visiting writer reported Petharam setting a rhythm for the other boys in their weaving and singing:

> 'Three reds and one blue', Petharam sings, in a high pitched voice, and this is not only repeated by the assistant concerned, but as soon as said nimble fingers seize the red and then the blue and with the swiftness of buoyant youth, dash the coloured threads through the warp and with a sudden jerk tie a knot just in time, for in a second, the other hand brings

down the circular knife that severs the remainder of the thread. 'Miss two and give one blue', in a sonorous tone is next sung out (in Hindustani) and it is no sooner heard than a second voice repeats the command, and the thread is left in its prescribed place. This busy sight is much appreciated by visitors.[22]

Swoboda chose to paint one of the youngest boys, nine-year-old Ramlal from Kanpur. Ramlal is depicted wearing a white collarless cotton tunic and a red-orange turban on his small head. He has large eyes, clear skin, a delicate nose and the slight pudginess of childhood on his cheeks. His gaze is turned away, facing downwards to his right, his hands are not visible, so he may still be working at his loom. Ramlal appears distracted, bored and even unhappy, perhaps he was longing for the opportunity to play, or simply missing home. It is not clear why this nine-year-old was put in prison. So while the press mostly raved about the cheeriness of the child carpet weavers, Swoboda chose to capture a different emotion.

Ramlal may also have been drawn by another artist. Two black-and-white sketches featured in the *Illustrated London News* of July 1886, accompanying an extensive article about the exhibition, show a young turbaned boy about his age. The first depicts a boy sitting in the archway of the Durbar Hall in the exhibition, another shows him dressed in a traditional shalwar kurta (trousers and tunic), standing with his arms folded, looking expressionless and staring straight ahead. A white-skinned girl dressed in European style shyly hides behind her mother's skirts and takes a peek at both the boy and an old man who is walking close by, using a stick to aid him. He too has a turban with tufts of his white hair visible around the sides. Could this be both Bukshiram and Ramlal? Sadly, unlike Swoboda's paintings, no names are offered up by the illustrator and these characters merely form part of the scenery of the exhibition.[23]

The Swoboda paintings feature others from Agra prison too. A portly gentleman in a rich saffron-coloured tunic and a domed hat of emerald green with a thick band of gold brocade around it stares straight ahead. He has heavy eyelids and his eyebrows are furrowed in a frown of concentration. A full beard covers much of his lower face and curls of hair are tucked behind his ears. This is Shahban, a forty-five-year-old silk spinner, who worked alongside two assistants, all of them from the city of Benares. A newspaper reporting on Victoria's visit to the workshops noted her attention being drawn to Shahban who was 'gorgeously dressed and looked picturesque with large silver rolls on his arms', likely amulets with verses from the Qur'an on them. Swoboda's painting shows Shahban wearing a long necklace and a chain around his upper left arm, both of which have medallion-shaped amulets on them. The Queen bought a piece of brocade from Shahban and also placed an order for several pieces to be made for herself and other women in the royal family.[24] Victoria was presented with gifts from several of the artisans. Two stone carvers from Bharatpur had created alabaster curved screens for her and a pair of ivory-and-sandalwood fans, known as *chowries*, a product distinctive to their region.[25] One of them was chosen for a portrait by Swoboda; Radha Bullabh Mistry is wearing a beautifully embroidered cream-and-gold robe with a red-and-gold cap or turban as he gazes into the distance. Muhammad Hussain, a coppersmith in his mid-twenties from Delhi, was painted in profile; he is wearing an olive-green waistcoat with a burnt-orange trim over a white tunic, on his head a skullcap sits above black bushy hair and a neatly trimmed beard covers his lower chin. One visitor described him as a 'handsome young man ... with a rather melancholy air'.[26]

All of these workers lived inside a specially built 'native compound' behind the exhibition buildings. This meant that, unlike the Indian civil servant Mukherji, they were largely kept away from the rest of London, only to be seen on display in their workshops. They did, however, visit Windsor Castle for an audience with the Queen,

and each individual was presented in turn and knelt down to receive a blessing from her. Victoria described the procession of them all in St George's Hall at Windsor Castle, noting in her diary that 'their different brilliant coloured dresses had a very beautiful effect, in the bright sun lit Hall'.[27] On this visit, and throughout their journey, the workers were escorted by the superintendent of Agra prison, Dr Tyler, who was on hand to act as an interpreter and no doubt also to keep an eye out in case of any trouble. So just how pleased or unhappy were they to be in Britain and on display in this manner? Although they received wages, half of which were paid in advance, given that they were prisoners it is unlikely they had a great deal of say over their fates.[28] Rather disturbingly, a homeless Indian man who was already living in Britain and had been seen as a nuisance by the authorities was also enlisted into this live exhibit. He is described in reports as Tulsi Ram, a sweet-maker.[29]

Ultimately, the live exhibition of artisans was a work of propaganda – a spectacle to encourage Britons to buy into the idea of Empire. Much was made in official accounts of these being 'genuine' and authentic artisans, and yet we know that they were first and foremost prisoners who had learned crafts while serving their sentences.[30] A display of crafts being made by hand was also based on an idealised view of the Orient; it presented a picture of 'tradition' in India, in contrast to modern, industrialised Britain, and some of the press coverage reflects this:

> The native artificers who in the court of the Indian palace pursue their various callings in native fashion, are eagerly watched by crowds daily; but they can never be rivalled by English workers, for their work requires not only delicacy of manipulation but patient labour, only possible in a land where workers are numerous and wages extremely low.[31]

The exhibition was also taking place in a period when the Arts and Crafts Movement, a social movement of artists that was critical

of mass production and believed in individual craftsmanship, was developing in Britain. But this exhibit was not just about demonstrating crafts – the bodies of the artisans themselves were on display. In some ways they too were meant to represent 'types' of 'natives' in India; they were introduced almost as if being categorised according to age, region and religion. Yet, one newspaper was not satisfied, demanding that the clay and plaster models which represented different 'races' be replaced with more 'living specimens' from across the Empire:

> Why can we not have groups of native workmen from all the provinces of India instead of a beggarly half dozen who at present afford such a welcome contrast to the clumps of clay figures which now alone represent the varieties of our Indian fellow subjects? Nor is India the only part of the realm that ought to be represented by living specimens of its native tribes.[32]

The Swoboda paintings were a part of the propaganda and, for Victoria, these were 'beautifully done' examples of her imperial subjects as Empress of India.[33] In September, a total of eight paintings were completed, consisting of five Indian men and three others who had arrived from British colonies to work at the exhibition. One painting depicts a girl with a voluminous green scarf around her head, tied in a knot at the front of her neck, wearing matching jewelled earrings and a rusty red dress. She stares straight at viewers with a piercing gaze from her chestnut eyes. This was Georgina Manan, a sixteen-year-old Malay girl from South Africa who had come over to the exhibition with her parents and worked as a dressmaker. John Kabua Silos was also from South Africa, he worked at the diamond exhibit in the African Court and his portrait shows him wearing a headdress and beads around his neck. The final portrait of this set is that of Rhodothea Petrou, a fifteen-year-old girl from Nicosia in Cyprus. She wears an indigo-blue waistcoat

embroidered with gold patterns and a brown scarf with floral motifs is tied behind her head. Petrou had travelled with her relatives, a woman in her twenties with whom she wove silk and the woman's husband, who was a policeman. An interpreter also stood alongside them as they worked, as they did not speak English.[34]

We know little about the lives of those who were put on display at the exhibition. They were brought to perform and to be watched, to play their bit parts in the theatre of Empire put on for Britons at home. Somehow, though, their portraits capture a little of their personalities and moods; they may have been described as 'happy' in the newspapers, but in Swoboda's paintings none are smiling. There is a somewhat melancholy air about these portraits. So while these humans were transported to Britain to be gazed at, when we look at their images in the corridors of Osborne House today, it feels like these 'artisans' are also returning a gaze, prompting questions and serving as a memory of their presence in Britain.

The live display of 1886 was not the only one of its kind. Two years later, the Glasgow International Exhibition also featured 'artisans' from India. Determined to show off the city's industries and outdo Edinburgh and Manchester, this exhibition of 1888 was a huge affair and brought in more than five million visitors. Several adverts for the exhibition listed the 'Indian Courts and Galleries; Indian artisans at work' and Colonial Exhibits as highlights. Some of the ornamental screens on display in London in 1886 were once again put on show, alongside many more especially crafted items, and a detailed guide about the art products of India was written by Mukherji as a special accompaniment to the exhibition.[35] A brightly coloured building with minarets and a dome influenced by both Moorish and Indian architecture was built to house the main events, and newspapers dubbed the scene 'Baghdad by Kelvinside' or 'the Alhambra by Kelvinside'. One reporter marvelled at the contrast on the banks of the Kelvin River between 'the steep roofs and spires of a Gothic college' on one side and the 'burnished domes and

cupolas and minarets of a gorgeous Moorish palace' on the other.[36] James Sellars, the forty-five-year-old Glaswegian architect who had won a competition to design the building, seems to have made the ultimate sacrifice for it – he sadly died just one month before the exhibition closed. The pressure of this huge project had apparently left him exhausted and unwell. Sellars had also allegedly stepped on a nail during the construction process causing him to suffer blood poisoning.[37] The building was a temporary design made of timber and no longer exists, but the profits from the exhibition went towards the construction of Kelvingrove Art Gallery and Museum on the same site, and the museum still holds a few pieces from the 1888 exhibition today.

<p style="text-align:center">*</p>

On a mid-September day, Glasgow is dry, mild and bright, although an occasional blast of Atlantic wind serves as a reminder that summer is coming to an end. As I walk through Kelvingrove Park and past a menacingly fast-flowing section of the River Kelvin, a building of burnt-orange sandstone reveals itself. Inside, the grand interior courtyard of Kelvingrove Art Gallery is filled with hundreds of visitors animatedly looking above the entrance door. On the first floor the balcony is lined with more people, leaning against the handrail, and these eyes all also point upwards as if mesmerised. I follow their gazes and realise the daily organ recital is about to begin. As the sound of ethereal music fills the hall, the chatter subsides, but the excitement of visitors today mirrors that of those who came to this site more than a hundred years ago. An oil painting by John Lavery on display inside one of the galleries captures the mood of 1888: densely packed crowds cross the bridge over the River Kelvin towards the entrance of the dome- and minaret-topped building; there is a twilight glow from the crescent moon and a string of crimson lamps hung up around the building, the artist's choice of colours and quick

brushstrokes conveying a sense of commotion and enthusiasm in the air.[38]

Under the grand dome of the 1888 exhibition, there was a central recreational area with a fountain and palm trees. The building was then divided into courts with a Main Avenue leading to the different sections, and exhibits included displays on fine arts, agriculture and horticulture. At the west end of Main Avenue, one prominent company had constructed an 'Indian Pavilion', a structure featuring minarets and cupolas, made of glazed and enamelled terracotta tiles, which imitated Persian originals. Inside this structure, displays of pottery by British workers were featured.[39]

It is interesting to see how the Britons performing their work at this exhibition were described in contemporaneous reporting, compared to the Indians doing the same. Some of the observations were innocent statements of curiosity, one account noting how Indian wood carvers worked 'with their boots off' and used their feet as well as their hands.[40] But other remarks once again show a haughty obsession with presenting Britain as technologically advanced and India as traditional and primitive. One report contrasted the 'serenity of the phlegmatic sons of the Orient' with 'the restless energy of the British workmen, who by the aid of the latest inventions and machinery manufacture similar articles'. The British potters were said to be showing 'many improvements on the simple art' of the Indian potter. The latter's wheel was described as 'simple and primitive', with a 'rude and clumsy character', while the Britons were using 'mechanical power'.[41]

Nine Indian men came to work as 'artisans' during the exhibition. Two of them were wood carvers from Bhera in Punjab, Muhammad Din and Muhammad Buksh. The latter, notably, has the same name and comes from the same place as one of the craftsmen who built the wood-carved 'Indian Palace' now inside Hastings Museum. Could he have stayed in Britain and gone on to carry out a display in Glasgow or was this another man with

the same name? The other men all came from Bengal: there were
two potters, Tarini Charan Pal and Harikumar Guha, who created
hookah pipes and flower vases; Heralal Ghose and Ramdass Singh
were jewellers who fashioned items in gold, brass and silver; and
there were a couple of pastry cooks, Girish Chandra Roy and Lal
Sul, who spent their time using two gas cookers to bake cakes
and sweetmeats, which were 'bought up eagerly by the visitors'.[42]
In addition to these craftsmen, a number of Indian men were
brought to Glasgow to work as waiters inside the exhibition. The
culinary experiences on offer included a Ceylon and Indian tea
room and the Royal Bungalow Dining Room, which offered
curries and was also the most expensive place to eat in the
building. We know little about these 'native waiters', other than
that they lived alongside the craftsmen in Glasgow and all of
them were 'sent home afterwards'.[43] Ambling around Tate Britain
in London on one occasion, my eye caught an oil painting in a
recognisable style. Another of Lavery's depictions of the 1888
exhibition is on display here and it appears to be a scene from
the dining room.[44] It shows seated customers, Victorian men and
women clad in black with tall hats on their heads, lamps strung
up above them. A waitress dressed in a black dress and white
pinny clears away a table. But look closely, and in the background
there appears to be a figure in a yellow-gold turban and matching
robes, standing facing away from us. The informal artist in resi-
dence of the exhibition seems to have left a record of one of the
Indian waiters.

A Scotsman called Harry Bald, who spoke Bengali, was tasked
with managing the Indian men. They were all housed on site in
living quarters hidden away behind the machinery exhibits. Their
facilities included rooms for sleeping in, a washhouse and cooking
apparatus. Not content with seeing the men display their work,
the Glasgow Evening Citizen took great affront at them daring to
seek any privacy in these living quarters, noting that 'while in their
lodging, they demand the utmost exclusion, and it is with the

greatest difficulty anyone can be admitted to see them'. Nevertheless, it seems a source for the newspaper did somehow get a glimpse behind the scenes, because a report of the men's bathing habits then follows:

> ... their habits are most cleanly and it is rather interesting to see them wash – a process they go through by pouring water copiously on their head – instead of as here, laving up the water with the hands.[45]

Today, in a corner close to the balcony on the first floor of Kelvingrove Art Gallery, a glass cabinet displays a small assortment of items purchased at the 1888 exhibition for the Glasgow Museum collections, most of which were bought in the Indian section. The objects include a silver rosewater sprinkler, a brass dish decorated with peacocks and tigers, and a tortoise-shaped platter with an accompanying lid fashioned to look like a frog. A sign explains the background to the event and provides detail on the Indian court, with a mention of 'being able to watch Indian craftsmen at work', but no other information about the men is offered. Again, the only substantial trace of them in Kelvingrove and in Britain can be found in a collection of John Lavery's paintings, one of which depicts an Indian potter – this is either Tarini Charan Pal or Harikumar Guha. The moustached man wears a black cap and a midnight-blue coat and trousers, the colours of which complement vases in shades of azure and turquoise set out on the table behind him. He is glancing down at his work and delicately fashioning another vase in his hands, though he gives the impression of knowing he is being watched. There is no other visual record of any of the other Indian workers here. Though the Swoboda paintings produced two years earlier may have been a piece of colonial propaganda, they managed to immortalise the memory of those brought to London, while the faces of those brought to Glasgow have been lost.

John Lavery's painting of an Indian potter (either Tarini Charan Pal or
Harikumar Guha) at the 1888 Glasgow International Exhibition.

*

Victoria was so pleased with her paintings that she wanted more.
Swoboda was now commissioned to travel to India, given money
for his expenses and provided with specific instructions:

> The Sketches Her Majesty wishes to have are of the various
> types of the different nationalities. They should consist of
> heads of the same size as those already done for the Queen.[46]

In October 1886, he began his journey on board the *Ballarat* ship,
and over a number of years travelled across the subcontinent,

spending most of his time in the regions of Punjab and Kashmir. He also made visits to the cities of Bombay (Mumbai), Agra, Hyderabad and Madras (Chennai). Some of those he met were familiar acquaintances like Dr Tyler, the superintendent of Agra prison, others were royal connections; the Queen's son and daughter-in-law, the Duke and Duchess of Connaught, introduced him to several people.[47]

Swoboda produced a total of forty-three 'heads' for Victoria. Several paintings are of children; these include the apple-faced four-year-old Miran, a 'boat girl' from Srinigar in Kashmir who has stunning bold black eyes lined with kohl and a cobalt cap on top of long braided hair that flows down her back; a small boy called Kibira Khylan wears a dirty grey robe partly torn at his arm, a black amulet around his neck and an intense, forlorn look about him; while Munni, a sixteen-year-old sweeper from Lahore, has large dangling loops in her ears and a silver ornament jangling from her hair, which is partly covered by a silver-grey *dupatta*. A number of military personnel were chosen for portraits too. Ghulam Muhammad Khan was a *subadar* or lieutenant in the 24th Bengal Infantry, he sports scarlet robes decorated with a medal on his left breast and a stunning gold, black and red turban which is tied pointing upwards, resembling the plumes of feathers spouting out from a cockatoos' head; while thirty-one-year-old Bulbir Gurung from Nepal, a *sepoy* (infantryman) in the 4th Gurkha Rifles, was painted in his bottle-green dress uniform, complete with a high top hat kept in place by a stiff band around his chin. Some subjects were merchants; others rejected all worldly possessions and embraced poverty, like Shanker Girr from Nepal and Ramanandi from Mount Abu, both *fakirs*. Shanker Girr has long uncombed hair, orange fabric swathed around his body and large brown wooden beads round his neck; while Ramanandi has a *tilaka* on his forehead, a mark of two vertical lines, traditionally made of sandalwood paste, to signify his devotion.

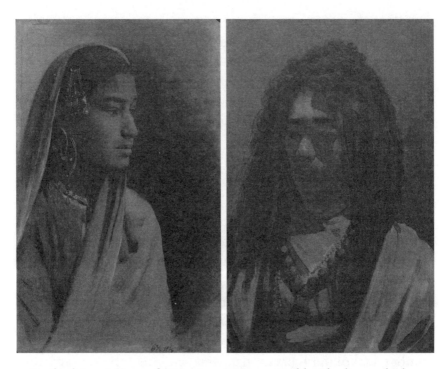

Swoboda's paintings of Munni, a sixteen-year-old girl who worked as
a sweeper in Lahore; and Shanker Girr, a twenty-three-year-old fakir
from Nepal.

Five years on from Swoboda's first journey, the collection of paint-
ings was complete and brought back to Britain. Their arrival was
reported widely in the press and Swoboda was described as the
'fashionable artist of the hour'.[48] The portraits were first sent to
Windsor Castle, then moved to Osborne, where they have remained
hanging for more than a hundred years, apart from a short period
when Victoria lent the paintings to an exhibition in Vienna. She
was delighted with them, declaring they were 'such lovely heads,
beautiful things'.[49]

Once back in Britain, Swoboda also painted Victoria's Indian
attendants at Osborne, including the man who would controver-
sially become her friend and closest confidant, Muhammad Abdul
Karim. These portraits also hang in the Durbar Corridor. Abdul

Karim is gleaming in robes of striped gold and white, with an intricately tied turban to match. In his hands he holds a book partly open and glances towards the floor, deep in contemplation. Victoria admired Swoboda's work; this was not just about documenting her colonial subjects – she urged many of her loved ones to sit for portraits by him – so it was natural she would order Abdul Karim be painted too. In fact, on a dull day at Balmoral, Victoria herself set about making a copy of this painting using watercolours; her sketch remains in the Royal Collection today but is not currently on display anywhere.[50]

Abdul Karim had been a clerk at Agra prison, working for Dr Tyler. He had helped Tyler prepare for the 1886 Indian and Colonial Exhibition, selecting carpets to be displayed in London and a pair of gold bracelets decorated with dragon heads as presents for the Queen.[51] A year later, twenty-four-year-old Abdul Karim arrived in Britain himself. Dr Tyler had been asked to send a couple of Indian servants to the Queen to help with her Golden Jubilee celebrations and Abdul Karim had agreed to take up the role, believing it was a promotion. Victoria was impressed by him almost instantly, describing him in her diary as 'tall, & with a fine serious countenance'.[52] Although he was disappointed to discover he was only to be a domestic servant, Abdul Karim worked hard to impress the Queen, even surprising her with his cooking by serving up chicken curry, daal, pilau and biryanis.[53] Much to the anger of many in the royal court, he soon became a favourite, and Victoria, declaring that he was 'very intelligent and useful', decided he was no longer to be a servant, but instead would be her teacher and Indian Secretary, with the title of *Munshi*.[54] This was a Persian and Urdu word that originally described a respected linguist but was later used by the Mughal Empire and then British India to refer to political secretaries.

The *Munshi* taught the Queen to speak and write in what was then known to Britons as 'Hindustani'; essentially the Hindi and Urdu languages. She learned the *Nastaliq* writing system of Urdu which itself derives from Persian. Victoria wrote extensively about

these language lessons in her diary, saying they were of 'great interest' to her especially because she had 'naturally never come into real contact with the language and the people'. Despite the monarch saying she found learning Hindustani difficult because of the changes in words according to tense and person being addressed, she would work at it almost every day, carefully copying out letters and words under Abdul Karim's supervision and practising by herself when he was away.[55] In recent years, some of her hand-written diaries and exercise books have been put on display in special exhibitions at Osborne House and at Kensington Palace; they show Urdu words and letters, neatly swirled in black ink, occasionally marked by the unsteadiness and caution common to those still mastering a new script. Victoria also wrote letters to Abdul, partly in English and partly in Urdu, often offering him personal advice.

The *Munshi*'s wife was invited to join him in Britain. The couple lived on various sites on the royal estates, moving with Victoria and the rest of the royal court according to the season. At Windsor they lived at Frogmore Cottage (now most famous for having briefly been the home of Harry and Meghan, the Duke and Duchess of Sussex), while at Balmoral Abdul Karim and his wife resided at the especially built Karim Cottage. Here the *Munshi* held a housewarming to celebrate his new abode, giving a speech where he declared gratitude for the 'good faith and kindness' shown to him by the 'people of Scotland and especially the people of Balmoral'.[56] On first meeting Abdul Karim's wife, Victoria said she found her to be 'nice looking' but 'so shy' that she could not raise her eyes.[57] However, this soon changed and the Queen became a regular visitor to their household, sometimes taking female family members or ladies-in-waiting with her. She wrote to her daughter in Germany, fondly describing 'the wife of my *Munshi*' and explaining how, although she was able to observe how 'beautifully dressed' her hostess was when visiting their home, as per her religious beliefs, the *Munshi*'s wife remained 'entirely covered' when stepping outside.[58]

The monarch took great pride in being able to hold basic conver-
sations in Urdu with other Indian visitors to her court and intro-
duced members of her own family to them using the language.
On one occasion, she found particular delight in hearing a visitor
wish that 'English ladies in India' had followed the Queen's
example.[59] Her guests also curiously observed her making private
remarks to Abdul Karim in Urdu. In June 1895 the visiting Crown
Prince of Afghanistan, catching a conversation between the two,
was astonished to hear Victoria speak the language and apparently
'could talk of nothing else to his retinue on the homeward
journey'.[60] He may have been impressed, but controversy over the
Queen's friendship was soon to ensue.

As the *Munshi* began to gain influence with Victoria, he built
more of a public profile too. Newspapers reported on his activ-
ities, describing him as 'no person of small importance' and
detailing his travels; a journey he made from London to Frogmore
was 'quite the state affair' as 'railway officials paid him every
deference', and even his salmon fishing on the River Dee in
Aberdeenshire with 'much success' was deemed newsworthy.[61]
Another publication printed a photograph of Abdul Karim, his
hand on his hip, dressed in the same gold-and-white turban as
he is depicted wearing in the Swoboda painting. The accompa-
nying story reports that 'the Queen is enthusiastic over his merits
as a teacher'.[62] Members of the royal household became enraged
at Abdul Karim's increasingly elevated status. In a confidential
letter, the Queen's Private Secretary Sir Henry Ponsonby wrote
of his frustrations, saying that they had been having 'a good deal
of trouble lately about the Munshi here' and that he was
concerned about the possibility of Abdul Karim having access
to state papers:

We cannot get the Queen to realise how very dangerous it is
for Her to allow this man to see very confidential papers
relating to India ... The Queen insists on bringing the Munshi

forward as much as she can & were it not for our protest I don't know where she would stop.

Victoria, however, was unmoved by the anger of her household, even accusing them of racism towards her friend. Ponsonby goes on to describe how the monarch dismissed their complaints: 'But it is no use, for the Queen says that it is a race prejudice & that we are all jealous of the poor Munshi(!)'.[63]

She even wrote to her personal physician to say that she felt 'continually aggrieved' and 'greatly distressed' at the attempts by her courtiers to 'spy upon and interfere with' her 'shamefully persecuted *Munshi*'.[64]

Despite their best attempts to discredit him, the royal household was unable to dislodge the friendship between Abdul Karim and Victoria during her lifetime. One British statesman quietly remarked to the wife of another that he believed 'all the Queen's Eastern ideas were the *Munshi*'s and were invariably wrong'.[65] When Abdul Karim was taken ill, Victoria found that she was 'quite lost without him'.[66] Upon her death, however, her son Edward endeavoured to expunge Abdul Karim's presence from the national memory, ordering letters between and photographs of his mother and her *Munshi* to be burnt. Abdul Karim himself was forced to head back to India. For more than a hundred years, his story was known in Britain only among niche audiences, until his diary was unearthed by one of his few remaining relatives in India. The diary was passed on to an author in 2010, resulting in a book and a major film, and the *Munshi* was brought to the public eye in Britain once again, meaning that Abdul Karim has now perhaps become one of the more recognisable faces in the Durbar Corridor at Osborne.

<center>*</center>

A lesser known face also painted by Swoboda at Osborne and now hanging in this same space is *Bhai* Ram Singh, the designer

and architect of the room that the Durbar Corridor leads to. He is dressed in a long-sleeved orange tunic with an embroidered collar, and a cream-and-gold turban. He sports a bushy beard and moustache, and has an impatient look about him; after all, this was a sitter who had quite the task to complete while he was at Osborne.

Ram Singh came from a family of traditional carpenters. He was born in the district of Gurdaspur in Punjab, but at a young age moved with his family to Amritsar, where his talents first came to the attention of a British colonial administrator, who then encouraged Ram Singh to enrol as a student of art in Lahore.[67] It was in Lahore that he met the artist and curator John Lockwood Kipling, father of the author Rudyard. Lockwood Kipling had been appointed as Principal of the Mayo School of Art in Lahore and curator of the city's Central Museum. Ram Singh was quickly identified as one of the 'most promising students' at the school, and he rose in the ranks from student to teacher himself, eventually becoming Assistant Principal.[68]

As a member of the Arts and Crafts Movement, Lockwood Kipling firmly believed in the appreciation and promotion of India's traditional arts. His aim was to 'revive crafts now half forgotten and to discourage as much as possible the crude attempts at reproduction of the worst features of Birmingham and Manchester work'.[69] While British art schools in India had previously focused on only teaching European classical forms of art, Lockwood Kipling was inspired by artwork in the city and country around him and determined to champion it. He founded and edited a publication as a manifesto for his ideas – The Journal of Indian Art – in which he outlined this belief:

> ... surely it is a strange omission that in a college for Indian students there should be no Oriental department. Not a single native draughtsman turned out from this school has been taught the architecture of this country.[70]

In this publication he also aired disagreements with other artists of the era, challenging what he saw as mischaracterisation of Indian arts, and writing detailed articles promoting various forms of indigenous crafts. He outlined the history and the technical skills required for these crafts including pottery in Multan, Burmese silver work and copperware from Kashmir. Lockwood Kipling described how Indian art had been influenced by and had connections to other countries of the Orient; a detailed article explained the Iranian and Central Asian style of Lahore's Wazir Khan mosque; while another essay on Punjabi wood carving noted its similarity to latticework seen in Cairo.[71] While he was undoubtedly a part of the colonial infrastructure, running a British school in India, Lockwood Kipling appeared to reject ideas of colonial cultural superiority, bemoaning the fact that Indian arts such as 'ornamental carving' were not being taught to children in Europe.[72]

Lockwood Kipling also curated displays and presented the work of the School at exhibitions as part of a commercial strategy for their art to find new markets and patrons. At one such exhibition, in Calcutta in 1883, Lockwood Kipling and Ram Singh met and impressed particularly powerful patrons, the Duke and Duchess of Connaught, son and daughter-in-law of Queen Victoria. Lockwood Kipling showed the royal guests around the Calcutta Exhibition, pointing out his star exhibits which included a huge frieze painted in the style of frescoes from the Wazir Khan mosque and items of furniture carved in walnut.[73] The Duchess wrote to the Queen saying Lockwood Kipling was a 'very clever man' and a 'pleasant and interesting guide'.[74] The following year, after the Duchess read Lockwood Kipling's travelogue of Lahore, the Connaughts visited the Mayo School of Art in the city for themselves, where the students were working on carving wooden screens intended for display in London at the 1886 exhibition. Lockwood Kipling and Ram Singh had already worked extensively on creating the furniture and architecture of buildings in British

India, now they would receive their first large commission in Britain itself – creating a billiards room at Bagshot Park, the Connaughts' home in Surrey.

The design and construction work took place in Punjab. The room was to be made up of 241 wood panels fitted into the walls and carved with different icons: these included flowers (roses, irises, carnations, daffodils and tulips); trees; animals (elephants, rabbits, turtles and cobras); and birds (peacocks, pigeons, parrots and king-fishers).[75] Animals also featured on the doors to the room, which were created with brass handles in the form of flying birds. Four of the wooden panels featured symbols to represent the room's owners and designers. The Duke and Duchess each had emblems of their own on a panel, while two panels placed on each side of the fireplace included an inscription carved with the names of the two architects, J. L. Kipling and Ram Singh, the latter's panel including 'a pair of dividers, a pencil and a chisel as a symbol of his skills'.[76] These wood panels were then fitted into the room at Bagshot Park by Muhammad Buksh and Juma, the two Punjabi craftsmen who had previously constructed the Durbar Hall for the 1886 exhibition, which is now in Hastings Museum. They stayed on in Britain to work on the billiards room.

Bagshot Park is currently the home of Prince Edward, the Earl of Wessex, and his family, and sadly is not open to visitors, so at present this work of Ram Singh and Lockwood Kipling can only be enjoyed through photographs and reports. Victoria, however, visited the billiards room at Bagshot Park on a number of occasions and admired it. On one 'very hot day' she wrote an account of how she took tea inside an 'Indian tent' and then:

... went into the house & looked at the beautiful Indian room designed by Ram Singh, much of the carving having been executed by him. It is full of beautiful things they brought back from India, & so is the corridor leading it.[77]

She decided that she too wanted an 'Indian' room, and so through her son a connection to Lockwood Kipling and Ram Singh was made. In Lahore, the architects started creating a design for a Durbar Room fit for the Queen, but Ram Singh was then required to head to the Isle of Wight and work on site. The Queen was 'sceptical as to the capabilities of the British workmen' who were tasked with carrying out the building work and believed his guidance was needed.[78] The Queen's Private Secretary, Sir Henry Ponsonby, wrote to Lockwood Kipling to agree the terms of the stay: the Crown would cover the cost of Ram Singh's journey to and from Britain, he could be given a stipend and lodgings in Cowes, close to Osborne, but cooking would remain his own responsibility because Ponsonby was not prepared to accommodate any dietary requirements, having decided that the 'feeding of Mohammedans is always troublesome'. Of course, Ram Singh was Sikh and not Muslim, a fact pointed out to Ponsonby by Lockwood Kipling in his reply.[79]

In January 1891, Ram Singh arrived in Britain, spending time at Osborne and in London as he worked on his designs for the new room. Copies of some of these plans can be found in the National Archives today; they show every detail of the room neatly drawn out in pencil and ink. Victoria saw his sketches during the planning phase and wrote about them in her diary on a number of occasions, describing them repeatedly as 'lovely' and 'beautiful'.[80] She also wrote to her eldest daughter, the Empress of Germany, updating her on the progress which she said was 'going on rapidly' and again stating that Ram Singh 'draws beautifully'.[81] However, there was a point of disagreement with her younger daughters Louise and Beatrice. As the very youngest child, Beatrice remained her mother's live-in companion until her death, while Louise had her own apartments in Kensington Palace but regularly squabbled with her mother over styles of decor. Victoria declared herself 'not very fond of electric light everywhere', claiming it hurt her eyes or was simply too dark for her tastes, but Louise and Beatrice were fans.[82] This caused something of a dilemma for Ram Singh. At first

he was advised to leave the issue of electricity for 'some time', but eventually it seems the daughters won the argument and the architect incorporated 'lamp stands for light and a hanging lamp for a bay window' into his designs.[83] The Durbar Room was thus not only one of the first chambers at Osborne to be lit by electricity, but also one of the earliest domestic rooms in the whole of Britain to use it, and two years later even Victoria acknowledged it was a 'great success'.

Ram Singh stayed in Britain for more than two years. He was photographed at work on site at Osborne and the image can be seen in the English Heritage archives today. It is a posed picture, but the subject looks as if he can only be briefly interrupted from his work. Ram Singh is dressed in a neatly tied voluminous white turban and a dark overcoat; he leans against a table, his hands placed on top of spread-out plans of the room. The Durbar Room is half finished, the lower parts of the wall are still exposed, a ladder, planks of wood and sawdust surround him. There were some tensions during the building process. For cost reasons, Ram Singh had to work with a specialist plaster company based in Britain, rather than his own craftsmen. This led to disagreements, and the company complained to the Queen's Private Secretary of the decorations being 'more elaborate' than they first expected and 'exceeding their contract'.[84] Then there were several royal family members to please, each with their own opinion on what should be done. In frustration, Sir Henry Ponsonby wrote to his wife saying, 'This new room at Osborne abounds in difficulties.' Ram Singh had recommended the room should be painted in light blue and gold but one of the Queen's daughters objected, arguing 'colour is common', so the finish was eventually completed in white and gold.[85]

When his business took him to London, Ram Singh engaged in social activities such as speaking at a function held by the National Indian Association in Kensington, an organisation set up to facilitate conversations between Indian visitors and Britons. Press

The architect Ram Singh at work in Osborne House, 1892.

coverage of the event reported him to be 'one of the most inter-
esting guests'.[86] But most of the time, he was absorbed in his
commission, as Lockwood Kipling described to a friend:

A Punjabi in London takes, as you may imagine a very curious
and entertaining view of things. Ram Singh sticks closely to

his work but at the same time takes a lively interest in a new life and new world, much of which he cannot comprehend.[87]

Tragically, while he was away from home, Ram Singh's son died. He wrote to Lockwood Kipling saying he would be 'very glad to return to India' because of the death and 'other family matters', but he wanted to complete his work at Osborne first.[88]

The final results of Ram Singh's work were universally praised. Several newspapers ran profiles of the room and introduced the architect's history to the public. The Durbar Room was declared a 'noble chamber of rare beauty and elegance' and the 'finest part of the palace'.[89] One report declared it as evidence that 'there is much to be learned from India', while another noted 'every detail of the elaborate design has been worked out with the greatest care and fidelity' and that Ram Singh's 'career has been in every way successful'.[90] Victoria and her family loved to show off their new room; it was a place to hold state banquets and host dignitaries including the German emperor and the King of Siam.[91] Princess Beatrice used it as a backdrop for her theatrical productions and *tableaux vivants*, silent scenes staging moments of history, posed for by members of the royal household including the *Munshi*.

On 22 January 1901 Victoria died at Osborne and her private rooms were closed off. In 1903, the grounds of the royal palace were turned into a naval college. During the First World War parts of the estate were used as a nursing home for British Officers and this use continued until 2000. After extensive restoration work by English Heritage, today the Durbar Room at Osborne can once again be seen in its full glory and it is an astonishing sight. Bright, white and opulent, every inch boasts a beautiful pattern carved into plaster and papier-mâché. From the ceiling, vase-like shapes hang down as if they are icicles; they are mounted on square panels and inside of each one is an octagonal-shaped flower motif. The walls boast the trademark geometric latticework of Punjab,

influenced by Arab architecture, as well as the cornice work seen on Mughal-era buildings in India such as the Taj Mahal. Rails made of teak frame each section of the wall, but the showpiece is a stunning peacock carved above the fireplace, intricate details of feathers and their eyespots chiselled to make up its patterned plumage. For the controversial electric lighting, there are standing lamps on the floor and built into the walls, the latter inside pillared cages made of teak with plastered umbrella shapes above them. Around the sides of the room, glass display cases house jubilee gifts given to Victoria by various maharajas of the princely states, while in the centre a banqueting table dressed for a dinner party, complete with cutlery, flowers and fruits, recreates the atmosphere of the state events held here.

The showpiece of the Durbar Room at Osborne House on the Isle of Wight is a carved peacock above the fireplace. It was completed in 1892.

When the room was initially finished, its design was described in newspapers as authentically following an 'ancient Hindu and Sikh Pattern'. In fact, it is a fusion of Mughal and Hindu architecture, uniquely blended together by a Sikh designer.[92] Ram Singh showcased rich elements of architecture from the Indian subcontinent and the broader Orient that would not have been paired in India itself; it feels as if the room is inspired by both mosque and temple. Above the doorway is a carved statue of the Hindu elephant deity Ganesh, while underneath the gallery a feature wall painted in red and gold has a swirling floral pattern with a phrase calligraphed in Arabic as a repeating motif: 'Wa La Ghaliba illa Allah' meaning 'There is no victor except God'. It is the same phrase calligraphed hundreds of times over the Alhambra in Granada, and Ram Singh, as a student of all forms of art, would have been conscious of this.

Ram Singh, unlike many of the sitters in the Swoboda paintings, was able to leave behind an imprint of his own in Britain. The Durbar Room serves as a reminder both of a colonial connection and of how the Orient has influenced art and architecture at the highest levels of British society. In this heritage site, there is no need to search out the one or two objects from the Orient hiding away. The depth of Britain's relationship with the Orient is on display, carved into the walls surrounding us, a reminder of how this history is woven into the very fabric of Britain itself.

<div align="center">★</div>

Yet, that fabric has been embroidered with the misery of millions, then and now. Those who seek to indulge the twin myths of the British Empire – its virtue and its emergence out of an innate British superiority – are often the most resistant to understanding what empire is in material terms. In its simplest sense, empire relies on the logic that the conquest and subjugation of faraway lands and peoples is necessary to improve and maintain living

standards at home. Of course, the idea that Britain's transport infrastructure, grandest architecture, art and wealth could only be built upon the massacre and subjugation of millions of people around the world must be maintained by a constant stream of propaganda directed at Britons.

The live displays of 1886 were one such exercise in justifying the twin myths of the British Empire. They presented the Empire as both natural and necessary. Press coverage of the 1888 exhibition also reinforced that message by portraying the 'phlegmatic sons of the Orient' as indolent and decadent. This description, used then and now, serves a dual purpose. On the one hand, if Indians and other targets of colonisation were perceived as merely a cheap source of labour rather than fully human and equal in status to Britons, it would be far easier to persuade Britons that their military and political representatives were doing their rightful duty in colonising and subordinating this human resource. At the same time, presenting the target population as primitive and backward was essential to the perceived virtue of the imperial project, transforming bondage into liberation. After all, if technologically advanced Britain could not civilise the Indian worker by introducing superior management systems and machinery, who would? Such a process of dehumanisation also requires a detachment from the histories of other peoples.

It is here that our heritage sites have a particular responsibility. These sites and the objects in them have often been used to project the power and majesty of the British Empire. But such power is rarely given or conferred to any political entity. It is usually taken by force. When our heritage sites fail to adequately explain the political contexts in which estates or objects came into the possession of landed families, traders or imperial officers, they simply serve as vessels to perpetuate the twin myths of the Empire – its virtue and it arising from British superiority. Whether intentional or not, this becomes a form of soft propaganda, by omission and elision.

Yet Empire had unpredictable and, for some, undesirable effects, such as Queen Victoria's relationship with the *Munshi*, Abdul Karim. It is tempting to cast this interaction as a symbol of Victoria's personal openness to new cultures and desire to better understand the territories that had come under her rule. There is certainly some truth to this. If we are to trust Ponsonby's account of Victoria's outrage over her courtiers' treatment of Abdul Karim, the Queen was convinced of and spoke out against racism influencing interpersonal relations and political influence in her court. What, then, would she make of the act of protest in Leeds' Hyde Park in 2020 where a statue of her was sprayed with the words 'racist', 'coloniser' and 'murderer'? It is unlikely that she would be amused. The markings on this statue remind us that, although the personal is political, it is not where politics ends. The current fashion for privileging 'lived experience' over material realities would have us portray Victoria as a noble warrior for equality in the workplace while overlooking her far more important record at the head of an expansionist empire responsible for the dispossession of a great proportion of the world's population.

It is significant, then, that even Victoria's mild and purely personal interventions in her court on questions of race would still be regarded in contemporary Britain as inappropriately 'radical' by sections of the commentariat keen to stake out a position as more conservative than parts of the monarchy itself. Victoria's enthusiasm for Urdu, her passion for art and culture of the Orient, and her defence of her friend Abdul Karim are admirable. They are under-reported inspirations in Britain's history for us to draw upon. Yet they cannot whitewash her presiding over a repressive, destructive colonial empire. Ultimately, it is the structural, and not the personal, that determined the fate of the millions she ruled.

As for someone like Abdul Karim, could he ascend to a position of seniority and influence today? To an extent, his racial identity would be less of a problem. A political, economic and cultural system that outwardly eschews its reliance on racial hierarchies

depends to some extent on well-placed people of colour to provide legitimacy, validation and a model of how non-threatening minorities ought to behave. This is both the purpose and effect of the vast and growing 'diversity' industry, which promotes quotas and superficial representation rather than introducing challenging ideas to corporate and political environments.

But the existence and proliferation since 2001 of a vast industry – a pantheon of think tanks, commentators, politicians, media outlets and state policies that aim to mystify Islam and demonise Muslims – means that a contemporary Abdul Karim would be at risk of finding himself on a no-fly list long before his arrival to the UK and, even with well-placed patronage facilitating his safe passage, would be identified as a source of potential 'radicalisation' and surveilled. However, if he were willing to serve as a loyal handmaiden to stale, preordained ideas of Britishness that are largely ahistorical, he would be enthusiastically embraced and rise quickly through the ranks, serving as corporeal proof of the supremacy and openness of a society that is in fact deeply insecure about its history and its prevailing ideology. Over a century after Queen Victoria's death and Abdul Karim's unceremonious expulsion, the *Munshi*'s spectre still haunts the halls of power in Britain.

The Durbar Court

The Foreign and Commonwealth Office, London;
Kedleston Hall, Derbyshire

THE WORD 'DURBAR' is repeated in rippling echoes through the building, as visitors snake around the central courtyard. I listen to the diverse accents; a multitude from regions around the United Kingdom, as well as those from India, China, America, remarking on architectural elements they spot, signs they read, and quizzically articulating the name of this chamber – the *Durbar Court*. This is a rare day, when ordinary members of the public are allowed in to a place normally paced by diplomats and dignitaries: the Foreign and Commonwealth Office, in Westminster. Whether mandarin or not, how many have stopped to ask why it is that a room inside the building at the beating heart of Britain's foreign policy should be named in Urdu, using a word that itself was borrowed from Persian? It is a phrase we have heard before, used at Osborne House for the chamber designed for Queen Victoria by Ram Singh and in the 1886 exhibition's Indian Palace.

The Foreign Office's Durbar Court is not merely a piece of history, it is where Britain shapes its relations with the rest of the world, and this room has hosted presidents, prime ministers and royals galore. I have attended a number of official receptions here as a journalist, but on this day it is open to all and filled with the sound of snapping cameras and curious questions from members of the public. A young woman looks up at a statue, reading aloud the inscription below it; 'Clive,' she says, turning to her boyfriend, an eyebrow raised. 'Didn't he have a last name?' He shrugs his

shoulders in return, replying, 'Wasn't he something to do with India?' Further along the balcony, an older couple are more absorbed in the room's contemporary features: 'See that? They've got a modern speaker system in.' It is an odd feature to pick out from a room so steeped in history.

The grand stone courtyard is surrounded by three storeys composed of arched windows, and can be looked into from all the corridors, rooms and balconies that border it. In each corner of the bottom and middle storeys is a statue of a man and in between them are carved panels depicting scenes. Some of the men in these scenes wear turbans. Numerous symbols and icons are also carved into a pattern that appears around the entire room; among these decorative features are cherubs and a cross entwined with a crescent, the symbols of Christianity and Islam. Around the top of the room is a series of busts, all of men, jutting out from curling shells on the walls, their names inscribed under their faces. As the sun moves through clouds, changing the direction of light hitting the room through its glass roof, some of the men's faces gleam, others are part in shadow. Above them, the names of cities and towns on the Indian subcontinent are carved into the walls.

In present times this department is keen to emphasise 'twenty-first-century government'. Around the Durbar Court and the rest of the building are displays introducing 'global change-makers' and banners proudly proclaiming 'diversity'. Even the civil servants manning the open day are a diverse bunch, standing smiling, patiently explaining their work to the hundreds traipsing through. But in this courtyard, they cannot block out the statues behind them, and while they are concerned with present and future foreign policy, this room has a history which too often remains untold, yet perhaps even continues to affect current policy.

In 1858, the Government of India Act abolished the East India Company and transferred its powers directly to the British Crown. This was in response to the great rebellion in India a year earlier, which had begun with a mutiny by Indian soldiers serving in Bengal

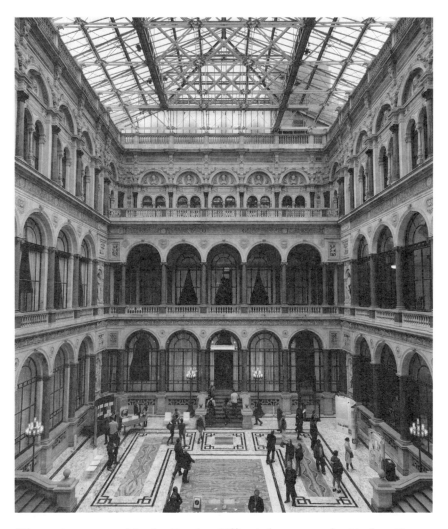

The main courtyard in the Foreign Office is known as the Durbar Court, and features carvings and statues glorifying Britain's dominance over the Indian subcontinent.

against their British officers, and continued with thousands of Indian soldiers and civilians resisting the authorities and joining the uprising, angry at the way they were being governed. The shock of this revolt forced the British government to alter the administration of India. A proclamation from Queen Victoria pledged to grant

Indians the same rights as 'all our other subjects'; a policy of reli-
gious tolerance rather than the Christian missionary project was
enshrined, and the British agreed that they would no longer seek
to expand their existing territories in India, so that the remaining
rulers of princely states could be secure about their positions and
thus used as allies, incorporated into a new system of rule over
India.[1] A new Secretary of State, an India Council and a govern-
ment department named the India Office were set up, although
the costs, including that of a new building for the department,
would be paid for by revenues from India. A decision was made to
move the London administrative offices closer to Westminster and
away from East India House, which was sold. With the Foreign
Office about to be rebuilt in Westminster, land to the east of it was
bought for the India Office, and the architects Gilbert Scott and
Matthew Digby Wyatt were commissioned to design the building.[2]

Wyatt was responsible for the space we now know as the Durbar
Court. The three-storey courtyard was built in Portland stone, with
the columns and arches constructed from polished granite, red from
Peterhead and grey from Aberdeen.[3] Ornately carved and richly
decorated internal courtyards were a common feature across the
Orient, and no doubt had some influence on the design of this space,
but more noticeable is the way in which it is a monument to the
British colonial presence in India. There was some consciousness of
a new era for governing India in the design of the room – fusing
together the cross and crescent perhaps acknowledges the newly
introduced system of respecting religious beliefs of India, rather than
the previous proselytising under East India Company rule. But the
characters and scenes chosen for depiction here largely represent
Britain's military and political triumph over India. The statues are of
men who served as Governors General of India. These include
Richard Wellesley, the Earl of Mornington, who decided to launch
the final attack against Tipu Sultan. Wellesley's statue evokes that of
a Roman emperor, an almost toga-like cloak slung over one shoulder
and arm as he gazes out into the distance, right hand under his chin

aiding his contemplation, a scroll clutched in his left hand. The statue of Robert Clive, better known as 'Clive of India', has a repeating motif of ferocious-looking lions carved around its base. The busts are of civil or military figures connected with India, including some of those considered heroes for their part in the final defeat of Tipu, such as General Sir David Baird and General Lord Harris.

In each corner of the room, carved marble panels show reliefs depicting key moments in the establishment of British India. Stand facing away from the balcony which leads to the India Council Room and the panel at the front of the room on the left shows two moustached men in the distinctive elaborate ruff-neck costume of the Tudor and Stuart period, approaching a turbaned monarch sitting cross-legged upon a high cushion. This was to show the first formal embassy from Britain to the Mughal Court, headed by Thomas Roe in 1615, which would lead to the beginning of the activities of the East India Company in the region. The panel directly opposite depicts a pudgy British soldier, sword in hand, haughtily pointing down towards blades, spears and shields being lain at his feet by three men dressed in full armour. This represents Sikh chiefs laying down their arms after British victory over their armies in Punjab. Meanwhile, at the back of the room, in the left corner, a Mughal emperor is sitting cross-legged upon a high seat, but this time the courtiers around him look saddened; one has his head in his hands in grief, as he sees a British man taking a scroll from the emperor's hands. Like the painting hanging in Powis Castle, this panel marks the moment Robert Clive forced the Mughal emperor to hand over the legal powers for tax collection in key Indian states, having defeated Mughal governors in battles, thus establishing the British Empire on the subcontinent. Finally, in the fourth corner of the room, a panel shows two Indian boys in jewelled headdresses, characters behind them in anguish, weeping or praying, while the boys are led away by a benevolent British hand. These, of course, are the sons of Tipu being taken hostage. All around the court, above various decorations featuring

the heads of Queen Victoria and Prince Albert, foliage, flowers and classical cherubs, the names of places important to British India are inscribed: Bombay, Madras, Calcutta, Agra, Lahore, Karachi. One of these is misspelt, with the word 'Nezagapatam' being carved instead of 'Negapatam', the old name of the town of Nagapattinam in present-day Tamil Nadu.[4]

On 19 July 1867, the courtyard would have been shown off to the world, hosting as its first event a reception for the state visit from the Ottoman Sultan. Nearly three centuries earlier, Elizabeth I had sent letters to an Ottoman Sultan, Murad III; now London would personally receive another, Abdul Aziz Khan, the thirty-second Sultan of the Ottoman Empire. However, there had been a change in the power dynamic; Britain was no longer a mere collection of isles, it had a growing empire of its own, while the Ottomans had decreased in importance and were struggling financially. But the Ottomans were still seen as key allies to Britain, firstly as a balance against Russian power; Britain had been on the same side as the Ottomans in the Crimean War. Secondly, Sultan Abdul Aziz also had considerable influence, not just over the huge swathes of Europe and Asia, which the Ottomans governed, but also in British India, a point made in political commentary at the time. One newspaper noted:

> The Sultan is Caliph as well as Sovereign; he is heard in Mecca as well as Constantinople, and through Mecca his judgement weighs very heavily in all parts of our Indian dominion ...[5]

Another added that '20 million of our Mahomedan fellow subjects in India, look up to the Sultan as head of their faith', and so they believed it was fitting that the India Office would entertain the Sultan in an official reception.[6] A third publication claimed that, despite the Sultan being a Muslim sovereign, Queen Victoria now ruled over more Muslims than him and so it was Britain that should in fact be deemed the 'great Mohammedan power'.[7]

In the late sixteenth and early seventeenth centuries, the attitude from London towards the Ottomans was fearful, and yet ambitious, as alliances were sought with a superior power. By the mid-nineteenth century, however, Britain had become an imperial force, and intended to mould the Ottoman state in its image. European powers wanted the Ottomans to reform along Western lines, and were desirous for the Sultan to introduce banking and free trade, which would be beneficial for European financial aims. *The Times* declared that the best thing would be for the Sultan to be 'indoctrinated with Western ideas', while the *Herald* decided that Abdul Aziz had 'far more European than Asiatic blood in his veins' and that he could do no 'better than make a study' of Britain to reshape his own land.[8] With France having already invited Abdul Aziz for a visit, Britain could ill afford to be left behind. But before the invite could be issued, there was a significant obstacle to be overcome – Queen Victoria herself. The monarch had largely retired from public life after the death of her husband Prince Albert, and made excuses of grief and ill health to avoid engagements. She was cajoled into the visit with assurances that the government would cover the expenses of his entertainment, although the invitation to the Sultan was issued even before she had actually agreed.[9]

The visit to France, and then immediately on to Britain, was to be the first of any Ottoman Sultan to Western Europe. For his part, the Sultan publicly declared the aim of his trip was to see what reforms could be adopted in his own country and to establish a 'feeling of brotherhood' between his people and the other nations of Europe, which he considered to be the 'foundation of human progress and the glory of our age'.[10] With the state visit scheduled, among the British political elite there was the additional question of how to rival Paris. In the press it was pointed out that London had 'no scenery like that of the Bosphorus' and that St Paul's Cathedral may seem 'cold and gloomy' in contrast to the Hagia Sophia. It was hoped that a visit to Windsor Castle might be sufficiently glorious.[11]

On 12 July 1867, Dover prepared for his arrival. The entire town was decked in flags and a fleet of ships lined up on the waves in front of the iconic white cliffs to salute him in greeting, while on shore military bands stood with their instruments at the ready, along with Queen Victoria's son Edward, Prince of Wales, and her cousin George, Duke of Cambridge. Anticipation was high for the man described by journalists as 'the great chief of the Mussulman race' and 'the representative of the long line of Caliphs and Sultans whose power a little more than a century ago, was the dread of Western Europe'. This was to be an 'event of extraordinary significance'.[12] But the actual moment of arrival was somewhat scuppered by rather ordinary British weather. A strong tide and blustering north-eastern winds meant the imperial yacht struggled to get alongside the Admiral Pier. As it eventually drew closer, at first there was no sign of the Sultan on deck. Instead an entire party of attendants and courtiers drawn from across the Ottoman Empire was assembled, many of them in state uniforms with sleeves and shoulders brocaded in gold lace and a seven-pointed star medal of honour attached to their breasts with a red ribbon, while others were dressed in exquisitely embroidered velvet jackets.[13] A young boy was also visible on board. This was ten-year-old Prince Yusuf Izzedin, the Sultan's son and heir who was accompanying him on the visit to Western Europe. He too wore a miniature version of the state uniform and the heaviness of the gold shoulders weighed down his small frame.[14] As soon as the winds eased and the yacht was able to moor, the Prince of Wales and the Duke of Cambridge clambered onto it to pay their respects. Shortly afterwards, the pair emerged with the much anticipated guest; the party walked onto the pier under the shadow of the white cliffs and thus the Sultan stepped onto British soil for the first time.

The air was filled with puffs of white smoke and the throbbing sound of gun salutes from both the ships out at sea and the series of cannon placed just below Dover Castle. The Sultan passed

through lines of soldiers, who presented their arms, and climbed into a carriage that would take him to the Lord Warden hotel. Named in honour of Arthur Wellesley, the Duke of Wellington, who after his battles with Tipu Sultan and Napoleon was given the position of Lord Warden of the Cinque Ports and Constable of Dover Castle, the hotel was a frequent stopover for wealthy and well-known clientele on their way to or from France. The building still remains opposite the cruise terminal, and now hosts offices owned by the Port of Dover authorities. Today the approaching road features a mundane car park and a roundabout, but back in 1867, the path to the hotel was vivid and vibrant, decorated in bright-coloured awnings, flowers and foliage. The royal parties spent an hour breakfasting at the hotel, after which the Mayor of Dover and other local dignitaries arrived to offer their welcome to the Sultan. With the pleasantries exchanged, it was now time for the onward journey to London, which would be conducted by train.

The royal train had been prepared in its largest configuration yet, consisting of four state saloon carriages and twelve first-class carriages with separate luggage and guard vans. As they left Dover, there was a final series of salutes from the guns. At first the Sultan, the Prince of Wales and the Duke of Cambridge all sat together in a carriage, but only minutes later as they approached Folkestone, the train came to a halt. The Sultan, perhaps exhausted by his journey, wished to sleep, and so a reconfiguration of the seating arrangements had to take place. This was rather unfortunate for the people of Tunbridge Wells, who had beautifully decorated their station in anticipation of a brief scheduled stop. Crowds had excitedly amassed on the platform for a glimpse of the Ottoman leader, but all they saw was a train whizzing past at full speed; perhaps because the star of the show was asleep or because they were behind schedule, the party did not stop at all. The throngs awaiting him at Charing Cross station in London were more fortunate. At a quarter to three, the royal train arrived and the crowds provided an enthusiastic welcome as the Sultan alighted. From

there, he was conveyed to Buckingham Palace – where he would stay for the visit – in a cortège of royal carriages complete with footmen in full state livery and a guard of honour provided by the Grenadiers, with spectators continuing to cheer along the procession as it passed by Parliament and along the Mall.

The following day, the Sultan set out to visit Queen Victoria at Windsor. Once again, the journey was to be conducted by train. At a quarter to eleven he and his entourage embarked from Paddington station, to the sounds of a royal salute being fired from the assembled guard of honour and a band playing the 'Aziziye Marşı' (or 'March of Abdul Aziz'), the imperial anthem of the Ottoman Empire under Abdul Aziz's reign. The Sultan himself was dressed in 'loose red trousers, a tight dark blue frock coat, braided over with gold lace and a plain red fez'. Forty-five minutes later, they arrived at Windsor where, despite the poor weather, thousands had enthusiastically lined the streets along the entire route to the castle itself.[15] A sketch in the *Illustrated London News* shows the procession along the iconic Long Walk to Windsor Castle; the Sultan is seated in an open-top carriage, accompanied by Scots Fusilier guards in ceremonial uniform on horseback. As the crowds clamber to catch sight of him, a police constable appears to be restraining one rather squashed group where the ladies are leaning forward towards the carriage while the gentlemen theatrically doff their top hats in greeting.[16]

Inside the castle, Victoria stood at the foot of the Sovereign's staircase. The Sultan arrived and kissed her hand, and she in turn embraced his young son Prince Yusuf Izzedin, who reportedly 'seemed somewhat surprised' at this welcome.[17] They then headed to the White Drawing Room, where both monarchs exchanged introductions of various family members and courtiers. The conversation took place through interpretation by Fuad Pasha, the Ottoman Foreign Minister. Lunch was then served in the Oak Room; Victoria wrote in her diary that the Sultan ate 'most things (which I was glad to see) but never touched wine' and that 'he seemed to me to cut his meat with difficulty'. She found her guest

to be 'fine, dignified', of a 'pleasing countenance, with a pleasant smile' and 'good features', which must have been a relief given her reluctance to entertain him in the first place. But after he had departed, she noted feeling 'tired and headachy', having been 'very nervous' and missing her deceased husband Albert, adding it was 'dreadful to me to have to do this all alone'.[18]

The Sultan's schedule was packed with events. There were daily dinners and receptions and a huge demand to catch sight of him. At the Royal Opera House in Covent Garden, 12,000 plants had been commandeered to be used in decoration, and visitors paid a guinea to see him pass through the hall on his way to sit in the State Box with the Prince of Wales and the Duke of Cambridge. After 'God Save the Queen' was sung, the orchestra performed a specially composed song praising him:

> God Preserve thee Sultan long;
> Ever keep thee from all woes;
> May thy State and thee be strong;
> To dismay and resist thy foes!
> O may thou continue great,
> Of thy nations love secure
> On thee may all blessings wait
> And remain for ever sure ...

That night, it was reported, no one seemed to pay the slightest attention to the opera performance of *Masaniello*, apart from those in the box, to which all other 'glasses and eyes were incessantly directed'.[19] At the Crystal Palace, the glass-and-iron centrepiece of the 1851 Great Exhibition which had now been re-erected in south London, there was also a musical performance scheduled, in fact an entire concert programme had been composed involving a choir of 1,600 people. By two o'clock in the afternoon, hours before the concert was due to start, 20,000 to 30,000 spectators had already assembled, all wishing to get the best possible view

of the Sultan. This led to a great deal of pushing and crushing to 'the detriment of the temper, clothes and perhaps even the ribs' of those involved, as one paper put it.[20]

The Sultan himself did not arrive until after eight, more than three hours after the scheduled start time, once again accompanied by the Prince of Wales. The concert had begun without him, but as the audience became aware of his entrance, there were 'deafening shouts and cheers'. In 1599 Queen Elizabeth I had sent a musical clockwork organ to woo the Ottoman Sultan on behalf of English merchants seeking trade in Constantinople, now once again music would play a central role in an attempt to foster a strong diplomatic relationship with the Ottoman Empire. A Turkish song composed by an Italian musician, in praise of the star guest and grandly entitled 'Ode to the Sultan', was performed by the choir. The melody incorporated elements of the Sultan's imperial anthem and its lyrics were printed in Turkish, in both Ottoman Turkish and Roman script, alongside an English translation in concert books on the night. The English words were later reprinted by the press. The song lavished praise upon the Ottoman ruler, declaring it was a 'happy day for England's people' to witness the 'dazzled sight' of the Sultan:

> Why O Palace built of diamond, still with fragrant flowers
> be light
> Do thy stones all flame as rubies, flash and glow with fiery
> light? . . .
> The Sultan Abdul Aziz comes, hail the cause of our delight!
> Hail Sultan! thou mighty ruler, London bids thee welcome
> here!
> Worthy thou the throne of Osman, long remain our hearts
> to cheer!

While calling on 'heaven' and 'prayers' to preserve the Sultan, it also proclaimed his benevolence: 'Sons of Islam call him Father, Christians own his kindly care.'[21]

The evening ended with a firework display, which newspapers breathlessly reported was the 'most magnificent display of fireworks probably ever seen in Europe'.[22] Whether that was accurate or mere hyperbole, the Sultan was sufficiently impressed and donated a huge sum towards rebuilding a portion of the Crystal Palace which had been recently damaged by fire. Sadly, seven decades later the entire building would be destroyed in another fire.

Britain was determined to put on a great show for the Sultan. He was so sought after throughout the ten-day visit that he had more invites than he had time to accept, such as one from the Mayor and citizens of Manchester inviting him to come and see the cotton trade in the city.[23] Mostly the events went to plan, but there was the occasional hiccup. At a ceremony to inspect military personnel on Wimbledon Common, as the Sultan rode upon a white Arabian horse belonging to the Queen, a mob of people eager to see him broke through various barriers, creating chaos. Despite the best efforts of the police officers present, crowds swarmed onto the muddy ground and were only prevented from coming too close by the 'exertions' of the Prince of Wales and a number of officers who created a pathway for the Sultan to safely get back into his carriage. Meanwhile 'several peers and gentlemen' got into physical fights with 'the mob' to try and release a number of royal ladies from the blockade. If the guest of honour was shocked or amused by these scenes, he did not show it. Apparently the Sultan 'maintained his usual impassive expression of countenance'. The royals in their carriages eventually managed to get away, but for thousands of spectators a tougher journey awaited. The railway 'utterly broke down', leaving them with 'no alternative but to walk home'.[24]

The British weather was less responsive to the Sultan's visit. A display of the navy's fleet for the Queen and the Sultan took place at Spithead on the Solent, between the Isle of Wight and Portsmouth. It was seen as a way in 'which England could at once present the

Sultan with a great pageant and an effective display of strength'.[25]
But this was all somewhat undermined by the forces of the sky. The
Queen, perhaps like many of those involved, was hoping the poor
weather in the morning would lead to the event being postponed
that day. She writes in her diary that it was to her 'vexation' that it
was not.[26] With heavy rain pelting down and violent gusts of wind
blowing around, communication between boats became difficult
and only 'the most adventurous yachts' were able to sail. The planned
inspection of the fleet by the two monarchs was curtailed as much
as possible. Victoria writes that at first both she and Abdul Aziz sat
out on the deck of the Royal Yacht, but the Sultan soon seemed
'uncomfortable' in the conditions and headed below for much of
the rest of the event. There were also some flaws in the choreog-
raphy, with the ships coming too close to the Royal Yacht, or at
least that is what Victoria believed when she saw them saluting 'so
violently' that she thought the windows of the yacht would break.
Nevertheless, the event successfully honoured the Sultan with an
award of the Order of the Garter, making him the 756th Knight of
the Garter. A watercolour painting commissioned by Victoria records
the moment and remains in the Royal Collection, though is not
currently on public display.[27] Victoria, in a black dress and headscarf,
pins a medal onto the Sultan's breast as a small entourage, including
the Prince of Wales and young Prince Yusuf Izzedin, watches on.
There are a few dark clouds looming but directly above the party
sunshine and blue skies reign. There were no weather troubles, as
far as this depiction is concerned.

The grand finale and most important event for the Sultan's visit
was a ball held in the recently built Foreign and India Office, in
the space we now know as the Durbar Court. This state reception
was the first opportunity to show off the new building, and the
aim was to display plenty of pomp and magnificence. Just a fort-
night earlier, the quadrangle was a 'dirty chaos of mud, scaffoldings,
piles of rough hewn stone, and mounds of mortar'. Now the
courtyard was turned into a ballroom and a temporary floor was

laid to accommodate dancing. Gilt baskets of flowers and flags
were strewn from the balconies, half of which were blue with the
monogram of Queen Victoria, the others were red and bore the
cipher and crescent of Abdul Aziz. Clusters of exotic palms, tree
ferns and rare creepers were used to adorn the staircases and land-
ings around the court. For light, twenty glass chandeliers were
hung from a temporary roof made of waterproof material,
stretched on wire ropes, while massive candelabras festooned with
pink artificial flowers were placed in front of the mirrors that now
lined the sides of the room. (The glass roof had not yet been
constructed and originally the courtyard was open to the skies.)
A newspaper report later approvingly noted that, though the deco-
rations were elaborate, they did not conceal the 'fine enrichments
and architecture of the building', including the 'busts of our great
Indian warriors and statesmen'. By Indian, the paper in fact meant
the Britons in India who were considered colonial heroes.

A newspaper printed this sketch of the Ball held in honour of Sultan
Abdul Aziz at the India Office in 1867.

At 11 p.m., the Sultan, wearing a uniform of blue and gold, arrived and was greeted by the Prince of Wales and a party of royals. They then headed in procession to the courtyard, which was heaving with ambassadors, dignitaries, military personnel and politicians. Some of the statesmen wore gold-breasted coats of green or blue, others were in court suit. The officers were in uniform, with those from highland regiments in plaid and kilt, while all the ladies were dressed entirely in white. The royal party made their way to the 'chairs of State' which had been placed on a dais at the front of the court. This was curtained and canopied in crimson velvet studded with golden crescents, and stood upon a scarlet carpet. A display of dancing soon began, and the Sultan calmly looked on. He was reported to be 'impressed' but yet again 'nothing could be divined from his impassive countenance'.[28]

At half past midnight, he and the other royals present headed upstairs for supper in the India Council Room. This intimate first-floor room looks out onto the Durbar Court and retains many of its original pieces today, including the doors and a marble mantelpiece which were brought over from the East India Company's original headquarters at Leadenhall Street, thus representing a sense of continuity for governing India, as power was transferred from the Company to the Secretary of State for India and the India Council. The marble mantelpiece depicts Britannia (the traditional female personification of Britain) sitting by the sea, holding a trident in her hand, two female figures approaching her, one with a lion, the other a camel. This symbolised Britain receiving 'the riches of the East' from Asia and Africa.[29] Until 1947, this was the backdrop for British officials' decisions on matters relating to the Indian subcontinent. What then did the Sultan of the Ottoman Empire think of this backdrop for his state dinner? Sadly, he left no record of his feelings on the matter.

On the night of the ball, the chamber was transformed into a suitable dining room: the walls were covered in rich draperies and

decorative items such as shields and flags, with gold vases and centrepieces used to further adorn it. These items were borrowed from Windsor Castle and Buckingham Palace – or as one newspaper put it, the palaces were 'ransacked' for the night.[30] A rather apt choice of word, given that one of these objects had originally been obtained by the ransacking of an Indian palace – a large gold tiger head, its open jaw flashing teeth of rock crystal, taken from the base of Tipu Sultan's throne. As if the symbolism of the marble mantelpiece was not enough, here was a literal example to demonstrate the wealth Britain received from its empire, having vanquished an enemy who opposed it. While the party of royals sat down to enjoy a banquet served on gold plates, to be eaten with gold knives and forks, alongside ice served to them from gold pails, the dancing continued downstairs. However, this required some effort to maintain; many of the guests, having seen the Sultan, felt they had already experienced the main highlight of the night and decided to head off. The army officers present were left persevering with the dances to prevent the ball from flagging. They seem to have been successful enough, for when the Sultan bade the audience farewell at 1.12 a.m., there was enough of a crowd to cheer him out.

The evening was considered a triumph, as was the entire state visit. On the morning of his departure, the Sultan sent a donation to the Lord Mayor of London for distribution among the poor of the city. He and his entourage made one last train journey in Britain from Charing Cross station to Dover, and along the way staff of the South Eastern Railway were given monetary gifts. From Dover, it was then swiftly across the Channel into Calais.[31] Upon reaching France, Abdul Aziz sent a telegraph of thanks to Victoria, offering his most sincere wishes and stating that 'I shall keep an eternal remembrance of the pleasant days I have passed on the hospitable soil of England'.[32] He was certainly impressed enough to later make orders of British-built ships and to hire British advisors to expand the Ottoman navy.

In London, in the immediate aftermath of the state visit, there
was an objection raised regarding the ball given at the India Office.
Why, asked a Member of Parliament, were the people of India
paying for the state entertainment of a 'European monarch' in
Britain?[33] (That the Sultan was labelled European by a British poli-
tician at this point is fascinating; the days of fearing 'The Turk'
certainly seemed to have disappeared, however briefly.) The govern-
ment explained that they believed this event was in the 'interests
of our Indian Empire', given the backdrop of the recent revolts
and because the Sultan was seen as a leader by the Muslim popu-
lation of India. It was a way to show the new India Office being
treated with respect by a ruler whom Muslims in India respected.
This explanation did not satisfy everyone. The Pall Mall Gazette
pointed out that, even if the Muslim population of India would
perhaps be 'flattered' at the Sultan being welcomed for their sake,
Muslims were only one group of Indian subjects, and many of
them, like Hindus and 'European residents' of India, were currently
already protesting against the way they were being taxed, with
reports of public meetings being held in Calcutta and elsewhere,
to raise their objections. The newspaper believed that being made
to pay the bill for this ball would be an 'incomprehensible semi
abomination in the eyes' of Hindus and Muslims alike.[34]

The Pall Mall Gazette also bemoaned the lack of scandal gener-
ated from the state visit, believing gossip about what the Sultan
really thought of Britain had been suppressed, partly because of
the need for an interpreter, which limited the communication, but
also because the visitor had his time filled with an 'unceasing and
relentless round of ceremony' and that 'the poor man was much
in the position of one tied in front of a wheelbarrow and trundled
along from behind willy nilly'. The newspaper added that he had
'bore it with all the most admirable resignation' and 'good
humour'.[35] It was also sceptical over one report from Paris regarding
the Sultan's impressions of Europe, which claimed that Abdul Aziz
had apparently been so impressed that he had been seen 'leaning

his brow on his hand and muttering low to himself; "Oh this great West"'. The *Pall Mall Gazette* said while this story may possibly have been a 'mythological representation of the Sultan's real feelings', it was more likely the 'reflection of a French gossip's own mind' because the 'antithesis of East and West is an exclusively European idea'. Then as now, there were those who were cynical of the simplistic idea that 'East' and 'West' were clearly distinguishable cultures at odds with each other, regardless of how decision-makers might have been weaponising such a myth to further their own ends.

At the India Office, after the ball itself, there was also a house-keeping scandal, reported in the press as a 'dastardly occurrence' and a 'very disgraceful affair'.[36] A number of gold and silver plates belonging to the Queen and borrowed from the royal palaces for the night had gone missing. Police believed they had been 'mysteriously carried off on the night of the festivity' in a planned robbery with 'confederates employed about the refreshments department'. Despite spending weeks attempting to trace the thieves, it seems the investigations were unsuccessful and the police feared the plates had been melted down. It was the only real sour note of the night.

<p style="text-align:center">*</p>

The ball for the Sultan was to be the first of many grand diplomatic events hosted at the India Office. But it was not until three decades later that the space received the name it is known by today, the Durbar Court. After Queen Victoria's death, the coronation of her successor Edward VII was scheduled to take place in June 1902. As part of the celebrations for the new King, a reception was planned at the India Office. This time, it was designed to host the rulers of Indian princely states, who would be coming to London to publicly pledge allegiance to the man who had inherited his mother's title and would now become the Emperor of India. The princely states were areas ruled indirectly by Britain, governed by

local rulers who generally received power through hereditary means, their families having been first awarded land and titles under Mughal rule. Now they were known by monikers such as Maharaja, Maharani, Nawab and Nizam.[37] These states were religiously, culturally and linguistically diverse, had their own currencies and legal set-ups and different treaties or political agreements with Britain. However, the Government of India Act in 1858 had essentially cemented the position of these rulers as an elite class collaborating with the colonial power of the Empire. They were given apparent free rein to administer laws in their own territories, where around one fifth of the population of South Asia lived. However, there is an ongoing debate among historians over how much autonomy they really had. They were undoubtedly constrained by British imposed systems of land ownership and taxation. They also could not make independent political treaties or military decisions, nor keep armies.[38] The British 'Residency', a political office within each state, would keep a close eye on all developments, and interventions were regularly made, such as in the setting up of educational systems, the appointment of ministers and debates on succession. If a prince or princess proved particularly troublesome to British interests, he or she was deposed.

A number of these princely or 'native' rulers made visits to Europe, and Queen Victoria had particularly enjoyed receiving them. In 1902, a selection of rulers were chosen by the Viceroy of India, Lord Curzon, for invitations to the coronation, and they began to arrive a few weeks ahead of the planned date. The first to land was the Maharaja of Koch Bihar, the ruler of an area in present-day west Bengal. He and his wife were already great favourites among the upper class in Britain and regarded as 'Hindu reformers' who shared Western sensibilities. Both in their thirties, the Maharaja had been educated in England and was a great fan of tennis, billiards and dancing the waltz, while his wife Maharani Suniti Devi had made her first visit in 1887 as part of the celebrations for Queen Victoria's Golden Jubilee.[39] The Maharani did not

share her husband's keenness for dancing. At a state ball for this celebration, she had rather shyly turned down a request for a dance from the then Prince of Wales, who teased her about her refusal and noted she had 'tiny little feet'.[40] Now the couple were returning to Britain for his coronation, and would stay at a country home named Ditton Park near Slough, and a residence in Lancaster Gate, just north of Hyde Park in central London.

The Maharaja of Jaipur made the most dramatic entrance into Britain, much to the delight of onlookers in Dover. Sixteen years earlier, he had paid for a gateway to be built and exhibited in Britain. Now the man himself and his 400-strong entourage made quite the appearance. Luggage was strewn all over the deck of his vessel, four pastry chefs were working away on board – one of them 'industriously fanning the cakes to keep the dust off' – while other cooks appeared to be mixing curry. The Maharaja had brought around forty-five tons of cargo with him; the crowds watched as baskets of vegetables, sacks of charcoal, half a dozen cooking stoves and 'six enormous copper jars filled with the holy water of the Ganges', alongside a 'gilded and jewelled' idol 'accompanied by a priest', were unloaded from the boat and installed in a special compartment of the train that would take him to London. No one was allowed to touch the jars of holy water apart from the two Hindu men who had travelled with them and carried the vessels using rope and a pole. A special constable was then assigned to stand at the door of the compartment to prevent anyone else touching them.[41]

India was to play a central role in the coronation. As well as the presence of the Indian princes, hundreds of Indian soldiers were to be included in the procession accompanying the King's carriage through the streets of London, in a display similar to that conducted for Queen Victoria's Diamond Jubilee in 1897. A coronation symbolises continuity with the past, and the inclusion of Indian troops would cement the idea of Edward carrying on the Emperorship of India. These men were diverse in faith,

Hindu, Muslim and Sikh, and came from regions across the Indian subcontinent.

By mid-June, more than 1,000 Indian soldiers had arrived at Southampton after a rough journey, the early days of which had left many of them very seasick. Just before their steamer drew into the harbour, they caught a glimpse of Osborne House on the Isle of Wight, where Queen Victoria had spent her final moments.[42] They then made their way to the capital, where they would set up camp in the grounds of Hampton Court Palace, and at Bishops Park close to Fulham Palace. There is no tribute to their presence at either of these places today. In 1902, one newspaper hoped that the arrival of these troops would be beneficial for both Britons and Indians and 'should simulate the loyalty and devotion of both and vividly bring home to them the vital and essential truth that they are both citizens of the same Empire'.[43] At Hampton Court, the soldiers pitched tents with wooden floors and bedding to make them more comfortable, and they were given supplies of milk, mutton and vegetables. A few days into the visit, the men visited the palace itself and its famous maze of hedges. They were also paid a visit by Arthur, the Duke of Connaught, Queen Victoria's second-youngest son and brother of the new King. All the men lined up for inspection at a parade and the Duke of Connaught conversed with many of the officers in Urdu, which he had learned during his time posted in India.[44]

London was now buzzing with visitors and the coronation had been meticulously planned, but just two days before the event, the star of the show was afflicted with illness. Edward had been suffering from pain in his abdomen for a number of days, which at first was presumed to be caused by overindulgence at the many parties he had been attending. As the King then became feverish and a large abscess formed in his swollen abdomen, he was diagnosed with appendicitis, then known as perityphlitis and a very serious condition. Urgent surgery was needed, but the patient was resistant, insisting repeatedly that he had to go to Westminster

Abbey for the coronation. It was only when the surgeon pointed out to him that he would end up going as a corpse that Edward acquiesced.[45] The coronation was postponed and official announcements of the King's serious illness were published in the press.[46]

When the news reached the Indian soldiers, who were attending a reception at Fulham Palace as guests of the Bishop of London, some of the men decided to urgently pray for the King's health. They laid out their prayer mats on the lawn and reportedly spent up to an hour praying devoutly. The Bishop of London delighted in recounting this to a congregation afterwards: '"They raised their hands like this" said the Bishop suiting the action to the word and said "We go to pray!"'[47]

The incident was also admiringly relayed in numerous publications.[48] One newspaper called it a 'striking scene' and included a sketch depicting Muslim soldiers with turbans on their heads, medals on their chests and swords attached to sashes around their waists. Some are standing, others bowing, at different stages in prayer. A handful of onlookers, the men in top hats and the women in white dresses clutching parasols, watch the soldiers in curiosity.[49]

With the coronation delayed, the soldiers were encamped in Fulham for far longer than anticipated and became such a familiar sight that one report declared:

> it is a far cry from the Punjab to Putney ... and yet the Indian troops who have been waiting and watching for that long expected day of coronation have appeared for all the world as though the banks of the Thames and the confines of a ten acre field constituted their natural habitat; one might even imagine that the curious white-faced spectators and not the dusky and handsome soldiers were the unfamiliars of Fulham.[50]

Many of the foreign dignitaries who had arrived for the coronation left to go back home, but the imperial subjects largely remained, waiting for the King's health to improve so that the ceremony

could be held. To break up the 'monotony' of the fields in which
they were encamped, the Indian soldiers were taken on organised
visits to see the sights of London, including the Tower of London
and Parliament.[51] The National Portrait Gallery holds a photograph
of one group of Indian soldiers posing on the terrace of the House
of Commons, where they were snapped by Sir Benjamin Stone,
MP for Birmingham East and a keen photographer, who docu-
mented many visitors to Parliament.

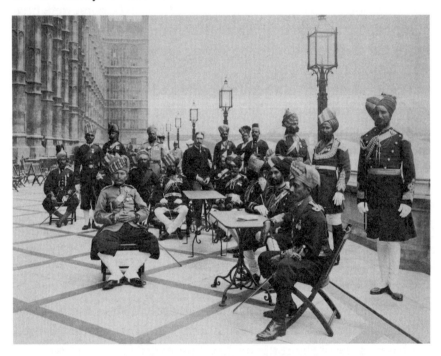

Sir Benjamin Stone MP's photograph of Indian soldiers visiting the
Houses of Parliament in July 1902.

There was also a special trip to the north-west of England. The
soldiers travelled down from London to Southampton, where they
boarded a steamer ship to Liverpool, arriving into the city at 8 p.m.
on a fairly stormy night. The port was so beautifully lit up it
'surpassed the lightning itself'.[52] The Indian men were instructed
to remain on their steamer ship that evening, but so eager were the

Liverpudlians to see them that they climbed into boats to take a peek. These small vessels were 'stuffed with people' and took spectators back and forth until midnight. As one officer put it: 'We went to Liverpool in order to have a view of the city but the most striking feature was that we became the object of the people's curiosity.'[53]

Many of the soldiers had already heard of one particular Liverpudlian. At a special civic reception at St George's Hall, some 500 soldiers stood up and cried out 'Allahu Akbar' ('God is Greatest'), in a mark of respect to him as he walked in to the room.[54] This was Abdullah William Quilliam, a solicitor who had famously converted to Islam after visiting Morocco in 1887 and had set up the Liverpool Muslim Association. By the time the Indian men were visiting the city, Abdullah Quilliam had established a mosque, educational institute and orphanage in Liverpool, and was leading a community of around 600 converts. He had also been granted the Ottoman title of Sheikh-Al Islam (designated lead scholar for a territory) for the British Isles by the Sultan of the Ottoman Empire. So it was no surprise that the Muslim contingent among the Indian troops were enthusiastic about his presence.

The soldiers were also taken for a tour of the Lever factory (the pioneering soap and cleaning company which later merged into the firm we now know as Unilever) in Port Sunlight in the Wirral, and given a box of soap each as a souvenir. Then it was on to Manchester, where they visited the zoological gardens and watched a firework display. Once again, the city's residents were keen to catch a glimpse of them and, eager to outdo their rivals' hospitality, the Mancunians put up boards with the word 'Welcome' written in Persian. (The phrase had already been adopted into Urdu, so would have been used and widely understood by Indians.) Another tour of a factory followed, this time that of a cotton manufacturer, and the soldiers all came away with a coronation towel featuring portraits of the new King and Queen.[55]

But aside from these managed visits and parades, the men were not able to move around as they wished. The fear was that there

were too many 'temptations ... were they allowed to mingle too freely with such a population as that of London'.[56] One such feared temptation was that Indian men might spark up relationships with local women. The Viceroy to India, Lord Curzon, was particularly disapproving of such a prospect, writing to the government as part of planning for the coronation to warn of the 'difficulty' around 'the women aspect':

> ... strange as it may seem English women of the housemaid class, and even higher do offer themselves to these Indian soldiers, attracted by their uniform, enamoured of their physique and with a sort of idea that the warrior is also an Oriental prince.[57]

Curzon also frowned upon the Indian princes being honoured too highly while visiting Britain, particularly those he personally disliked. On a number of occasions, he wrote in frustration at the 'disproportionate compliments' being paid to and the honours being 'squandered' on 'dubious Oriental potentates'. Why, he asked, was every man wearing a 'turban with bad pearls' regarded as royalty in Britain?[58] But the social circles of the British upper class seemed to pay little attention to Curzon's warnings and, while waiting for the coronation, there were parties aplenty for the Indian princes. They were entertained in gardens, at the races and at shooting parties. The Maharani of Koch Bihar made a return visit to Hatfield House in Hertfordshire, where some fifteen years earlier she had been 'lost' in a hedgerow maze along with a small party of other ladies. The whole affair had ended in screaming and a breaking through of the hedges, causing their 'dainty muslin and laced gowns' to be ripped. Upon her return in 1902, she delighted in hearing from her host that she couldn't 'possibly be the lady' who had been lost in the maze, because she seemed too young.[59]

Meanwhile the Maharaja of Jaipur travelled extensively around the country, along with a coterie of cooks and attendants responsible

for transporting Ganges water. On one trip to Thorney Abbey, near Peterborough, where the Maharaja enthusiastically inspected horses, his friend and host Sir Walter Roper Lawrence, the Private Secretary to the Viceroy of India, who was on leave and on a visit home himself, noticed a familiar face: the Maharaja's jeweller. It turned out that the jeweller was required to travel alongside him everywhere he went, so that he would never lose sight of the jewels the Maharaja was wearing.[60] The jeweller had also been tasked with bringing over to Britain a gift for the new King, a rich sword and scabbard studded with 719 diamonds, which remains in the Royal Collection today.[61] The Maharaja of Jaipur was one of the Indian princes Lord Curzon approved of as 'bona fide' and 'old fashioned', perhaps partly because he could be relied upon to write to the British government in approving terms about the Viceroy's policies towards the princely rulers.[62] During his trip to Britain, the Maharaja also paid a visit to Lord Curzon's ancestral home in Derbyshire, Kedleston Hall.

Today, Kedleston Hall is run by the National Trust and hosts a treasure trove of objects from Asia collected by Lord Curzon. Even before he became Viceroy to India, Curzon had travelled extensively. Many of the items he acquired along the way now live in the Victoria and Albert Museum in London, but an incredible selection remain in Derbyshire. Kedleston's Eastern Museum features glass cabinets filled with jewellery, caskets and ornaments from India, China, Nepal, Afghanistan and Central Asia. The items are so numerous it is difficult to pick out only a few for attention. The glint of a gold serving spoon with a Persian inscription and the intricacy of silver filigree amulet boxes catch my eye. Next to a case filled with brass and silver shields, swords and armoury, I observe two older gentlemen arguing over which weapon 'would inflict the most pain', while a poor creature who has already been subject to a great deal of pain lies in the centre of the room. Just as in Powis Castle, a tiger is spread out on the floor, a gnarled face silently growling, the beautiful honey-coloured body patched up

in places. It was apparently shot by Curzon himself in 1903. But where once this creature's skin would have been laid out in pride, now it is an object of shame; a small girl, no older than seven, stares at it in alarm, then in disgust and upset, as she pulls on her mother's hand begging for explanation. Her sentiments are echoed in a wonderful exhibition featuring a film of local schoolchildren responding to the objects in the Eastern Museum. A historian explains the symbolism of the object at the time: 'to dominate the tiger was to dominate India'. A child from Curzon Primary School responds saying she would have liked to ask Lord Curzon why he believed he had 'the right to kill the tiger'.

In 1902, amid the attempts to impress the Indian princes, at least one newspaper felt a sense of inferiority over the ornaments on offer in England, and hoped desperately that the scenery and 'price-less pictures, antique armour and beautiful tapestry and furniture' at Warwick Castle would be sufficiently absorbing for the visitors, as a party of them took lunch there:

> We cannot compare with the Orientals in gorgeous colouring and grandeur, but the scene in which they bore a distinguished part ... might serve to convince them that there are lovely and interesting sights – moving and beautiful pictures – to be seen even in England. It only lacked the sun to light up the Old Courtyard with its historic memories to shine on the grey walls which have defied the blasts and assaults of a thousand years ...[63]

Lord and Lady Warwick had invited guests from around the country to come and meet those from abroad. The Maharani of Koch Bihar, wearing a coif of exquisite white lace on her head was, as ever, the subject of a lot of attention. But it was Sir Baba Khem Singh, a Sikh leader from Punjab, in his robes of bronze, who attracted more interest, with one publication describing him as the most 'picturesque figure of all', and another prominently placing

him in the centre of a sketch showing the guests conversing in a party outside Warwick Castle. Unfortunately, the merriment in the grounds was somewhat ruined by a thunder shower and, as rain pelted down, the entire party was forced inside the castle, where the state apartments became so 'packed with people and it was almost impossible to move from room to room to inspect the pictures and other art treasures'.[64]

The most important party for the Indian dignitaries visiting in 1902 was held at the India Office. The original invitation cards had stated that the new King and Emperor of India would be present, but these had to be hastily adjusted given Edward's health. By now he was out of danger and the coronation had been rescheduled for August, but his place at the India Office would be taken by his eldest son. As with the ball for the Ottoman Sultan thirty-five years earlier, opulence was the theme of the night and, once again, despite protestations in Parliament that it was 'too mean' for India to bear the costs of the party, it was indeed India that would pay.[65] On the night, the court was covered with a canvas painted to represent the Indian skies with stars, accurately placed according to astrological charts, twinkling away thanks to the efforts of a talented electrical engineer. This was much admired by some as adding a touch of 'realism', while others felt it was 'too much of theatre' for a 'sober political function'.[66] Some 3,000 guests filled the space and by midnight it became almost impossible to move, though a pleasant breeze was created with 'great blocks of ice' strategically concealed behind floral arrangements of lilies of the valley, roses and geraniums to help cool the courtyard down.

But the decor of the room was considered less impressive when compared with the adornment on the guests. Newspapers reported how the 'coronets of emeralds and diamonds' sported by the British ladies were outdone by the 'sparkling diamonds' and jewels in the turbans and around the 'necks of Indian princes'.[67] An elaborate ceremony took place as the princes lined up in procession and each of them bowed down or presented a sword to the

King's son, who touched it to signify he had accepted their alle-
giance on behalf of his father. It was dubbed an English style of
'Durbar'. The British had been using this word in India ever since
Victoria had been proclaimed Empress of India to describe ceremo-
nies where Indians could pay loyalty to the British Raj. Now it had
been brought to London. So the Durbar Court received its name.

Ironic, then, that this Indian-inspired chamber with a Persian and
Urdu name should continue to exist at the heart of British foreign
policy, when there is now little interest in Britain in learning
languages of the Orient. At the Foreign Office itself, efforts have
been made to address this for the purposes of diplomacy; the
department's specialist language school was revived in 2013, after
being closed down for cost-cutting reasons six years earlier. But
MPs have suggested British diplomats still have an 'alarming short-
fall' in language skills and the FCO has admitted it still does not
have enough Arabic speakers, with only 30 per cent of 'relevant
officers' speaking the language to sufficient fluency.[68]
 In 1917, Britain set up a specific university to provide language
instruction and specialist knowledge of the various religions,
customs and traditions of Asia and Africa to its colonial officers.
The School of Oriental and African Studies (SOAS) evolved from
its colonial origins into a prestigious international teaching institu-
tion for languages of the Orient, yet since 2016 admissions overall
have fallen by 37 per cent. While the take-up of Arabic has
increased, the university is no longer offering specialist teaching
of many other languages of the Orient, including Bengali and
Punjabi.[69] Certain languages are simply not considered profitable
and the university is no longer willing to subsidise the few who
wish to learn them. The situation is much worse in secondary
schools. Although languages are part of the national curriculum,
some exam boards have dropped provision of languages including
Arabic and Urdu. This contraction is not limited to languages of
the Orient, of course. There is a wider problem with language

teaching. Year after year, extensive research by the British Council has found that schools struggle to make teaching languages financially viable and that students have misconceptions about language learning or believe that, because English is the world's lingua franca, other languages are 'neither useful nor important'.[70] A number of alarms have been raised about Britain's habit of monolingualism and the consequences it has on competitiveness for businesses and diplomatic 'soft power'. It has also been pointed out that 'community languages', including those of the Orient, spoken by Britons of South or West Asian descent, are undervalued and a recent report by Cambridge University called for a cross-governmental strategy to address this problem.[71]

Britain's historical enthusiasm for language learning was tied deeply to colonialism. Knowledge of Arabic, Urdu, Hindi, Persian or Turkish was useful for imperial ends and great efforts were made to teach languages of the Orient as a result. Arguably, some of those expressing consternation about modern diplomats' lack of language skills do so only with concern for what is conventionally and troublingly described as the 'national interest' (usually defined by a small group of corporate bosses, policymakers, diplomats and military figures who hew ideologically towards imperial nostalgia) as separate from the public interest (that of the broad mass of citizens the aforementioned group governs).

But why think only in this utilitarian way? Encouraging the wider teaching and learning of languages of the Orient in Britain, whether in schools or through community programmes, would be culturally important and add layers to our understanding of history, and of different communities living in this country today. The fearmongers who talk of not recognising the country after hearing people speak a language other than English on the train will always exist, but making Britain less monolingual would take the steam out of their sails. If more of us were multilingual, it would become increasingly ridiculous to demonise those speaking in another tongue. The singing of a song in Turkish to impress

the Sultan in 1867 may well have been an act of 'soft power' by
the state, but why not also look to the people of Manchester in
1902 who held up boards to welcome Indian soldiers using a Persian
greeting? Or indeed to Queen Victoria herself, who took pride and
pleasure in learning Urdu and appeared to have a real love for the
language? Britain once enthusiastically sought to learn languages
of the Orient, valued them and frequently borrowed their words.
That cannot be easily divorced from its imperial motives, but we
could adopt the same enthusiasm of those who believed it added
richness to their lives. Our national aversion to understanding the
words, concepts and ideas of other cultures and peoples appears
to be a peculiarly post-imperial phenomenon, and serves to
strengthen perceptions of Britain as a nation struggling to come
to terms with its receding global importance.

Britain is now reliant for its security on the superpower that
succeeded its own imperial global dominance. So deeply has this
relative power imbalance and dependence become ingrained that,
among all the impassioned national debates about sovereignty, none
have centred on the fact that the USA maintains more than ten
active Air Force bases in the UK, in addition to those used by
NATO. Britain's cultural output too, though outsized, has long
been surpassed in volume and influence by that of the USA. For
several decades, successive governments have chosen to relinquish
Britain's competitive advantage in manufacturing, which was
initially established through the seizure of natural resources from
other nations and maintained through the importation of colonial
subjects as labourers.

Commentators and politicians on both the right and left have
skirted around the central challenges of Britain's waning global
influence, and instead have at times exploited it for their own polit-
ical ends. On the right, the electoral popularity of a bunting-and-
borders brand of nationalism leads to the particularly short-sighted
assumption that jingoism – in curricula, national media, political
rhetoric and policy – will restore Britain's pride and prominence.

The country's identity crisis can be solved through suppression and suffocation of any alternative narrative. Uncomfortable realities about race, religion and wars of conquest can be silenced by more loudly and effectively promoting imperial nostalgia, while presenting contrary opinions as extreme and unpatriotic. Britain is still great and the Empire never died. The question of how to recover from a systemic economic collapse caused by over-reliance on the financial services sector is deftly avoided and distracted from by endless 'Tebbit tests'. The phrase was coined after the Conservative politician Norman Tebbit suggested British Asians who support a team other than England at cricket are not sufficiently integrated into Britain. It has since been used to refer to moments when the descendants of immigrants to Britain are required to prove their assimilation or loyalty. In an interview with an American newspaper, Tebbit asked of British Asians: 'Are you still harking back to where you came from or where you are?'[72] This book's answer to his question might be 'where I am was always influenced by where I came from'.

For a time, the left too built its own naive national mythology, though based more on an ahistorical present than the past. Britain is the world's fifth largest economy – or sixth depending on the metric used – and so we can afford to reshape both the state and the nation's role in the world. Corbynism offered a vision of Britain shedding its imperial past and taking on a new role as a peacemaker abroad, while confronting historical and ongoing class and racial struggles at home. It failed to garner public support because a simplistic version of Britain's past remains captivating to many. But at least part of its failure to persuade, despite its overwhelming popularity among younger people, arose from a narrative incoherence. The left's plan to address Britain's identity crisis contained both moralism and materialism, but these were not woven into a compelling, overarching myth that could compete with that of the right.

How then to reshape stale and outdated stories of Britishness? Our collective response, if we are to seriously confront the question

of Britain's role in the world and its accounts to be settled, both with alienated communities at home and dispossessed nations abroad, can draw on the stories of the Durbar Court. The *Pall Mall Gazette*'s astute observation in 1867 that the 'antithesis of East and West is an exclusively European idea' ought to form the bedrock of the UK's position towards the Orient, and inform policy in relation to its own citizens who originate from West and South Asia. So much of our collective confusion about British identity is a consequence of policies driven by obsessive civilisationism – the idea that a pure and unadulterated 'Western' identity or interest ever existed and that it must be preserved or returned to, as well as imposed on others.

Successive British governments have banked on the same hopes that drove *The Times* to desire Sultan Abul Aziz to be 'indoctrinated with Western ideas' in 1867. Multiple media commentators mirrored the desires of the newspaper thereafter, observing the Indian soldiers parading in the coronation of 1902 and wishing the martial display would 'stimulate the loyalty and devotion' of both the British crowds and the Indian men marching. But indoctrination, loyalty and devotion are the demands of ideological republics like France or the United States, not a post-imperial monarchy like the UK. Non-ideological states cannot demand loyalty – there is no single belief to be loyal to – and we should resist attempts to turn Britain into an insular ideological state that demands loyalty to one narrow set of beliefs. We can and should be a multilingual society that recognises its own cultural inheritance as complex.

The Wounded Soldiers

Brighton Pavilion and Brighton Museum, Sussex

BRITAIN'S HISTORIC ADMIRATION for the Orient might be most visible at Brighton Pavilion, though the building's fame was no insurance against far-right social media users' anger when it was used as a backdrop at a Labour Party conference in 2017 and they mistakenly believed it was a mosque.[1] It is unique in style, quite unlike anything in Britain when it was first built, and perhaps even now. On a gusty September day, from a distance, the Pavilion's sand-coloured structure looks as if it might have been superimposed onto a dull sky. From every angle there are domes, towers and minarets, with the effect so giddying that I am unsure where to fix my gaze; perhaps the fat turnip domes with jagged motifs all around them, or the archways decorated with the *pinjara* lattice cage pattern, reminiscent of so many other Orient-inspired or -originated buildings. It is astonishing, surreal and fantastical, yet so much a part of Brighton that on one side of the building, at a bus stop, people are standing impatiently looking down at their phones, without even a second glance at the incredible building beside them.

The design by John Nash is known as Indo-Saracenic, inspired by Mughal, Moorish, Hindu and Tatar architecture for its exterior, and Chinese for its interiors. He was particularly influenced by a series of sketches in a book called *Oriental Scenery*, in which an uncle and nephew team, sponsored by the East India Company, had documented hundreds of landscapes across India over seven years.[2] The Pavilion was completed in 1823, six decades after the mosque structure at Kew had been built, and its scale and impact

were significant. Created as a seaside palace for the Prince Regent, who was famed for his extravagant lifestyle filled with parties, promenading and plenty of drinking, the Royal Pavilion has a colourful history.

But one piece of architecture at the south entrance to the Pavilion estate was not added until 1921. The Indian gate is a dome resting on four pillars, and though the design is simpler and the stone it is built with darker than the main building, it seems so blended into the overall architecture that many a visitor might be deceived into thinking it is part of the original. Yet it is a clue to a lesser known story of the Pavilion, from a time when men from the Orient lived in it. During the First World War the former palace was converted into a war hospital for wounded men from the Indian army, who provided the British with the largest number of troops of anywhere in the Empire. The Pavilion itself marks this history with a permanent display in one of its rooms, yet the stories of these wounded soldiers – how they lived and even died here – is not as well known as it should be.

More than a million Indians fought with the British across Europe, Africa and Asia in the Great War, the first time men of the Indian army had been deployed to Europe. In the autumn of 1914, the first divisions arrived in Marseilles, and they were soon involved in some of the most difficult battles as they bolstered the British troops. The men had been particularly recruited from areas which were considered to have 'martial races' – Punjabis, Pathans, Gurkhas – from countries now known as India, Pakistan and Nepal. Then they were all simply known as 'Indian'. They signed up for prestige, adventure or simply monetary reward, yet, like their British counterparts, many were naive about the reality of war. These men found themselves in a bitter and torturous environment, struggling with unfamiliar weaponry and equipment, while fending off gas attacks and shells raining down on them. The trenches were miserable and the weather that year was particularly treacherous, with heavy rain and snow that left the men battling

in thigh-deep freezing water and mud. Two Gurkhas drowned in their own trenches. Then there was the battle with disease: measles, mumps, influenza; the damp cold caused bronchitis and pneumonia, while unclean drinking water led to outbreaks of dysentery.[3]

With resources stretched at the base hospitals in France, Indian soldiers who had been injured or were sick had to be shipped to Britain. From the port of Southampton, they were initially dispersed to specially created hospitals in the Hampshire villages of Brockenhurst, Netley and New Milton, but these quickly began to overflow. A fire on board a ship docked in Southampton, which was being used as a temporary hospital, made the problem worse.[4] By November 1914, the Lady Hardinge hospital at Brockenhurst in the New Forest was caring for 1,000 wounded soldiers, having been established for only half that number, and many of their patients were now sleeping on the floor.[5] Further arrangements would have to be made, and the task was given to a civil servant who had previously served as Private Secretary to the Viceroy of India, Sir Walter Roper Lawrence, who was now appointed Commissioner for sick and wounded Indian soldiers. Lawrence believed it was important these men were treated in Europe and not sent back to India, partly because he thought 'the spectacle of wounded and sick men in Hospital clothes will have a very depressing effect in India and a very bad effect on recruiting'.[6]

He hoped initially that they could be accommodated in Marseilles, believing this was the 'right place' and that the sunshine there would be better than the 'damp climate of the New Forest' currently on offer to the men. Yet the resources and railways required to transport large numbers of wounded Indian soldiers to Marseilles did not exist. So Lawrence turned instead to Brighton, initially seeking to commandeer hotels, but the local authorities were worried this would have a negative effect on the town's economy. Instead they offered him the use of the pier or the racecourse, which he quite understandably turned down given that both these places lacked a roof. Eventually, after Lawrence

emphasised the 'crying need of the Indians', the Royal Pavilion was suggested instead, and this would become one of three hospitals in Brighton, with a school and a workhouse also converted.[7] It was to be much more than a physical space. Though the Pavilion was no longer in use by the monarch, official publications and briefings to the press suggested that the King had personally given up his palace for use as a hospital for wounded Indian soldiers, thus becoming a tool of propaganda to boost morale and loyalty towards the Emperor of India.[8]

Preparations took place in haste; the furniture was removed and more than 700 beds were installed. The grand banqueting room, music room, south drawing room and saloon were converted into hospital wards. The ornamentation on the walls was covered by a protective wood screen, while the polished floors were covered in linoleum. The building's cut-glass chandeliers, however, were left in place, their dragon and lotus shapes grandly hanging over the patients' beds; warm clothing and an enamel bowl for food and drink were placed on a table by each bedside.[9] An X-ray facility was set up and the Pavilion's kitchen would now serve as an operating theatre, while kitchens to supply food for the wounded men were assembled in huts outdoors. These were divided according to religious dietary requirements – no pork for the Muslims, and no beef for the Hindus who considered the cow to be a sacred animal – and a new slaughterhouse was opened in the county's abattoir to supply the hospital with appropriate meat.[10]

The medical treatment would be led by British doctors and nurses, many of whom had previously worked in India and so had familiarity with local customs as well as the Hindi/Urdu language, and they would be assisted by Indian medical students studying in Britain. These volunteers were organised by the Indian Ambulance Corps, a force assembled at the outbreak of war by Indian students wanting to join the war efforts: their services were soon in demand as the number of wounded grew, and more units of the Corps had to be established by recruiting medical students in Oxford and

Edinburgh. The hospital's facilities would be manned partly by British orderlies from the St John's Ambulance service, but most of the assistant surgeons, nursing orderlies, clerks, cooks and sweepers were of Indian origin and had either volunteered as part of the Ambulance Corps or been brought over from camps in France.[11] Sir Walter Lawrence initially feared that the inclusion of Indian students was a dangerous experiment, and was concerned that they might influence the soldiers with talk of Indian nationalism or criticism of the British government. However, when he later inspected the hospitals, he found himself impressed with their 'zeal and devotion' and declared that these volunteers had a 'splendid spirit'.[12] The students helped ensure signs in Urdu, Hindi and Gurmukhi (Punjabi) were placed around the wards. In advance of the patients arriving, large boxes from the Red Cross containing blankets, wadding and medical supplies began to be piled up outside the buildings assigned as hospitals, including the Pavilion.[13] Brighton was ready.

One month later, in December 1914, the first contingent – some 300 wounded Indian soldiers – headed for Brighton to stay at the Pavilion. On board the Red Cross trains, as they passed through towns en route, some of the men peered out of windows to try and work out what awaited them, and were spotted in their khaki turbans by curious onlookers.[14] Brightonians themselves were excited. The Brighton Herald considered it 'romantic for Brighton to have these Eastern men brought to its Eastern pavilion', adding that Brighton was 'agog to see the warriors from the East'.[15] The arrival of the first group of Indian men led to an impromptu procession from the railway station to the Pavilion, with the crowds cheering loudly as they escorted them into Brighton. Not all arrivals were so ceremonious; sometimes it was the weather that made for a bleak disembarkation, while at other times the patients themselves were so severely injured and in pain that they had to be carried out of the trains on stretchers. Regardless, newspapers made fairly regular reports of these arrivals, with descriptions of

men in muddy uniforms and turbans hobbling in with frostbitten feet swathed in bandages or slightly lifting their shell-shocked faces from the stretchers they were lying on. The appearances soon became such a familiar sight in Brighton that one local paper declared it was 'no more surprising now to hear the varied dialects of Urdu than to hear the dialect of Yorkshire or Somerset' being spoken at the railway station.[16]

Once the patients were inside the hospitals, the entrances were closely guarded by police officers, and locals bemoaned the secrecy operated by military authorities, which meant they had to peer through railings to catch a glimpse of their guests. When a small party of Indian men was spotted in the street, having just come out of a shop, they were followed by overexcited children. On another occasion, having witnessed an Indian soldier playfully pick up a small boy in his arms, a group of mothers began jostling with each other for their babies and children to have a turn being held by the soldiers.[17] Part of the local curiosity must have been encouraged by the photographs in newspapers showing the men in the grounds, against the backdrop of the Pavilion. These were accompanied by detailed reports of how the Pavilion and its patients looked, the living arrangements for the men, how they prayed, played and ate, even specifying what was cooking in the kitchens on a particular day – a lentil and pea soup, and a pilau. One account from a reporter who spoke some Urdu, having spent his childhood in Calcutta, gave details of conversations he had had with the patients; stories of their encounters with Germans, the experience of coming under heavy shelling in the trenches and the injuries they had sustained. The encounter ended with the patients apparently keen for the reporter to share dinner of a curry and some chappatis with them, but it seems a military official decided the interview had gone on long enough and put an end to it.[18] Meanwhile, dignitaries in the region were able to gain access to visit. The Mayor of Hastings was taken for a tour around the hospital, accompanied by a young Indian student who acted as an

interpreter. Though the Mayor was unable to speak Urdu, he was apparently somewhat familiar with Arabic and reportedly spoke a few words to a patient, who delightedly responded by asking if the Mayor himself was a Muslim. Another patient showed him the injuries sustained from five bullets entering his body.[19]

Aside from curiosity, the presence of the patients also prompted wider reflection. A philosophy society in Brighton gave a lecture on the 'The Welding of Western and Eastern thought', urging respect for the religious beliefs of the men from the 'East' and emphasising that they 'contain in essence exactly the same ideals as our own'.[20] Within the grounds of the various hospitals in town, some of the British orderlies began to learn Urdu to chat to the patients.[21] There was immense generosity from around the country too, with gifts including sweets and cigarettes sent to the patients. An Indian Soldiers Fund had been established nationally to help provide coats, warm clothing and comforts for the soldiers. The organisation also made a concerted effort to procure religious books, such as the Qur'an, Bhagwad Ghita and Guru Granth Sahib, and rosaries for the men.[22]

But what was the experience like for the patients themselves? An extraordinary insight into their opinions and feelings can be garnered from letters they attempted to send to friends and family. Any correspondence written by Indian soldiers and those working in the hospitals was subject to a twofold process of censorship. First it was read by their British and Indian officers, the latter of whom were responsible for translating the letters, which were mainly written in Urdu, but also in a variety of other regional languages including Bengali, Gujarati and Gurmukhi. The second layer of censorship was conducted by a specially set up government office based in France, responsible for checking mail sent and received by Indian soldiers in France and wounded patients in hospitals in England.[23] This office sent reports on the censorship together with extracts of the letters to a number of British government departments and thanks to these documents, which are

preserved in the British Library, it is possible to hear from the Indian patients in their own words.

Some of the men were clearly very appreciative of their hosts, and even enjoyed the experience of being in hospital in Britain. One patient wrote to a friend in India praising the kindness of the people of England, adding he regarded it as a 'fairyland' and that he had 'never been so happy in all my life'. A Sikh soldier quoted a Persian couplet inscribed inside the Mughal-era Red Fort in Delhi to describe how he felt about Brighton: 'If there be a paradise on earth it is this.'[24] Did he really feel so strongly, or was this written in the awareness that his letters would be read by officers in the censorship process? The men certainly valued the efforts made for them to enable them to observe religious rituals. At each of the hospitals spaces for worship were assigned: a Gurdwara for the Sikh soldiers in the form of a tent was erected on the lawn outside the Pavilion; a temporary Hindu temple was also organised; and an area was allocated for Muslims to face towards Makkah and pray. During the month of Ramadhan, when Muslim soldiers (who were well enough) fasted, one soldier described the arrangements as 'excellent', while another explained that 'fresh milk and fruits' were made available both in the morning for the pre-dawn meal and in the evening for the breaking of the fast.[25] The weather, however, caused many of the men difficulty, particularly since it was unhelpful for convalescence. As one patient put it:

> In this sinful country, it rains very much and also snows, and many men have been frost bitten. Some of their hands and feet cannot be stretched out, and those who stand up cannot sit again. Some have died like this and some have been killed by bullets.[26]

Another talked of it much more simply: 'It is very cold in this country and it rains a great deal.'[27] Others found some pleasure in snow falling and on one occasion some of those who were fit

enough to move about were spotted making a huge snowball on the eastern lawn of the Pavilion.[28] The men generally occupied themselves with conversation, card games, prayer and even an occasional football match with British hospital staff on the Pavilion lawn, watched on by the wounded in wheelchairs or leaning on their crutches. The patients could enjoy plenty of music: gramophones and Indian records had been donated for their use, and there were frequent visits from organists to the Pavilion's Music Room, where recitals were held. There were organised trips too: a garden party for some of the soldiers was held in Hove by a local philanthropist, and those who were 'sufficiently convalescent' attended a special matinee performance at Brighton's Palace Pier Theatre, featuring a variety of acts such as music from a Sufi order and an adaptation of a poem from the *Mahabharata*.[29]

Yet, despite these amusements, it is clear that many of the men continued to feel the trauma of their ordeals in the trenches, particularly those who were badly injured. Rajawali Khan wrote a letter to a friend still serving in France saying he was 'filled with anxiety' after his leg had been amputated. He found his wooden prosthetic leg 'vile' and could not walk with it, believing that there was now 'nothing but my corpse left' and that he could not face going home with this 'useless' body.[30] The recipient never found out how upset Rajawali Khan was – the letter was censored. So too were the writings of those who attempted to warn friends against signing up for battle. While lying injured in Brighton, Buta Singh wrote to a contemporary posted in Yemen, telling him to 'Make any excuse you can and return home so that one of us can be saved'.[31] Those who attempted to convey the true brutality of battle were also censored. One patient, lying in hospital with a bullet in his arm, tried to explain to his brother how only those with amputations were being spared from being sent back to the trenches and all others were made to return after recovery. To him it felt as if 'A whole world is being killed'. Several men attempted to ask relatives if they were hearing the truth or 'lies' about 'how

the war goes on', or even warned 'what you read in the newspapers
in not true' and then proceeded to explain the true horror them-
selves.[32] Some tried to seek information about the treatment of
other colonial soldiers. Ram Jawan Singh, who was working as a
storekeeper at a Brighton hospital, wrote to a friend in France
asking how the Republic treated Algerians who were fighting on
French soil: How were they kept in the country? Were they allowed
to move freely and go into towns when off duty? What uniforms
were they given and did their pay differ from French soldiers? He
added that he hoped that there would not be a difference in pay,
given that both were 'fighting under the same French flag'. But
Ram Jawan Singh likely never found out the answers to these
questions. The letter was withheld, the topic of pay and treatment
of colonial soldiers would be too close to home for the British
authorities.

Increasingly aware of the censorship process, some soldiers
resorted to using code words in a quest to bypass it. Commonly
used were 'black pepper' to represent Indian troops and 'red pepper'
meaning British soldiers. A patient in Brighton wrote to his brother
at home that 'the black pepper is finished, now the red pepper is
being used' adding 'the black pepper is very pungent and the red
pepper is not so strong'. Unfortunately for him, these particular
code words were now so commonly used that the censor was not
fooled.[33]

There were frustrations too about the movements of the Indian
men in Britain being restricted. This applied not just to the patients,
but also to the Indian students who had volunteered to work in
the hospitals. As one patient at the converted workhouse in
Brighton known as the Kitchener hospital explained in a letter to
a friend: 'We are under strict observation and control in going out
of our compound to visit the town. We are allowed only on passes
within a certain specified and limited time.'[34]

The authorities had decided to impose 'special measures' to limit
contact between the Indian men and the civilian population. This

caused consternation, not just for the Indian men, but also for the population of Brighton, with both official military correspondence and reports in newspapers suggesting that the public were left feeling 'aggrieved' at not being able to visit the patients in hospitals. In the early days of the Indian troops' arrival, some of the women in the town had been particularly annoyed at not being allowed to serve as nurses – they had been hoping that enrolling in an 'ambulance class' would allow them to do so.[35]

It was interactions with women that were the particular reason for the special measures, with a fear expressed that 'scandals' might arise should the Indian men come into contact with the kinds of Englishwomen who displayed 'perverted behaviour'. The 'lessening' of this 'evil' was regarded as paramount. To provide reassurance, the Chief Constable of Brighton informed Sir Walter Lawrence that Brightonians were pleased at having the 'Indian soldiers in their midst' and that 'not a single unpleasant incident of any kind' had occurred, nor had any complaint been made. Lawrence in turn wrote to the Viceroy of India assuring him that, 'in spite of great temptations', the patients had 'behaved like gentlemen' when allowed out for exercise. However, he was concerned about the Indian personnel of the hospitals, who could not be so easily locked up inside. But he added that there was no need to worry because 'we have a very efficient plain clothes police system at Brighton', noting that if any rumours of improper behaviour had been reaching India, it was because:

> ... there is so much gossip and scandal in England at present and there is so much jealousy on the part of certain people that unkind things have been said regarding the Indians, which I can assure you are untrue.[36]

The censors were also conscious of any letters which included references to relationships with white women. Among those flagged up in the censors' report is that of an Indian soldier who

wrote to a friend in Urdu with a translation of phrases he had been learning in French, including: 'Will you come with me?', 'Where is your home?' and 'I love you'.[37] Of course, it was not the first time the fear of Indian soldiers striking up relationships with local women while in Britain had arisen. Similar concerns had been expressed during the coronation of 1902 and the subsequent coronation of George V in 1911. The zeal with which letters were censored over this issue in 1915 was merely the latest manifestation.

While Brighton Pavilion became a home for sick Indians during the First World War, a century earlier, an Indian man had been responsible for healing sick Britons in the very same place. Clues to his story lie just across the road from the Pavilion, inside Brighton Museum.

<p style="text-align:center">*</p>

Deen Mohammed thrived in Brighton.[38] In his early nineteenth-century portrait, he wears chains of gold around his neck and rings on the smallest fingers of both his hands; the two on his left are gold bands topped with precious stones, one ruby red, the other sparkling like a diamond. His right hand, adorned with a ring featuring a large clear oval stone, clutches a pair of expensive-looking ivory-coloured gloves. He is dressed in the European style, but the warm tones of his skin and darkness of his eyes are unusual for the setting. His jet-black hair matches his coat and the curly locks are still full around the sides but recede from the front of his brow. He sits on a chair of green and gold, and the painting conveys an air of distinction about this gentleman, which feels appropriate given his remarkable life and entrepreneurial skill.

Born in Patna in northern India in the year 1759, Deen Mohammed began working for the East India Company army at the age of eleven and rose through the ranks thanks to an Anglo-Irish officer who became his patron. Deen Mohammed was one

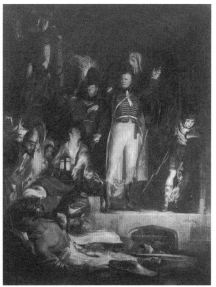

General Sir David Baird discovers the body of Tipu Sultan. Sir David Wilkie's depiction of the scene was commissioned by General Baird's wife, perhaps to emphasise her husband's role in the defeat of Tipu, and conveys both the triumph of the British forces and the anguish of Tipu's companions.

The Huma bird from the canopy of Tipu Sultan's throne is made of gold and encrusted with diamonds, emeralds, pearls and rubies. The East India Company presented it to George III and it remains in the Royal Collection today.

Tipu Sultan's lavishly decorated, chintz cotton tent would likely have been used for official receptions in the Mysore kingdom; at Powis Castle in Wales, where it now resides, it was used for garden parties.

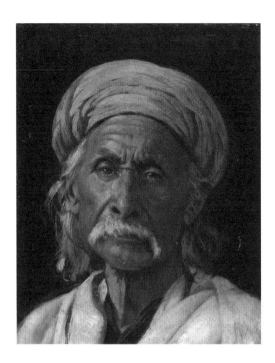

Rudolf Swoboda's portraits capture some of the artisans from Agra prison who were part of a live display at the 1886 Indian and Colonial Exhibition in London. Bukshiram the potter was believed to be more than one hundred years old when he met Queen Victoria, who reportedly expressed concern for his welfare, while nine-year-old Ramlal was a carpet weaver.

Queen Victoria honours Sultan Abdul Aziz, the first Ottoman leader to visit Britain, on board the royal yacht. The ceremony, which took place off the coast of Portsmouth, had to contend with heavy rain; George Housman Thomas's watercolour, however, suggests sunnier skies.

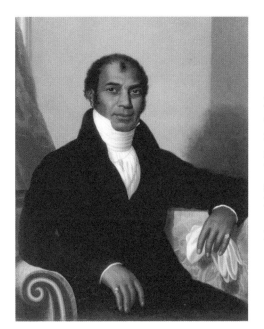

Deen Mohammed lived an extraordinary life, opening the first Indian restaurant in Britain in 1810, and running a famous bathhouse in Brighton which served rich and notable clients. He also introduced the word 'shampooing' into the English language.

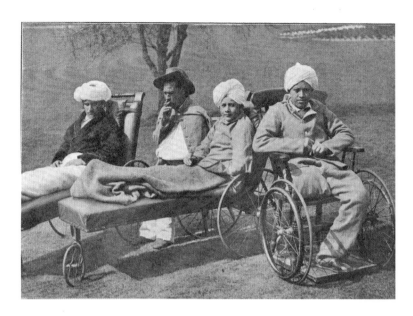

Wounded Gurkha soldiers convalesce in the grounds of Brighton's Royal Pavilion in 1915. Two appear to be young boys: they may be sixteen-year-old Pim, who lost his left arm and fractured his legs, and eighteen-year-old Bal, who lost his leg. There are accounts of both meeting King George V and Queen Mary.

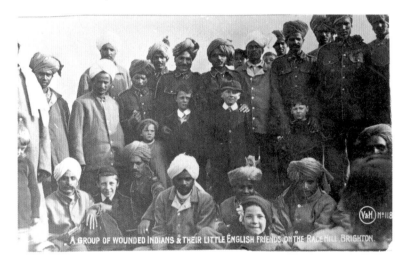

Brightonians were curious about the visiting wounded soldiers from the Indian subcontinent. Newspapers reported that children would follow the men through the town in excitement, and even mothers apparently jostled each other so that their child could have a turn at being held. This image, like many others of the patients, was printed as a postcard and circulated to boost wartime morale.

of the newly recruited sepoys (from the Persian term *sipahi* meaning infantry) – Indian soldiers who would serve under British command – and he travelled extensively across northern India with the Company's army. But then, aged twenty-five, Deen Mohammed decided to create a new life for himself; he resigned from the army and emigrated to colonial Ireland. This was no mean feat, but Deen Mohammed had a patron and so, unlike other Indians who may have been in Ireland as servants or sailors, he was able to move in somewhat elite circles. In Cork, he married a woman from an upper-class Protestant family, began studying literature and eventually published a travelogue of his life story and adventures in India. This was composed as a series of letters addressed 'Dear Sir' to an unnamed friend. The letters paint scenes of life in Indian cities and countryside, with detailed descriptions of landscapes, explanations on Muslim and Hindu customs and even an outline of religious beliefs, in an attempt to bust stereotypes held by his Western audience. *The Travels of Dean Mahomet* is an extraordinary piece of work, documenting a country changing under the East India Company, and it provides a rare example of an Indian telling his own story to a European audience, in the European style. It is also thought to be 'the first book ever written and published by an Indian in English'.[39]

Twenty years after arriving in Ireland, Deen Mohammed and his family moved to London, drawn by the opportunities the city could offer. Initially he worked for a Scottish nobleman who ran a Turkish bath at his London home, but Deen Mohammed then opened up his own Oriental coffeehouse. At this time, the city had a long tradition of coffeehouses, with the craze for the 'Turkish drink' having been established more than a century ago by those who had come into contact with the Ottoman Empire. But Deen Mohammed's institution which opened in 1810, the Hindoostane Coffee House (also known as the Hindostanee Dinner and Hooka Smoking Club), would effectively become the first Indian restaurant in the British isles. It offered dishes 'dressed with curry powder, rice, cayenne and

the best spices of Arabia', which could be 'served up at the shortest notice'. The rooms were fitted with furniture made of bamboo canes, and with ornaments and pictures from China and elsewhere in Asia decorating the walls, some depicting landscape views of India, others groups of people or traditional sports. There was also a smoking room where diners could smoke tobacco blended with Oriental herbs through water pipes known as hookah (also often known as shisha or nargileh). The aim was to attract an elite clientele, particularly those Britons who had travelled or lived in India. Truly ahead of his time, Deen Mohammed also offered a home delivery service, with a newspaper advert promising punctual dinner deliveries and even a service which could set up a hookah for those gentlemen who wished to smoke at home. In addition to all this, the restaurant sold Indian pickles, preserves, betel nuts and 'the real curry powder'.[40] In 2018, a rare eighteenth-century cookery book featuring a handwritten menu from the Hindostanee Dinner and Hooka Smoking Club was discovered and sold at an auction by a London antiquarian bookseller. It listed twenty-five dishes, including lobster curry and pineapple pilau.[41]

All this was an astonishing offering, but perhaps too ambitious. Deen Mohammed's institution struggled to compete with established London coffeehouses and could not tempt away their regulars. Moreover, although many had already developed a taste for dishes from India, the wealthy East India Company officials and merchants usually had private kitchens in their London homes, complete with Indian servants who could cook up cuisine from the East.[42] The venture lasted only a year and Deen Mohammed went bankrupt.

Now aged fifty-five, Deen Mohammed moved to a new location and once again reinvented himself, this time in Brighton. Already well established as a health resort, in the era of George IV the town had become more popular and fashionable than ever and was growing fast. There was also an appetite for the Orient, the Pavilion having been constructed with Indian and Oriental themes. This

provided Deen Mohammed with an opportunity. He set up a bath-house and claimed that, as a 'native' of India, he had specialist skills from the Orient, unlike rival bathhouse owners.[43] He and his wife would offer a type of Turkish bath named an 'Indian Vapour Bath', using medicinal herbs as part of the more conventional practice of steam bathing, and combine it with 'Shampooing', a massage using Indian oils. His adverts pledged that these bath rituals would help alleviate 'any disease to which the human frame is liable' and were 'sanctioned by the first medical men in the United Kingdom'.

The bathhouse owner now also invented a new occupational title for himself – Shampooing Surgeon – and gave himself the honorific 'Sheikh'; henceforth he would be known as Sake (Sheikh) Deen Mohammed. He soon built up a clientele base and his bath-house, complete with paintings of Indian landscapes, musicians and mausoleums on the walls, became 'the epitome of fashion in Brighton for nearly two decades'.[44] With his fame growing, Deen Mohammed now wrote a new publication: *Shampooing; or benefits resulting from the use of Indian medicated vapour bath as introduced into this country by S D Mahomed, a native of India.* In it he explained how he previously had to struggle against 'doubts and objections', despite the 'indisputable evidence' he had provided, and that the 'virtues' of his bath practices were 'now well known and estab-lished'.[45] Detailed testimonials from cured clients were included, with claims that his bathhouse had treated their asthma, palsy, piles, gout, rheumatism and even paralysis. The Shampooing Surgeon was also at pains to point out these techniques could not be practised by anyone, and that 'I have my imitators, but the public must decide'. They clearly decided in favour of him and three editions of the book were published, each time including more testimonials.

But running a bathhouse was not without difficulty. On one occa-sion an employee at the baths accidentally fell into a twenty-foot-deep tank of water and almost drowned. Deen Mohammed was praised in the local paper for showing 'great presence of mind', by quickly

turning off the water valve and then plunging into the water himself to keep the labourer's head above the water, until it was sufficiently lowered for them to stand.[46] In the early years of establishing his baths, there were also two horrific incidents involving customers. One of Deen Mohammed's workers snapped a bone close to a rheumatic patient's shoulder, causing further damage to it and he eventually had to have his arm amputated; while another client, an elderly gentleman, died while undergoing a bath, perhaps because of the shock of the water pressure. In this case, however, the coroner decided that the cause was 'death by the visitation of God'.[47]

Deen Mohammed was so successful that he even secured royal patronage. He was appointed as 'personal Shampooing Surgeon' to the King, firstly under George IV and then William IV after him, and became a regular visitor to the Pavilion. At court assemblies and the Brighton races, he presented himself wearing Mughal-style dress, which added to his notoriety.[48] There were clients from European nobility too. Displayed close to his portrait in Brighton Museum is a shiny silver cup and saucer, decorated ornately around the sides, with the cup's lid featuring the delicate form of a curled-up swan. This was a gift from Princess Poniatowsky of Poland, who testified that she had been 'completely cured' of the stabbing facial nerve pain and rheumatism she had been suffering with, thanks to Deen Mohammed's treatment and oils.[49]

In his later years, however, Deen Mohammed faced fierce competition and his bathhouse increasingly began to be seen as a curiosity in comparison to the latest trends of Brighton. After his death, one of his sons continued to operate a bathhouse, but failed to receive the same fame and accolades. Still, the word shampooing continued to live on in the English language to denote hair washing. In Brighton, a blue plaque marks the site of Mahomed's Baths, while Deen Mohammed is buried alongside his wife Jane in St Nicholas' churchyard in the town. Today the graveyard provides a moment of stillness away from the frenzy of Brighton. Around the side of

the church, tucked away in a locked area, a weathered tombstone, grey but turning smoky-pink in places, is inscribed: 'To the memory of Sake Deen Mahomed of Patna Hindoostan aged 101 years.'[50] Deen Mohammed died in 1851, shortly after Queen Victoria closed down the Pavilion as a royal palace, no longer favouring the town as monarchs had done previously. It was almost as if the fates of the Shampooing Surgeon and the Orient-inspired palace were inter-twined.

More than six decades after Deen Mohammed's death, the town of Brighton and the Pavilion itself had new Indian residents, but did they ever hear about the town's previously famous inhab-itant? In December 1914, as buildings in the town began to be assigned as hospitals for the Indian men, one local newspaper reminded readers about Deen Mohammed, with a short report on his living to a ripe old age, his founding of the baths and his burial site.[51] But it is unclear whether this report reached the patients of the hospitals or, indeed, what they would have made of Deen Mohammed.

<center>★</center>

The patients in Brighton during the First World War soon became famous themselves. Images of them inside the Pavilion hospital, taken by a specially commissioned local photographer, were turned into postcards. These were carefully stage-managed – there was no suffering on display and the message was that of fortitude. Some showed the patients inside the hospital wards: a row of men in white turbans, sitting upright while tucked into bed covers, some arms in slings, others folded, all of them looking sombrely straight ahead. The contrast between the hospital paraphernalia installed for them and the ornate surroundings never more apparent. Others were group portraits in the grounds of the Pavilion, with the convalescing men categorised according to ethnicity or religion,

labelled as 'Gurkhas', 'Sikhs' or 'Dogras'. In each of these photographs, even the men who need crutches as aids somehow look like they are standing tall.

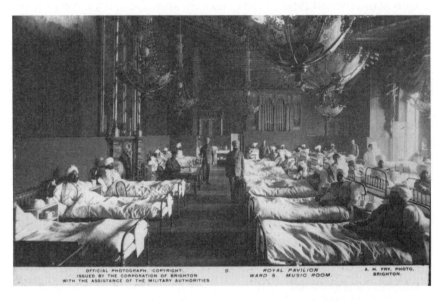

OFFICIAL PHOTOGRAPH. COPYRIGHT. 9 ROYAL PAVILION A. H. FRY, PHOTO,
ISSUED BY THE CORPORATION OF BRIGHTON WARD 5 MUSIC ROOM. BRIGHTON.
WITH THE ASSISTANCE OF THE MILITARY AUTHORITIES

Patients pose for a photograph (*c.* 1915) in the Royal Pavilion's Music Room, which had been turned into a hospital ward. A female nurse can be seen attending to one of them.

An official guide to the Indian Military Hospital at the Royal Pavilion was produced in 1915 and it included a number of these photographs. The author gave a lecture on the subject for Brightonians, furnishing them with details not just on the history of the Pavilion, but also the activities of its current occupants.[52] Yet the intended audience for this publication was not really in Brighton; it was printed in three languages – English, Gurmukhi and Urdu – to serve as a useful tool of propaganda in India, where it was distributed. A copy was given to patients when they left the hospital too. The guide outlined a short history of the Pavilion, then provided details on how the hospital was being run. There was an emphasis on the way in which religious and caste customs were being respected,

and on how much effort was being made for the patients, such as details on the catering which outlined how daal and ghee (clarified butter) were especially brought into the Pavilion. In addition to this, it gave the impression that the Indians were now living in an active royal residence, despite the fact the Pavilion had long been given up by the royal family. It falsely claimed the building had been transformed into a hospital for Indian patients 'at the suggestion of His Majesty King George', as well as providing a detailed account of the various visits made by the King to the Pavilion.[53]

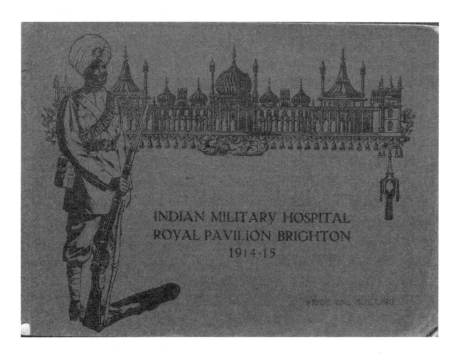

An official guidebook from 1915, published in three languages – English, Gurmukhi and Urdu – and distributed in India.

George V and his wife Queen Mary made at least two visits to see the wounded Indian soldiers in Brighton. Among the patients they met was a man who had lost his eyesight after being hit by shrapnel from a shell, another who was unable to speak after his jaw had

been shattered and his tongue blown away, and there were two young Gurkha brothers who had both been wounded by the same shell: sixteen-year-old Pim lost his left arm and had his legs badly fractured, while eighteen-year-old Bal lost his leg. Stories and photographs of the visits were published extensively in newspapers around the country, and a cinematographer was commissioned to film the visit so that it could be shown in India. These reports depicted the patients cheering their royal guests, explained that the King, dressed in his khaki uniform, had spoken to many of the patients in Urdu and said that the Queen was 'deeply moved', particularly by young Pim, who was photographed lying in bed, a flower given to him by the Queen propped up on his bedsheet. There was also a story about how amused the royal pair were when one patient complained that a fellow soldier had stolen a bullet which had been extracted from his ankle. Another detailed how the King and Queen watched at a respectful distance as some of the patients took off their shoes and entered a tent erected on the lawn and began praying; the sound of 'chanting' was reported to 'fill the air', although it is not clear whether these were Hindus, Sikhs or Muslims at worship.[54]

Unsurprisingly, neither official propaganda nor newspapers reporting on the King's visits made mention of an incident which told a less happy story. A well-known soldier who had received a decoration made a personal request to the King that wounded men should not be sent back to the trenches. The conversation was mentioned in a letter written by one of the patients and picked up in the censors' report, but it is not known if and how George V replied to this request.[55] It was certainly not the only time such sentiments were expressed; an Indian patient lying injured in a hospital in a Hampshire village wrote a moving letter insisting that 'no one except the King' should open it. He complained about the treatment the patients were receiving, claiming they had not been fed well and, most importantly, pointing out that men who were

in hospitals wounded were having to return to the trenches 'three or four times'.[56] Another convalescent wrote to a fellow soldier in India saying:

> Everyman who recovers goes straight to the trenches. If a man is worthless they send him to India. Even if a man has only one finger on his left hand he goes to the firing line. The truth is we are all to be killed ...[57]

The authorities were certainly aware of these complaints and did their best to suppress them from being circulated. An Indian medical student serving in the Brighton Pavilion hospital was removed after he was heard telling patients they should not be sent back.[58]

The man who had made the request directly to the King had become famous for being awarded the Victoria Cross. Mir Dast, in his early forties, came from a region now known as Khyber Pakhtunkhwa in Pakistan, then of course a part of British India. He had been among a group of men hit by a surprise chlorine gas attack at Ypres. They had no gas masks and desperately resorted to dipping the ends of their turbans into chlorides of lime and tying them over their mouths, which failed to give them much protection. In these horrific circumstances, Mir Dast showed immense courage; he was one of the few who not only held their ground, but also managed to rally others and lead them to safety, amid the cloud of gas and incoming heavy machine-gun fire. He then repeatedly risked his life carrying wounded British and Indian officers to safety and managed to save eight men.[59] Mir Dast was wounded twice in his left hand, leaving two of his fingers power-less, and from the Brighton Pavilion hospital he wrote a letter explaining how he was still suffering the impact of the gas attack, saying, 'The Victoria Cross is a very fine thing but this gas gives me no rest.'[60]

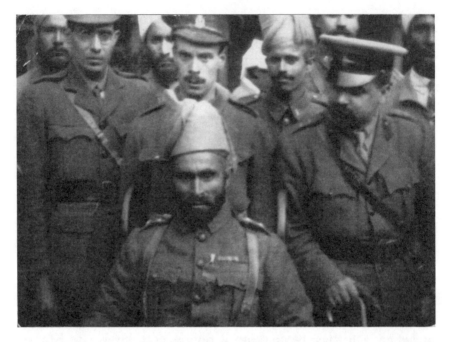

Subedar Mir Dast in his wheelchair at the Pavilion after receiving the
Victoria Cross in 1915.

The story of Mir Dast's bravery and the subsequent awarding of
the Victoria Cross soon hit the headlines. The King personally
awarded him the medal and, although Mir Dast was so wounded
he had to use a wheelchair, he insisted on standing up to receive
it from the monarch. All of this was documented in photographs
and the film made to mark the King's visit. Mir Dast became the
perfect hero for propaganda purposes and his face was printed on
cigarette packs and postcards. But in a twist of fate, his own brother
became the perfect wartime villain.

Mir Dast's brother Mir Mast had also been on the frontline in
France, but in the spring of 1915, he and a group of up to twenty-
four other Indian soldiers defected to the German side. Rumours
soon circulated that Mir Mast had been awarded the Iron Cross by
the Kaiser. Why did he and others desert the British? They could
just have been seeking escape from the hellish conditions of the

trenches in the hope that the enemy might have something better to offer. But they may have also have been influenced by their religious beliefs. The Ottoman Empire was on the side of Germany and it had issued a proclamation calling on Muslims to fight against Britain, France and Russia. Clearly, this did not change the views of many, given the millions of Muslims who fought for both the British and the French. But there was concern about maintaining the loyalty of Indian Muslim soldiers, especially as German propaganda targeted parts of Africa and South Asia, publishing material in different languages and printing photographs of dead Indian soldiers, while presenting the Germans as an anti-colonial force who were fighting the British, French and Russian empires.[61] Later in the war, when Indian soldiers were deployed to West Asia, some refused to fight near holy sites in modern-day Iraq, while a whole regiment in Basra collectively vowed not to fight against other Muslims, leading to more than 400 of them being arrested and punished. Mir Mast himself reportedly went to Istanbul and then to Kabul on a mission with Germans and Turks to encourage anti-colonial uprisings against the British.[62] In light of this, it is understandable that Mir Dast's story of courage in support of Britain was so heavily promoted by British authorities.

Fears around maintaining the loyalty of the Indian soldiers and managing news from the front, defection or otherwise, were not the only challenging matters facing the authorities. There was some controversy around the staffing of hospitals for the wounded Indians too. In May 1915, the *Daily Mail* newspaper published a photograph of a white female nurse standing behind a wounded Indian in a Brighton hospital. The picture was not intended to stir trouble; it was a posed scene introducing the first Indian man to receive the Victoria Cross medal, Khodadad Khan, and there was no negative reaction from the British public. However, a complaint was made to the War Office from the upper echelons of the British army and, two months later, an order was issued for all female staff to be withdrawn from hospitals treating Indian patients. The

presence of women in these hospitals had been the subject of contention early on in the war; there had been a debate among officials, with some strongly believing female nurses had no place in these buildings and others advocating that they could be 'advantageous'.[63] A compromise had been reached; hospitals would be able to draw on the services of women, but these nurses would be tasked with sanitation of the ward and cleanliness, rather than dressing the wounds of the Indian men. It had been agreed that this could take place with 'efficiency' and 'without scandal.'

When the new order to remove women from the hospitals was issued in June 1915, it was largely obeyed, and female nurses were removed from Brighton hospitals. But there was some pushback from a hospital which was run by a charitable institution, rather than directly controlled by the War Office. At the Lady Hardinge hospital in Brockenhurst, twenty women were employed as matrons and nurses; they had been especially selected because of their experience in India and knowledge of some Urdu. Those in charge of this hospital told the War Office the edict against female nurses was a matter of 'surprise and regret' and insisted 'no irregularity of any kind' had occurred at Brockenhurst. They pointed out that a positive inspection of the hospital had been undertaken by Sir Walter Lawrence, and that the nurses had already been contracted, even adding that it was difficult to see how a hospital could be run without trained nurses. Eventually, their arrangements were left undisturbed, while women were removed from all the other institutions.

The pressure of the restrictions placed on the Indian men, both staff and patients, to prevent any interactions with women outside the hospitals, boiled over in a few cases. Some arrangements appeared to have been stricter than others, depending on the policy of the hospital and the seniority of the personnel. At the Kitchener hospital in Brighton, those of officer rank were allowed out unaccompanied without a pass during the day; the rest, nearly 600 in number, were 'kept at all times in the hospital area' except for

when organised groups were taken out for a routine march or for a drive in a motor ambulance for an hour.[64] The walls of the building were surrounded by barbed wire and guarded by military police. This was also the case at a convalescent home in New Milton in Hampshire, as one Indian man employed as a storekeeper wrote to a friend in Calcutta:

> We Indians are treated like prisoners, on all sides there is barbed wire and a sentry stands at each door who prevents us from going out ... if you ask me the truth, I can say I have never experienced such hardship in all my life. True we are well fed and are given plenty of clothing, but the essential thing – freedom – is denied.[65]

In Brighton, one Indian man working as an assistant surgeon decided to take serious action in protest at these restrictions, apparently attempting to shoot the commanding officer of the Kitchener hospital. He was court-martialled and imprisoned for seven years. Official documents suggest this was the only serious incident that took place, but a letter written by a patient at the Pavilion hospital describes another altercation between a British orderly and an Indian soldier. It claims that the British man hit the soldier until he was bleeding, and when the matter was reported to a commanding British officer, the officer claimed he could not 'say anything to a white man on account of a sepoy'. The writer of the letter, who was in hospital in Brighton for the second time, uses the alleged incident to reflect on the status of Indian soldiers and comes to a sad conclusion:

> ... we have crossed the seven seas and left our homes and our dear ones and our parents and for the honour of such an unjust and false promising King we have sacrificed our lives and now this is the honour that we get in his council. No doubt before them we are regarded as inarticulate animals.[66]

Unsurprisingly, the text was censored, and a note adds that the 'writer seems to have suppressed his name on purpose, but his identity should not be difficult to discover'. An additional report then identifies him as Lance Malik Abdul Haq of 57th Rifles, and claims he had a 'bullet in his brain and two or three operations have been performed to get this out ... so it might perhaps be best to take no notice of the indiscretion of his earlier communication'. Interestingly, though this report of a serious wound to the brain may be an attempt to discredit the writer, no denial of the actual incident taking place is made.

Regardless of his head injury, perhaps Lance Malik Abdul Haq had a point about the lack of respect. As much as propaganda was needed to extol the bravery of the Indian soldiers, there was at the same time a concerted effort to 'downplay the contribution of colonial soldiers'. Senior British officials did not want to give the impression that Indians were doing most of the fighting, partly because of the impact it would have on recruitment in India. A planned book detailing 'gallant deeds performed by Indian soldiers', due to be published in English and Urdu, was declared by the India Office to be undesirable. Instead it suggested a book of 'brave deeds done by British and Indian troops in the proportion of about 3 to 1 would do no harm'.[67]

There was also some concern expressed about how Indian soldiers would be treated if they died while in hospital in Britain. The bodies of wounded soldiers who passed away were put in separate mortuaries according to their religious beliefs. Hindus and Sikhs were mainly driven in a motor hearse to a spot on the South Downs, near Patcham, four miles away from Brighton. Here the body of the deceased would be carried by contemporaries of the same caste on a bier, and placed on to an open-air cremation slab. A funeral pyre would then be built and the ashes were thrown into the sea nearby.[68] Authorities had granted special permission for these open-air cremations as they were not usually allowed. A total of fifty-three men were cremated here and other cremations

also took place in the New Forest area for those men who died in hospitals there.

For deceased Muslim soldiers, burials were required. These were carried out in Surrey, around fifty miles away from Brighton. One soldier described the arrangements for a contemporary who had died in the Pavilion hospital:

A fine coffin was provided on which his name and age were engraved. The inside was lined with silk cloth and cushions of silk ... he was buried in a Muslim cemetery near London with great honour and dignity.[69]

But not everyone described the process in such a praiseworthy manner and in fact there were several problems. First of all, the motor hearse taking the deceased to the cemetery in Surrey regularly broke down along the way. Then there were more serious issues. A decision had been made to send the Muslim dead to Woking in Surrey, the site of the Shah Jahan Mosque. Built in 1889, among its best-known worshippers in the Victorian era was Queen Victoria's *Munshi*, Abdul Karim. Now it had become a hub for Muslims in Britain, and a place where dignitaries would often visit. During the First World War, the Imam of the mosque, *Maulvi* Sadr-ud-din, was responsible for overseeing the funerals of Muslim soldiers. In August 1915, he complained to the government about the way in which 'dead heroes' were being treated, with a number of grievances. He explained bodies were being sent to him 'bearing the wrong names', arriving at 'any hour of the day or night without any previous notice', and that he was having to bury them in a 'marshy piece of unfenced ground over which people and dogs stray'. The *Maulvi* had asked the government to provide a gravedigger, a caretaker and a place where bodies could be left for the night, as well as 'a gateway in Eastern style' – however inexpensive – as a memorial to the fallen Indian soldiers. But he found his requests had been ignored and that the burial ground had been left in a 'disgraceful state'. Faced with

this problem, the *Maulvi* paid for the burial of twenty-five soldiers himself in the nearby Brookwood graveyard. He also put off comrades of the dead from visiting, so that they would not see the upsetting situation themselves. In his complaint he added a pointed warning, saying the impression would be left that the Indian dead were not being shown respect, and that this would have a serious effect, felt both in the trenches and in India itself.[70]

The complaint caused quite a stir. In internal correspondence among officials, the *Maulvi* was described as an 'exceedingly difficult person' and 'an acrimonious character'. The neglect of the cemetery was blamed on him complaining to the wrong departments and it was suggested that he may simply be 'out for mischief'. Officials wondered if he could be dispensed with; could a small burial ground be found near Patcham, where the cremations took place, instead? But then it was pointed out the *Maulvi* was performing these funerals without payment and burying the soldiers out of his own piety. More importantly, conversations with Muslim patients at the hospitals suggested that the manner in which he conducted these funerals was giving 'great satisfaction', and it might in fact prove impossible to dispense with him or make other arrangements. When he visited Woking himself, Sir Walter Lawrence also found some of the complaints were well founded. So instead, it was decided, a charm offensive would be deployed to placate the *Maulvi*; he would be provided with the services of a gravedigger, refunded his expenses and two convalescent Muslim soldiers would be deployed as caretakers to assist in funerals and facilitate visitors. After the war, in the 1920s, there were problems with the burial grounds again. The graveyard was found neglected and complaints were made that headstones were not facing towards Makkah as Islamic burial practice dictated. The Imperial War Graves Commission was concerned that it was unclear who exactly was responsible for the upkeep of the area. While the local authorities were keen to make use of common land surrounding it, the India Office was left feeling 'anxious about Muslim sensibilities' because of this neglect.[71]

★

By early 1916, Indian soldiers were largely deployed away from Europe, sent to Egypt or the area known then as Mesopotamia – now Iraq, Kuwait and parts of Syria. As a result, those who were sick would no longer be sent to Britain, and all the hospitals including the Brighton Pavilion were closed down. But the politics over how they should be recognised – or indeed acknowledging that recognition was due at all – continued in Britain, and does to this day. In the immediate years after the war, the former commander of the Indian Corps, General Sir James Wilcocks, fearing the role of Indian soldiers would be entirely forgotten, wrote a book describing events in the trenches. He believed it was his 'sacred duty to place on record the loyalty of the King's soldiers from Hindustan', and published a poem in the voice of a fictional soldier called 'Hurnam Singh', reminiscing over the sacrifices made in France.[72] He also wrote that the pay given to Indian officers 'was almost an insult', and described extensively how he believed they had not been treated with the respect and honour they deserved. Wilcocks himself had resigned in 1915, though the exact reason for his resignation was unclear.

A number of memorials were erected in Britain in memory of the wounded Indian soldiers. At the cremation site in Patcham, a monument constructed in Sicilian marble was built and officially unveiled in 1921. As I attempt to reach it on a freezing winter day, my journey involves trekking up a muddy farm track, alongside fields of nonchalant cows and sheep, a derelict farm building, and at times a powerful stench of manure, which almost makes me vomit. Once past that, bitter gusts of wind bluster away at anyone heading up the path, and for a while nothing but mud, grass and the occasional dog accompanied by its walker are visible. But it is worth it. Slowly the top of the memorial comes into view. Known as the Chattri ('umbrella' in Hindi), it is a tall pavilion-like structure made of smooth marble, octagonal at its bottom, with eight pillars

supporting a dome. Here fierce flames on slabs burnt, taking with them the bodies of the Hindu and Sikh soldiers who died while in Sussex. On one side, an inscription reads:

> To the memory of all the Indian soldiers who gave their lives in the service of their King Emperor in the Great War, this monument erected on the site of the funeral pyre where the Hindus and Sikhs who died in hospital at Brighton passed through the fire is in grateful admiration and brotherly affection dedicated.

From the base of the Chattri, there is a pleasing panoramic view of the homes, roads and fields below, while wreaths containing poppies and pine cones entwined are scattered at the steps leading up to the memorial.

In the decades immediately after it was constructed, the Chattri quickly fell into disrepair. There were bullet holes in its structure from the years the South Downs was used for military training during the Second World War. These were repaired in the 1950s and the British Legion began holding annual ceremonies in June at the Chattri, which continued until 1999, when they had to be stopped due to the veterans ageing and becoming fewer in number. A local Sikh teacher formed a Chattri Memorial Group and, together with other British South Asians, took over managing remembrance at the site from the year 2000.[73] It was not until 2010 that the names of the fifty-three men actually cremated there were added on a separate memorial stone close to the Chattri itself, after lobbying by the Chattri Memorial Group. They are now all listed under a verse in Hindi, Punjabi and English which reads: 'In honour of these soldiers of the Indian army whose mortal remains were committed to fire.' There is also an explanatory sign nearby, offering more detail on how the men came to be cremated here and why the memorial was built.

At Horsel Common in Woking, the burial site for Muslim soldiers, a domed 'Eastern'-style gateway as recommended by the

Maulvi was created in 1917. Minarets marked the corners of a stone-and brick wall surrounding the site. The design supposedly drew inspiration from the Taj Mahal in Agra.[74] After years of neglect, however, and with the site facing vandalism, the bodies buried there were moved to Brookwood cemetery in 1968. For decades, despite the best efforts of some local people, the state of this site was representative of the way in which soldiers from the Indian subcontinent had been forgotten in Britain's national narrative of the First World War. There were occasional moments when the country was forced to remember. In 2009, a high-profile campaign for Gurkha veterans to be able to retire in the UK, supported by the actor Joanna Lumley, prompted some explanatory reporting in the press about the role of the Gurkhas who had fought in the First World War. But beyond those with particular interests in the matter, there was little recognition of these soldiers, let alone their stay here in Britain.

In recent years, there has been a change, a revival in remembrance. This is partly due to the work of tireless campaigners and also because of state-led policies to mark the centenary of the First World War; the results of these combined efforts are highly visible at the once neglected site in Woking. Work began on the site in 2013 and three years later the original burial ground was revived, with the creation of a garden of peace and remembrance. It was funded by a variety of sources including local and national government. Now it is a truly peaceful, respectful and reflective place. In the midst of tall dark everglades stands a restored walled courtyard with a domed gateway and minarets at each corner. As I enter through the arches, a long, thin, rectangular water feature is revealed at the centre of the garden. Twenty-seven Himalayan birch trees, currently bare of their leaves, have been planted around its sides to symbolise the twenty-seven men who were originally buried here. Their names have been written on a memorial stone at the back, under an Arabic phrase used by Muslims when speaking of death, translated into English as 'From God we are

and to God we go'. My quiet weekday morning visit means the sounds of the stream – trickling, dribbling and an occasional gurgle – almost block out the hum of cars on the road just feet away. Only the rumble of a plane overhead jolts the sense of tranquillity. It is a fitting tribute in pristine condition and a place Britain can be proud of.

The men who were originally buried in Woking were moved six miles away to Brookwood, where there is a cemetery so vast that getting lost is almost inevitable. They are now buried in the Military Cemetery section run by the Commonwealth War Graves Commission. A map is highly advisable. Here the graves are in perfectly formed neat rows and uniform colours, like an infantry lined up for parade inspection. Plot 2a, in the far corner, reveals the graves of the Indian First World War soldiers. They include Ahmad Khan, who was wounded in action in France and sadly died on board a ship on his way to Britain for treatment. In November 1914, his funeral was attended by a handful of individuals mainly from Woking's Muslim community and a visitor described in a newspaper report as 'an Arab from Medina'. Bunches of flowers were placed on his coffin, sent by a group of Woking women who appeared to have converted to Islam.[75] Today, each headstone features the carved insignia of the deceased's regiment, followed by an Arabic calligraphic inscription meaning 'God is forgiving', as well as the name and date of death of the man buried there. Here too is the same commonly used Arabic phrase to describe death as imprinted on the Woking memorial – 'From God we are and to God we go' – a sentence familiar to any Muslim around the world. As light drizzle falls, I watch the small plants by these tombstones sway gently. Somehow the simplicity of the site, though carefully maintained, conveys the sadness of how men far away from home and their families were laid to rest in an unfamiliar country.

Three Indian men are buried in the New Forest, close to the oldest church in the forest by the village of Brockenhurst. On a

misty morning in November, as the last of the golden-orange leaves prepare to fall from the trees, the cemetery is empty of all other visitors and there is a stillness in the air, except for the soundtrack of birds chirping and whistling their melodies so loudly it feels like they are in competition. As I look out across the horizon, the iconic animal of the area, a chestnut-coloured pony, patters softly through a field. The three men lie in a section dedicated to Commonwealth soldiers, most of whom are from New Zealand. The majority of Indian men who died of wounds while at the Lady Hardinge hospital were cremated at a site in the New Forest, but Arogyasami, Sumeer and Sukha were buried here. The last had been working as a cleaner in army camps in France and then at the hospital in Brockenhurst, where he became sick with pneumonia and died. Sukha was a Hindu, so his body was not sent to Woking like that of Muslim soldiers, but he was also considered an 'untouchable' according to the Hindu caste system and therefore his co-believers objected to carrying out a cremation. Instead Brockenhurst parishioners paid for his gravestone, and a memorial inscribed on it remains today, saying that:

> He left country, home and friends to save our King and Empire in the Great European War as a humble servant in the Lady Hardinge hospital for wounded Indian soldiers in this parish.

The site of the hospital itself is a short walk from the graveyard along a country lane. It was once nicknamed 'Tin Town' by the villagers, because of the temporary huts and structures set up to house the patients, but nowadays it is a camping and outdoor centre.

At Brighton Pavilion, the Indian gate was unveiled in 1921, a gift from several Indian maharajas and benefactors, dedicated to the inhabitants of Brighton for tending to the wartime patients. It was not designed as a memorial for the Indian soldiers, however. That came much more recently, in 2010, with a room in the building's

attic now dedicated to the memory of the patients themselves. In this gallery, objects discovered in the grounds of the Pavilion have been put on display, such as a fragment from a handwritten note listing patients' diets on a ward and a tobacco-stained glass jar with a bamboo straw placed inside it – an improvised hookah found on the site in 1916. The black-and-white postcard photographs of patients in the grounds, and of the operating rooms and kitchens at work can also be seen, as well as the propaganda film made of the King's visit. There are a couple of oil paintings too: one shows the Brighton Dome room turned into a hospital ward where the turbaned patients lie or sit on their beds; another shows a patient in a wheelchair in conversation with two companions who stand in a gap between the beds, leaning slightly against their frames, while in the background three medical attendants appear to fuss over a patient's legs. The grandeur of the setting, complete with chandeliers, is conveyed, yet the warmth of the copper and blue walls painted with oils leaves the atmosphere feeling more relaxed and intimate than the more composed photographs.[76] A third oil painting in this series is held at the Imperial War Museum. In 2016, a blue plaque in memory of Mir Dast was also unveiled at the Pavilion.

But, despite the best efforts of historical institutions and campaigners, across Britain the memory of these men still feels forgotten. Granted, there are many more displays and events, several with public funding, but the story of the Indian men who fought for Britain and those who came to the country wounded are somehow still not seen as an integral part of Britain's national memory of war. While some documentaries and exhibitions have attempted to highlight the role of colonial soldiers, in major film and television dramas there is clearly an absence of their presence, which further feeds into the myths of Britain standing alone or of the war only being fought by Europeans. At times, the telling of their story can feel tokenistic or, worse, conditional. In 2014, a think tank promoting 'British integration' found that only one in five Britons were aware that people of Muslim faith had fought for

Britain in the First World War. The think tank and a Muslim activist group then commissioned a young Muslim art student to design a poppy hijab. The clothing item featured the traditional symbol of remembrance on a scarf designed to be worn by Muslim women and was, to some extent, a well-meaning attempt to draw recognition for Muslim soldiers who had died in the First World War. But the marketing and language used to describe it was problematic; one of its advocates described it as 'a way for ordinary Muslim citizens to take some attention away from extremists'. The campaign was then seized on, with calls for Muslim women to sport the item as a way to 'defy' extremists and rebuke those who 'spout hatred' against the armed forces.[77] It almost turned into a test of patriotism. With controversy ensuing around the poppy hijab and commentaries appearing in newspapers, both for and against, sadly the clothing choices of Muslim women once again became totems in a political and cultural battle. The conversation turned to extremism and integration, rather than true remembrance.

If Britain is to properly acknowledge the debt it owes to these men, then remembrance should not be used as a vehicle to 'de-radicalise' or 'integrate' descendants of the Orient today. To do so is not just an act of disrespect, it is a flattening of history and a failure to recognise the stories of these men. Undoubtedly great acts of bravery and courage were shown, but mere platitudes about sacrifice are not enough. There is a need to recognise the truths that may be uncomfortable; whether that is the misery of trench life, the way in which the presence of these men in Britain was used as propaganda, or the efforts made to keep them away from white women.

Yet there are positives to draw on too. The First World War hospitals in Brighton and elsewhere were a model for respecting and accommodating religious practices, and the enthusiasm and generosity of many Britons towards the patients is heart-warming. Remembrance must recognise all this; that is the real tribute to the wounded soldiers.

Epilogue

IN THE SEARCH for fragments of events long forgotten, I have journeyed around Britain – along the south coast, in rural Wales, through London, Edinburgh and Glasgow – traipsing countryside and city amid imperial treasures. Among them were riches brutally plundered by the British Empire as the spoils of war, detached from their origins, their meaning and their majesty, and uprooted by the same crude and cruel twists of fate and state that brought many of us to these shores.

Along the way there were reminders too of a hidden history pre-dating the past two centuries, when the relationship between Britain (and initially England) and the Orient was one born of respect; a hunger for knowledge; and a desire to import and emulate Oriental arts, sciences and architecture.

It was not all so rosy. Of course, when the English state dined with Arab diplomats or regaled Turkish envoys, it was not curiosity alone that motivated this hospitality. Alliances were forged, however fickle, and a weak English state gradually became a British Empire, built on commercial risks taken by privateers who amassed wealth on the backs of slaves and sepoys.

The influences on British culture resulting from these ever more frequent collisions with the Orient were often regarded with suspicion. Then, as now, moral panics were manufactured by breathless xenophobes. Coffee was once regarded as the muddy puddle water that would turn the country Turk. Such moral panics continue to be manufactured, using more artful means. In recent years, for

example, similarly bizarre conspiracy theories have emerged about shari'a – a rarely understood and overused term which means 'a set of laws'. And when it is not shari'a that is the source of conspiracy theories, it is the construction of so-called 'mega-mosques'. In reality, of course, these are usually little more than modest community centres reflecting the needs of Muslims whose presence in Britain is no longer regarded – at least by them – as temporary, transient or negotiable. Sadly, a paranoid ecosystem of commentators, think tanks and media outlets who share deep-rooted ideological hostility towards Islam and Muslims seem determined to push Muslims who cannot be depoliticised or demoralised out of public life. In effect, they serve the same neurotic worldview of the Victorian courtiers horrified that the Queen would learn Urdu or keep the *Munshi* as her confidant, seeing this as a threat to the state as well as their own power base. On that front, little has changed.

But it would be a mistake to see the cosmopolitan optimism in Britain's past which embraced the Orient as merely an elite pursuit. In these pages, I have shared glimmers of how ordinary Britons reacted to and received guests and cultural influence from the Orient, with curiosity, wonder and admiration. Too often, however, their accounts and the views of ordinary people across West and South Asia in the same time period are absent. Undoubtedly, some stories in this work were easier to unravel than others. It is a sad reality that the lives of elites are considered more important and, therefore, are more frequently documented. The visits of monarchs and dignitaries were extensively reported on, as were the stories of elites of the Orient who came to serve as collaborators under British colonial rule. Nevertheless, poorer visitors from the Orient, even those who could formally or otherwise be regarded as captives, left their mark on Britain, from the prisoners turned craftspeople of the Victorian Arts and Crafts Exhibitions to the soldier patients of the First World War, even if they are absent from the British national imagination today.

That absence is the consequence of structural factors. Every now and then, a debate about the restitution of an object acquired in colonial plunder hits the headlines. Since I began this work, a conversation around historical statues in Britain has raged as a result of the Black Lives Matter protests, which in turn has led to some further questions relating to museums and places of history. In popular media narratives, these discussions have generated more heat than light.

The fact remains that too many heritage sites still tell only a monolithic, narrow story of Britain's history, which isolates these isles from their place in global exchanges of ideas, technologies, capital and culture. Too often, when Britain's place in the world is considered, the question arises only within the frame of a benevolent Britain performing the noble duty of civilising the world. Though this is obviously hokum, states need myths to justify their existence – or we would perhaps soon realise they may not be such a good idea. But such an absurd myth, and one so profoundly disrespectful to those who paid and continue to pay the price for the infrastructure and relatively luxurious living standards Britons enjoy, is unworthy of a Britain reconsidering its status and role in the world. The myth of British Empire as a civilising mission is a fairytale enthusiastically endorsed by many British adults who otherwise perceive themselves as unrelenting sceptics. This peculiar delusion is the result of a system of schooling, cultural production and political discourse which reinforces the fantasy at the expense of a collective national reckoning, with the conflict between national interest – the idea of basing foreign policy on resource grabs – and public interest – the idea of seeing foreign policy and the maintenance of global security as simultaneously competitive and collaborative, in order to protect people rather than companies or elite decision-makers.

Our heritage sites, as the gatekeepers of national memory and stewards of the perimeters of history, should be at the forefront of reimagining the national story. The narratives in this book, I

hope, offer some inspiration for those who seek to tell that story
anew, both with the hidden histories elaborated upon here and to
discover new tales that place Britain's relationship with the cultures
and peoples of the Orient in its proper context.

At the moment, as I discovered through the process of researching
this book, our heritage sites are not performing this task. It would
be unfair to single out and name particular sites. After all, this is
a structural problem. But too often the information provided on
certain objects was scant or only viewed from the perspective of
the coloniser, with scarcely a thought for the experience of those
at the receiving end of England or Britain's conquests. Despite the
appearance of neutrality, the way in which objects or artworks are
displayed and the information provided alongside them are political
choices, as are the stories told by those who guide us around places
of heritage. Many who work in these places do so by giving up
their free time and show great dedication as volunteers, seeking
out additional sources of information beyond the training they are
given. Sometimes, however, they are poorly informed or they
choose to give additional weight to their own political opinions in
the stories they tell.

Changing attitudes firstly requires action on the part of the
charitable organisations that run heritage sites. Some excellent work
is already being done. For the past few years, the National Trust
has embarked on a number of programmes 'challenging our
history'; this includes one entitled 'Colonial Countryside', a child-
led writing project which brings primary school pupils together
with experts on Caribbean and East India Company connections
to stately homes. The aim is to make the colonial connections
within country houses more widely known, and it is an engaging
project. More recently, in response to Black Lives Matter protests,
the National Trust has also explicitly stated its commitment to
uncover and tell histories of colonialism, with specific mention of
the Clive Museum at Powis Castle and Kedleston Hall. The organ-
isation says it will make its 'places and collections relevant and

responsive to increasingly diverse audiences' and that it intends to 'learn' from 'mistakes'.[1] Meanwhile, in 2019 the National Trust for Scotland identified relics in its properties which will be recognised as 'war booty' because of their links to colonial pillaging. It intends to change the way these objects are displayed with explanations recognising their 'troubling history'.[2]

It is essential that these proclamations made with good intentions result not just in the modification of displays, but in a transformation of attitude at every level. Colonial objects and, indeed, objects from the Orient generally are not niche history. They are in many ways integral to the story of Britain. Talk of engaging with 'diverse audiences' is not enough. Of course, it is important to ensure those people who would not ordinarily visit heritage sites do so – that is part of the purpose of this book too. But visitors or potential visitors to heritage sites who have their own Oriental heritage should not be seen as grateful guests who need to be taught the ways and myths of 'native' Britons. By choice and by bondage, we made these islands too. And so, clearly, much more work needs to be undertaken in terms of disseminating information to those who serve as guides in country homes, as well as in seeking out new audiences. If the moral imperative is not enough, there is a commercial case for this. Heritage sites need to be explored, enjoyed and understood by people from all walks of life to keep them viable; ensure maintenance and restoration work remain possible; and relieve the burden on charitable organisations that would otherwise bear these costs.

But change cannot only come about through heritage sites themselves and those who work in the sector. It also requires people of colour and all those wishing to explore and tell alternative stories to get involved. The objects that interest us vary according to our own backgrounds, social circle and political outlook, so it is essential to have a diversity of both background and worldview among those volunteering in heritage sites, painting different stories of Britain's history. We need visitors of all backgrounds, asking

difficult questions, demanding information where it is not forth-coming and challenging monolithic or simplistic narratives. This will allow us to hear the voices that were previously unheard and the stories that go untold.

In the course of my own education and in the observation and consumption of popular cultural conversation, I feel I have been cheated out of an alternative history, which is rich and intriguing, at times troubling, at others inspiring. In completing this work, I find myself continuing to ask questions about why the stories are not better known. How did it come to be that, in all the incessant education on and dramatisation of the Tudors, the gold-dusted letters received by Elizabeth I from Istanbul were never once considered worthy of mention? Why have all traces of a mosque at Kew been lost? How did the stories of visitors from the Orient to Britain – whether a sultan, maharajas, soldiers or prisoners turned craftsmen – become so forgotten? Why did the stories of Empire in the countries of the Orient become so divorced from what is considered the history of Britain? I am determined that future generations should not be denied these histories, and I sincerely hope that this book can serve as a leaping-off point for you to discover many more objects, characters and stories. The secrets of Britain's heritage sites await you. This is not just about whiling away weekends in museums. It is about who governs the boundaries of our collective national imagination, our self-perception and our idea of what Britain means. This matters, because the stories of yesterday inform and shape the events of today and tomorrow. Our failure to unearth history, in all its complexities, is a betrayal of the duty we owe future generations. The paintings, portraits, swirls and sculptures of our heritage sites are all crying out to us, ready to tell the stories of the characters behind them – a reminder of all that has been forgotten and all that can yet be forged. Are we ready to listen?

Notes

Introduction

1 'Enoch in India', *The Times*, 12 Feb. 1968

Chapter One – The Ambassador

1 F. H. Blackburne Daniell (ed.), *Calendar of State Papers Domestic: Charles II, 1680–1* (1921), digitised by British History Online http://www.british-history.ac.uk/cal-state-papers/domestic/chas2/1680-1

2 Ibid.

3 F. H. Blackburne Daniell (ed.), *Calendar of State Papers Domestic: Charles II, 1682* (1932), digitised by British History Online http://www.british-history.ac.uk/cal-state-papers/domestic/chas2/1682

4 *The London Gazette*, 5 Jan. 1681, issue 1684

5 John Reresby, *Memoirs of Sir John Reresby* (London, McMillan, 1813); John Evelyn, *The diary of John Evelyn 1620–1706* (Washington and London, M. W. Dunne, 1901), digitised by MSN/University of California https://archive.org/stream/diaryofjohnnevely02eveliala/diaryofjohnnevely02eveliala_djvu.txt; Narcissus Lutterell, *A brief historical relation of state affairs, from September 1678 to April 1714* (Oxford, Oxford University Press, 1857), digitised by Haathi Trust/University of Michigan https://hdl.handle.net/2027/mdp.39015008188313

6 Evelyn

7 Ibid.

8 C. H. Josten (ed.), *Elias Ashmole – His autobiographical and historical notes, his correspondence and other contemporary sources relating to his life and work* (Oxford, Clarendon Press, 1966) p. 246

9 Evelyn

10 John Spurr (ed.), *The entering book of Roger Morrice 1677–1691, Volume II The Reign of Charles II* (Woodbridge, Suffolk, The Boydell Press, 2007)

11 Blackburne Daniell (ed.), *Calendar of State Papers Domestic: Charles II, 1682*

12 Lutterell, 4 March

13 Lincoln's Inn Archives

14 Blackburne Daniell (ed.), *Calendar of State Papers Domestic: Charles II, 1682*, 15 Jan.

15 J. E. Foster (ed.), *The Diary of Samuel Newton Alderman of Cambridge 1662–1717* (Cambridge, Cambridge Antiquarian Society, 1890), p. 82

16 Blackburne Daniell (ed.), *Calendar of State Papers Domestic: Charles II, 1682*, 11 Mar.

17 Lutterell, 1 April

18 Blackburne Daniell (ed.), *Calendar of State Papers Domestic: Charles II, 1682*, 23 Apr.

19 Andrew Clark (ed.), *The Life and Times of Anthony Wood, his diaries and other papers,* Vol III (Oxford, Clarendon Press, 1894); *The London Gazette,* 1 June 1682, issue 1726

20 P. M. Holt, 'The Study of Arabic Historians in Seventeenth Century England: The Background and the Work of Edward Pococke', *Bulletin of the School of Oriental and African Studies, University of London* 19.3 (1957), pp. 444–55

21 P. M. Holt, *Studies in the History of the Near East* (London, Frank Cass and Company, 1973) pp. 16–17

22 Clark (ed.)

23 Ibid.

24 Ibid.

25 *The London Gazette,* 1 June 1682, issue 1726

26 *Impartial protestant mercury of recurrence foreign and domestick,* 28 Jan. 1681, issue 81

27 Blackburne Daniell (ed.), *Calendar of State Papers Domestic: Charles II, 1682*, 4 Feb.

28 *The London Gazette,* 23 Mar. 1682

29 Blackburne Daniell (ed.), *Calendar of State Papers Domestic: Charles II, 1682*, 13 June

30 *Impartial protestant mercury of recurrence foreign and domestick,* 13 May, issue 142; Lutterell, p. 185

31 Lutterell, p. 209

32 *Loyal Protestant and True Domestick Intelligence,* 5 Oct. 1682, issue 216; William Franklin, 'A letter from Tangier concerning the death of Jonas Rowland, the renegade, and other strange occurrences since the embassadors arival [*sic*] here', 1682, digitised by Early English Books Online http://name.umdl. umich.edu/A40405.0001.001

33 A. B., 'A letter from a Gentleman at Fez to a Person of Honour in London concerning the death of the embassadour from the Emperour of Fez and Morocco to his Majesty of great Britain', London, 1682, digitised by Early English Books Online https://collections.folger.edu/detail/A-letter-from-a-gentleman-at-Fez-to-a-person-of-honour-in-London/f9724e6d-536b-4c93-a38c-424985ace733

34 Unknown author, 'Apostacy Punish'd: or, a New poem on the deserved death of Jonas Rowland, the renegado, lately executed at Morocco', British Library

35 J. F. P. Hopkins (trans. & ed.), *Letters from Barbary 1576–1774: Arabic documents in the Public Record Office* (Oxford, Oxford University Press, 1982), p. 20

36 Ibid, p. 23.

37 Lutterell, p. 245

38 Hopkins, pp. 30–31

39 Ibid., pp. 26, 28

40 Ibid., pp. 30–31

41 Sir William Waller, 'A New Poem To Condole the going away of his excellency the Ambassador from the Emperour of Fez and Morocco to his own countrey', 24 July 1682, British Library

42 Letter from Queen Elizabeth I of England to Emperor Akbar I, Feb. 1583, quoted in Richard Hakluyt, *The principal navigations, voyages, traffiques and discoveries of the English nation* (Edinburgh, E & G Goldsmid, 1889), digitised by University of Alberta, Vol. X Asia Part III p. 9

43 Jerry Brotton, *This Orient Isle* (London, Allen Lane, 2016), p. 56; Bernadette Andrea, 'Elizabeth I and Persian Exchanges', in Charles Beem, *The Foreign Relations of Elizabeth I* (New York, Springer, 2011), pp. 186–7; Kurosh Meshkat, 'The Journey of Master Anthony Jenkinson to Persia, 1562–1563', *Journal of Early Modern History* 13.2 (2009), pp. 209–28

44 Brotton, pp. 50, 60; Janet Arnold, *Queen Elizabeth's Wardrobe Unlock'd* (Leeds, Maney & Son, 1988); Merry E. Wiesner-Hanks, *Mapping Gendered Routes and Spaces in the Early Modern World* (London, Routledge, 2016), p. 299; Bernadette Andrea, *The Lives of Girls and Women from the Islamic World in Early Modern British Literature and Culture* (Toronto, University of Toronto Press, 2017), p. 26

45 Evelyn Phillip Shirley, *The Sherley brothers, an historical memoir of the lives of Sir Thomas Sherley, Sir Anthony Sherley, and Sir Robert Sherley, knights* (London, Chiswick Press, 1848), digitised by the University of Cornell/MSN p. 59; Bernadette Andrea, *The Lives of Girls and Women*, pp. 28–35

46 Bernadette Andrea, 'Elizabeth I and Persian Exchanges', p. 178

47 S. A. Skilliter, *William Harbone and the trade with Turkey 1578–1582: A documentary study of the first Anglo-Ottoman relations* (London, The British Academy, 1977), p. 105

48 David Thomas and John Cresworth (eds), *Christian–Muslim Relations: A Bibliographical History volume 8 1600–1700* (Leiden, Brill, 2016), p. 112; Arthur John Butler (ed.), 'Elizabeth: June 1580, 1–10', in *Calendar of State Papers Foreign: Elizabeth, Volume 14, 1579–1580* (London, 1904), pp. 284–302, digitised in British History Online http://www.british-history.ac.uk/cal-state-papers/foreign/vol14/pp284-302

49 Skilliter, p. 23

50 Nabil Matar, *Turks, Moors and Englishmen in the Age of Discovery* (Cambridge, Cambridge University Press, 1999), p. 20

51 Nabil Matar, 'Elizabeth through Moroccan Eyes', in Charles Beem, *The Foreign Relations of Elizabeth I* (New York, Springer, 2011), p. 154

52 Matar, 'Elizabeth through Moroccan Eyes', pp. 158–9; Matar, *Britain and Barbary 1589–1689* (Gainesville FL, University Press of Florida, 2005), p. 13

53 Matar, *Britain and Barbary 1589–1689*, p. 16

54 Brotton, pp. 155, 171

55 Matar, *Britain and Barbary 1589–1689*, p. 25

56 Matar, *Turks, Moors and Englishmen*, p. 34

57 Thomas and Cresworth (eds), p. 141

58 Ibid., p. 111

59 Ibid.

60 Skilliter, p. 37

61 Letters between Elizabeth I and Sultana Safiye, MS Nero B VIII folio 61–62

62 S. A. Skilliter, 'Three Letters from Ottoman Sultana Safiye to Queen Elizabeth I', in S. M. Stern (ed.), *Documents from Islamic chanceries, Oriental Studies Volume III* (Oxford, Oxford University Press, 1965), p. 148

63 Skilliter, 'Three Letters', p. 132

64 Stanley Mayes, *An organ for the Sultan* (New York Putnam, 1956), p. 68

65 'Queen Elizabeth – Volume 270: January 1599', in Mary Anne Everett Green (ed.), *Calendar of State Papers Domestic: Elizabeth, 1598–1601* (1869), digitised by British History Online http://www.british-history.ac.uk/cal-state-papers/domestic/edw-eliz/1598-1601

66 John Mole (ed.), *The Sultan's Organ, London to Constantinople in 1599 and adventures on the way – The Diary of Thomas Dallam* (London, Fortune, 2012); Thomas Dallam's diary of his journey to Constantinople, MS 17480

67 Ibid.

68 Brotton, p. 228

69 Thomas and Cresworth (eds), p. 120

70 Ibid.; Brotton, p. 228

71 Mole (ed.)

72 Ibid.

73 Brotton, p. 133

74 Thomas and Cresworth (eds.), p. 128

75 Ibid., p. 215

76 Brotton, p. 8

77 Ibid., p. 211

78 Margaret Ellis, 'The Hardwick wall hangings: an unusual collaboration in English sixteenth-century embroidery', in *Renaissance Studies* 10.2, 'Women Patrons of Renaissance Art, 1300–1600' (June 1996), pp. 280–300

79 Nabil Matar, *Islam in Britain 1558–1685* (Cambridge, Cambridge University Press, 1998), p. 111

80 Brian Cowan, *The Social Life of Coffee: The Emergence of the British Coffeehouse* (New Haven CT, Yale University Press, 2008), pp. 94–5

81 Holt, *Studies in the History of the Near East*, p. 14

82 Matar, *Islam in Britain*, pp. 115–16

83 Ibid., p. 112

84 Unknown author, *The women's petition against coffee representing to publick consideration the grand inconveniencies accruing to their sex from the excessive use of that drying, enfeebling liquor: presented to the right honorable the keepers of the liberty of Venus/by a well-willer. London: [s.n.]* (1674), digitised by the University of Michigan https://quod.lib.umich.edu/e/eebo/A66888.0001.001?rgn=main; view=toc

85 Gerald Maclean and Nabil Matar, *Britain and the Islamic World 1558–1713* (Oxford, Oxford University Press, 2011), p. 19

86 John Evelyn, *The history of the three late, famous impostors, viz. Padre Ottomano, Mahomed Bei and Sabatai Sevi the one, pretended son and heir to the late Grand Signior, the other, a prince of the Ottoman family, but in truth, a Valachian counterfeit, and the last, the suppos'd Messiah of the Jews, in the year of the true Messiah, 1666: with a brief account of the ground and occasion of the present war between the Turk and the Venetian: together with the cause of the final extirpation, destruction and exile of the Jews out of the Empire of Persia* (1669), Oxford Text Archive http://hdl.handle.net/20.500.12024/A38790, pp. 33–4

87 Thomas and Cresworth (eds), pp. 535–6

88 Brotton, p. 287

89 The Othello Project, English Touring Theatre https://www.ett.org.uk/whats-on/othello/additional-events

90 Matthew Taylor, 'Racist and anti-immigration views held by children revealed in schools study', *Guardian*, 19 May 2015, https://www.theguardian.com/education/2015/may/19/most-children-think-immigrants-are-stealing-jobs-schools-study-shows

91 James Ker Lindsay, 'Did the unfounded claim that Turkey was about to join the EU swing the Brexit referendum?', London School of Economics blog, 15 Feb. 2018, http://blogs.lse.ac.uk/politicsandpolicy/unfounded-claim-turkey-swing-brexit-referendum/

92 Andrew Norfolk, 'Christian child forced into Muslim foster care', *The Times*, 28 Aug. 2017, https://www.thetimes.co.uk/article/christian-child-forced-into-muslim-foster-care-by-tower-hamlets-council-3gcp6l8cs

93 Vanessa Allen et al., 'Council finally breaks silence to insist it IS trying to place Christian girl, five, with her own family but claims 'mixed race' Muslim foster carers "CAN speak English"', *Mail Online*, 29 Aug. 2017, https://www.dailymail.co.uk/news/article-4832242/Christian-girl-s-parents-begged-stay-gran.html

94 Trevor Phillips, 'The decision to put a five-year-old Christian girl into Muslim foster care is like child abuse and the council must pay', *The Sun*, 31 Aug. 2017, https://www.thesun.co.uk/news/4357747/trevor-phillips-christian-girl-muslim-foster-care-like-child-abuse/

95 Brian Cathcart, Full text of official summary of final court judgment in 'Muslim fostering' case published at https://www.byline.com/column/68/article/2282

96 Pew Research Center, USA, July 2016, http://www.pewglobal.org/2016/07/11/negative-views-of-minorities-refugees-common-in-eu/

Chapter Two – *The Lost Mosque*

1 The Royal Botanic Gardens, Kew website states: 'The dragons were removed in 1784 and were rumoured to have been sold to settle George IV's gambling debts. However, experts believe that since they were made of wood, they had simply rotted over time', https://www.kew.org/

2 The description of the mosque is derived from William Chambers' own description and the sketches provided in *Plans, Elevations, Sections and Perspective Views of the Gardens and Buildings at Kew*, first published 1763 (Farnborough, Gregg Press Limited, reproduced 1966)

3 Wilson is widely seen as a pioneer of British landscape art. Chambers describes him as 'Mr Wilson of Covent Garden, the celebrated landscape painter', Chambers p. 6

4 Ibid.

5 Chambers provides these verses in Latin in *Plans* (p. 6), saying these were the extractions from the Qur'an and the explanations offered to him. For this page, the Latin has been translated with reference to the original Arabic verses from the Qur'an for the most appropriate English translation.

6 Ibid., p. 5

7 John Harris, *Sir William Chambers, Architect to George III* (New Haven CT, Yale University Press, 1996), p. 65

8 William Marlow, 'A View of the Wilderness at Kew, 1763', in Chambers

9 Ray Desmond, *Kew, The History of the Royal Botanic Gardens* (London, Royal Botanic Gardens/Harvill Press, 2016), p. 61

10 Ibid.

11 *Gentleman's Magazine*, vol. 42 (1772), original at Harvard University, digitised by Haathi Trust

12 Lucy Worsley, *Courtiers, The Secret History of Kensington Palace* (London, Faber and Faber, 2010)

13 Lewis Maximillian Mahomet, *Memoirs of Lewis Maximilian Mahomet* (London, H. Curll, 1727), Gale Digital Collection at the British Library

14 Ibid.

15 Ragnhild Hatton, *George I, Elector and King* (London, Thames and Hudson, 1978), p. 99

16 Worsley, p. 79

17 Hatton, p. 142

18 Mary Cowper, *Diary of Mary Cowper, Lady of the bedchamber to the Princess of Wales, 1714–1720* (London, J. Murray, 1864), digitised by University of Toronto/MSN

19 Ibid., p. 149

20 Letter from Count Broglio to King of France, 6 July 1724, included in William Coxe, *Memoirs of the Life and Administration of Sir Robert Walpole* (London, Cadell and Davies, 1798), p. 303, digitised by Google

21 James Caulfield, *Portraits, Memoirs and Characters of remarkable persons: from the revolutions in 1688 to the end of the reign of George II: collected from the most authentic accounts extant* (London, Young and Whitley, 1819), p. 124, digitised from collection at University of Wisconsin

22 John Perceval diary entry, 26 Jan. 1715, The Egmont Papers at the British Library MSS 47028

23 J. J. Caudle, 'Mustapha Ernst August', in *Oxford Dictionary of National Biography* (Oxford, Oxford University Press, 2004)

24 Sir Godfrey Kneller, *Muhammad (Mehemet)*, 1715, Royal Collection, RCIN 405430

25 J. J. Caudle, 'Muhammad Van Koningstreu', in *Oxford Dictionary of National Biography*

26 Isobel Grundy, *Lady Mary Wortley Montagu, Comet of the Enlightenment* (Oxford, Oxford University Press, 1999) p. xviii

27 Lady Mary Wortley Montagu, *Letter 'To Mr Pope', Belgrade 12 Feb. 1717*, in *The Travel Letters of Lady Mary Wortley Montagu*, ed. A. W. Lawrence, first published 1763 (London, Jonathan Cape, 1930), p. 120

28 Ibid., p. 135

29 Lady Montagu, *Letter 'To the Lady Rich', Belgrade 17 June 1717*, in Lawrence, p. 202

30 Ibid., p. 128

31 Ibid., p. 127

32 Ibid., p. 129

33 Ben Quinn, 'French police make woman remove clothing on Nice beach following burkini ban', *Guardian*, 24 Aug. 2016, https://www.theguardian.com/world/2016/aug/24/french-police-make-woman-remove-burkini-on-nice-beach

34 Grundy, p. 139

35 Lady Montagu, *Letter 'To the Countess of Bristol', Belgrade 1 Apr. 1717*, in Lawrence, p. 145

36 Lady Montagu, *Letter 'To the Countess of Mon', Belgrade 1 Apr. 1717*, in Lawrence, pp. 148–9

37 Lady Montagu, *Letter 'To Mrs Sarah Chiswell', Belgrade, 1 Apr. 1717*, in Lawrence, pp. 163–4

38 Grundy, pp. 99–101

39 Lady Montagu, *Letter 'To Mrs Sarah Chiswell', Belgrade 1 Apr. 1717*, in Lawrence, p. 164

40 A. F. M. Stone and W. D. Stone, 'Lady Mary Wortley Montagu: medical and religious controversy following her introduction of smallpox inoculation', *Journal of Medical Biography*, no. 10 (2002), p. 235

41 Lady Montagu, *Letter 'To the Countess of Bristol', Belgrade 10 Mar. 1718*, in Lawrence, p. 230

42 Vanessa Berridge, *The Princess's Garden, Royal intrigue and the Untold Story of Kew* (Stroud, Amberley, 2015), p. 138

43 *A view of Lord Bute's Erection at Kew, with some part of Kew Green and gardens*, c.1767, Royal Collection, RCIN 702946

44 Sawney Gesner, *The Scotch Broomstick & the Female Beesom, a German tale*, c.1762 and *The loaded Boot or Scotch preferment in Motion or Monsieurs will you ride*, c.1762, both at the British Museum, ref. no. 1868,0808.4262/4250

45 Berridge, p. 163

46 *Lloyds Evening Post & British Chronicle*, 24 July 1761, issue 629; *St James Chronicle*, 25 July 1761, issue 59

47 Nebahat Avcioglu, *Turquerie and the Politics of Representation 1728–1876* (Farnham, Ashgate, 2011)

48 John Sweetman, *The Oriental Obsession* (Cambridge, Cambridge University Press, 1998), p. 3

49 Theodore Cuyler Young, *Near Eastern Culture and Society* (Princeton NJ, Princeton University Press, 1951), p. 24

50 Multiple contributors, *Les Delices des Châteaux royaux: or A Pocket Companion to the Royal Palaces of Windsor, Kensington, Kew and Hampton Court* (Windsor, C. Knight, 1785), p. 40, digitised by National Library of the Netherlands

51 Desmond, p. 62

52 W. J. Bean, *The Royal Botanic Gardens, Kew: Historical and Descriptive* (London, Cassell & Co, 1908), digitised by Google

53 Desmond, p. 308

54 'Anti-mosque campaigners demonstrate through city', ITV Yorkshire, 24 Jan. 2014, http://www.itv.com/news/central/story/2014-01-18/east-anglian-patriots-march-in-lincoln/

55 'EDL anti-Islam protest and anti-racism demo in Lincoln proceed peacefully', *The Lincolnite*, 25 July 2015, https://thelincolnite.co.uk/2015/07/video-edl-anti-islam-protest-and-anti-racism-demo-in-lincoln-proceed-peacefully/

56 Richard Kerbaj and Robin Henry, '"Mosque buster" lawyer gives free advice on how to block worship', *The Times*, 13 Jan. 2013, https://www.thetimes.co.uk/article/mosque-buster-lawyer-gives-free-advice-on-how-to-block-worship-bt37p6pr3zd; Michael Safi, 'UK "mosque-buster" advising Bendigo residents opposed to Islamic centre', *Guardian*, 23 June 2014, https://www.theguardian.com/world/2014/jun/23/uk-mosque-buster-advising-bendigo-residents

57 Rosemary Belson, 'Hate crimes against UK mosques doubled in a year', *Politico*, 9 Oct. 2017, https://www.politico.eu/article/hate-crimes-against-uk-mosques-doubled-in-a-year-report/

58 Lizzie Dearden, 'Finsbury Park mosque terror attack: Victim Makram Ali's family describe trauma of losing "peaceful" grandfather', *Independent*, 2 Feb. 2018, https://www.independent.co.uk/news/uk/crime/finsbury-park-mosque-attack-victim-makram-ali-terror-grandfather-loss-trauma-osborne-darren-terror-a8191731.html

59 YouGov Poll for Caabu, 24 Sep. 2017, https://www.caabu.org/news/news/yougov-poll-british-attitudes-toward-arab-world-caabu-press-launch-arab-news

60 British Social Attitudes (BSA) National Survey, 2008, https://www.bsa.natcen.ac.uk/media/38990/bsa-26-annotated-questionnaires-2008.pdf

Chapter Three – *The Tiger and the Lion*

1 'Controversial Indian ring auctioned at Christie's', BBC News, 22 May 2014, https://www.bbc.co.uk/news/world-asia-india-27529905; Christie's, *The Raglan Collection: Wellington, Waterloo and The Crimea And Works of Art from the Collection of the Marquesses of Londonderry* (London, Christie's, 22 May 2014), https://www.christies.com/lotfinder/jewelry/an-indian-antique-gold-ring-5797668-details.aspx?from=searchresults&intObjectID=5797668&sid=64 2f32e6-1567-41d0-9720-3f8a284628e8; Bonhams, 'Tiger of Mysore Tipu Sultan's weaponry makes £6 million' (London, Bonhams, 21 Apr. 2015), https://www.bonhams.com/press_release/19055/

2 *General Evening Post* (London), 20 Mar. 1800, issue 10, 528

3 *The Times*, 17 Jan. 1785, issue 14, p. 3

4 'Song written to describe Indian campaign – to the tune of Corporal Cagey', published in various newspapers including *Ipswich Journal*, 25 Aug. 1792

5 Theodore Edward Hook, *The Life of General the Rt Hon Sir David Baird*, vol. 1 (London, R. Bentley, 1832), p. 39

6 *Chester Chronicle*, 31 Dec. 1790

7 *Hampshire Chronicle*, 10 Jan. 1791, and *Caledonian Mercury*, 3 Jan. 1791

8 *The Times*, 14 Oct. 1790, issue 1700, p. 2

9 An Officer in the East India Service, *Authentic memoirs of Tippoo Sultaun, including his cruel treatment of English prisoners* (London, M. Allen, 1799), pp. 139–45

10 Colonel Bayly, quoted in Mohammad Moienuddin, *Sunset at Srirangapatam: After the Death of Tipu Sultan* (Śrīraṅgapaṭṭaṇa India, Orient Longman, 2000), p. 90

11 Denys Forrest, *Tiger of Mysore, The Life and Death of Tipu Sultan* (London, Chatto & Windus, 1970), p. 276

12 C. H. Philips, *Young Wellington in India* (London, University of London Athlone Press, 1973), p. 8; Maya Jasanoff, *Edge of Empire: Lives, Culture, and Conquest in the East 1750–1850* (London, Fourth Estate, 2005), pp. 165–7

13 Jasanoff, p. 169; 'THE LAST DAY OF TIPPU, From information given to Colonel Beatson by Officers and Servants of the Sultan', in Reverend E. W. Thompson, *THE LAST SIEGE OF SERINGAPATAM: An Account of the Final Assault, May 4th, 1799; of the Death and Burial of Tippu Sultan; and of the Imprisonment of British Officers and Men; taken from the Narratives of Officers present at the Siege and of those who survived their captivity* (Mysore City, Wesleyan Mission Press, 1923), p. 50

14 David Price, *Memoirs of a Field Officer* (London, W. H. Allen, 1839); Thompson, p. 51; Charles Stewart, *A Descriptive Catalogue of the Oriental Library of the late*

Tippoo Sultan of Mysore (Cambridge, Cambridge University Press, 1809), pp. 88–93

15 'Major Allan's Account of his Interview with the Princes in the Palace of Seringapatam, and of finding the Body of the late Tippoo Sultaun', in Lt Col Alexander Beatson, *A View of the Origin and Conduct of the War with Tippoo Sultaun; comprising a narrative of the operations of the army under the command of Lieutenant-General George Harris, and of the siege of Seringapatam* (London, W. Bulmer & Sons, 1800), Appendix No. XLII

16 Beatson, Appendix XLII

17 'Several Particulars, relating to the Conduct of Tippoo Sultaun on the 4th of May 1799; collected chiefly from the relation of the Killadar of Seringapatam and from Accounts given by some of his own Servants', in Beatson, Appendix XXXIII

18 Hook, p. 221

19 General Alexander Walker's account, quoted in Susan Stronge, *Tipu's Tigers* (London, V&A Publishing, 2009), p. 49

20 Price, p. 429

21 E. Samuel and Lawrence Dundas Campbell (eds), *Asiatic annual register, or, A View of the history of Hindustan, and of the politics, commerce and literature of Asia*, vol. 1, 1799 (London, J. Debrett, 1800), p. 281, digitised by Princeton University/Haathi Trust

22 Letter to the Earl of Mornington, 8 May 1799, in Arthur Richard Wellesley, 2nd Duke of Wellington, ed., *Supplementary despatches and memoranda of Field Marshal Arthur, duke of Wellington, K. G.*, vol. 1 (London, John Murray, 1858–72), p. 119, digitised by University of Michigan/Haathi Trust

23 Mir Hussein Ali Khan Kirmani, *The history of the reign of Tipu Sultan*, trans. by Colonel William Miles (London, W. H. Allen, 1864), pp. 272–3

24 Hook, p. 226; Beatson, p. 168

25 Letter to the Earl of Mornington, 8 May 1799, in Wellesley, p. 119

26 Stronge, p. 16

27 Price, pp. 438–9

28 Letter from Hastings Fraser to General Harris, quoted in Moienuddin, p. 3

29 Moienuddin, p. 31

30 Price, pp. 440–1

31 Copy of a letter from Arthur Wellesley, first Duke of Wellington, to J. W. Croker, explaining his appointment in 1799 as Governor of Seringapatam, 24 Jan. 1831, The Wellington Papers Database at the University of Southampton WP1/1174/7, vol. 7, p. 396

32 Hook, p. 242

33 *Caledonian Mercury*, 28 Oct. 1799

34 Letter to the Earl of Mornington, 19 Aug. 1799, in Wellesley, p. 290

35 Moienuddin, pp. 92–3

36 'Presents from the East' reported in *Kentish Gazette*, 7 Oct. 1800; *Derby Mercury*, 9 Oct. 1800; *Chester Courant*, 9 Oct. 1800

37 Stronge, p. 50

38 Stewart, p. iii

39 Nancy K. Shields (ed.), *Birds of Passage, Henrietta Clive's Travels in South India 1798–1801* (London, Eland, 2009), p. 91

40 Stronge, p. 13

41 Jasanoff, p. 184

42 Price, p. 446

43 Ibid., p. 444

44 William Dalrymple, *The Anarchy: The Relentless Rise of the East India Company* (London, Bloomsbury, 2019)

45 Ibid., p. 138

46 *Letter from Henrietta Clive to Edward Clive, 12 July 1800*, quoted in Shields, p. 161

47 Stronge, p. 18

48 Forrest, p. 360

49 Bonhams auction house records

50 *Letter from Henrietta Clive to George Herbert, 2nd Earl of Powis*, quoted in Shields, p. 82

51 *Letter from Lord Mornington to Arthur Wellesley, 19 June 1799*, in Wellesley, p. 246

52 Mildred Archer, Christopher Rowell and Robert Skelton, *Treasures from India, The Clive Collection at Powis Castle* (London, Herbert Press in association with the National Trust, 1987), p. 95

53 *Kentish Gazette*, 7 Oct. 1800, quoted in Archer et al., p. 29

54 Shields, pp. 182–3

55 Ibid., pp. 38, 89; Archer et al., p. 29

56 Shields, p. 90

57 Ibid., p. 299; Archer et al., p. 29

58 Shields, p. 185

59 Archer et al., p. 65

60 Beatson, p. 156

61 Moienuddin, p. 42

62 *The Penny magazine of the Society for the Diffusion of Useful Knowledge*, 15 Aug. 1895 (London, Charles Knight), digitised by Haathi Trust/University of Michigan

63 *Letter from Arthur Wellesley to Lord Mornington*, 17 Aug. 1799, in Wellesley, p. 289

64 *Caledonian Mercury*, 24 Apr. 1800, and *Ipswich Journal*, 26 Apr. 1800

65 Unknown (ed.), *Narrative sketches of the Conquest of the Mysore: effected by the British Troops and their allies, in the capture of Seringapatam and the death of Tippoo Sultaun, May 4 1799: with notes, descriptive and explanatory*, second edn (London, W. Justins, 1800), digitised by MSN/University of California

66 Extract of a Letter from a Gentleman to his Friend at Calcutta, 23 Dec. 1792, in the *Gentleman's Magazine*, 63.2 (July–Dec. 1793), p. 671 (London, E. Cave, 1736–1833), digitised by Haathi Trust/Princeton University

67 Mildred Archer, *Tippoo's Tiger* (London, V&A Museum, 1959), p. 4

68 Stronge, pp. 66, 69; *Evening Mail*, 9 Dec. 1803

69 *The Penny magazine of the Society for the Diffusion of Useful Knowledge*

70 Quoted in Archer, p. 3

71 *Tippoo Saib. The Overture, Favorite Songs and Finale in the Musical Entertainment of Tippoo Saib. As performed, with universal applause, at Sadlers Wells Theatre. The words by Mr [Mark] Lonsdale. Folio. The music Composed by W[illiam] Reeve* (London, Longman & Broderip, 1791), pp. 18–19, digitised by Google

72 Forrest, p. 318

73 Anne Buddle, *Tigers around the throne, The Court of Tipu Sultan 1750–1799* (London, Zamana Gallery Limited, 1990), p. 15

74 Wilkie Collins, *The Moonstone* (London, Century, 1905)

75 'The British Lion's Vengeance on the Bengal Tiger', *Punch* 33, 22 Aug. 1857, pp. 76–7

76 Archer, p. 2

77 Stronge, p. 71

78 Buddle, p. 6

79 Subi Shah, 'Multiculturalism On TV Has Been Hijacked', *The Voice*, 22 Mar. 2014

Chapter Four – *Portraits of the Forgotten*

1 A loose drape worn over the head and shoulders by women in the Indian subcontinent

2 *The People*, 9 May 1886, p. 6; *Reynolds' Newspaper*, 9 May 1886, p. 2

3 Trailokyanātha Mukhopādhyāya (T. N. Mukharji), *A Visit to Europe* (Calcutta, W. Newman & Co, 1889), p. 67, digitised by the British Library

4 *Reynolds' Newspaper*, 9 May 1886, p. 2; *The People*, 9 May 1886, p. 6; *The Referee*, 9 May 1886, p. 2

5 Frank Cundall (ed.), *Reminiscences of the Colonial and Indian Exhibition 1886* (London, William Clowes, 1886), pp. 10–11; *Lloyd's Weekly Newspaper*, 9 May 1886, p. 3

6 Mukhopādhyāÿa, p. 251

7 Ibid., p. 27

8 Ibid., p. 106

9 Ibid., p. 102

10 Ibid., p. 132

11 *Colonial and Indian Exhibition, 1886: official catalogue* (London, William Clowes, 1886), digitised by University of Alberta; Cundall (ed.)

12 Inscription on Hastings Durbar Room; Cundall (ed.)

13 Mukhopādhyāÿa, p. 69; Cundall, p. 24

14 *The Colonial and Indian Exhibition 1886, Supplement to the Art Journal* (London, National Art Library, Victoria and Albert Museum, 1886)

15 *Pall Mall Gazette*, 4 May 1886, pp. 1–2

16 J. R. Royle, *Report on the Indian Section of the Colonial and Indian Exhibition 1886* (London, William Clowes Ltd, 1887), p. 13

17 *Penny Illustrated Paper*, 24 July 1886, p. 6

18 Mukhopādhyāÿa, p. 99

19 Queen Victoria's diary entry, 6 May 1886 (Princess Beatrice's copies), vol. 83, pp. 141–3, supplied by Royal Archive, RA VIC / MAIN / QVJ (W)

20 Ibid., 22 Apr. 1886, vol. 83, p. 119

21 *Homeward Mail from India, China and the East*, 10 May 1886, p. 8

22 The writer refers to Hindustani, this is the language now known as Hindi or Urdu, printed in *Homeward Mail from India, China and the East*, 10 May 1886, p. 8; *The Graphic*, 15 May 1886

23 *Illustrated London News*, 17 July 1886, issue 2465, p. 1

24 Cundall, p. 29; *Homeward Mail from India, China and the East*, 10 May 1886, p. 8

25 *Homeward Mail from India, China and the East*, 10 May 1886, p. 8

26 *Penny Illustrated Paper*, 24 July 1886, p. 6

27 Queen Victoria's diary entry, 8 July 1886, vol. 83, pp. 238–42

28 Saloni Mathur, *India by Design, Colonial History and Cultural Display* (Berkeley CA, University of California Press, 2007), p. 65

29 Mathur, p. 69

30 Cundall; see also Mathur, p. 66

31 Unknown author, 'ART III – The Colonial and Indian Exhibition, 1886', *Westminster Review* 126.251 (July 1886), pp. 29–59

32 *Pall Mall Gazette*, 4 May 1886, pp. 1–2

33 Oliver Millar, *The Victorian Pictures in the Collection of Her Majesty the Queen* (Cambridge, Cambridge University Press, 1992), p. 244

34 Cundall, p. 18

35 *Glasgow Herald*, 27 Jan. 1888; T. N. Mukharji, *Art Manufactures of India* (Calcutta, Superintendent of Government Printing, 1888), digitised by University of Toronto

36 *Illustrated London News*, 12 May 1888, p. 530

37 Perilla Kinchin and Juliet Kinchin, *Glasgow's Great Exhibitions* (Glasgow, White Cockade Publishing, 1988), p. 21; Jonathon Kinghorn, *Glasgow's International Exhibition 1888, Centenary Celebration* (Glasgow, Glasgow Museum & Art Galleries, 1988), p. 6

38 John Lavery, *Glasgow Exhibition* (1888), painted scene, on display in the 'Glasgow Boys Gallery' of Kelvingrove Art Gallery and Museum

39 *Glasgow Herald*, 31 May 1888; Kinchin and Kinchin, p. 9

40 'Workers at Work – the Indian workmen', Supplement – Mail Exhibition Extra, *North British Daily Mail*, 24 May 1888

41 *Glasgow Herald*, 31 May 1888; *Glasgow Herald*, 27 July 1888

42 'Workers at Work – the Indian workmen'

43 Kinghorn, p. 26

44 Sir John Lavery, *The Glasgow Exhibition, 1888*, painted scene, Tate Collection, No5271 on display in the Tate Britain main collection

45 'The Indian Workers', *Glasgow Evening Citizen*, 31 May 1888

46 Letter from Sir Fleetwood Edwards, dated 4 Oct. 1886, quoted in Millar p. 245

47 Julius Bryant and Susan Weber, *John Lockwood Kipling, Arts and Crafts in the Punjab and London* (York, York University Press, 2017), p. 447; Mathur, p. 90; Millar p. 241

48 *Edinburgh Evening News*, 23 Mar. 1892, p. 2

49 Letter from Queen Victoria to the Duke of Connaught, quoted in Millar, p. 245

50 Queen Victoria's diary entry, 9 Sep. 1888, vol. 88, p. 68; Victoria's painting is archived in the Royal Collection RCIN 980043.eb

51 Shrabani Basu, *Victoria and Abdul, The Extraordinary Story of the Queen's Closest Confidant* (Cheltenham, The History Press, 2017), p. 39

52 Queen Victoria's diary entry, 23 June 1887, vol. 85, pp. 285–7

53 Basu, pp. 66–7

54 *Munshi* was originally a Persian word used in British India as a title of respect for teachers, secretaries and translators; Queen Victoria's diary entry, 11 Aug. 1888, vol. 88, pp. 34–6

55 Queen Victoria's diary entries, 3 Aug. 1887 and 11 Nov. 1887, vol. 86, pp. 39, 127

56 *Aberdeen Evening Express*, 15 June 1894, p. 2

57 Queen Victoria's diary entry, 18 Nov. 1893, vol. 98

58 Agatha Ramm (ed.), *Beloved and Darling Child, Last Letters between Queen Victoria and her Eldest Daughter 1886–1901* (Stroud Glos., Alan Sutton, 1990), p. 163

59 Queen Victoria's diary entries, 2 Dec. 1887, vol. 86, pp. 152–4, and 4 Sep. 1891, vol. 94, p. 89

60 *Canterbury Journal Kentish Times* and *Farmers' Gazette*, 8 June 1895, p. 7

61 *Dover Express*, 24 Nov. 1893; *Pall Mall Gazette*, 4 June 1897

62 *Illustrated London News*, 20 Aug. 1892

63 British Library MSS Eur F84/126/a

64 Letters from Queen Victoria to Dr James Reid, quoted in Michaela Reid, *Ask Sir James, The Life of Sir James Reid, Personal Physician to Queen Victoria* (London, Eland, 1987), pp. 149, 151

65 Letter from Lady Curzon to Lord Curzon, 19 Aug. 1901, in John Bradley (ed.), *Lady Curzon's India, Letters of a Vicerine* (New York, Beaufort Books, 1985), pp. 125–6

66 Letter from Queen Victoria to her eldest daughter Victoria, Empress of Germany, 26 Feb. 1890, in Ramm (ed.)

67 Pervaiz Vandal and Sajida Vandal, *The Raj, Lahore and Bhai Ram Singh* (Lahore, National College of Arts Pakistan, 2006), p. 125

68 Ibid., p. 127

69 Bryant and Weber, p. 45

70 J. L. Kipling, 'Indian Architecture of Today', *The Journal of Indian Art* 1886 1(1–16), pp. 12–15

71 J. L. Kipling, 'Punjab Wood Carving', *The Journal of Indian Art* 1886 1(1–16), pp. 8–13

72 Ibid.

73 Vandal and Vandal, p. 134

74 Bryant and Weber, p. 445

75 Vandal and Vandal p. 158; Bryant and Weber, p. 435

76 Bryant and Weber, p. 441

77 Queen Victoria's diary entry, 25 June 1894, vol. 99, pp. 192–3

78 Letter from Sir Henry Ponsonby to Lockwood Kipling, 1 Nov. 1890, Kipling Papers, University of Sussex Library SxMs-38/1/1/2/2

79 Letter from Sir Henry Ponsonby to Lockwood Kipling, 3 Nov. 1890, and Copy of letter sent from Lockwood Kipling to Sir Henry Ponsonby, Kipling Papers, University of Sussex Library SxMs-38/1/1/2/2

80 Queen Victoria's diary entries: 4 Feb. 1891, vol. 93, p. 37; 21 Mar. 1891, vol. 93, p. 50; 17 Feb. 1891, vol. 93, p. 94

81 Letter from Queen Victoria to her eldest daughter Victoria, Empress of Germany, 11 Feb. 1891, in Ramm (ed.), p. 122

82 Ibid., 12 Oct. 1893, p. 162

83 Letter from Ram Singh to Lockwood Kipling, 25 July 1892, Kipling Papers, University of Sussex Library SxMs-38/1/1/2/2

84 Letters from Sir Henry Ponsonby to Lockwood Kipling, 27 Nov. 1891 and 6 Jan. 1892, Kipling Papers, University of Sussex Library SxMs-38/1/1/2/2; see also Bryant and Weber, p. 457

85 Letter from Sir Henry Ponsonby to Lockwood Kipling, 6 Jan. 1892 and Letter from Ram Singh to Lockwood Kipling, 25 July 1892, Kipling Papers, University of Sussex Library SxMs-38/1/1/2/2

86 *Birmingham Daily Post*, 25 Feb. 1892

87 Letter from Lockwood Kipling to Lockwood De Forest, 31 Mar. 1891, Kipling Papers, University of Sussex Library SxMs-38/1/1/1/2

88 Letter from Ram Singh to Lockwood Kipling, 25 July 1892, Kipling Papers, University of Sussex Library SxMs-38/1/1/2/2

89 *Southern Echo*, 20 Aug. 1892, p. 2, and 24 Dec. 1892; *Dundee Evening Telegraph*, 20 Aug. 1892, p. 2

90 *Illustrated London News*, 12 Aug. 1893, issue 2834; *The Graphic*, 29 Oct. 1892; *South Wales Daily News*, 9 Feb. 1894

91 *Southern Echo*, 20 Aug. 1892, p. 2; *The Graphic*, 14 Aug. 1897, p. 2

92 *The Graphic*, 29 Oct. 1892; *South Wales Daily News*, 9 Feb. 1894

Chapter Five – *The Durbar Court*

1 *Proclamation by the Queen in Council to the Princes, Chiefs and people of India (published by the Governor-General at Allahabad)*, 1 Nov. 1858, British Library IOR/L/PS/18/D154

2 Ian Toplis, *The Foreign Office, An Architectural History* (London, Mansell, 1987), p. 81

3 William Foster, *A Descriptive Catalogue of the Paintings, Statues &c in the India Office* (London, His Majesty's Stationery Office for the India Office, 1924), p. 12; 'The Courtyard of the India Office, Westminster', *The Builder*, 26 Oct. 1867, vol. 25

4 Foster, p. xv

5 *Pall Mall Gazette*, 27 July 1867

6 *Southampton Herald*, 29 June 1867

7 *Illustrated London News*, 1 June 1867

8 'Epitome of Opinion in the Morning Journals', *Pall Mall Gazette*, 13 July 1867

9 Freda Harcourt, 'The Queen, The Sultan and the Viceroy: A Victorian State Occasion', *The London Journal and Review of Metropolitan Society, Past and Present* 4.1 (1978)

10 Abdul Aziz made this statement in a Turkish speech, which was then translated into English for the audience at a reception in London and reported as 'The Sultan at Guildhall', *Illustrated London News*, 27 July 1867

11 *Illustrated London News*, 1 June 1867

12 *Bedfordshire Mercury*, 20 July 1867

13 *Cheltenham Examiner*, 17 July 1867

14 A photograph of Prince Yusuf taken by Queen Victoria's photographer William Downey at Buckingham Palace remains in the Royal Collection, RCIN 2908346

15 *Cheltenham Examiner*, 17 July 1867; *Glasgow Evening Citizen*, 15 July 1867

16 'The Sultan in England', *Illustrated London News*, 20 July 1867, issue 1437

17 *Glasgow Evening Citizen*, 15 July 1867

18 Queen Victoria's diary entry, 13 July 1867 (Princess Beatrice's copies), supplied by Royal Archives RA VIC/MAIN/QVJ (W)

19 *Bedfordshire Mercury*, 20 July 1867; 'The Sultan in England', *Illustrated London News*, 20 July 1867

20 'Sultan and his Music', *Pall Mall Gazette*, 17 July 1867

21 *Maidstone Journal and Kentish advertiser*, 20 July 1867

22 *Pembrokeshire Herald and General Advertiser*, 19 July 1867; *Maidstone Journal and Kentish advertiser*, 20 July 1867; *Sussex Agricultural Express*, 20 July 1867

23 *The Times*, 18 July 1867, p. 12

24 'The Wimbledon Review', *Pall Mall Gazette*, 22 July 1867; *Inverness Courier*, 25 July 1867; *Illustrated Weekly News*, 25 July 1867; *Pembrokeshire Herald and General Advertiser*, 26 July 1867

25 *The Spectator*, 20 July 1867, p. 11

26 Queen Victoria's diary entry, 17 July 1867

27 George Housman Thomas (1824–68), *The investiture of Sultan Abdülaziz I with the Order of the Garter, 17 July 1867*, watercolour painting, drawn 1867, Royal Collection RCIN 450804

28 'The India Office Ball', *Pall Mall Gazette*, 20 July 1867

29 Information from the Foreign and Commonwealth Office

30 'The Ball to the Sultan', *The Globe*, 20 July 1867

31 'Departure of the Sultan', *Greenock Telegraph and Clyde Shipping Gazette*, 24 July 1867; *Illustrated London News*, 27 July 1867

32 *Leicester Chronicle*, 27 July 1867

33 *Hansard*, 16 July 1867, HC vol. 188

34 *Pall Mall Gazette*, 20 July 1867

35 'What the Sultan said and thought of us', *Pall Mall Gazette*, 26 July 1867

36 *Canterbury Journal Kentish Times and Farmers Gazette*, 17 Aug. 1867

37 The terms Maharaja and Maharani mean Great King or Queen, while Nawab and Nizam come from Arabic and were terms used by the Mughals to denote the governor of an area

38 Waltraud Ernst and Biswamoy Pati, 'People, princes and colonialism', in Waltraud Ernst and Biswamoy Pati (eds), *India's Princely States, People, princes and colonialism* (London, Routledge, 2007); The Lord Curzon of Kedleston, Confidential Correspondence with his Majesty the King Emperor, 1901–1905, British Library IOR Mss F111/136 M

39 *Croydon's Weekly Standard*, 31 May 1902; *Northern Scot and Moray & Nairn Express*, 12 July 1902; *Bexhill on Sea Observer*, 13 Sep. 1902

40 Biswanth Das (ed.), *The Autobiography of an Indian Princess, Memoirs of Maharani Sunity Devi of Cooch Behar* (Kolkata, Theshee Book Agency, 2015)

41 'The Indians at Dover, A Curious Sight at the Pier', *Dover Express*, 6 June 1902; Sir Walter Roper Lawrence, *The India We Served* (London, Cassell & Company, 1928), p. 213

42 Risaldar Major Sheikh Fareed Sirdar Bahadur, Native ADC to the Governor of Madras, *My Coronation Visit to London* (London, Thomson & Co., 1904), p. 14

43 'The Coronation Indian Troops', *Western Daily Press*, 13 June 1902

44 Bahadur, p. 29

45 Harold Ellis, *Operations that made History* (Boca Raton FL, CRC Press, 2018)

46 *Coventry Evening Telegraph*, *Dundee Evening Post* (and many others), 24 June 1902

47 *South Wales Daily News*, 27 June 1902

48 *Daily Mail*, 26 June 1902; *Evening Star*, 26 June 1902; *The Globe*, 26 June 1902

49 *Penny Illustrated Paper*, 5 July 1902

50 *Luton Times and Advertiser*, 4 July 1902

51 Bahadur, pp. 40–1

52 Ibid., pp. 57–60

53 Ibid., p. 59

54 Ron Geaves, *Islam in Victorian Britain: The Life and Times of Abdullah Quilliam* (Leicester, Kube Publishing Ltd, 2010), pp. 1–2

55 Bahadur, p. 60

56 *Homeward Mail*, 7 July 1902

57 The Lord Curzon of Kedleston, *Confidential Correspondence with Secretary of State Lord Salisbury, & Sir A. Godley*, 15 Nov. 1901, p. 347, British Library IOR Mss F111/160

58 Ibid., 1900, p. 204, British Library IOR Mss Fiii/159
59 Das (ed.), p. 116
60 Roper Lawrence, p. 214
61 Sword and Scabbard presented to King Edward VII by the Maharaja of Jaipur, Royal Collection RCIN 11288
62 The Lord Curzon, Confidential Correspondence with his Majesty the King Emperor, 1901–1905, British Library Mss Fiii/136 M
63 'Indian Princes and Colonial Premiers at Warwick Castle', *Warwick and Warwickshire Advertiser*, 9 Aug. 1902
64 Ibid; *Homeward Mail*, 5 Aug. 1902; *Illustrated London News*, 9 Aug. 1902
65 *Hansard*, 10 July 1902, HC vol. 110
66 *Illustrated London News*, 12 July 1902; *Morning Post*, 5 July 1902; *Daily Telegraph and Courier*, 5 July 1902
67 *London Evening Standard*, 5 July 1902; *Morning Post*, 5 July 1902
68 William Hague, speech: 'Foreign Secretary opens Foreign Office language school', Foreign and Commonwealth Office, 19 Sep. 2013; James Landale, 'Foreign Languages', *Diplomat Magazine*, Apr. 2019; BBC News, 'UK diplomats have "alarming shortfall" in language skills', 27 Feb. 2015, https://www.bbc.co.uk/news/uk-politics-31646908
69 'SOAS, one of Britain's most unusual universities, is in trouble', *The Economist*, 13 June 2019
70 British Council annual language trends surveys, 2015–2019
71 Robert Long and Shadi Danechi, 'Language Teaching in Schools (England)', House of Commons Library Briefing Paper Number 07388, 16 Oct. 2019
72 Dan Fisher, 'Split Between Britain, U.S. Seen as "Inevitable": Foreign policy: The Conservative Party chairman fears that a "less European" America will provide the wedge', *Los Angeles Times*, 19 Apr. 1990, https://www.latimes.com/archives/la-xpm-1990-04-19-mn-2009-story.html

Chapter Six – *The Wounded Soldiers*

1 Jim Waterson, 'People Think Labour Is Using A Picture Of A Mosque, But It's Actually Brighton Pavilion', Buzzfeed, 25 Sep. 2017, https://www.buzzfeed.com/jimwaterson/people-are-angry-labour-is-using-a-picture-of-brighton?utm_term=.ut4g5OL7d#.eyDZxkQOL
2 Thomas and William Daniell, *Oriental scenery: ... containing ... views of the architecture, antiquities and landscape scenery of Hindoostan/by Messrs. Thomas and William Daniell; reduced from their folio edition of the same work, and carefully copied under their direction* (London, T. and W. Daniell, 1812–15)

3 Joyce Collins, *Dr Brighton's Indian Patient, December 1914–January 1916* (Brighton, Brighton Books Publishing, 1997), p. 14

4 Ibid., p. 6

5 Shrabani Basu, *For King and Another Country, Indian soldiers on the Western Front 1914–1918* (London, Bloomsbury, 2015), p. 140

6 Letter from Sir Walter Lawrence to Lord Kitchener, quoted in Andrew Jarboe, 'Indian and African soldiers in British, French and German propaganda during the First World War,' in Troy Paddock (ed.), *World War One and Propaganda* (Leiden, Brill, 2014), p. 189

7 Letter from Sir Walter Lawrence to Lord Hardinge, 16 Mar. 1915, in *Correspondence with Charles Hardinge, 1st Baron Hardinge of Penshurst (1858–1944), Viceroy of India 1910–16, mainly relating to Indian hospitals*, in Papers of Sir Walter Lawrence, IOR Mss Eur F143/73; Sir Walter Roper Lawrence, *The India We Served* (London, Cassell & Company, 1928), p. 270

8 'Brighton Pavilion for Indian Soldiers – The King's Wish', *Brighton Herald*, 28 Nov. 1914; 'A Short History in English, Gurmukhi and Urdu of the Royal Pavilion Brighton and a description of it as a hospital for Indian soldiers', Corporation of Brighton, 1915, Mss Eur F143/94; Letter to Sir Walter Lawrence, 30 Mar. 1915, in Lawrence Papers, IOR MSS EUR F143/66–69

9 Basu, p. 141; *Brighton Herald*, 28 Nov. 1914; *Nottingham Journal*, 29 Dec. 1914

10 *The Scotsman*, 4 Sep. 1915

11 Letter from Lieutenant Colonel of India Field Training Corps to the Secretary of State for India, Jan. 1915, in Lawrence Papers, IOR MSS EUR F 143/74; *The Scotsman*, 19 Dec. 1914

12 Letter from Sir Walter Lawrence to Lord Hardinge, 16 Mar. 1915, in *Correspondence with Charles Hardinge, 1st Baron Hardinge of Penshurst (1858–1944), Viceroy of India 1910–16, mainly relating to Indian hospitals*, Mss Eur F143/73

13 Collins, p. 7

14 *Surrey Mirror*, 4 Dec. 1914; *Dundee Courier*, 15 Dec. 1914; *Birmingham Daily Gazette*, 16 Dec. 1914; *Chichester Observer*, 23 Dec. 1914

15 'Indian Soldiers in the Pavilion', *Brighton Herald*, 5 Dec. 1914

16 'Three Hundred Indians Arrive', *Brighton Herald*, 13 Mar. 1915

17 'An Indian Comedy', *Brighton Herald*, 16 Jan. 1915

18 'Indian Soldiers in the Pavilion', *Brighton Herald*, 5 Dec. 1914

19 'Mayor Visits Wounded Indians', *Hastings and St Leonard's Observer*, 19 Dec. 1914

20 'The Welding of Western and Eastern thought', *Brighton Herald*, 19 Dec. 1914

21 *General correspondence about matters relating to Indian hospitals in England, Correspondence with Charles Hardinge, Viceroy of India*, in Lawrence Papers, IOR MSS EUR F143/66–69 and 73

22 'For the Indian Soldiers', *Pall Mall Gazette*, 7 Dec. 1914; Letter from the Indian Soldiers Fund to Sir Walter Lawrence, 26 Mar. 1915, in Lawrence Papers, IOR MSS EUR F143/66–69; Censor of Indian Mails 1914–1918 L/MIL/5/828 FF 1–102

23 David Omissi, *Indian voices of the Great War, Soldiers Letters 1914–18* (London, Macmillan, 1999), p. 6

24 Censor of Indian Mail 1914–1918 L/MIL/5/828 FF 1–102 and FF203–408

25 Letters about the twice-weekly Hindi and Urdu paper *Akbar-i-Jang*, with copies of letters written by Indian soldiers to the paper, Mss Eur F143/75; Letter from Havildar Ghufran Khan Afridi to Subedar Zaman Khan, quoted in Omissi p. 86

26 Censor of Indian Mails 1914–1918 L/MIL/5/828 FF203–408

27 Ibid. FF1–102, p. 118

28 'Indians Make a Snowball', *Brighton Herald*, 23 Jan. 1915

29 The *Mahabarata* is an ancient Sanskrit epic and of central importance in Hinduism; 'A Joy Day for the Wounded at Brighton', *Tatler*, 4 Aug. 1915; *West Sussex Gazette*, 11 Feb. 1915; *Brighton Herald*, 13 Feb. 1915, 6 Mar. 1915, 1 May 1915

30 Letter from Rajawali Khan to Ghulam Hussein in France, 'printed' in Omissi, p. 98

31 Letter from Buta Singh to Harnam Singh with the 23rd Pioneers in Aden, 'printed' in Omissi, p. 86

32 Censor of Indian Mails 1914–1918 L/MIL/5/828 FF203–408

33 Ibid.

34 Ibid., p. 81

35 *Arrangements to prevent free intercourse between patients of Indian hospitals Brighton and civilian population*, IOR L/MIL/7/18926; *Letter from Colonel Campbell Senior Medical Officer Pavilion and York place General hospitals for Indian Troops Brighton*, 11 Mar. 1915, Mss EUR F143/66–69; *Brighton and Hove and South Sussex Graphic*, 12 Dec. 1914

36 Letter to Sir Walter Lawrence from Chief Constable in Brighton, in Lawrence Papers, MSS EUR F143/66–69; Correspondence with Charles Hardinge, 1st Baron Hardinge of Penshurst (1858–1944), Viceroy of India 1910–16, mainly relating to Indian hospitals, Mss Eur F143/73

37 Censor of Indian Mails 1914–1918 L/MIL/5/828 FF203–408, p. 83

38 Both his names have been spelled in a number of ways e.g. Dean or Din; he also later adopted the title Sheikh, an Arabic word meaning leader, which is used as a title of respect in many Muslim cultures, this is often written as Sake in historical manuscripts referring to Deen Mohammed

39 Michael H. Fisher (ed.), *The Travels of Dean Mahomet, An Eighteenth Century Journey through India* (Berkeley CA, University of California Press, 1997)

40 Ralph Rylance, *The Epicure's Almanack; Or Calendar of Good Living: Containing a Directory to the Taverns, Coffee-houses, Inns, Eating-houses, and Other Places of Alimentary Resort in the British Metropolis and Its Environs* (London, Longman, Hurst et al., Dec. 1815); *Morning Post*, 17 Feb. 1810; *The Sun* (London), 11 Jan. 1811

41 Prasun Sonwalker, 'Menu of first Indian restaurant in UK auctioned for £8,500', *Hindustan Times*, 1 June 2018; 'Rich diet', *Telegraph of India*, 4 June 2018, https://www.telegraphindia.com/india/rich-diet/cid/1347144

42 Fisher (ed.), p. 151

43 Michael H. Fisher, *The First Indian Author in English, Dean Mahomed in India, Ireland and England (1759–1851)* (Oxford, Oxford University Press, 1996), p. 322

44 Fisher (ed.), *Travels*, pp. 161, 163

45 S. D. Mahomed, *Shampooing, or Benefits Resulting from the use of the Indian medicated Vapour Bath as introduced into this country by SD Mahomed* (Brighton, William Fleet, 1838)

46 *Brighton Gazette*, 1 June 1826

47 Fisher (ed.), *Travels*, pp. 159–60

48 Ibid., p. 173

49 S. D. Mahomed, p. 108

50 His own writings suggest he was born in 1759, so he was more likely to have been ninety-one or ninety-two when he died; however, both his gravestone and a newspaper obituary reporting his death declared he had been 101. It is unclear why.

51 *Brighton and Hove and South Sussex Graphic*, 26 Dec. 1914

52 'Lecture on the Pavilion', *Brighton Herald*, 6 Mar. 1915

53 'A Short History in English, Gurmukhi and Urdu of the Royal Pavilion Brighton and a description of it as a hospital for Indian soldiers', Corporation of Brighton, 1915, Mss Eur F143/94

54 *The People*, 10 Jan. 1915; *Sheffield Daily Telegraph*, 11 Jan. 1915; *Dundee Courier*, 11 Jan. 1915; *Volume of newspaper cuttings about the Brighton Indian hospitals*, in Lawrence Papers, Mss Eur F 143/96

55 Censor of Indian Mails 1914–1918 L/MIL/5/828 FF203–408, p. 83

56 Omissi, pp. 61–2

57 Censor of Indian Mails 1914–1918 L/MIL/5/828 FF203–408, p. 41

58 Letter from Sir Walter Lawrence to Lord Hardinge, 16 Mar. 1915, in *Correspondence with Charles Hardinge, 1st Baron Hardinge of Penshurst (1858–1944), Viceroy of India 1910–16, mainly relating to Indian hospitals*, in Lawrence Papers, Mss Eur F143/73

59 Omissi, p. 68; David Omissi, *Mir Dast* (Oxford, Oxford Dictionary of National Biography, 4 Oct. 2008); *Brighton Herald*, 28 Aug. 1915; Volume of newspaper cuttings about the Brighton Indian hospitals, in Lawrence Papers, Mss Eur F 143/96

60 Censor of Indian Mails Sep. 1916–Nov. 1916 IOR/L/MIL/5/826/8, p. 68

61 Jarboe, p. 189

62 Santanu Das, *India, Empire, and First World War Culture: Writings, Images, and Songs* (Cambridge, Cambridge University Press, 2018), p. 8; Censor of Indian Mails 1914–1918 L/MIL/5/828 FF 1–102

63 Objections to the Employment of Ladies in Indian Hospitals IOR/L/MIL/7/17316; Colonel Sir Bruce Seton, 'A report on Kitchener Indian Hospital, Brighton. c. 1916', IOR/L/MIL/17/5/2016

64 Seton

65 Censor of Indian Mails 1914–1918 L/MIL/5/828 FF 1–102, p. 120

66 Ibid., p. 125

67 Jarboe, p. 188; *'The War: Indian propaganda'*, proposed volume of 'Tales of Gallantry of the Indian troops in the Field', IOR/L/PS/11/107

68 Copies of reports and returns for the Pavilion and York Place Hospitals, Brighton, in Lawrence Papers, Mss Eur F143/81

69 Letter from Saddler Ibrahim, Jan. 1916, printed in Omissi, *Indian voices*, p. 137

70 *Maulvi* is a term used in South and Central Asia as a title of respect for a religious scholar, it originates from an Arabic term *Maulawi*; War Office Woking – arrangements with Imam of mosque, in Lawrence Papers, IOR MSS EUR F 143/80

71 Provision of burial grounds near the mosque at Woking and at Brookwood for Mahomedan soldiers who have to be interred in England IOR L/MIL/7/17232

72 General Sir James Wilcocks, *With the Indians in France* (London, Constable and Company, 1920)

73 Susan L. T. Ashley, 'Recolonising spaces of memorialising: The case of the Chattri Indian Memorial', *Organization* 23.1 (Jan. 2016)

74 'A Garden of God in England', *Times of India*, July 1916, clipping in IOR L/MIL/7/17232

75 'A Muslim Funeral', *West Surrey Times*, 13 Nov. 1914

76 Charles Burleigh, *Music Room of the Royal Pavilion as a Hospital for Indian Soldiers*, 1915, oil painting

77 Athar Ahmad, '"Poppy hijab" to mark Muslim soldier's Victoria Cross 100 years on', BBC Asian Network, BBC Online archives https://www.bbc.co.uk/news/uk-england-29833296; Jack Doyle, 'The poppy hijab that defies the

extremists: British Muslims urged to wear headscarf as symbol of remembrance', *Daily Mail*, 20 Oct 2014, *Mail Online* archives https://www.dailymail. co.uk/news/article-2813500/The-poppy-hijab-defies-extremists-British-Muslims-urged-wear-headscarf-symbol-remembrance.html

Epilogue

1 National Trust website, Addressing the histories of slavery and colonialism at the National Trust, June 2020, https://www.nationaltrust.org.uk/features/addressing-the-histories-of-slavery-and-colonialism-at-the-national-trust
2 Marc Horne, 'British Empire relics to be deemed "war booty"', *The Times*, 28 June 2019

Bibliography

Chapter One – The Ambassador
Books and Journals

Andrea, Bernadette, 'Elizabeth I and Persian Exchanges', in Charles Beem, *The Foreign Relations of Elizabeth I* (New York, Springer, 2011)

Andrea, Bernadette, *The Lives of Girls and Women from the Islamic World in Early Modern British Literature and Culture* (Toronto, University of Toronto Press, 2017)

Andrea, Bernadette, 'The Tartar Girl, The Persian Princess, And Early Modern English Women's Authorship From Elizabeth I To Mary Wroth, in Anke Gilleir, Alicia A. Montoya and Suzanna van Dijk (eds), *Women Writing Back / Writing Women Back: Transnational Perspectives from the Late Middle Ages to the Dawn of the Modern Era* (Leiden, Brill, 2010)

Andrea, Bernadette, *Women and Islam in Early Modern English Literature* (Cambridge, Cambridge University Press, 2007)

Arnold, Janet, *Queen Elizabeth's Wardobe Unlocked* (Leeds, Maney & Son, 1988)

Ben-Srhir, Khalid, *Britain and Morocco during the Embassy of John Drummond Hay 1845–1886*, trans. by Malcolm Williams (London, Routledge Curzon, 2005)

Bent, James Theodore (ed.), *Early voyages and travels in the Levant* (London, Routledge, 2017)

Brotton, Jerry, *This Orient Isle* (London, Allen Lane, 2016)

Clark, Andrew (ed.), *The Life and Times of Anthony Wood, his diaries and other papers*, vol. III (Oxford, Clarendon Press, 1894)

Cowan, Brian, *The Social Life of Coffee: The Emergence of the British Coffeehouse* (New Haven CT, Yale University Press, 2008)

Ellis, Margaret, 'The Hardwick wall hangings: an unusual collaboration in English sixteenth-century embroidery', *Renaissance Studies* 10.2, 'Women Patrons of Renaissance Art, 1300–1600' (June 1996), pp. 280–300

Epstein, Mortimer, *The Early History of the Levant Company* (London, Routledge, 1908)

Evelyn, John, *The diary of John Evelyn 1620–1706* (Washington and London, M. W. Dunne, 1901), digitised by MSN/University of California https://archive.org/stream/diaryofjohnevely02eveliala/diaryofjohnevely02eveliala_djvu.txt

Evelyn, John, *The history of the three late, famous impostors, viz. Padre Ottomano, Mahomed Bei and Sabatai Sevi the one, pretended son and heir to the late Grand Signior, the other, a prince of the Ottoman family, but in truth, a Valachian counterfeit, and the last, the suppos'd Messiah of the Jews, in the year of the true Messiah, 1666 : with a brief account of the ground and occasion of the present war between the Turk and the Venetian : together with the cause of the final extirpation, destruction and exile of the Jews out of the Empire of Persia* (1669), Oxford Text Archive http://hdl.handle.net/20.500.12024/A38790

Foster, J. E. (ed.), *The Diary of Samuel Newton Alderman of Cambridge 1662–1717* (Cambridge, Cambridge Antiquarian Society, 1890)

Foster, Sir William, *The Travels Of John Sanderson In The Levant (1584–1602)* (London, The Hakluyt Society, 1931), digitised by Public Library of India

Franklin, William, 'A letter from Tangier concerning the death of Jonas Rowland, the renegade, and other strange occurrences since the embassadors arival [*sic*] here', 1682, digitised by Early English Books Online http://name.umdl.umich.edu/A40405.0001.001

Hakluyt, Richard, *The principal navigations, voyages, traffiques and discoveries of the English nation* (Edinburgh, E & G Goldsmid, 1889), digitised by University of Alberta, vol. X Asia Part III

Holt, P. M., *Studies in the History of the Near East* (London, Frank Cass and Company, 1973)

Holt, P. M., 'The Study of Arabic Historians in Seventeenth Century England: The Background and the Work of Edward Pococke', *Bulletin of the School of Oriental and African Studies, University of London* 19.3 (1957)

Hopkins, J. F. P. (trans. and ed.), *Letters from Barbary 1576–1774 Arabic documents in the Public Record Office* (Oxford, Oxford University Press, 1982)

Josten, C. H. (ed.), *Elias Ashmole – His autobiographical and historical notes, his correspondence and other contemporary sources relating to his life and work* (Oxford, Clarendon Press, 1966)

Lutterell, Narcissus, *A brief historical relation of state affairs, from September 1678 to April 1714* (Oxford, Oxford University Press, 1857), digitised by Haathi Trust/University of Michigan https://hdl.handle.net/2027/mdp.39015008188313

Maclean, Gerald, *The Rise of Oriental Travel* (Basingstoke, Palgrave Macmillian, 2004)

Maclean, Gerald, and Nabil Matar, *Britain and the Islamic World 1558–1713* (Oxford: Oxford University Press, 2011)

Matar, Nabil, *Britain and Barbary 1589–1689* (Gainesville FL, University Press of Florida, 2005)

Matar, Nabil, *In the Lands of Christians* (London, Routledge, 2003)

Matar, Nabil, *Islam in Britain 1558–1685* (Cambridge, Cambridge University Press, 1998)

Matar, Nabil, *Turks, Moors and Englishmen in the Age of Discovery* (Cambridge, Cambridge University Press, 1999)

Matar, Nabil, 'Elizabeth through Moroccan Eyes', in Charles Beem, *The Foreign Relations of Elizabeth I* (New York, Springer, 2011)

Mayes, Stanley, *An organ for the Sultan* (New York, Putnam, 1956)

Meshkat, Kurosh, 'The Journey of Master Anthony Jenkinson to Persia, 1562–1563', *Journal of Early Modern History* 13.2 (2009)

Mole, John (ed.), *The Sultan's Organ, London to Constantinople in 1599 and adventures on the way – The Diary of Thomas Dallam* (London, Fortune, 2012)

Nash, Richard, *Wild Enlightenment, The Borders of Human Identity in the 18th Century* (Charlottesville VA, University of Virginia Press, 2003)

Reresby, John, *Memoirs of Sir John Reresby* (London, McMillan, 1813)

Rowland, Albert Lindsay, *English Commerce and exploration in the reign of Elizabeth I, England and Turkey: The Rise of Diplomatic and Commercial Relations* (Philadelphia PA, University of Pennsylvania, 1924)

Shirley, Evelyn Phillip, *The Sherley brothers, an historical memoir of the lives of Sir Thomas Sherley, Sir Anthony Sherley, and Sir Robert Sherley, knights* (London, Chiswick Press, 1848), digitised by the University of Cornell/MSN

Skilliter, S. A., 'Three Letters from Ottoman Sultana Safiye to Queen Elizabeth I', in S. M. Stern (ed.), *Documents from Islamic chanceries, Oriental studies Volume III* (Oxford, Oxford University Press, 1965)

Skilliter, S. A., *William Harbone and the trade with Turkey 1578–1582: A documentary study of the first Anglo-Ottoman relations* (London, The British Academy, 1977)

Spurr, John (ed.), *The entering book of Roger Morrice 1677–1691, Volume II The Reign of Charles II* (Woodbridge, Suffolk, The Boydell Press, 2007)

Stern, S. M. (ed.), *Documents from Islamic chanceries, Oriental studies Volume III* (Oxford, Bruno Cassirer, 1965)

Stewart, J. D., *Sir Godfrey Kneller,* National Portrait Gallery, 1971

Thomas, David, and John Cresworth (eds), *Christian–Muslim Relations: A Bibliographical History volume 8 1600–1700* (Leiden, Brill, 2016)

Unknown author, 'Apostacy Punish'd: or, a New poem on the deserved death of Jonas Rowland, the renegado, lately executed at Morocco', British Library

Unknown author, *The women's petition against coffee representing to publick consideration the grand inconveniencies accruing to their sex from the excessive use of*

that drying, enfeebling liquor: presented to the right honorable the keepers of the
liberty of Venus/by a well-willer, London: [s.n.] (1674), digitised by the University
of Michigan https://quod.lib.umich.edu/e/eebo/A66888.0001.001?rgn=main;
view=toc

Waller, Sir William, 'A New Poem To Condole the going away of his excellency
the Ambassador from the Emperour of Fez and Morocco to his own coun-
trey', 24 July 1682, British Library

Wiesner-Hanks, Merry E., *Mapping Gendered Routes and Spaces in the Early Modern
World* (London, Routledge, 2016)

Newspapers, Magazines and Websites

Allen, Vanessa, et al., 'Council finally breaks silence to insist it IS trying to place
Christian girl, five, with her own family but claims "mixed race" Muslim
foster carers "CAN speak English"', *Mail Online*, 29 Aug. 2017, https://www.
dailymail.co.uk/news/article-4832242/Christian-girl-s-parents-begged-stay-
gran.html

Cathcart, Brian, Full text of official summary of final court judgment in 'Muslim
fostering' case published at https://www.byline.com/column/68/article/2282

Impartial protestant mercury of recurrence foreign and domestic (1681, 1682) British
Library

The London Gazette (1681, 1682) British Library

Loyal Protestant and True Domestick Intelligence (1682), British Library

Norfolk, Andrew, 'Christian child forced into Muslim foster care', *The Times*,
28 Aug. 2017, https://www.thetimes.co.uk/article/christian-child-forced-
into-muslim-foster-care-by-tower-hamlets-council-3gcp6l8cs

Phillips, Trevor, 'The decision to put a five-year-old Christian girl into Muslim
foster care is like child abuse and the council must pay', *The Sun*, 31 Aug.
2017, https://www.thesun.co.uk/news/4357747/trevor-phillips-christian-girl-
muslim-foster-care-like-child-abuse/

Taylor, Matthew, 'Racist and anti-immigration views held by children revealed
in schools study', *Guardian*, 19 May 2015, https://www.theguardian.com/
education/2015/may/19/most-children-think-immigrants-are-stealing-jobs-
schools-study-shows

Manuscripts and Other Sources

A. B., 'A letter from a Gentleman at Fez to a Person of Honour in London
concerning the death of the embassadour from the Emperour of Fez and
Morocco to his Majesty of great Britain', London, 1682, digitised by Early
English Books Online https://collections.folger.edu/detail/A-letter-from-a-

gentleman-at-Fez-to-a-person-of-honour-in-London/f9724e6d-536b-4c93-a38c-424985ace733

Blackburne Daniell, F. H. (ed.), *Calendar of State Papers Domestic: Charles II, 1680–1* (1921), digitised by British History Online http://www.british-history.ac.uk/cal-state-papers/domestic/chas2/1680-1

Blackburne Daniell F. H. (ed.), *Calendar of State Papers Domestic: Charles II, 1682* (1932), digitised by British History Online http://www.british-history.ac.uk/cal-state-papers/domestic/chas2/1682

Brown, Horatio F. (ed.), *Calendar of State Papers Relating To English Affairs in the Archives of Venice*, vol. 9 (1592–1603)

Butler, Arthur John (ed.), *Calendar of State Papers Foreign: Elizabeth, Volume 14, 1579–1580* (London, 1904), digitised by *British History Online* http://www.british-history.ac.uk/cal-state-papers/foreign/vol14

Commandments from Shah Abbas of Persia regarding Sir Anthony Shirley MS Nero B VIII folios 70–72

Everett Green, Mary Anne (ed.), *Calendar of State Papers Domestic: Elizabeth, 1598–1601* (1869), digitised by British History Online http://www.british-history.ac.uk/cal-state-papers/domestic/edw-eliz/1598-1601

Ker Lindsay, James 'Did the unfounded claim that Turkey was about to join the EU swing the Brexit referendum?', London School of Economics blog, 15 Feb. 2018, http://blogs.lse.ac.uk/politicsandpolicy/unfounded-claim-turkey-swing-brexit-referendum/

Letters between Elizabeth I and Sultana Safiye, MS Nero B VIII folios 61–64

The Othello Project, English Touring Theatre https://www.ett.org.uk/whats-on/othello/additional-events

Pew Research Center USA, July 2016 http://www.pewglobal.org/2016/07/11/negative-views-of-minorities-refugees-common-in-eu/

Thomas Dallam's diary of his journey to Constantinople MS 17480

Chapter Two – The Lost Mosque
Books and Journals

Avcioglu, Nebahat, *Turquerie and the Politics of Representation, 1728–1876* (Farnham, Ashgate, 2011)

Barry, Iris, *Portrait of Lady Mary Wortley Montagu* (Aylesbury and London, Hazell, Watson and Viney Ltd, 1928)

Bean, W. J., *The Royal Botanic Gardens, Kew: Historical and Descriptive* (London, Cassell & Co., 1908)

Berridge, Vanessa, *The Princess's Garden, Royal intrigue and the Untold Story of Kew* (Stroud, Amberley, 2015)

Caudle, J. J., 'Muhammad Van Koningstreu', in *Oxford Dictionary of National Biography* (Oxford, Oxford University Press, 2004)

Caudle, J. J., 'Mustapha Ernst August', in *Oxford Dictionary of National Biography* (Oxford, Oxford University Press, 2004)

Caulfield, James, *Portraits, Memoirs and Characters of remarkable persons: from the revolutions in 1688 to the end of the reign of George II: collected from the most authentic accounts extant* (London, Young and Whitley, 1819), digitised from collection at University of Wisconsin

Cowper, Mary, *Diary of Mary Cowper, Lady of the bedchamber to the Princess of Wales, 1714–1720* (London, J Murray, 1864), digitised by University of Toronto/MSN

Coxe, William, *Memoirs of the Life and Administration of Sir Robert Walpole* (London, Cadell and Davies, 1798), digitised by Google

Cuyler Young, Theodore, *Near Eastern Culture and Society* (Princeton NJ, Princeton University Press, 1951)

Desmond, Ray, *Kew, The History of the Royal Botanic Gardens* (London, Royal Botanic Gardens/Harvill Press, 2016)

Gibbs, Lewis, *The Admirable Lady Mary – The Life and Times of Lady Mary Wortley Montagu* (London, JM Dent and sons, 1949)

Grundy, Isobel, *Lady Mary Wortley Montagu, Comet of the Enlightenment* (Oxford, Oxford University Press, 1999)

Halsband, Robert, *The Life of Lady Mary Wortley Montagu* (Oxford, Clarendon Press, 1956)

Harris, John, *Sir William Chambers, Architect to George III* (New Haven CT, Yale University Press, 1996)

Harris, John, and Michael Snodin (eds.), *Sir William Chambers: Architect to George III* (New Haven CT, Yale University Press, 1996)

Hatton, Ragnhild, *George I, Elector and King* (London, Thames and Hudson, 1978)

Howard, Phillip, *The Royal Palaces* (London, Hamish Hamilton, 1970)

Mahomet, Lewis Maximilian, *Memoirs of Lewis Maximilian, Mahomet* (London, H Curll, 1727), Gale Digital Collection at the British Library

Melman, Billie, *Women's Orients: English Women and the Middle East, 1718–1918* (London, Palgrave Macmillan, 1992)

Multiple contributors, *Les Delices des Châteaux royaux: or A Pocket Companion to the Royal Palaces of Windsor, Kensington, Kew and Hampton Court* (Windsor, C Knight, 1785), digitised by National Library of the Netherlands

Stone, A. F. M., and W. D. Stone, 'Lady Mary Wortley Montagu: medical and religious controversy following her introduction of smallpox inoculation', *Journal of Medical Biography* no. 10 (2002)

Sweetman, John, *The Oriental Obsession* (Cambridge, Cambridge University Press, 1998)

Worsley, Lucy, *Courtiers, The Secret History of Kensington Palace* (London, Faber and Faber, 2010)

Wortley Montagu, Lady Mary, *The Travel Letters of Lady Mary Wortley Montagu*, ed. A. W. Lawrence, first published 1763 (London, Jonathan Cape, 1930)

Newspapers, Magazines and Websites

Belson, Rosemary, 'Hate crimes against UK mosques doubled in a year', *Politico*, 9 Oct. 2017, https://www.politico.eu/article/hate-crimes-against-uk-mosques-doubled-in-a-year-report/

Dearden, Lizzie, 'Finsbury Park mosque terror attack: Victim Makram Ali's family describe trauma of losing "peaceful" grandfather', *Independent*, 2 Feb. 2018, https://www.independent.co.uk/news/uk/crime/finsbury-park-mosque-attack-victim-makram-ali-terror-grandfather-loss-trauma-osborne-darren-terror-a8191731.html

Gentleman's Magazine. vol. 42 (1772), original at Harvard University, digitised by Haathi Trust

Historical Account of Kew to 1841, *Bulletin of Miscellaneous information*, vol. 1891, no. 60, and vol. 1911, no. 3

ITV News, 'Anti-mosque campaigners demonstrate through city', ITV Yorkshire, 24 Jan. 2014, http://www.itv.com/news/central/story/2014-01-18/east-anglian-patriots-march-in-lincoln/

Kerbaj, Richard and Robin Henry, '"Mosque buster" lawyer gives free advice on how to block worship', *The Times*, 13 Jan. 2013, https://www.thetimes.co.uk/article/mosque-buster-lawyer-gives-free-advice-on-how-to-block-worship-bt37p6pr3zd

The Lincolnite, 'EDL anti-Islam protest and anti-racism demo in Lincoln proceed peacefully', 25 July 2015, https://thelincolnite.co.uk/2015/07/video-edl-anti-islam-protest-and-anti-racism-demo-in-lincoln-proceed-peacefully/

Lloyds Evening Post & British Chronicle, 24 July 1761, issue 629

Quinn, Ben, 'French police make woman remove clothing on Nice beach following burkini ban', *Guardian*, 24 Aug. 2016, https://www.theguardian.com/world/2016/aug/24/french-police-make-woman-remove-burkini-on-nice-beach

Safi, Michael, 'UK "mosque-buster" advising Bendigo residents opposed to Islamic centre', *Guardian*, 23 June 2014, https://www.theguardian.com/world/2014/jun/23/uk-mosque-buster-advising-bendigo-residents

St James Chronicle, 25 July 1761, issue 59

Manuscripts and Other Sources

British Social Attitudes National Survey, 2008 https://www.bsa.natcen.ac.uk/media/38990/bsa-26-annotated-questionnaires-2008.pdf

Chambers, William, *Plans, Elevations, Sections and Perspective Views of the Gardens and Buildings at Kew*, first published 1763 (Farnborough, Gregg Press Limited, 1966)

John Perceval diary entry, 26 Jan. 1715, The Egmont Papers at the British Library MSS 47028

Royal Botanic Gardens, Kew website https://www.kew.org/

YouGov Poll for Council for Arab-British Understanding (Caabu), 24 Sep. 2017, https://www.caabu.org/news/news/yougov-poll-british-attitudes-toward-arab-world-caabu-press-launch-arab-news

Chapter Three – The Tiger and the Lion
Books and Journals

An Officer in the East India Service, *Authentic memoirs of Tippoo Sultaun, including his cruel treatment of English prisoners* (London, M. Allen, 1799)

Archer, Mildred, *Tippoo's Tiger* (London, V&A Museum, 1959)

Archer, Mildred, Christopher Rowell and Robert Skelton, *Treasures from India, The Clive Collection at Powis Castle* (London, Herbert Press in association with the National Trust, 1987)

Beatson, Lt. Col. Alexander, *A View of the Origin and Conduct of the War with Tippoo Sultaun; comprising a narrative of the operations of the army under the command of Lieutenant-General George Harris, and of the siege of Seringapatam* (London, W. Bulmer & Sons, 1800)

Buddle, Anne, *Tigers around the throne, The Court of Tipu Sultan 1750–1799* (London, Zamana Gallery Limited, 1990)

Buddle, Anne, *The Tiger and the Thistle, Tipu Sultan and the Scots in India* (Edinburgh, National Gallery of Scotland, 1999)

Collins, Wilkie, *The Moonstone* (London, Century, 1905)

Dalrymple, William, *The Anarchy: The Relentless Rise of the East India Company* (London, Bloomsbury, 2019)

Desmond, Ray, *The India Museum 1801–1879* (London, Her Majesty's Stationery Office, 1982)

Forrest, Denys, *Tiger of Mysore, The Life and Death of Tipu Sultan* (London, Chatto & Windus, 1970)

Gidwani, Bhagwan S., *The Sword of Tipu Sultan, A historical novel about the life and legends of Tipu Sultan of India* (India, Allied Publishers, 1976)

Habib, Irfan (ed.), *Resistance and Modernisation under Haider Ali and Tipu Sultan* (New Delhi, Indian History Congress, 1999)

Hook, Theodore Edward, *The Life of General the Rt Hon Sir David Baird* vol. 1 (London, R. Bentley, 1832)

Husain, Mahmud (trans.), *The Dreams of Tipu Sultan* (Karachi, Pakistan Historical Society Publications, 1970)

Jasanoff, Maya, *Edge of Empire: Lives, Culture, and Conquest in the East 1750–1850* (London, Fourth Estate, 2005)

Kausar, Kabir, *Secret Correspondence of Tipu Sultan* (New Delhi, Light and Life publishers, 1980)

Kirkpatrick, Colonel William, *Select letters of Tippoo Sultan to various public functionaries* (London, Black Parry and Kingsman/The East India Company, 1811)

Kirmani, Mir Hussein Ali Khan, *The history of the reign of Tipu Sultan*, trans. by Colonel William Miles (London, W. H. Allen, 1864)

Moienuddin, Mohammad, *Sunset at Srirangapatam: After the Death of Tipu Sultan*, (Śrīraṅgapaṭṭaṇa India, Orient Longman, 2000)

Philips, C. H., *Young Wellington in India* (London, University of London Athlone Press, 1973)

Price, David, *Memoirs of a Field Officer* (London, W. H. Allen, 1839)

Quraishi, Salim al Din, *Autobiographical memoirs of Tipu Sultan* (Karnataka, India, Imprint publishing, 2010)

Samuel, E., and Lawrence Dundas Campbell (eds), *Asiatic annual register, or, A View of the history of Hindustan, and of the politics, commerce and literature of Asia*, vol. 1, 1799 (London, J. Debrett, 1800), digitised by Princeton University/Haathi Trust

Shields, Nancy K. (ed.), *Birds of Passage, Henrietta Clive's Travels in South India 1798–1801* (London, Eland, 2009)

Stewart, Charles, *A Descriptive Catalogue of the Oriental Library of the late Tippoo Sultan of Mysore* (Cambridge, Cambridge University Press, 1809)

Stronge, Susan, *Tipu's Tigers* (London, V&A Publishing, 2009)

Thompson, Reverend E. W., *The LAST SIEGE OF SERINGAPATAM: An Account of the Final Assault, May 4th, f2799; of the Death and Burial of Tippu Sultan; and of the Imprisonment of British Officers and Men; taken from the Narratives of Officers present at the Siege and of those who survived their captivity* (Mysore City, Wesleyan Mission Press, 1923)

Weller, Jac, *Wellington in India* (London, Longman Group, 1972)

Wellesley, Arthur Richard, 2nd Duke of Wellington, ed., *Supplementary despatches and memoranda of Field Marshal Arthur, duke of Wellington, K. G.*, vol. 1 (London, John Murray, 1858–72), digitised by University of Michigan/Haathi Trust

Newspapers, Magazines and Websites

BBC News website, 'Controversial Indian ring auctioned at Christie's', BBC News, 22 May 2014, https://www.bbc.co.uk/news/world-asia-india-27529905

Caledonian Mercury, 3 Jan. 1791, 28 Oct. 1799, 24 Apr. 1800, British Newspaper Archive

Chester Chronicle, 31 Dec. 1790, British Newspaper Archive

Chester Courant, 9 Oct. 1800, British Newspaper Archive

Derby Mercury, 9 Oct. 1800, British Newspaper Archive

Evening Mail, 9 Dec. 1803

General Evening Post (London), 20 Mar. 1800, issue 10 (528), 17th and 18th century, Burney Collection of Newspapers

Gentleman's Magazine, vol. 63 (2 July–Dec. 1793) (London, E. Cave, 1736–1833), digitised by Haathi Trust/Princeton University

Hampshire Chronicle, 10 Jan. 1791, British Newspaper Archive

Ipswich Journal, 'Song written to describe Indian campaign – to the tune of Corporal Cagey', 25 Aug. 1792, British Newspaper Archive

Ipswich Journal, 26 Apr. 1800, British Newspaper Archive

Kentish Gazette, 7 Oct. 1800, British Newspaper Archive

The Penny magazine of the Society for the Diffusion of Useful Knowledge, 15 Aug. 1895 (London, Charles Knight), digitised by Haathi Trust/University of Michigan

Punch, 'The British Lion's Vengeance on the Bengal Tiger', 22 Aug. 1857, no. 33, pp. 76–7

Shah, Subi, 'Multiculturalism On TV Has Been Hijacked', *The Voice*, 22 Mar. 2014

The Times, 14 Oct. 1790, issue 1700, and 17 Jan. 1785, issue 14

Manuscripts and Other Sources

Bonhams, 'Tiger of Mysore Tipu Sultan's weaponry makes £6 million' (London, Bonhams, 21 Apr. 2015), https://www.bonhams.com/press_release/19055/

Christie's, *The Raglan Collection: Wellington, Waterloo and The Crimea And Works of Art from the Collection of the Marquesses of Londonderry* (London, Christie's, 22 May 2014), https://www.christies.com/lotfinder/jewelry/an-indian-antique-gold-ring-5797668-details.aspx?from=searchresults&intObjectID=579 7668&sid=642f32e6-1567-41d0-9720-3f8a284628e8

Copy of a letter from Arthur Wellesley, first Duke of Wellington, to J. W. Croker, explaining his appointment in 1799 as Governor of Seringapatam, 24 Jan. 1831, Wellington Papers Database at the University of Southampton WP1/1174/7, vol. 7

Tippoo Saib. The Overture, Favorite Songs and Finale in the Musical Entertainment of Tippoo Saib. As performed, with universal applause, at Sadlers Wells Theatre. The words by Mr [Mark] Lonsdale. Folio. The music Composed by W[illiam] Reeve (London, Longman & Broderip, 1791), pp. 18–19, digitised by Google

Tipu Sultan papers at the British Library Mss Eur E196: 1799–1808

Unknown (ed.), *Narrative sketches of the Conquest of the Mysore: effected by the British Troops and their allies, in the capture of Seringapatam and the death of Tippoo Sultaun, May 4 1799: with notes, descriptive and explanatory* (second edn) (London, W. Justins, 1800), digitised by MSN/University of California

Chapter Four – Portraits of the Forgotten
Books and Journals

Ali, S. Amjad, *Painters of Pakistan* (Islamabad, National Book Foundation Pakistan, 1995)

Anand, Sushila, *Indian Sahib: Queen Victoria's Dear Abdul* (London, Duckworth Publishers, 1996)

Ata-Ullah, Naazish, *The Formation of Art Education in India* (London, Institute of Education, University of London, 1993)

Barringer, Tim, and Tom Flynn (eds), *Colonialism and the Object – Empire, Material Culture and the Museum* (London, Routledge, 1998)

Basu, Shrabani, *Victoria and Abdul, The Extraordinary Story of the Queen's Closest Confidant* (Cheltenham, The History Press, 2017)

Bradley, John (ed.), *Lady Curzon's India, Letters of a Vicerine* (New York, Beaufort Books, 1985)

Bryant, Julius, and Susan Weber, *John Lockwood Kipling, Arts and Crafts in the Punjab and London* (York, York University Press, 2017)

Burton, Antoniette, *At the Heart of Empire; Indians and the Colonial Encounter in Late Victorian Britain* (Berkeley CA, University of California Press, 1998)

Çelik, Zeynep, *Displaying the Orient – Architecture of Islam at Nineteenth Century World Fairs* (Berkeley CA, University of California Press, 1992)

Cundall, Frank (ed.), *Reminiscences of the Colonial and Indian Exhibition 1886* (London, William Clowes, 1886 – published with the sanction of the Royal Commission)

Hoffenburg, Peter, *An Empire on Display: English, Indian and Australian Exhibitions from the Crystal Palace to the Great War* (Berkeley CA, University of California Press, 2001)

Kinchin, Perilla, and Juliet Kinchin, *Glasgow's Great Exhibitions* (Glasgow, White Cockade Publishing, 1988)

King, Brenda M., *Silk and Empire* (Manchester, Manchester University Press, 2005)

Kinghorn, Jonathan, *Glasgow's International Exibition 1888, Centenary Celebration* (Glasgow, Glasgow Museum & Art Galleries, 1988)

Kipling, J. L., *Beast and Man in India* (London and New York, Macmillan, 1891)

Kipling, J. L., 'Indian Architecture of Today', *The Journal of Indian Art* 1 (1886) (1–16)

Kipling, J. L., 'Punjab Wood Carving', *The Journal of Indian Art* 1886 1 (1–16)

Mathur, Saloni, *India by Design, Colonial History and Cultural Display* (Berkeley CA, University of California Press, 2007)

Millar, Oliver, *The Victorian Pictures in the Collection of Her Majesty the Queen* (Cambridge, Cambridge University Press, 1992)

Mukhopādhyāya, Trailokyanātha (T. N. Mukharji), *A Visit to Europe* (Calcutta, W. Newman & Co, 1889), digitised by the British Library

Mukharji, T. N., *Art Manufactures of India* (Calcutta, Superintendent of Government Printing, Calcutta, 1888), digitised by University of Toronto

Ramm, Agatha (ed.), *Beloved and Darling Child, Last Letters between Queen Victoria and her Eldest Daughter 1886–1901* (Stroud Glos, Alan Sutton, 1990)

Reid, Michaela, *Ask Sir James, The Life of Sir James Reid, Personal Physician to Queen Victoria* (London, Eland, 1987)

Tarapor, Mahrukh, 'John Lockwood Kipling and British Art Education in India', *Victorian Studies* 24.1 (1980), pp. 53–81

Unknown author, 'ART III – The Colonial and Indian Exhibition, 1886', *Westminster Review*, vol. 126, issue 251 (July 1886)

Vandal, Pervaiz, and Sajida Vandal, *The Raj, Lahore and Bhai Ram Singh* (Lahore, National College of Arts Pakistan, 2006)

Visram, Rozina, *Ayahs, Lascars and Princes* (London, Pluto, 1986)

Zemen, Herbert, *Der Orientmaler Rudolf Swoboda 1859–1914 Lebed und Werk* (Vienna, Privatdruck, 2004) (German)

Newspapers, Magazines and Websites

Birmingham Daily Post, 25 Feb. 1892, British Newspaper Archive

Aberdeen Evening Express, 15 June 1894, British Newspaper Archive

Canterbury Journal, 8 June 1895, British Newspaper Archive

Dover Express, 24 Nov. 1893, British Newspaper Archive

Dundee Evening Telegraph, 20 Aug. 1892, British Newspaper Archive

Edinburgh Evening News, 23 Mar. 1892, British Newspaper Archive

Farmers' Gazette, 8 June 1895, British Newspaper Archive

Glasgow Evening Citizen, 31 May 1888, British Newspaper Archive

Glasgow Herald, 27 Jan. 1888, 31 May 1888, 27 July 1888, British Newspaper Archive

The Graphic, 15 May 1886, 29 Oct. 1892, 14 Aug. 1897, British Newspaper Archive

Homeward Mail from India, China and the East, 10 May 1886, British Newspaper Archive

Illustrated London News, 17 July 1886, 12 May 1888, 20 Aug. 1892, 12 Aug. 1893, *Illustrated London News* Historical Archive

Kentish Times, 9 June 1895, British Newspaper Archive

Lloyd's Weekly Newspaper, 9 May 1886, British Newspaper Archive

North British Daily Mail, 24 May 1888, British Newspaper Archive

Pall Mall Gazette, 4 May 1886, 4 June 1897, British Newspaper Archive

Penny Illustrated Paper, 24 July 1886, British Newspaper Archive

The People, 9 May 1886, British Newspaper Archive

The Referee, 9 May 1886, British Newspaper Archive

Reynolds' Newspaper, 9 May 1886, British Newspaper Archive

Southern Echo, 20 Aug. 1892 and 24 Dec. 1892, British Newspaper Archive

South Wales Daily News, 9 Feb. 1894, British Newspaper Archive

Manuscripts and Other Sources

British Library MSS Eur F84/126/a

Colonial and Indian Exhibition, 1886 official catalogue, William Clowes, 1886, digitised by University of Alberta

The Colonial and Indian Exhibition 1886, Supplement to the Art Journal (London, National Art Library, Victoria and Albert Museum, 1886)

Letters to and from Lockwood Kipling, Kipling Papers, University of Sussex Library SxMs-38/1/1/1/2 and SxMs-38/1/1/2/2

Queen Victoria's diary entries, Supplied by Royal Archives RA VIC/MAIN/QVJ (W) (Princess Beatrice's copies), vols 83, 85, 86, 88, 93, 94, 98, 99

Royle, J. R., *Report on the Indian Section of the Colonial and Indian Exhibition 1886* (London, William Clowes Ltd, 1887)

Vere Boyle, Eleanor, *A London Sparrow at the Colinderies* (London, Sampson Low, 1886)

Chapter Five – The Durbar Court
Books and Journals

Bahadur, Risaldar Major Sheikh Fareed Sirdar, Native ADC to The Governor of Madras, *My Coronation Visit to London* (London, Thomson & Co., 1904)

Bodley, John Edward Courtenay, *The Coronation of Edward VII* (London, Methuen and Co., 1903)

'The Courtyard of the India Office, Westminster', *The Builder*, 26 Oct. 1867, vol. 25

Das, Biswanth (ed.), *The Autobiography of an Indian Princess, Memoirs of Maharani Sunity Devi of Cooch Behar* (Kolkata, Theshee Book Agency, 2015)

Ellis, Harold, *Operations that made History* (Boca Raton FL, CRC Press, 2018)

Ernst, Waltraud, and Biswamoy Pati (eds), *India's Princely States, People, princes and colonialism* (London, Routledge, 2007)

Foster, William, *A Descriptive Catalogue of the Paintings, Statues &c in the India Office* (London, His Majesty's Stationery Office for the India Office, 1924)

Geaves, Ron, *Islam in Victorian Britain: The Life and Times of Abdullah Quilliam* (Leicester, Kube Publishing Ltd, 2010)

Harcourt, Freda, 'The Queen, The Sultan and the Viceroy: A Victorian State Occasion', *The London Journal and Review of Metropolitan Society, Past and Present* 4.1 (1978)

Harris, Russell, *The Lafayette Studio and Princely India* (India, Lustre Press, 2001)

Ramusack, Barbara N., *The Indian Princes and their States* (Cambridge, Cambridge University Press, 2004)

Roberts, Jane (ed.), *Royal Treasures, A Golden Jubilee Collection* (London, Royal Enterprises Ltd/HM Queen Elizabeth II, 2002)

Robinson, John Martin, *The Wyatts, An Architectural Dynasty* (Oxford, Oxford University Press, 1979)

Roper Lawrence, Sir Walter, *The India We Served* (London, Cassell & Company, 1928)

Seldon, Anthony, *An Illustrated History of the Place and its People* (London, HarperCollins, 2000)

Toplis, Ian, *The Foreign Office, An Architectural History* (London, Mansell, 1987)

Vadgama, Kusoom, *India in Britain, The Indian Contribution to the British way of life* (London, Robert Royce Ltd, 1984)

Newspapers, Magazines and Websites

BBC News, 'UK diplomats have "alarming shortfall" in language skills', 27 Feb. 2015, https://www.bbc.co.uk/news/uk-politics-31646908

Bedfordshire Mercury, 20 July 1867, British Newspaper Archive

Bexhill on Sea Observer, 13 Sep. 1902, British Newspaper Archive

Canterbury Journal Kentish Times and Farmers Gazette, 17 Aug. 1867, British Newspaper Archive

Cheltenham Examiner, 17 July 1867, British Newspaper Archive

Coventry Evening Telegraph, 24 June 1902, British Newspaper Archive

Croydon's Weekly Standard, 31 May 1902, British Newspaper Archive

Daily Mail, 26 June 1902, Associated Newspapers Limited

Daily Telegraph and Courier, 5 July 1902, British Newspaper Archive

Dover Express, 'The Indians at Dover, A Curious Sight at the Pier', 6 June 1902, British Library Newspapers

Dundee Evening Post, 24 June 1902, British Newspaper Archive

The Economist, 'SOAS, one of Britain's most unusual universities, is in trouble', 13 June 2019

Evening Star, 26 June 1902, British Newspaper Archive

Fisher, Dan, 'Split Between Britain, U.S. Seen as "Inevitable": Foreign policy: The Conservative Party chairman fears that a "less European" America will provide the wedge', *Los Angeles Times*, 19 Apr. 1990, https://www.latimes.com/archives/la-xpm-1990-04-19-mn-2009-story.html

Glasgow Evening Citizen, 15 July 1867, British Newspaper Archive

The Globe, 'The Ball to the Sultan', 20 July 1867, British Newspaper Archive

The Globe, 26 June 1902, British Newspaper Archive

Greenock Telegraph and Clyde Shipping Gazette, 'Departure of the Sultan', 24 July 1867, British Newspaper Archive

Homeward Mail, 7 July 1902 and 9 Aug. 1902, British Newspaper Archive

Illustrated London News, 1 June 1867, 27 July 1867, 12 July 1902 and 9 Aug. 1902, *Illustrated London News* Archive

Illustrated London News, 'The Sultan in England', 20 July 1867, issue 1437, *Illustrated London News* Archive

Illustrated London News, 'The Sultan at Guildhall', 27 July 1867, *Illustrated London News* Archive

Illustrated Weekly News, 25 July 1867, British Newspaper Archive

Inverness Courier, 25 July 1867, British Newspaper Archive

Landale, James, 'Foreign Languages', *Diplomat Magazine*, Apr. 2019

Leicester Chronicle, 27 July 1867, British Library Newspapers

London Evening Standard, 5 July 1902, British Newspaper Archive

Luton Times and Advertiser, 4 July 1902, British Newspaper Archive

Maidstone Journal and Kentish advertiser, 20 July 1867, British Newspaper Archive

Morning Post, 5 July 1902, British Newspaper Archive

Northern Scot and Moray & Nairn Express, 12 July 1902, British Newspaper Archive

Pall Mall Gazette, 'Epitome of Opinion in the Morning Journals', 13 July 1867, British Newspaper Archive

Pall Mall Gazette, 'The India Office Ball', 20 July 1867, British Newspaper Archive

Pall Mall Gazette, 'Sultan and his Music', 17 July 1867, British Newspaper Archive

Pall Mall Gazette, 'What the Sultan said and thought of us', 26 July 1867, British Newspaper Archive

Pall Mall Gazette, 'The Wimbledon Review', 22 July 1867, British Newspaper Archive

Pall Mall Gazette, 20 July 1867 and 27 July 1867, British Newspaper Archive

Pembrokeshire Herald and General Advertiser, 19 July 1867 and 26 July 1867, Welsh Newspapers Online – National Library of Wales

Penny Illustrated Paper, 5 July 1902, British Newspaper Archive

Southampton Herald, 29 June 1867, British Library Newspapers

South Wales Daily News, 27, June 1902, British Newspaper Archive

The Spectator, 20 July 1867, p. 11, The *Spectator* Archive

Sussex Agricultural Express, 20 July 1867, British Newspaper Archive

The Times, 18 July 1867, p. 12, The *Times* Digital Archive

Warwick and Warwickshire Advertiser, 'Indian Princes and Colonial Premiers at Warwick Castle', 9 Aug. 1902, British Newspaper Archive

Western Daily Press, 'The Coronation Indian Troops', 13 June 1902, British Newspaper Archive

Manuscripts and Other Sources

British Council annual language trends surveys, 2015–2019

Confidential Summary of the Proceedings of the Government of India in the Foreign Department during the Viceroyalty of Lord Curzon of Kedleston, January 1899 to November 1905 Native States, Superintendent Government Printing, Calcutta, India, 1908 British Library IOR Mss F111/541

Foreign and Commonwealth Office

Hague, William, speech: 'Foreign Secretary opens Foreign Office language school', Foreign and Commonwealth Office, 19 Sep. 2013

Hansard, 16 July 1867, HC vol. 188, and 10 July 1902, HC vol. 110

India Office records and private papers: *Payment to contractors for work at new India Office,* IOR/ L/ SUR/2/5, *Names of Indian 'Worthies' for busts in new India Office, Sale of Fittings from Sultan's Ball, Repairs to furniture damaged at ball* IOR/L/ SUR/2/6 f166, f453, f463

Long, Robert, and Shadi Danechi, 'Language Teaching in Schools (England)', House of Commons Library Briefing Paper Number 07388, 16 Oct. 2019

The Lord Curzon of Kedleston, Confidential Correspondence with Secretary of State Lord Salisbury, & Sir A. Godley, 1900 and 1901, British Library IOR Mss F111/159–160

The Lord Curzon of Kedleston, Confidential Correspondence with his Majesty the King Emperor, 1901–1905, British Library IOR Mss F111/136 M

Proclamation by the Queen in Council to the Princes, Chiefs and people of India (published by the Governor-General at Allahabad), 1 Nov. 1858, British Library IOR/L/PS/18/D154

Queen Victoria's diary entry, 13 July 1867 and 17 July 1867 (Princess Beatrice's copies). Supplied by Royal Archives RA VIC/MAIN/QVJ (W)

Chapter Six – The Wounded Soldiers
Books and Journals

Ashley, Susan L. T., 'Recolonising spaces of memorialising: The case of the Chattri Indian Memorial', *Organization, the Critical Journal of Organization, Theory and Society* 23. 1 (Jan. 2016)

Basu, Shrabani, *For King and Another Country, Indian soldiers on the Western Front 1914–1918* (London, Bloomsbury, 2015)

Collins, Joyce, *Dr Brighton's Indian Patient, December 1914–January 1916* (Brighton, Brighton Books Publishing, 1997)

Daniell, Thomas and William, *Oriental scenery: ... containing ... views of the architecture, antiquities and landscape scenery of Hindoostan/by Messrs. Thomas and William Daniell; reduced from their folio edition of the same work, and carefully copied under their direction* (London, T. and W. Daniell, 1812–15)

Das, Santanu, *India, Empire, and First World War Culture: Writings, Images, and Songs* (Cambridge, Cambridge University Press, 2018)

Fisher, Michael H., *The First Indian Author in English, Dean Mahomed in India, Ireland and England (1759–1851)* (Oxford, Oxford University Press, 1996)

Fisher, Michael H. (ed.), *The Travels of Dean Mahomet, An eighteenth century journey through India* (Berkeley CA, University of California Press, 1997)

Innes, Lynn, 'Ignatius Sancho and Sake Dean Mahomed', in Susheila Nasta (ed.), *Reading the New Literatures in a Postcolonial Era* (Cambridge, The English Association/DS Brewer, 2000)

Jarboe, Andrew, 'Indian and African soldiers in British, French and German propaganda during the First World War', in Troy Paddock (ed.), *World War One and Propaganda* (Leiden, Brill, 2014)

Mukerji, Ashok, *Valour and Sacrifice, The First Indian Soldiers in Europe 1914–1916* (London, High Commission of India London, 2010)

Omissi, David, *Indian voices of the Great War, Soldiers Letters 1914–18* (London, Macmillan, 1999)

Omissi, David, *Mir Dast* (Oxford, Oxford Dictionary of National Biography, 4 Oct. 2008)

Mahomed, S. D., *Shampooing, or Benefits Resulting from the use of the Indian medicated Vapour Bath as introduced into this country by SD Mahomed* (Brighton, William Fleet, 1838)

Roper Lawrence, Sir Walter, *The India We Served* (London, Cassell & Company, 1928)

Rylance, Ralph, *The Epicure's Almanack; Or Calendar of Good Living: Containing a Directory to the Taverns, Coffee-houses, Inns, Eating-houses, and Other Places of*

Alimentary Resort in the British Metropolis and Its Environs (London, Longman, Hurst et al., Dec. 1815)

Stigger, Philip, 'How far was the loyalty of Muslim soldiers in the Indian army more in doubt than usual throughout the First World War', *Journal of the Society for Army Historical Research*, 87.225–223 (2003)

Willcocks, General Sir James, *With the Indians in France* (London, Constable and Company, 1920)

Newspapers, Magazines and Websites

Ahmad, Athar, '"Poppy hijab" to mark Muslim soldier's Victoria Cross 100 years on', BBC Asian Network, BBC Online archives, https://www.bbc.co.uk/news/uk-england-29833296

Birmingham Daily Gazette, 16 Dec. 1914, British Newspaper Archive

Brighton Gazette, 1 June 1826, British Newspaper Archive

Brighton Herald, 13 Feb., 6 Mar., 1 May and 28 Aug. 1915, British Newspaper Archive

Brighton Herald, 'Brighton Pavilion for Indian Soldiers – The King's Wish', 28 Nov. 1914, British Newspaper Archive

Brighton Herald, 'Three Hundred Indians Arrive', 13 Mar. 1915, British Newspaper Archive

Brighton Herald, 'An Indian Comedy', 16 Jan. 1915, British Newspaper Archive

Brighton Herald, 'Indian Soldiers in the Pavilion', 5 Dec. 1914, British Newspaper Archive

Brighton Herald, 'Indians Make a Snowball', 23 Jan. 1915, British Newspaper Archive

Brighton Herald, 'Lecture on the Pavilion', 6 Mar. 1915, British Newspaper Archive

Brighton Herald, 'The Welding of Western and Eastern thought', 19 Dec. 1914, British Newspaper Archive

Brighton and Hove and South Sussex Graphic, 12 Dec. and 26 Dec. 1914, British Newspaper Archive

Chichester Observer, 23 Dec. 1914, British Newspaper Archive

Doyle, Jack, 'The poppy hijab that defies the extremists: British Muslims urged to wear headscarf as symbol of remembrance', *Daily Mail*, 20 Oct. 2014, *Mail Online* archives, https://www.dailymail.co.uk/news/article-2813500/The-poppy-hijab-defies-extremists-British-Muslims-urged-wear-headscarf-symbol-remembrance.html

Dundee Courier, 15 Dec. 1914 and 11 Jan. 1915, British Newspaper Archive

Hastings and St Leonard's Observer, 'Mayor Visits Wounded Indians', 19 Dec. 1914, British Newspaper Archive

Morning Post, 17 Feb. 1810, British Newspaper Archive

Nottingham Journal, 29 Dec. 1914, British Newspaper Archive

Pall Mall Gazette, 'For the Indian Soldiers', 7 Dec. 1914, British Newspaper Archive

The People, 10 Jan. 1915, British Newspaper Archive

The Scotsman, 19 Dec. 1914 and 4 Sep. 1915, British Newspaper Archive

Sheffield Daily Telegraph, 11 Jan. 1915, British Newspaper Archive

Sonwalker, Prasun, 'Menu of first Indian restaurant in UK auctioned for £8,500', *Hindustan Times*, 1 June 2018

The Sun (London), 11 Jan. 1811, British Newspaper Archive

Surrey Mirror, 4 Dec. 1914, British Newspaper Archive

Tatler, 'A Joy Day for the Wounded at Brighton', 4 Aug. 1915, British Newspaper Archive

Telegraph of India, 'Rich diet', 4 June 2018, https://www.telegraphindia.com/india/rich-diet/cid/1347144

Times of India, 'A Garden of God in England', July 1916, clipping in IOR L/MIL/7/17232

Waterson, Jim, 'People Think Labour Is Using A Picture Of A Mosque, But It's Actually Brighton Pavilion', Buzzfeed, 25 Sep. 2017, https://www.buzzfeed.com/jimwaterson/people-are-angry-labour-is-using-a-picture-of-brighton?utm_term=.ut4g5OL7d#.eyDZxkQOL

West Surrey Times, 'A Muslim Funeral', 13 Nov. 1914, British Newspaper Archive

West Sussex Gazette, 11 Feb. 1915, British Newspaper Archive

Manuscripts and Other Sources

Arrangements to prevent free intercourse between patients of Indian hospitals Brighton and civilian population, IOR L/MIL/7/18926

Colonel Sir Bruce Seton, 'A report on Kitchener Indian Hospital, Brighton. c.1916', IOR/L/MIL/17/5/2016

Letter from Colonel Campbell Senior Medical Officer Pavilion and York place General hospitals for Indian Troops Brighton, 11 Mar. 1915, Mss EUR F143/66–69

Letters about the twice-weekly Hindi and Urdu paper *Akbar-i-Jang*, with copies of letters written by Indian soldiers to the paper, Mss Eur F143/75

Objections to the Employment of Ladies in Indian Hospitals, IOR/L/MIL/7/17316

Papers of Sir Walter Lawrence, Indian Civil Service, Punjab 1879–95, Private Secretary to Viceroy 1899–1903, Commissioner for sick and wounded Indian soldiers in France and England 1914–16 (1872–1940) IOR MSS EUR F143 (various correspondence and documents)

Provision of burial grounds near the mosque at Woking and at Brookwood for Mahomedan soldiers who have to be interred in England, IOR L/MIL/7/17232

Reports of the Censor of Indian Mails in France: vol. 1. (Dec. 1914–Apr. 1915) and vol. 2 (Sep. 1916–Nov. 1916), 1914–1918, IOR/L/MIL/5/825/1, 826/8 and IOR/L/MIL/5/828 (printed reports and abstracts, with related correspondence)

'A Short History in English, Gurmukhi and Urdu of the Royal Pavilion Brighton and a description of it as a hospital for Indian soldiers', Corporation of Brighton, 1915, Mss Eur F143/94

'The War: Indian propaganda', proposed volume of 'Tales of Gallantry of the Indian troops in the Field', IOR/L/PS/11/107

Epilogue

Horne, Marc, 'British Empire relics to be deemed "war booty"', *The Times*, 28 June 2019

National Trust website, Addressing the histories of slavery and colonialism at the National Trust, June 2020, https://www.nationaltrust.org.uk/features/addressing-the-histories-of-slavery-and-colonialism-at-the-national-trust

List of Illustrations

p. 41: 'The women's petition against coffee' pamphlet (1674), courtesy of the Folger Shakespeare Library and licensed under CC BY-SA 4.0; **p. 50:** Plans for the Mosque at Kew © RBG Kew; **p. 53:** *A View of the Wilderness, with the Alhambra, the Pagoda and the Mosque* © RBG Kew; **p. 54:** The King's staircase, Kensington Palace, London © Tony French/Alamy Stock Photo; **p. 95:** Anna Tonelli, *Tipu Sultan Seated on His Throne* (1800), on display at Powis Castle/Clive Museum; **p. 97:** Tiger finial from the throne of Tipu Sultan. Photo courtesy of Bonhams; **p. 101:** Tipu's cannon, on display at Powis Castle/Clive Museum. Photo © Fatima Manji; **p. 134:** John Lavery, *Potter at Work* (1888), on display at Kelvingrove Art Gallery and Museum. Photo © Glasgow Museums; **p. 136:** Rudolf Swoboda, *Munni* (1886–88) and *Shanker Girr* (1886–88) © Royal Collection Trust/Her Majesty Queen Elizabeth II, 2021; **p. 146:** Bhai Ram Singh at work in the Indian Room, Osborne House, Isle of Wight (1892). Photo by English Heritage/Heritage Images/Getty Images; **p. 148:** Detail of the peacocking carving in the Durbar Room, Osborne House, Isle of Wight (*c.* 1990–2010). Photo by English Heritage/Heritage Images/Getty Images; **p. 155:** The Durbar Court at the Foreign and Commonwealth Office, London © Dirk Hedemann/Alamy Stock Photo; **p. 167:** Ball in Honour of the Sultan at the New India Office, Westminster, London, from the *Illustrated London News* (1867) © Artokoloro/Alamy Stock Photo; **p. 176:** Sir Benjamin Stone, *Indian officers on the terrace at the house of Commons* (1902) © Royal Collection Trust/Her Majesty Queen Elizabeth II, 2021; **p. 204:** Magic lantern slide showing Indian soldiers in beds in the Music Room of the Royal Pavilion during its use as a Military Hospital (1915). Courtesy of the Royal Pavilion & Museums, Brighton & Hove; **p. 205:** Front cover of *Indian Military Hospital Royal Pavilion Brighton, 1914–1915: A Short History in English, Gurmukhi and Indian.* Courtesy of the Royal Pavilion & Museums, Brighton & Hove; **p. 208:** Monochrome photograph showing Jemadar Mir Dast surrounded by British army personnel,

taken in the grounds of the Royal Pavilion shortly after he was awarded the Victoria Cross (1915). Courtesy of Royal Pavilion & Museums, Brighton & Hove.

Plate I

Sir Godfrey Kneller and Jan Wyck, *Mohammed Ohadu, the Moroccan Ambassador* (1684) © Historic England Photo Library • Sir Anthony Van Dyck, *Sir Robert Shirley* (1622), Petworth House © NTPL; Sir Anthony Van Dyck, *Teresa, or Teresia Sampsonia, Lady Shirley* (1622), Petworth House © National Trust Images/Derrick E. Witty; 'True Faith and Mahomet', sixteenth-century silk hanging on display at Hardwick Hall, Derbyshire © Bridgeman Images • Sir Godfrey Kneller, *Mehemet (d. 1726)* (1715) © Royal Collection Trust/Her Majesty Queen Elizabeth II, 2021 • *Lady Mary Wortley Montagu with her son, Edward Wortley Montagu, and attendants*, attributed to Jean Baptiste Vanmour, oil on canvas (*c.* 1717) © National Portrait Gallery, London; Robert Home, *The Reception of the Mysorean Hostage Princes by Marquis Cornwallis, 26 February 1792* (*c.* 1793), on display at the National Army Museum, London.

Plate II

Sir David Wilkie, *General Sir David Baird Discovering the Body of Sultan Tippoo Sahib after Having Captured Seringapatam, on the 4th May, 1799* (1839), on display at the Scottish National Gallery, presented by Irvine Chalmers Watson, received 1985; Huma Bird, Bird of Paradise (*c.* 1787–91) from the throne of Tipu Sultan © Royal Collection Trust/Her Majesty Queen Elizabeth II, 2021; Tipu's tent (1725–50), Powis Castle and Garden © National Trust/David Brunetti • Rudolf Swoboda, *Bakshiram* (1886) © Royal Collection Trust/Her Majesty Queen Elizabeth II, 2021; Rudolf Swoboda, *Ramlal* (1886) © Royal Collection Trust/Her Majesty Queen Elizabeth II, 2021 • George Housman Thomas, *The investiture of Sultan Abdülaziz I with the Order of the Garter, 17 July 1867* (1867) © Royal Collection Trust/Her Majesty Queen Elizabeth II, 2021; Thomas Mann Baynes, *Sake Deen Mahomed* (*c.* 1810). Courtesy of the Royal Pavilion & Museums, Brighton & Hove • Monochrome photograph showing four wounded Gurkha soldiers in the gardens of the Royal Pavilion, taken during its use as an Indian Military Hospital (1915); Monochrome photographic postcard showing a group of Indian soldiers from the Kitchener Hospital in Elm Grove and British children gathered on the Race Hill, Brighton (1915). Both images courtesy of the Royal Pavilion & Museums, Brighton & Hove.

Acknowledgements

The process of writing history is almost always about imagining the future. Above all else, I owe thanks to all those who have taught me how to imagine the future – my parents, family, teachers and friends – and without whom the ideas that led to the production of this book would never have coalesced.

I am, of course, indebted to all the historians and scholars who have carried out so much vital research on the specific periods of history or characters that pop up in this book. They have made my work possible, and immeasurably easier. I urge you to use the bibliography to seek out their writing and learn more about the exchanges, alliances, rivalries and conflicts of which I have only been able to give a superficial rendering.

My family and friends have so patiently put up with my obsessions and convinced me that others may find them interesting too. They diligently traipsed around the country to visit heritage sites with me; helped me think differently about a line or a section when I became stuck; and perhaps most importantly have been wise enough to know when not to ask me about the book. You know who you are and you *should* know that I cannot thank you enough for your eager cheerleading.

My agent Emma Paterson believed in this book when it was merely a series of inchoate thoughts. She has walked me through every step of the process and been an invaluable guide to the quirks of the publishing industry. Emma helped me find a publisher that felt like a comfortable home. I would also like to thank Emma's assistant Monica MacSwan and colleague Steph Adam.

It has been a joy to work with the visionary team at Chatto & Windus. I am grateful to publishing director Clara Farmer, who expressed enthusiasm for my proposal and has been incredibly supportive and encouraging throughout. My brilliant editor Charlotte Humphery has worked incredibly hard to mould this book out of rough clay. Both her critical eye and her patient manner have been much appreciated.

The process of transforming ideas into a book is a finicky and painstaking one. I am thankful to production controller Eoin Dunne for helping bring the book to life, while assistant editor Tom Atkins has been a meticulous and organised taskmaster. The beautiful image adorning the front of the book is the work of designer Kishan Rajani and illustrator Namrata Kumar. It is a real delight to me that the cover is an exquisite artwork in itself, and I am very grateful to the team for their sustained work in establishing the right tone.

For their diligence and eagle-eyed reading, I would like to thank copy-editor Sharmilla Beezmohun, proof-reader Katherine Fry and indexer Alex Bell. Fran Owen, Mari Yamazaki and Sue Amaradivakara have worked on publicity with zeal and a deep understanding of the purpose of this book.

I cannot show enough gratitude to those who agreed to be interviewed for and/or consulted on this book. Some have been individually named in chapters. Others would rather not be. I am incredibly grateful to you all. In particular, Professor Tanveer Ahmed, Professor Jerry Brotton, Farookh Dhondy and Vinay Patel gave gracefully of their time and provided immensely valuable input that always pushed me to think anew about the ideas and history I was confronting, whether early-modern or contemporary.

I am also hugely grateful to staff at the various archival sites I visited, but especially to those at the British Library. While the librarians in the Rare Books, Manuscripts, and Asian and African Reading Rooms provided patient and clear guidance, the security guards supplied conversation and much-needed laughter on frustrating days.

I would also like to thank the curators, guides and volunteers at all of the heritage sites mentioned in this book. So many of them pointed me in the right direction; attempted to seek out information for me; and sometimes even snuck me into places I was not meant to be. A special mention should also be made of online archivists, some of whom have put together very well-crafted websites for the organisations mentioned herein. These were often crucial in helping me check factual details.

Visiting sites of art and culture is, unfortunately, very often too expensive. They belong to us all and should be much more accessible. The National Art Pass scheme enabled me to enter many sites for free or a reduced fee, which was invaluable for repeated research visits. It is an excellent programme from the National Art Collections Fund which I have been pleased to support. I was first introduced to the Art Pass by an elderly lady I got chatting to in Greenwich many moons ago – a serendipitous exchange without which the curiosity that led to this book may perhaps not have been stimulated in the same way. She, therefore, deserves special thanks.

My editor at *Channel 4 News*, Ben de Pear, has been immensely supportive and allowed me a little time and space away from the newsroom to research this work, despite the sheer frenzy of the news agenda in the last few years. Also deserving of gratitude are my many kind colleagues who have expressed support for the book and an unwavering belief in my abilities. In particular, my friend and producer Nanette Van der Laan, who shares an enthusiasm for museums and galleries, has been a great sounding board on long journeys to cover culture stories.

Finally, but perhaps most pertinently, I want to thank you for choosing to pick up this book. When I said I looked forward to hearing from you about the subjects raised here, I meant it. Shower me with lore about the objects and places you have found, and share your reflections. Culture is a dynamic process, not a cold, incontrovertible set of myths preserved in aspic. I hope this book begins new ways of thinking about culture for you, or at the very least is the inspiration for new conversations about our past, our identities, our place and our responsibilities.

Since early 2020, we have faced frightening and heartbreaking times in the pandemic. Far too many have left us too soon, and so many more around the world are still suffering. As I worked through editing this text in 2020, I often wondered if it was frivolous to write about art and myopic to reflect on politics.

But I realised that as the possibilities in our everyday lives narrowed and our opportunities for journeying to new cultures were limited, we needed more than ever to open our minds and reflect more deeply on the heritage that has been hidden from us. In the wake of the pandemic, rapid technological change will promise new ways to master information about other cultures as a tool of domination. It is up to us all to ensure that the pursuit of cultural knowledge is always an act of liberation.

Fatima Manji
May 2021

Index